Past and Present in Art and Taste

Francis Haskell
Past and Present in Art and Taste

Selected Essays

YALE UNIVERSITY PRESS
NEW HAVEN AND LONDON, 1987

To the memory of Benedict Nicolson

Designed by Faith Brabenec Hart
Filmset in Monophoto Bembo and printed in Great Britain by
BAS Printers Limited, Over Wallop, Hampshire

Library of Congress Cataloging-in-Publication Data

Haskell, Francis, 1928–
 Past and present in art and taste.

 Includes index.
 1. Aesthetics, Modern—18th century. 2. Aesthetics,
Modern—19th century. 3. Art patronage. I. Title.
N66.H28 1987 701′.1′7 86-24581
ISBN 0-300-03607-8

Introduction

THE CONVENTIONS governing the publication of a volume of this kind are now so well defined as to be almost obligatory. The author acknowledges that each separate essay is concerned with a different subject and was written under different circumstances but claims that despite this a certain continuity of theme underlying them all justifies their appearance together in a single volume. I am not quite sure to what extent this Introduction can conform to the general pattern. When it was suggested that I should collect some of my writings (this diffidence of tone is, of course, also obligatory), I looked through the available material and quickly realised that such unity as might be claimed for them would essentially be based on a series of negatives.

In the first place I was determined not to include any book reviews,★ and it then became clear to me that one thing that bound the remaining papers together was that (with the possible exception of 'The Apotheosis of Newton in Art') not one of them bore any direct relationship to my first book, *Patrons and Painters*.

When this was published in 1963, I was frequently asked to lecture and write again on the patronage of Italian seventeenth and eighteenth-century art which I had already explored in that book. Because I felt that I had exhausted everything I had to say on the subject, I decided that I would like to look at (and write about) the art of a different country and a different period.

I had ended *Patrons and Painters* by (implicitly) regretting the triumph of neo-classicism and by speculating why Italian art which had dominated European taste for so long ceased to be of universal significance after the eighteenth century. Soon afterwards, when asked to give a lecture (at the Slade School of Art), I chose to give a very tentative and exploratory talk about French 'academic' art which had, in part, emerged from neo-classicism and which had, in the nineteenth century, been of universal significance—but was now forgotten and despised. I suppose that I must have been hoping that giants would be discovered among the artists to be investigated, just as—a couple of generations or so earlier—giants had been discovered among the mass of Italian Baroque painters who had also been forgotten and despised. If that was my hope I was certainly disappointed. The subject continued to fascinate me, however, long after it was clear that the genuine discoveries to be made would concern only painters of relatively minor quality, because it presented me with

★ In this way the present volume differs very considerably from a selection of my essays published in Italian in 1978 by S.P.E.S. of Florence, *Arte e Linguaggio della Politica e altri saggi*.

a problem which had not hitherto attracted my attention much, but which now began to obsess me: the problem of the relativity of taste. This obsession eventually led to the publication of my second book, *Rediscoveries in Art,* and the absence from this volume of any essay directly related to that book (with the possible exception of 'Giorgione's *Concert champêtre* and its Admirers') gives it yet another claim to a form of unity built upon negatives.

When I first began to try to study the pictures and critical fortunes of Gérôme, Bouguereau and other acclaimed painters of the nineteenth century who had fallen into oblivion, I thought that I was being wholly original. I later found that a few art historians had preceded me, and, still later, I discovered that, far from being on my own, I was—as it were—part of a 'movement': just one of an increasingly large number of writers, many of them far more committed than I was to the values that were being rediscovered, who were anxious to look at 'The Two Sides of the Medal' (the name given to a pioneering exhibition of 'French Painting from Gérôme to Gauguin' held at the Detroit Institute of Arts in 1954). This caused me certain problems, which are partly responsible for the nature of the present volume.

I had once thought that it would not be excessively difficult to write an interesting book on a phenomenon which had never occurred before the nineteenth and early twentieth centuries: that is, the hostility met with, at the beginning of their careers and sometimes for much longer, by almost all those painters whom we today consider to have been the true creative innovators of their period and the huge success enjoyed by those Salon painters whose art seemed to be based on outworn formulas. Though I would not put the issue in quite that way today, I still think that such a book would be interesting and I would still like to write it. But the increasing number of articles and exhibitions, many of them of great value, devoted to the 'Non-dissenters' (the self-explanatory title of a series of shows of French nineteenth-century art held in a New York gallery in the 1960s) soon showed me that I had been wrong, and that it *would* be excessively difficult to write the book I had had in mind.

The assumptions I had been making, the provisional theories I had been formulating, were sustainable only so long as not too much was known about the period. They begin to dissolve in the blazing light now being directed at 'The Neglected Nineteenth Century' (the name of yet another exhibition held, in two parts in 1970 and 1971, at a New York art gallery). I did nonetheless write a number of shorter pieces which do (I believe) retain some validity, and three of these—'The Manufacture of the Past in Nineteenth-Century Painting', 'Art and the Language of Politics', 'Enemies of Modern Art'—are reprinted here, along with three others which are closely related to the theme—'The Sad Clown', 'The Old Masters in Nineteenth-Century French Painting' and 'Doré's London'. Thus another negative that characterises the frantically sought-for unity of this volume is the inclusion in it of fragmented ideas and proposals for a book that I have not (yet) written.

At a time when I was, however, still actively engaged in trying to write it, I received an invitation to take part in a conference in Rome to celebrate the bicentenary in 1976 of the publication of the *Decline and Fall of the Roman Empire.* It was a curious invitation both because I had never written a word about Gibbon and also because Gibbon's interest

in the history of art was negligible. This small conference turned out to be the most enjoyable and fruitful I have ever attended, and some of its consequences are to be seen in this volume—though it will not be apparent from them that much of the work I have been engaged in since arose from discussions held at that time. I found myself forced to think of some of the ways in which Gibbon and other historians had used, or misused, the evidence apparently provided by the visual arts when they tried to understand the past and at the same time of the ways in which art historians had used, or misused, Gibbon and other historians in order to interpret the art which interested them. Various papers I wrote on Leopoldo Cicognara who, with Seroux d'Agincourt, was the greatest art historian to study Gibbon are too slight to be reprinted here, and in some ways it is unfortunate that the only art historian of the second half of the eighteenth century to reveal an interest in the wider intellectual currents of his time to whom an essay is devoted in this volume should be the imaginative but disreputable 'Baron' d'Hancarville. I am, however, engaged in writing a full-scale book about the relationship between Historians and the Visual Arts, which I hope will be published before too long, and meanwhile it is perhaps not too specious to claim that there is a certain affinity between d'Hancarville and the English dealer, collector and pamphleteer Morris Moore (my essay on whom was originally published in French), another obsessive crank who yet managed to interest some of the more sensitive and intelligent men of the day by raising issues which are still problematic. The remaining three essays in the volume are concerned with three men—Sommariva, Khalil Bey and Benjamin Altman—from different cultures and periods whose collecting and patronage nonetheless raises in each case that eternally fascinating question of the ill-defined relationship between social ambition and true dedication to art.

Since the original appearance of these essays a great deal has been published on most of the topics discussed in them. The problem of how to cope with this sort of situation is not really soluble. I have decided to reprint the essays as they stand except for the silent correction of errors of fact and of misprints, although in one case ('The Apotheosis of Newton in Art') I have made more substantial changes because of the reappearance of a most important picture which was not known in 1967, and I have also made some fairly drastic cuts to 'Enemies of Modern Art' so as to avoid repetition of material which appears in 'Art and the Language of Politics'. However, where I am aware of new research which significantly affects my conclusions I have indicated this either in a note or in an appendix to the essay concerned. I have occasionally changed the original illustrations when new or more appropriate pictures have come to light, and I have sometimes given quotations at greater length than in the first version of these essays. Finally I have eliminated colloquialisms from those essays which were originally published as the lectures they had once been. This procedure is bound to be somewhat arbitrary, especially as much material of the utmost intrinsic value and interest is certain to have been omitted. But any attempt at completeness would only swamp a volume of this kind and destroy any claim to unity, however precarious, that could be made on its behalf. I have arranged the essays approximately in chronological order of the events with which they deal, though their nature means that this cannot always be done satisfactorily; but I have, of course, indicated precisely when and where each one originally appeared.

———————

One contribution differs fundamentally in character from all the others, and must therefore be referred to separately. The volume is dedicated to the memory of a close friend, Benedict Nicolson, who died in 1978. I have therefore decided to reprint the obituary of him that I wrote for the *Burlington Magazine* of July in that year, incorporating into it two important corrections made in a letter to the magazine by Nigel Nicolson.

———————

Contents

List of Illustrations

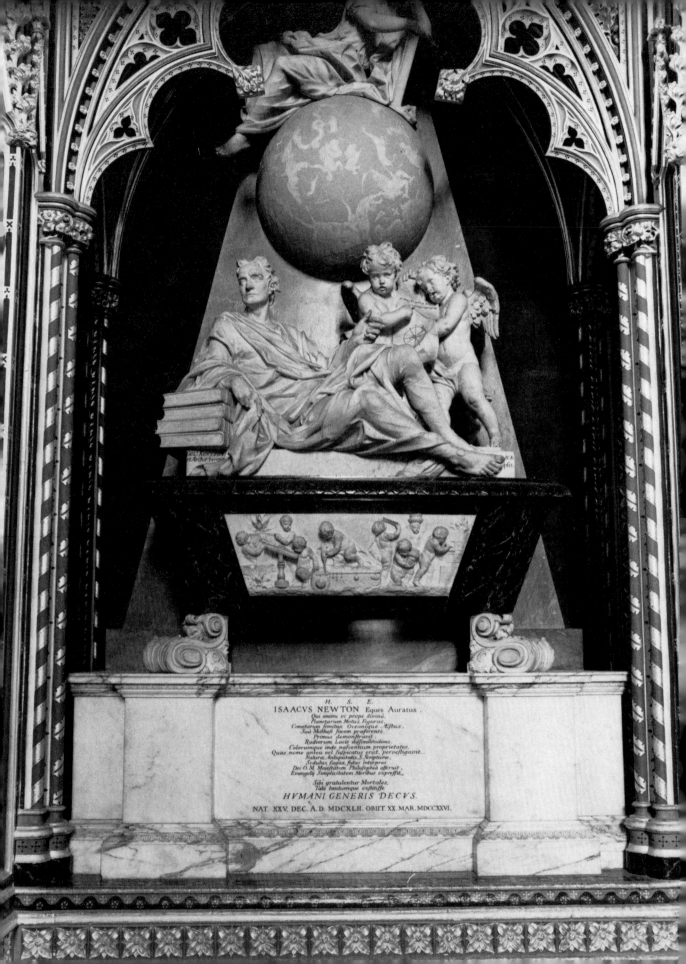

H. S. E.
ISAACVS NEWTON Eques Auratus,
Qui animi vi prope divinâ,
Planetarum Motus, Figuras,
Cometarum femitas, Oceanique Æstus.
Suâ Mathesi facem præferente,
Primus demonstravit:
Radiorum Lucis dissimilitudines,
Colorumque inde nascentium proprietates,
Quas nemo antea vel suspicatus erat, pervestigavit.
Naturæ, Antiquitatis, S. Scripturæ,
Sedulus, sagax, fidus Interpres
Dei O. M. Majestatem Philosophiâ afferuit,
Evangelii Simplicitatem Moribus expressit.
Sibi gratulentur Mortales,
Tale tantumque exstitisse
HVMANI GENERIS DECVS.
NAT. XXV. DEC. A.D. MDCXLII. OBIIT. XX. MAR. MDCCXXVI.

1. The Apotheosis of Newton in Art

'Had this great and good man', wrote John Conduitt in a short note just after Sir Isaac Newton's death in 1727, 'lived in an age when those superiour Genii inventors were Deified or in a country where mortals are canonised he would have had a better claim to these honours than those they have hitherto been ascribed to; his virtues proved him a Saint and his discoveries might well pass for miracles.'[1] Conduitt need not have been so jealous for his uncle's fame. As the century advanced Newton virtually was canonised—not only in England which, with King Charles I, had made such a limited and hitherto unpromising selection of saints, but also in countries which had a superfluity of the more conventional sort.

Well before Newton's death a poet could write of a vision:

> 'Tis Newton's soul that daily travels here
> In search of knowledge for Mankind below,[2]

and the sentiment was echoed on the Continent. Indeed part of the enthusiasm aroused by Newton in England is unquestionably due to the fact that he was one of the first Englishmen ever to attract really serious intellectual attention abroad. Fontenelle, Voltaire, Conti, Algarotti and a host of others spread his reputation throughout the world. Voltaire was not exaggerating when he wrote: 'We are now all the disciples of Newton.'[3] Such was the enthusiasm that he aroused in Algarotti, author in 1737 of *Newtonianismo per le dame* soon translated into English as *Sir Isaac Newton's philosophy explain'd for the use of the ladies,* that on the tomb that Frederick the Great had erected for his Italian friend in Pisa were merely inscribed the words: 'Algarotto/Ovidii Aemulo/Newtoni Discipulo.'

The enthusiasm is easy enough to explain. It has been convincingly argued that the hostility of the Enlightenment to the Catholic Church did not involve a corresponding weakening of religious sentiment.[4] For many people Newton merely replaced a more distant and shadowy creator as an object of adoration—a sentiment naïvely and clumsily expressed the year after his death and echoed throughout the century:

> Nature, compelled, his piercing Mind obeys,
> And gladly shows him all her secret ways;
> 'Gainst Mathematics she has no Defence,
> And yields t'experimental Consequence.[5]

1. Kent and Rysbrack: Monument to Sir Isaac Newton (London, Westminster Abbey)

The experiments into light and those into gravitation were of equal importance in arousing such fanatical adoration, for Newton's main achievement, in the eyes of the eighteenth century, was something much greater than either: it lay in showing that in whatever field man chose to explore, he could by his own efforts discover a rational purpose behind creation.

> Nature and Nature's Laws lay hid in night:
> God said, Let Newton be—And all was light.

The literary and philosophical consequences that followed from this assumption have been extensively discussed. But little attention has been paid to the effect of the worship of Newton on the visual arts. And in doing so I have been enormously helped by being able to draw upon a mass of unpublished manuscripts of great interest, shown to me by the librarian of my college, Mr A. N. L. Munby.

During his lifetime a very large number of portraits were painted of Newton—by Lely, Sir Godfrey Kneller, Vanderbank, Thornhill, William Gandy and others. The period of his life was probably the dimmest in the whole history of English art, and it seems to me that few if any of these rise much above the mediocre. Certainly none of them presents any particular interest for the present study.

The first great opportunity for a memorial came with the erection of Newton's tomb in Westminster Abbey. This was commissioned from William Kent and the Flemish sculptor Michael Rysbrack by John Conduitt, and it was completed in 1731, four years after Newton's death (Fig. 1).[6] A number of preliminary sketches exist, and to these already known I would like to add an unpublished drawing among the Conduitt papers in Cambridge (Fig. 2). This has recently been shown to be by Alexander Pope (see Appendix), though it must certainly follow very closely one made by Conduitt himself, who—as we will shortly see—was always keen on devising guide lines for the artists he employed. It is interesting because it includes an alternative version of Pope's famous verses, 'All Nature and its laws lay hid in Night', and all the essential features of the tomb as it was eventually executed—the reclining figure of Newton, the pyramid and the globe. Pope's lines were in fact published only in 1735, but we know from a letter that has survived that he and Conduitt were in correspondence about Sir Isaac Newton in November 1727,[7] and it is now clear that the famous lines were actually written for the tomb, but were then rejected for obvious reasons.

The symbolism is explained in a note in *The Gentleman's Magazine* of 22 April 1731: 'Behind the Sarcophagus is a Pyramid; from the middle of it a Globe arises in Mezzo Relievo, on which several of the Constellations are drawn, in order to shew the path of the Comet in 1681, whose period he has with the greatest Sagacity determin'd. And also the Position of the solstitial Colure mention'd by Hipparchus, by which (in his Chronology) he has fixed the time of the Argonautic Expedition—On the Globe sits the Figure of Astronomy weeping, with a Sceptre in her Hand, (as Queen of the Sciences) and a Star over the Head of the Pyramid.'[8]

We know that John Conduitt himself was responsible for choosing this highly complex scheme, for among his papers in Cambridge is a note by him outlining his ideas for the

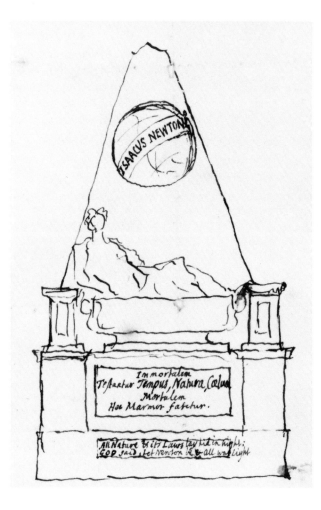

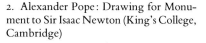

2. Alexander Pope: Drawing for Monument to Sir Isaac Newton (King's College, Cambridge)

bas-reliefs on the sarcophagus itself: 'In the Mainground—A boy weighing in a stillyard as in (a) the sun against all the other planets—On one side—a boy looking up to the sky thro' a prism, another looking thro' a reflecting Telescope. On the other side an aloes in a flower pott, to denote Vegetation and a limbeck to denote Chymistry, and a boy near pouring coin out of a horn; if the coins are so large as to be distinguished they may be the coins of K.Wm. Q.Anne. & K.G. those being the reigns in wch he was Master of the Mint.'[9] Conduitt, as we will see, was nothing if not thorough. The reliefs, as finally modified, are described in *The Gentleman's Magazine*: 'On a Pedestal is placed a Sarcophagus (or Stone Coffin) upon the front of which are Boys in Basso-relievo with instruments in their hands, denoting his several discoveries, viz. one with a Prism on which principally his admirable Book of Light and Colours is founded; another with a reflecting Telescope, whose great Advantages are so well known; another Boy is weighting the Sun and Planets with a Stilliard, the Sun being near the Centre on one side, and the Planets on the other, alluding to a celebrated Proposition in his Principia; another is busy about a Furnace, and two others (near him) are loaded with money as newly coined, intimating his Office in the Mint.'

Conduitt's admiration for Newton can also be seen in the bust which he commissioned from Roubiliac and which occupied the most prominent position in his drawing room,

represented for us in Hogarth's well-known painting of children performing 'The Conquest of Mexico'.

The tomb in Westminster Abbey aroused a good deal of interest which was reflected in, of all places, Venice. The Abate Conti, a great admirer and one-time friend of Newton, and Francesco Algarotti were both Venetians. For all that, Venice was hardly a centre of Newtonian studies, and to avoid the censorship Algarotti had later to publish his book in Milan. Even so it was severely criticised in the Venetian press as potentially subversive.[10] Despite this, reflections of the tomb as it actually was and possible designs for an alternative turn up in a number of drawings and gouaches by Sebastiano and Marco Ricci in about 1730.[11]

We can be pretty certain where the inspiration for these projects came from, for when several years later the Venetian poet Arrighi-Landini came to write a long philosophical poem on Newton's tomb he describes the attempts he made to find out the inscription on it. 'It was', he writes, 'very kindly given to me by Signor Giuseppe Smith, Consul of the English Nation in Venice, a man as remarkable for his rare talents, his goodness, and sweetness of temperament as for the love which he feels for the fine arts.'[12] Joseph Smith had been a prosperous businessman and art collector in Venice since early in the eighteenth century and we know from a number of sources that he was in close touch with Newton's London friends, in particular Dr Richard Mead, and was a keen admirer of the great scientist. The significance of this connection will become apparent later.

Burial in Westminster Abbey was no doubt a great honour, but it was one that Newton shared with many other men. To appreciate the real nature of the cult that was growing up around him we shall have to look elsewhere. In Stowe, his great country house, Lord Cobham commissioned from Kent and Rysbrack in about 1730 a curious Temple of British Worthies, which included a very strange collection of canonised Whig heroes: Sir Thomas Gresham, 'who by the honourable profession of a merchant having enriched himself and his country, for carrying on the commerce of the world, built the Royal Exchange'; Inigo Jones; John Milton; William Shakespeare; John Locke; Sir Isaac Newton; Sir Francis Bacon; King Alfred, 'the founder of the English constitution'; Edward, Prince of Wales, 'the terror of Europe, the delight of England'; Queen Elizabeth; King William III; Sir Walter Raleigh; Sir Francis Drake; and John Hampden. Beneath the bust of Newton are the magnificently arrogant words: 'Sir Isaac Newton, whom the God of Nature made to comprehend his works; and from simple principles, to discover the laws never known before, and to explain the appearance, never understood, of this stupendous universe.'

The two traditions which I have just examined—Venetian art and the deification of Newton as one of the great men of England—had, however, already joined forces a few years earlier in what is undoubtedly by far the most interesting project of all those designed to commemorate the great national hero.

Its protagonist is a strange figure, who has been much discussed in recent years—Owen McSwiny. He was an Irish operatic impresario and theatrical manager, at various times in charge of Drury Lane and the Haymarket. He had at one time known Dryden, and when later Dr Johnson was writing his *Lives of the Poets* he went to McSwiny for information but was told only that at Wills's coffee house Dryden used to have one special seat

in the winter and another in the summer.[13] But as a rule McSwiny was more imaginative and enterprising than this story would suggest, and some time in the mid-1720s he conceived the idea of commissioning some of the leading Italian artists to paint allegories, designed by himself, to commemorate many of the principal British heroes who had emerged from the Glorious Revolution of 1688. Italian sources vividly describe the mystification of the artists as they were called upon in teams of three to execute pictures whose meanings they totally failed to understand.[14] 'It was', wrote Zanotti, 'like serving under a captain who kept his orders secret and moved his troops on long journeys without explaining what their purpose was.'

These difficulties are easy enough to appreciate. The whole idea of raising monuments and tributes of this or any other kind was a new one. I think that it is true to say that until this period allegorical tributes to individuals had been confined entirely to rulers and to victorious commanders, although, of course, it would be easy enough to find many examples both in antiquity and during the Renaissance of men of letters being honoured by simple monuments. Even this, however, was unusual enough by the eighteenth century for it to be commented on as a specifically English habit. 'It is worthy of notice', wrote a Piedmontese author of the Enlightenment in 1767. 'that the practice of honouring men of talent with statues is still vigorously maintained by the English, who follow the Greeks and Romans in their esteem for talent as well as in their love of liberty', and he singles out busts of Newton, Locke, Wollaston and Clarke which had been placed by Queen Caroline in Richmond Park.[15] In fact the practice only became possible in the climate of optimism, patriotism and sentimentality that prevailed in England after the Whig Revolution.

But, far more than ethical considerations, what really worried the Italian artists and can still baffle us today was the actual content of the symbolism chosen by McSwiny. 'In each Piece', he wrote, 'is plac'd a principal Urn, wherein is supposed to be deposited the Remains of the deceased Hero. The Ornaments are furnish'd partly from the Supporters and Arms of the respective families; and the Ceremonies supposed to be performed at the several Sepulchres, as well as the Statues and Basso Rilievo's allude to the Virtues, to the Imployments, or to the Learning and Science of the Departed.'[16]

In fact there is a good deal of evidence to show that McSwiny's pictures were not understood fully by his contemporaries, nor as highly thought of as he felt to be their due.

Among the first pictures painted was one in honour of Sir Isaac Newton. The artists chosen—for McSwiny insisted that 'the Figures, the Landskips, the Buildings and other Ornaments are painted by different Hands; yet the Harmony of the Whole is so well preserved that each picture seems to be the work of one great Master'—were Giovanni Battista Pittoni, then aged forty and at the height of his powers, and the brothers Giuseppe and Domenico Valeriani, essentially theatrical painters of much less interest. All were Venetians. After some years McSwiny's pictures were issued as engravings in a handsome volume published under the title of *Tombeaux des Princes grands capitaines et autres hommes illustres, qui ont fleuri dans la Grande Bretagne vers la fin du XVII et le commencement du XVIII siècle,* and they can most easily be studied in this way.

The painting is preceded by an elaborate title-page (Fig. 3) which contains many allusions

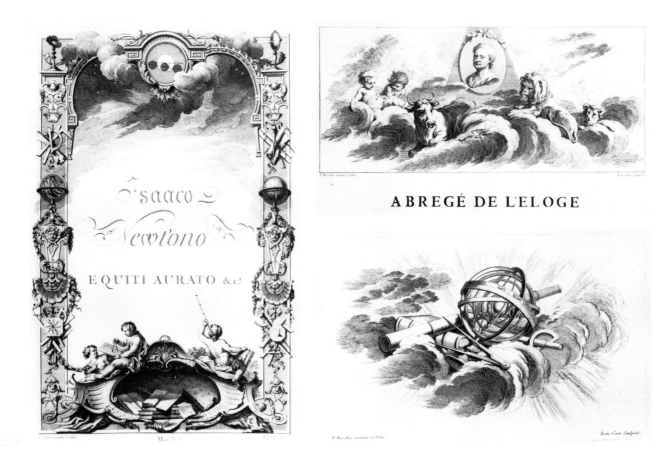

ABREGÉ DE L'ELOGE

in playful form to Newton's achievements, cunningly arranged into a rococo frieze. At the top there is what appears to be a reference to the transit of the planet Venus across the sun, and a wholly inaccurate version of his experiments with light. Elsewhere are globes, mathematical instruments arranged in the patterns made familiar by later Renaissance artists with trophies of armour and at the bottom a shell containing books and putti playing with dividers and a telescope. We then see the bust of Sir Isaac Newton (Fig. 4) crowned with a laurel wreath and inserted into a pyramid, which is surrounded by the figures of the zodiac, of which Gemini, Taurus, Scorpio, Leo and Aries stand out in high relief; while below is a book, a telescope, a pair of compasses, and an armillary sphere, designed on the Copernican system to illustrate the earth revolving round the sun. This was an instrument used for teaching, and is in no way especially associated with Sir Isaac Newton. Both these drawings are by François Boucher, and present a strange episode in the career of an artist more known for his celebration of the nonintellectual triumphs of the human race.

There then follows the picture itself, for which a number of drawings exist (Fig. 5).[17] At the base Minerva and the Sciences are led weeping to the urn containing Sir Isaac's remains. From a pyramid above the urn is a wholly fanciful allusion to Newton's experiment on the splitting of light. On a raised dais in front of it are allegorical figures of Mathematics and what I take to be Truth; while various figures clearly representing philosophers, ancient and modern, predecessors of Newton, are studying globes, books and mathematical

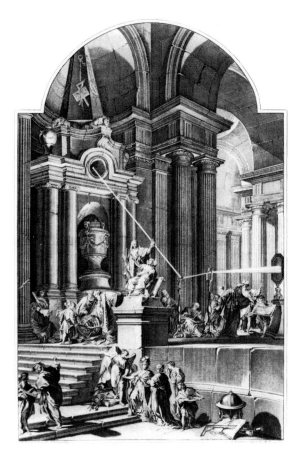

3. (far left) Pierre Josse Perrot (engraved Cars):
Eloge de Newton in *Tombeaux des Princes*

4. (middle left) Boucher (engraved Cars):
Eloge de Newton in *Tombeaux des Princes*

5. Giovanni Battista Pittoni, and Domenico
and Giuseppe Valeriani: (engraved Desplaces):
Allegory of Newton in *Tombeaux des Princes*

equations. Parts of the composition are obviously derived from Raphael's *School of Athens*, though it takes place in an architectural setting reminiscent of a stage design by Bibbiena. I am, of course, fully aware of the moral cowardice in saying that the characters are merely 'ancient and modern philosophers' and in proceeding no further with their identification. My excuse is that, in fact, the figures are not sufficiently characterised for further investigation to be very fruitful, and that, as we will see in a moment, it was just this aspect of the pictures ordered by McSwiny that was to cause so much trouble. For at some stage in the proceedings, when this picture had already been commissioned, and probably nearly completed, John Conduitt, Newton's friend, nephew and successor at the Mint, apparently unaware of the picture's existence, wrote the following letter, dated 4 June 1729, to McSwiny:

I fear you will be much surprised at my very long delay in answering your favour of September last which is owing to my waiting for the advice and opinion of Sir Isaac Newton's friends in relation to the monumental picture to his memory, and I assure you it is but very lately that I could fix upon any design & I hope that resolved upon will please you as much as it does everyone here; it is as follows:

It is proposed to have the monument not in any church because it is impossible to express all his discoveries in so little a place but in the open air & by the seaside as some of those are which you have already done—& by an arm of the sea on the left

hand a stately monument of the finest architecture with the proper symbols and attributes belonging to him wch I furnished you with so amply already wch I leave entirely to you—I would have the rest of the picture in some measure resemble the school of Athens—viz—

In one place a groupe of Philosophers looking on a scroll, with Mathematicall figures on the ground at the head of these I would have Pythagoras, Plato and Galileo looking with admiration & Descartes with a dejected countenance, as being concerned for the destruction of his system of Philosophy—I would have Aristotle who it is said threw himself into the Euripus because he could not solve the nature of his tide looking upon the sea rolling to the shore & pointing with admiration to a scroll with a problem of Sir Isaac's upon it showing the course of the tides—I would have him near these other philosophers because he belongs to them, & if it could be expressed he should in some measure triumph over Descartes, who had overturned the Aristotelian system upon the destruction of his by Sir I:N. The next groupe should be of Astronomers & at the head of these I would place Hipparchus, Ptolemy, Copernicus, Tyco Brahe, Kepler and Ulny Brighi. Kepler should be holding up in his hand a celestial globe which the others should be looking upon with admiration—You will find such a groupe in the picture of the school of Athens by Raphael which without doubt you have copies or prints of at Venice. The next groupe and which should be the least conspicuous should be a groupe of Geometers with Euclid, Archimedes and Apollonius at the head of them looking with admiration upon a scroll upon the ground with geometrical problems upon it. On the right hand of the picture should be the arch of a rainbow in the sky & some persons looking upon it with knowledge at the sky not at the rainbow & others through a reflecting telescope. At some distance behind the whole, there may be a beautiful landskip & lontananza.

You will perceive it is not designed to have any genii or poetical fantastical beings in these groups so they are all left to be made use of as you should think proper about the Monument, but it will be absolutely necessary to have the Philosophers, Astronomers and Geometers I have placed at the head of the 3 groupes to be very particularly described, for without that the whole beauty of the design will be lost—You can be at no difficulty to get the face and habits of Pythagoras, Plato, Aristotle, Euclid and Archimedes, Ptolemy & Hipparchus & Apollonius, because there are a number of books with prints of them from old statues or intaglios in almost every library—Tyco Brahe was Knight of the Elephant & is always painted with a flat nose having it is said been unfortunate in his amours but in the life of him & Copernicus writt by Gassendi you will see their pictures very well done & in Helvetius's Prodromius Astronomiae which is a book in all libraries you will find that of Galileo and Ulri Brighi an Arabian prince with short hair and mustachios hanging down, and Kepler who was Astronomer to an Emperor of Germany. As for Descartes who must be very particularly marked out you will find his picture before his own works and in Perrault's Hommes Illustres. As to the mathematical problems & the particular figures of a comet & upon the celestial globe I will have them done here afterwards & only desire you will have the scrolls & the shape of the globe painted.

This you will perceive will be a picture in character & only applicable to Sr I Newton which is what will give it its value with me, & I am persuaded you will forgive me if I tell you that it has been thought your other pictures, though finely painted, are defective in that respect & I have already seen two of them which turned to a quite different design from what they were intended. I mean those for the late Duke of Devonshire & Sir Cloudesly Shovel, the first of which is turned into a Brutus & the other into a Roman Admiral by my Lord Bingley in whose possession they are now. The sketch you intended for Sir Isaac Newton may I hope very easily be (& if not I shall willingly pay charges of the little alterations that can be wanting) applicable to any other great man, but I can not think of having it on any account as a monumental picture to him, nor indeed can I ever be satisfied or pleased with any but one after the design I have now sent you. If you will be so good as to superintend the execution of this I shall be much obliged to you, but it has been so thoroughly considered here by the best judges & is so much to my own fancy that though the ornaments and execution must be left to the painters I would not have any material alterations made in the main design. I must likewise declare that the picture be much broader than it is high, because I have no room in which I could possibly put one of the same height with those sent to the Duke of Richmond. I would have the height of those be the breadth of this, and the breadth of those be the height of this.[18]

It is clear that Conduitt, although he had not yet seen the picture, was wanting something far more precise than McSwiny had ordered. He was carefully dividing Newton's work into three constituent parts of Philosophy, Astronomy and Geometry. The triumph of Newton over Descartes, 'the French dreamer' as James Thomson called him, was, of course, a commonplace. We know, in fact, that Conduitt was not satisfied with Fontenelle's eulogy, because he suspected the Frenchman of reluctance to admit his compatriot's discomfiture. About this time (as Saxl has pointed out)[19] the same idea received a curious visual expression when a print by Picart of 1707 (Fig. 6) representing *Truth sought by Philosophers* was adapted by an English engraver, who made one crucial alteration (Fig. 7). The texts are virtually identical: 'Philosophy represented by a stately Woman accompany'd and followed by many Philosophers, conducts 'em to the knowledge of Truth', but whereas in the original French text and illustration it is Descartes who is being led, in the English plagiary it is Sir Isaac Newton.

The illustrations mentioned by Conduitt are indeed easily available, and in fact most of the books referred to could be found in the library of McSwiny's friend and host at the time, Joseph Smith: but was the picture ordered by Conduitt ever in fact painted? Here we face a problem that is still not fully resolved. In 1973 a beautiful painting which corresponds in almost all respects to the engraving published in McSwiny's commemorative volume *Tombeaux des Princes* turned up at Sotheby's and was acquired by the Fitzwilliam Museum in Cambridge (Fig. 8).[20] There can hardly be any doubt that this is the original version (previously known only from an incomplete copy) of the painting which had been commissioned by McSwiny before he received Conduitt's letter. However, a somewhat inadequate photograph reveals the existence of another, closely related, composi-

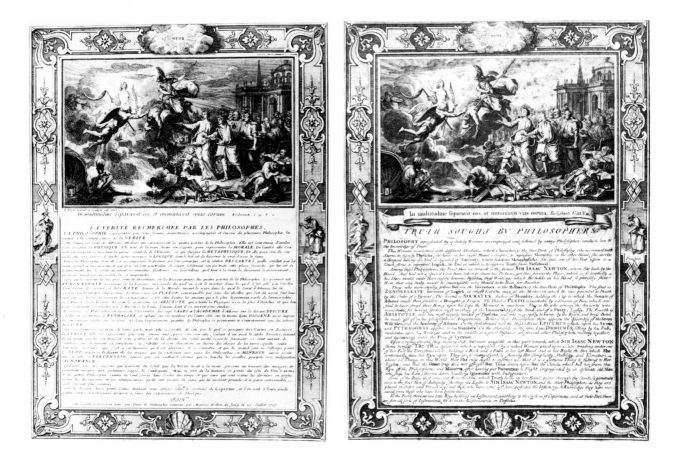

tion, which I have not seen and which is now in a private collection (Fig. 9). The differences between the two are highly revealing. In the first place the lost picture is 'much broader than it is high', as Conduitt had requested and as (we will see) was certainly arranged by McSwiny. In the second place the urn to the left has been replaced by a reasonably accurate representation of Newton's tomb in Westminster Abbey—and this alteration must surely also have been made as a result of Conduitt's intervention, for he was particularly keen that the picture should be 'only applicable to Sir I. Newton'. In the third place the architecture is far simpler and we do get some glimpse of the open air as Conduitt had wanted. More important than these changes is the complete disappearance of the famous experiment with the prism, and the extension of the architecture to the right, thus allowing the addition of several bas-reliefs in the wall of the platform. Unfortunately they are not decipherable in the photograph, though they clearly refer to Newton's achievements in allegorical form. Finally some new figures have been added—a philosopher with a scroll in a niche (could this be 'Aristotle . . . looking upon the sea rolling to the shore and pointing with admiration to a scroll'?), a representation of Fame crowning Merit in the apse, and two further figures with some broken statuary in the bottom right-hand corner possibly representing Descartes or any of the other thinkers Newton was held to have dislodged. Otherwise the paintings are virtually identical.

Having considered both versions of the picture we may now turn to McSwiny's reply to Conduitt. It was sent from Milan on 27 September 1730:

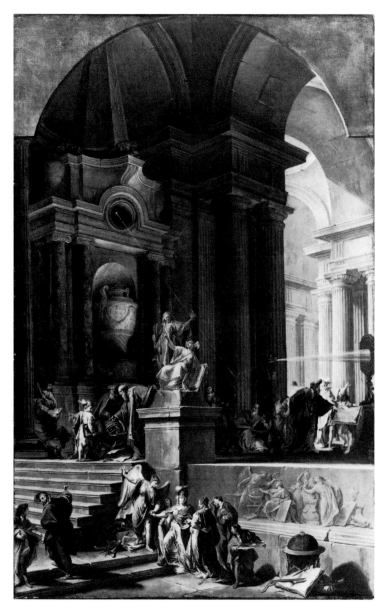

6. Bernard Picart: *La Vérité recherchée par les philosophes*, 1707 (engraving)

7. Anonymous plagiarist of Picart: *Truth sought by Philosophers* (engraving)

8. Giovanni Battista Pittoni, and Domenico and Giuseppe Valeriani: *Allegory of Newton* (Cambridge, Fitzwilliam Museum)

I have been out of Venice these three months, and on my arrival here, I found a letter from you, sent me by my friend Mr Smith. In it I see a copy of directions about the monumental piece to the memory of Sir Isaac Newton. I was formerly favoured with the same notices more than once, and sent you my opinion about them in a letter which I writ to you from Rome in the month of December last and which I put into the French post myself, though I find by what you write that it must have miscarried. I keep no copies of my letters, therefore shall give my present opinion about the piece, as you would have it, and as I intended it.

In all the pieces I have done, there is (in each of them) a Sepulchre wherein I suppose my Hero lies—the Sepulchres are adorned with statues, urns, basso-rilieves etc., allusive to the virtues, arms of the Family etc. of each of 'em. The sepulchres I suppose placed

in a solitary situation, and that there is an anniversary ceremony performed on a certain day at 'em— I introduce figures (under each of 'em) properly employed as I think to explain the meaning of the Visitants, and their intentions etc.

'Tis impossible to tell (in such a narrow compass) more than one Man's story, without running into what would be very trivial, and the pieces would resemble the cuts in the *Gerusalemme Liberata*. In the Monument to the memory of the Duke of Malborough I make a soldier, attended with guards etc. as visiting the monument of a great general. I mean nothing more in it but the visit—now if I was to represent his battles, Sieges and abilities as an able counsellor, I have no way to do it but by Medaglions, medals, basso-rilievos, statues etc.

To show you that I have not been negligent in serving you, I have ordered a piece to be done of the same size with those of the Duke of Richmond's—but turned longways—the perspective and the landscape have been done these six months, but how to dispose of the figures is the great difficulty and I'm afraid impossible, at least to my own satisfaction, and if it can't be done to my satisfaction I'll promise you shall never have it. I wish the gentlemen who assisted you with the plan of the landscape, and the disposition of the several groups of figures would make a small sketch of the picture which will explain the meaning much better than I can understand it by writing.

I would be glad to know what size he intends the figures to be (in a cloth of what length and breadth) and how he would have the resemblances kept of the several philosophers, astronomers etc., and the different meanings expressed of the different groups of figures etc.

In short better heads than mine in Rome and Bologna are puzzled how to contrive it–Sir Isaac Newton's monument is one of the collection which Sir William Morice has, and as soon as I send it to him, be so good as to cast an eye on it and let me have

9. Giovanni Battista Pittoni, and Domenico and Giuseppe Valeriani? *Allegory of Newton* (Valdagno, Marzotto collection)

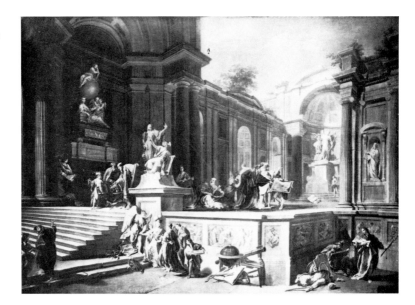

your opinion of it. If it or something like it will please you I will have it well executed by the same or some other able painter; if not I'll try whether anything can be done in the manner you desire; if neither pleases you then the fifty pounds which I received shall be repaid you by the same hand; this is all I think necessary to be said on this score.[21]

There the correspondence comes to an end, but from its contents and from the differences between the Fitzwilliam and the other version, it seems reasonable to infer that the latter was the picture (or a copy of it) commissioned by McSwiny after he had heard from Conduitt. It was intended to rectify all the causes for complaint exemplifed in the Fitzwilliam painting (which Conduitt had not actually seen though he could guess at its probable nature from his knowledge of the other pictures in the series). And yet it is clear that Conduitt's pedantically precise proposals were not fully carried out—as, of course, they could not be—and that McSwiny must have allowed his team of artists to copy many of the features of the first picture. Incidentally, the second painting is signed PITTONI ROMA. If this is authentic (which seems to me more than doubtful) it is the only record that we have that Pittoni ever visited Rome.

These pictures form by far the most elaborate attempts made in the eighteenth century to celebrate Newton in art. They are, of course, by no means the only ones. In Trinity College, Cambridge, is a stained glass window (Fig. 10), described by Newton's Victorian biographer as follows:

The subject represents the presentation of Sir Isaac Newton to his majesty King George III [*sic*], who is seated under a canopy with a laurel chaplet in his hand, and attended by the British Minerva, apparently advising him to reward merit in the person of the great philosopher. Below the throne, the Lord Chancellor Bacon is, by an anachronism legitimate in art, proposing to register the record about to be conferred upon Sir Isaac. The original drawing of this picture was executed by Cipriani and cost one hundred guineas.[22]

On the ceiling of the library in Home House, No. 20 Portman Square (now the Courtauld Institute), Newton is featured in a medallion along with Drake, Bacon, Milton, Addison and other Whig heroes; and there are countless more such memorials, without mentioning innumerable medals and book illustrations in which he appears throughout the century.[23]

The only other large painting I know of is a very late and deplorable work by George Romney. It is of interest only in showing how towards the end of the eighteenth century (and, of course, the trend was accentuated in Victorian times) the heroic gives way to the anecdotal and the genre. Newton is there seen experimenting with his prism while his two nieces look on with suitable expressions of astonishment.

But I want to turn from this pedestrian work and end instead with the strangest of all the projects designed to honour Newton—the plan for a cenotaph made by the visionary French architect and draughtsman Etienne Louis Boullée in 1784.[24] Boullée prefaces his scheme with a rhapsodical invocation—'Esprit Sublime: Génie vaste, et profond! Etre Divin! Newton! Daigne agréer l'hommage de mes faibles talents!'—which sets the tone

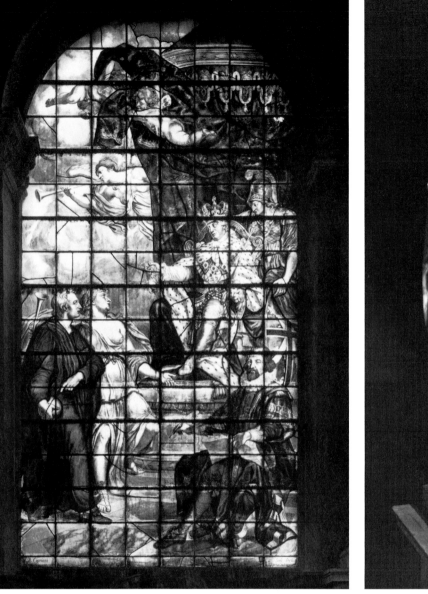

10. *Sir Isaac Newton being Presented to the King in the presence of Bacon, the Lord Chancellor* (East window of the Library of Trinity College, Cambridge – designed by Cipriani)

11. Louis and François Roubiliac: *Sir Isaac Newton*, 1755 (Ante-chapel of Trinity College, Cambridge)

for his gigantic sphere resting on a cypress-covered socle, at the base of which inside stands a small simple tomb, from which because of the spherical walls of the mausoleum the visitor would find it impossible to move. The apex was to be pierced with holes so that by day it would let in light which would appear to issue from the stars and planets. At night, on the other hand, the interior effect was to be one of brilliant sunlight achieved by a form of artificial illumination which was, in fact, not practicable in Boullée's lifetime. Although this fantastic project had considerable influence it goes without saying that—like most of Boullée's ideas—it was never constructed.

In fact by the end of the eighteenth century and with the rise of the Romantic movement Newton's sanctity was being seriously challenged. Blake indeed was first to cast him as the devil, the very incarnation of materialism, who believed that the great mysteries of the world could be solved by a pair of dividers and mathematical calculation. And yet

even for Blake he had a certain magnificence, as Satan had had for Milton, and in one of his finer watercolours[25] he paid tribute to him as a devil who at least served humanity by letting himself be known.

In 1817, in the studio of the artist Benjamin Robert Haydon, there took place the final reckoning of the Newton legend. The occasion was the 'Immortal Dinner', so vividly described by the painter:

> Wordsworth was in fine cue, and we had a glorious set-to on Homer, Shakespeare, Milton and Virgil. Lamb got exceedingly merry and exquisitely witty: and his fun in the midst of Wordsworth's solemn intonations of oratory was like the sarcasm and wit of the fool in the intervals of Lear's passion. He made a speech and voted me absent, and made them drink my health. 'Now,' said Lamb, 'you old lake poet, you rascally poet, why do you call Voltaire dull?' We all defended Wordsworth, and affirmed there was a state of mind when Voltaire would be dull. 'Well,' said Lamb, 'Here's Voltaire— the Messiah of the French nation, and a very proper one too.'
>
> He then, in a strain of humour beyond description, abused me for putting Newton's head into my picture; 'a fellow,' said he, 'who believed nothing unless it was as clear as the three sides of a triangle.' And then he and Keats agreed he had destroyed all the poetry of the rainbow by reducing it to the prismatic colours. It was impossible to resist him and we all drank 'Newton's health and confusion to mathematics.' It was delightful to see the good humour of Wordsworth in giving in to all our frolics without affection and laughing as heartily as the best of us.[26]

Wordsworth may have laughed, but he remained silent; for he had seen Roubiliac's magnificent statue of Newton in Trinity Chapel (Fig. 11) with its superbly apt quotation from Lucretius—'qui genus humanum ingenio superavit'[27]—and contemplating this finest of all visual homages to the great scientist he had matched it with an equally eloquent tribute of his own.

> The antechapel where the statue stood
> Of Newton with his prism and silent face,
> The marble index of a mind for ever
> Voyaging through strange seas of thought alone.[28]

APPENDIX

Since the publication of this article in 1967 the painting in celebration of Sir Isaac Newton by Pittoni and the Valeriani brothers, whose whereabouts were then unknown, has turned up and been acquired by the Fitzwilliam Museum in Cambridge. This has led me to rewrite substantially certain pages and also to bring the relevant bibliography up to date. I have not, however, made any additions to the far wider topic of Newtonian iconography.

However, since receiving the proofs of this revised version, I have been kindly informed by Dr Michael Halls, Archivist of King's College, Cambridge, that Peter Croft, the late Librarian, discovered that the (feeble) drawing which I had attributed to Conduitt is in the hand of Alexander Pope. Dr Halls will publish the evidence for this in the *Burlington Magazine* during the course of 1987.

2. Gibbon and the History of Art

AN ART HISTORIAN is bound to feel somewhat out of place among the scholars from so many other fields who have joined to pay homage to Edward Gibbon. The references to the visual arts in Gibbon's published works tend to be few and perfunctory, and although he counted such considerable artists, *amateurs* and artistic theorists as Reynolds, Walpole and Burke among his acquaintances, their enthusiasms hardly seem to have impinged on his own personality. Nor did he participate very actively in the artistic pursuits of his two dearest friends. During the 1770s John Holroyd was employing the architect James Wyatt to build Sheffield Place in Sussex, one of the earliest large-scale Gothic Revival country houses in England. Gibbon certainly showed the interest to be expected of a well-wisher, and he tried to help in small practical matters, but he makes only one comment (in a letter to his stepmother of 25 September 1776) on the issue of taste, and even that—'Mr H. wishes for an opportunity of promoting eloquence in Mrs Gibbon on Gothic Architecture'—suggests that he himself was not very concerned with the matter. And when, in September 1788, he was about to leave London for Switzerland and asked Wilhelm de Sévery to 'choisir pour moi ou plutôt pour Deyverdun quelques estampes nouvelles et d'un bon goût jusqua'à la concurrence de quatre ou cinq louis', the casual tone reveals clearly enough his own indifference to such matters. Nevertheless, I have decided somewhat recklessly to try to make out a strong (if, at first sight, rather paradoxical) case for the claim, which grew on me the more I thought about him, that Gibbon did, almost despite himself, play a really significant role in the development of art history and theory.

The recent publication in full of the journal that Gibbon kept during part of his Italian travels (though not, alas, in Rome, Naples or Venice) shows us how misleading is the brief and almost casual account of that journey which he has given us in his autobiography—an account only memorable for the few famous sentences in which he describes the impact on him of Roman associations and the inspiration for his life's work. In fact, we now know that Gibbon studied works of art, modern as well as ancient, with almost as much concentration as he did books and scholarly publications; consequently, we can assume that he may well have been the most 'visually educated' of any historian before—and of the great majority since—his period. He was the man, moreover, who in Parma was to acknowledge that the art of Correggio had quite unexpectedly revealed to him 'le pouvoir de la peinture' and, in Florence, to go into quite uncharacteristic raptures

over the *Venus de' Medici*.[1] One real and rewarding question that can be asked about him is why he should have put his artistic experiences to such little use.[2]

An enthusiastic admiration for Correggio or the *Venus de' Medici* was certainly not surprising in the middle of the eighteenth century, and in fact Gibbon's artistic tastes were strictly conventional—if anything, slightly *retardataire* and in no way touched by that incipient reaction against the Baroque which we find in some travellers of the period. But his actual approach to art was very distinctive, and it marks him off from most of the cultivated grand tourists of his own and previous generations.[3] We can see the point most clearly if we compare his attitude with that of the three visitors to Italy—an Englishman, a Frenchman and a German—whose published comments on art meant most to him. Joseph Addison had visited Italy in the first years of the century, and—as will become clear—Gibbon refers to his views almost exclusively for the purpose of refuting them. Johann Georg Keysler had made very exhaustive travels throughout various parts of Europe, including Italy, between 1729 and 1731, and his *Travels* were published some ten years later and translated into English in 1756. Winckelmann was to comment that 'les Voyages de Keysler, dans lesquels il traite des Ouvrages de l'Art qui sont à Rome & ailleurs, ne méritent aucune attention; car il a tiré tout ce qu'il dit des Livres les plus misérables'.[4] This characteristically ruthless judgement of a highly influential book is not wholly unjust; the English translation (which was used by Gibbon) teems with wild inaccuracies. But the four large volumes do contain a vast amount of information—social, political and intellectual—and many shrewd observations, though the artistic comments rarely venture beyond such generalised terms as 'fine', 'celebrated' or 'beautiful'.

Very different was the case of Charles Nicolas Cochin, whose *Voyage d'Italie,* first published in 1758, has always been looked upon as one of the most significant books of its kind to appear in the eighteenth century. The journey had been undertaken between December 1749 and September 1751 at the behest of Madame de Pompadour, who wished to prepare her brother, later to become the Marquis de Marigny, for his post of Directeur général des bâtiments. Cochin, a highly talented illustrator and administrator, the architect Soufflot and the Abbé Leblanc took their young protégé on a very elaborate tour of almost every public and private building in Italy in order to direct his taste toward the 'grand manner' and away from the rococo and genre painting that aroused his more spontaneous sympathies. Cochin's comments on the innumerable pictures which he saw with the eyes of an artist, as well as of a teacher, are fresh and perceptive, and Gibbon carried these three little volumes of encapsulated good taste around with him wherever he went. But his own judgements were very different. Where Cochin looked for beauty, Gibbon—who was clearly familiar with a problem that had been keenly discussed by theorists for many years—was interested primarily in 'expression'. The very word crops up on every page of his journal, and almost every picture is examined to see how far the expression is suited to the action it is meant to illustrate. Let me give one example among many. Looking at an *Incredulity of St Thomas* in Genoa, on 30 May 1764, Gibbon commented:

Il y a beaucoup d'expression dans la bonté du Sauveur qui cherche à vaincre l'infidélité de l'Apôtre et dans cette action de confiance avec laquelle il lui met lui-même la main

18

12. Obverse of *as* issued during the reign
of Tiberius portraying head of Agrippa
wearing rostral crown (Oxford, Ash-
molean Museum)

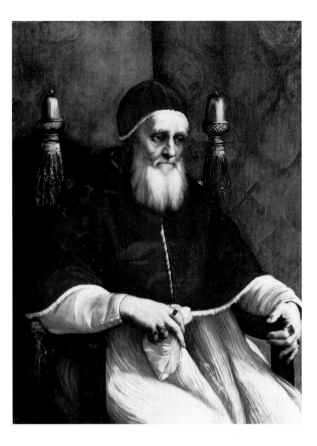

13. Raphael: *Pope Julius II* (London,
National Gallery)

dans sa côte. Je vois avec plaisir que Sᵗ Thomas conserve dans sa physionomie cette
defiance qui paroit plutôt l'ouvrage de tempérament que de la raison et du moment.
Ce n'est que ces habitudes que le peintre puisse exprimer dans les traits. Les passions
ne doivent se montrer que dans l'attitude, la couleur et les yeux . . .[5]

This concentration on the drama of the situation, so typical of Gibbon's general approach
to art, is significantly different from the more casual observations of earlier visitors to the
Palazzo Brignoletti, but, although already showing an acute insight into the resources at
the painter's disposal, it was only three weeks later, in Modena, that Gibbon took the
decisive step of appreciating that those 'expressions' on which he set such store only had
any recognisable meaning if the story they illuminated was already known. The revelation
came when he was looking at some medals in the Este collection. Faced with a portrayal
of Agrippa (Fig. 12) he commented: 'J'ai crû lire dans les traits d'Agrippa ce caractère
de franchise, de grandeur et de simplicitè qui distinguoient cet homme respectable, mais
ces sortes d'observations quoiqu'elles ayent eu la sanction d'un Addison me paroissent bien
creuses'. And then he suddenly asked himself: 'Est-il si commun que l'âme se lise dans
les traits? Je voudrais voir d'ailleurs qu'un ignorant à qui l'on montreroit une tête de Néron
s'écrit Voila un Scelerat! Cette decision est si facile à un Savant qui sait d'avance qu'il
l'a été.'[6] It is tempting to speculate whether Gibbon's very scepticism concerning the value
of the visual arts in providing psychological evidence for the historian may not have stimu-
lated the extraordinarily dynamic and subtle quality of his own *literary* portraiture. Nor
should his friendship with Garrick and his passion for the theatre be forgotten in this con-

text. It is, in any case, legitimate to claim that the questions he raised challenged the whole basis on which portraits had been made and judged ever since the Renaissance.

Indeed, it is only very recently and very tentatively that we have, even now, begun to understand that some knowledge of social history, convention and artistic techniques are just as important for interpreting the psychology of a sitter as is the apparent realism with which his features are rendered.[7] Gibbon himself, when looking at Raphael's *Portrait of Julius II* (see Fig. 13) in the Uffizi, was temporarily unnerved by his own scepticism, but he recovered enough to insist that, though in this case 'l'âme de ce pape fier est peinte sur la toile', as a general rule the evidence of portraiture was dangerously misleading.[8] And it was in the Uffizi that the future historian of the Roman emperors was once again put to the test. Confronted by the busts of virtually all the emperors—'peut-être le trésor le plus précieux de la galerie'—he yet confines to a minimum his meditations on the character of each (nor, later, does he make use of his notes when he comes to writing his book), and is struck, rather, by the 'plaisir bien vif . . . de suivre le progrès et la décadence des *arts* [my italics]'.[9]

To some extent, it is true, Gibbon was to draw on this very decadence as a symptom of the wider historical and spiritual decline which he was to begin to chart so vividly some ten years later, but he did so almost as an afterthought; and, although he sometimes refers to Winckelmann, whose *Geschichte der Kunst des Altertums* was published in the very year of Gibbon's arrival in Rome (but was only read by him in the French translation of two years later), he never followed the German historian in treating art as a sort of thermometer with which to determine the moral health of an age. For this act of self-control, he could also produce very cogent reasons, which he may indeed have derived from Winckelmann, not only through the books but even more directly through the medium of James Byres, the Scots antiquary who acted as his guide in Rome.[10] Winckelmann was rightly obsessed by the absurd archaeological theories that had again and again been built on foundations of heavily 'restored' antiquities, but he was convinced that he at least could see through such falsifications. Gibbon, however, despite a certain show of bravado, lacked self-confidence in his artistic judgement, but was intelligent enough to be just as aware of the dangers:

> Si l'homme de goût . . . est frappé de tant d'associations bizarres (car on a souvent suivi une autre manière et employé un marbre différent de la Statue antique), le Littérateur craint toujours de bâtir des systemes sur les caprices d'un Sculpteur moderne. On peut dire hardiment que de tous les ornemens qui paroissent caracteriser les Dieux ou les hommes il y en a très peu qui ne soient modernes. M. Gori a souvent prodigué l'érudition pour expliquer ou pour justifier l'imagination bizarre d'un artisan Florentin.[11]

At heart he knew that he was a 'littérateur' rather than an 'homme de goût', but I would claim that it was his very taste and extraordinary insight into the nature of art that encouraged him to reject any systematic reliance on the evidence provided by the arts when planning the *Decline and Fall*.

It was, however, just in the field of art historical scholarship that the book was to make its first considerable impact. Early in 1777, a few months after the publication of the first

volume, a very rich Frenchman—an 'homme de goût', if ever there was one—came to London.

Jean-Baptiste-Louis-George Seroux d'Agincourt was born in 1730 (seven years before Gibbon—the importance of this point can hardly be overemphasised); he was an extremely successful *fermier-général* of the widest possible interests and acquaintances. Voltaire himself had written to him, 'Je vois, Monsieur, que vous êtes patriote et homme de lettres autant pour le moins que fermier-général',[12] and he seems to have been on close terms with Buffon, Rousseau, Suard, Morellet and Marmontel—to name only a few of his more conspicuous friends among the *philosophes* and their circle.[13] His noble origins helped to win him the benevolent patronage of Louis XV—to whose memory he remained devoted to the end of his long life—and the entry to the estates of great families such as the Soubise. He was a habitué of the salon of Madame Geoffrin, who had had his portrait drawn and engraved by Cochin (Fig. 19).[14] Even more impressive were his links with the artistic world. Caylus, the most famous of Winckelmann's predecessors, had discussed antiquities with him, and Mariette, possibly the greatest of all connoisseurs, 'voulut bien, dans ma jeunesse, servir de guide à mes premiers travaux'. His exact contemporary, d'Angiviller, who in 1774 replaced Marigny as Directeur général des bâtiments—a post which he held with the utmost distinction until the Revolution—was on the most cordial terms with him,[15] and among his personal friends he numbered many of the leading artists of the day, Fragonard and Hubert Robert especially. His fine collection of drawings contained superb works by Boucher.[16]

It is not clear whether Seroux d'Agincourt met Gibbon in London: the historian, in fact, spent part of 1777 in Paris. But I have said enough about the width of Seroux's circle to make it clear that if they ever did come across each other (and as yet I have no evidence pointing in either direction) they could just as easily have done so in the French as in the English capital. It is not possible even to prove (though it seems to me most likely) that it was at this moment that Seroux d'Agincourt read the first volume of the *Decline and Fall,* but whenever it was, it had, I believe, a profound impact on him. The only certain facts that we do know about the journey to England are that during the course of it Seroux d'Agincourt visited the celebrated collection of antiquities which had been assembled by the great collector Charles Townley[17] and was warmly received at Strawberry Hill by Horace Walpole, who encouraged him to look at various Gothic cathedrals. This was evidently the first time he had been brought into touch with an utterly unfamiliar culture, for conspicuously absent from among his French friends seem to have been La Curne de Sainte-Palaye and the medievalists associated with him.[18] The contact with England was to prove of lasting importance.

From England, Seroux d'Agincourt travelled to the Low Countries and northern Germany, carefully examining the Gothic churches wherever he went, and thence, after a brief return to Paris, he left France (forever, as it turned out) and proceeded to Italy. In every city he seems to have met the local rulers and the local scholars—the King of Sardinia, the Abate Morelli, Tiraboschi—and at the very end of November 1779 he reached Rome,[19] where he was greeted by the brilliant society gathered round the French ambassador, the Cardinal de Bernis, and by the artists studying at the French Academy. A year or so later,

he went for a few months to Naples, Pompeii and Paestum. But after his return to Rome he never again left the city, and he died there in 1814 at the age of eighty-four.

Somewhere on the road to Rome, Seroux d'Agincourt, the rich, well-connected, amiable, scholarly dilettante, had found the inspiration for the arduous, grinding and painful task which was to keep him occupied until almost the end of his life.[20] What were the ruins among which he sat musing he never tells us, but certainly by the time he reached Bologna (and possibly before), he had decided to write his *Histoire de l'art par les monumens, depuis sa décadence au IVe siècle jusqu'à son renouvellement au XVe*. It is the contention of this paper—indeed its only justification in this context—that both the idea and much of the nature of this massive undertaking were derived from his study of Edward Gibbon, and that without an awareness of this relationship Seroux d'Agincourt's achievement was bound to be (and always has been) misunderstood.

That art *had* declined no one had ever doubted, at least since the Renaissance. No anticipation of Wickhoff or Riegl are to be found in Vasari's masterly preface to the *Vite de' più eccellenti architetti, pittori et scultori italiani da Cimabue insino a' tempi nostri*, which illustrated the process of decadence with an example that had already been used by Raphael and that was to be used again and again over the centuries (by Gibbon, among others):

> The triumphal arch made for Constantine by the Roman people at the Colosseum, where we see, that for the lack of good masters not only do they make use of marble reliefs carved in the time of Trajan, but also of spoils brought back to Rome from various places. Those who recognise the excellence of these bas-reliefs, statues, the columns, the cornices and other ornaments which belong to another epoch will perceive how rude are the portions done to fill up gaps by sculptors of the day.

Indeed, it would not be too misleading an exaggeration to say that Seroux d'Agincourt's hundreds of pages and thousands of illustrations constitute essentially a vast elaboration of Vasari's succinct account. But why devote huge volumes to the decline and fall of art when others, like Vasari himself, had been content to refer to the matter as briefly as possible before passing on to happier things? Seroux himself had doubts: 'J'aurais volontiers détourné mes yeux de ce spectacle, sans toucher au voile qui s'épaissit de plus en plus sur les détails et les preuves de cette décadence déplorable; mais . . . l'Histoire générale et la Philosophie m'ont semblé réclamer contre cet oubli, et vouloir que le vide fut rempli.'[21]

And so, backed up by unlimited wealth and influential contacts, Seroux began his formidable research into 'un désert immense, où l'on n'aperçoit que des objets défigurés, des lambeaux épars'.[22] The exploration of this unknown territory was too great a task for one man, however industrious, and Seroux naturally relied to some extent on the collaboration of correspondents in different parts of Europe; but his real innovation was to employ a significant number of artists to copy and engrave what I believe today still constitutes the largest number of late antique and medieval artefacts to be illustrated within the pages of a single book.[23] By 1782 much of the preparatory work was done; by 1789, shortly after the appearance of the last volume of the *Decline and Fall*, the whole enterprise seems to have been ready for publication.

The book cannot be considered here, even in outline, but certain points must be stressed.

Seroux d'Agincourt believed that it was useless to study the art with which he was concerned without first providing a summary of the political, civic and religious history of the twelve centuries between the Emperor Constantine and Pope Leo X, because only this would 'faire ressortir l'influence des causes générales qui, dans tous les temps et dans tous les lieux, décident du sort des beaux-arts comme de celui de tous les nobles produits de la civilisation'.[24] He devoted twenty-eight chapters to this *Tableau historique,* and his guides, as he himself made quite clear, were Montesquieu and Gibbon,[25] for both men had demonstrated that the ruin of Roman power had brought with it the ruin of literature as well and hence, by implication, that of the fine arts. On a number of occasions Seroux goes out of his way to acknowledge Gibbon as his source for some particular episode or argument, but in fact the indebtedness of this section of the book to the *Decline and Fall* is so apparent that the point need be pressed no further.

It is, however, worth giving two instances, one trivial, the other more significant, of Gibbon's impact on Seroux's treatment even of strictly artistic matters. As an ardent worshipper of Winckelmann's achievement, Seroux felt no doubts about the absolute supremacy of Greek art, and honesty compelled him to acknowledge that it was in Constantinople (which neither Winckelmann, nor Gibbon, nor he himself had ever visited) that Greek influence must have survived longest. Faced with the dilemma of reconciling this assumption with the views on the Eastern Empire which he had absorbed from the *Decline and Fall,* Seroux found himself explaining that the total degradation of art in the East was due more to the pernicious influence of Byzantine civilisation than to any inherent weakness of the artists living there. Like the ancient Egyptians, the Byzantine Church stifled true talent, but as soon as Greeks could escape to a more congenial atmosphere they at once demonstrated their superiority to local ability: this explained the particular excellence of Pisa Cathedral, which was believed by Seroux, in common with other scholars of the time, to have been designed by a Greek architect.[26]

More interesting are the conclusions that can be drawn from a survey of the changing critical fortunes of Diocletian's palace at Spalato. The extreme importance of these remains had been brought to the attention of scholarly Europe by those enterprising travellers Jacob Spon and George Wheler in 1678.[27] Their relatively complete account of what they had seen was neutral in tone, but they pointed out that the details of the Temple of Jupiter (which had been converted into a cathedral) 'n'étoient pas de si bonne manière que du temps des premiers Empereurs'. Early in the eighteenth century the great Austrian Baroque architect Fischer von Erlach made use of Spon and Wheler's description and their very puny illustration (Fig. 14) (as well as various drawings which were sent to him directly from Spalato) to 'reconstruct' Diocletian's palace as it must have been in its heyday for his *Entwurff einer historischen Architektur* (Fig. 15), which was first published in 1721 with some ninety plates illustrating the architecture of all civilisations from the Temple of Jerusalem to Von Erlach's own most recent buildings. The text, in French and German, refrained from any comment on the quality of the palace which Fischer von Erlach had, of course, never seen.[28] In 1764 Robert Adam, who had visited the site with the French draughtsman Charles-Louis Clérisseau seven years earlier, published his magnificently illustrated volume of the *Ruins of the Palace of the Emperor Diocletian at Spalatro in Dalmatia*

14. *Palace of Diocletian at Spalato*, reproduced from Jacob Spon and George Wheler, *Voyage d'Italie, de Dalmatie, de Grèce et du Levant fait aux années 1675 & 1676* (Amsterdam, 1679), I, p. 78

15. (above) Fischer von Erlach: *Entwurff einer historischen Architektur*, 1721, *Palace of Diocletian at Spalato*

16. (left) *Palace of Diocletian at Spalato – Porta Aurea*, reproduced from Robert Adam, *Ruins of the Palace of the Emperor Diocletian at Spalatro in Dalmatia* (London, 1764), pl. XII

(Fig. 16), and, as the impressive list of subscribers indicates clearly enough, the book achieved a wide and influential circulation throughout Europe. Its importance to Adam's own practice as an architect is not relevant here, nor are his small technical criticisms of such details as cramped staircases. It is, however, significant that the concept of the decline of late Roman art had already made such headway that Adam found it necessary to emphasise that 'Diocletian had revived a taste in Architecture superior to that of his own times and had formed architects capable of imitating, with no inconsiderable success, the stile and manner of a purer age'.[29]

The splendour of the book seemed to settle the matter, and Winckelmann was sufficiently impressed by it to agree that Diocletian's palace showed that Roman architecture had, to a large extent, escaped the degeneration that had by then corrupted painting and sculpture.[30] But ten years later the Abate Alberto Fortis, a Venetian polymath whose interests lay above all in geology and botany,[31] published his *Viaggio in Dalmatia,* which attracted attention throughout Europe partly through its rhapsodic account, clearly written under the influence of Rousseau, of the customs of the wild, nomadic Morlachs. Fortis went out of his way to disclaim any specific interest in art, and, when describing Spalato, he did no more than refer to 'l'Opera del Signor Adams, che à donato molto a que' superbi vestigj coll'abituale eleganza del suo toccalapis, e del bulino'.[32] But he could not refrain from insisting that, although the palace was among the most respectable monuments surviving from antiquity and he did not want in any way to detract from its merits, too close a study of it would nonetheless be damaging to architects and sculptors because 'in generale la rozzezza dello scalpello, e 'l cattivo gusto del secolo vi gareggiano colla magnificenza del fabbricato'.

Gibbon's account of Diocletian—his 'sumptuous robes . . . of silk and gold', his shoes 'studded with the most precious gems', his eunuchs, his theatrical ostentation and Persian magnificence—ranks among his most incisive portraits, and it was not easily reconcilable with Robert Adam's view that the Emperor had 'revived . . . the stile and manner of a purer age'. How welcome, therefore, must have been the biting comments of the Abate Fortis, eagerly quoted by Gibbon in a footnote, which, however, exaggerated their impact by omitting all the qualifications with which they had been hedged around in the *Viaggio in Dalmatia.*[33] Moreover, Gibbon pursued the issue by slyly observing that the elegance of Adam's 'design and engravings has somewhat flattered the objects which it was their purpose to represent'. This insinuation was repeated almost without alteration by Seroux d'Agincourt, who writes of Adam's volume that 'les planches donnent une belle et peut-être trop belle idée de cette architecture'; and his own comments on the illustrations of the palace indicate so clearly the impact on him of Gibbon, the moralist, at the expense of Adam, the witness, that they deserve to be quoted at some length:

Il est donc évident qu'il faut placer la corruption de l'Art avant Constantin. Les vices que nous venons de remarquer dans les constructions de Spalatro ne laissent aucun doute à cet égard. Cet édifice présente des dissonances de tous genres, un mélange discordant de colonnes en granit, en porphyre et en marbre, des colonnes dont le fût est de ces matières, et la base et le chapiteau d'une autre, des bas-reliefs enfin dont les sujets

annoncent un choix fait sans jugement et sans goût. Si l'impéritie des artistes se montre sur l'arc de triomphe de Constantin dans l'exécution des ornemens, elle ne se fait pas moins reconnoître avant le règne de ce prince, dans la surabondance et la lourdeur des parties accéssoires qui surchargent l'architecture.[34]

Seroux expressed the hope that the two French artists, Cassas and Dufourny, who had recently visited Spalato, would give a more faithful account of the palace than Adam had done. In fact, Cassas's beautifully designed and illustrated volume (Fig. 17) was accompanied by a text of Joseph Lavallé, which, without ever mentioning Adam (visitors to Dalmatia were noticeably ungenerous to their predecessors), provided a purely Gibbonian interpretation of the remains. While acknowledging their splendour, the general conclusion was as follows:

il est facile de reconnoître que, dès cette époque, l'art de l'architecture avoit déjà fait un grand pas vers la décadence. On peut l'attribuer au mauvais goût que la faste et la richesse, toujours avide d'ornemens, forçoient les architectes à contracter; et il est assez simple de penser que les princes qui, comme Dioclétien par exemple, avoient quitté la toge romaine pour le costume et le luxe des monarches asiatiques, avoient du penchant

17. L. F. Cassas: *Vestibule du Palais de Dioclétien*, reproduced from Joseph Lavallée, *Voyage pittoresque et historique de l'Istrie et de la Dalmatie* (Paris, 1802), pl. 40

18. (right) Seroux d'Agincourt, *Choix des plus beaux Monumens de la Sculpture Antique*, reproduced from *Histoire de l'art par les monumens, depuis sa décadence au IV^e siècle jusqu'à son renouvellement au XVI^e*, IV (Paris, 1823), pl. I

à trouver beau ce qui n'étoit que riche: car si l'on considère la pureté de la porte de
ce temple et de la galerie extérieure, il est aisé de se convaincre que ces architectes étoient
encore sensibles aux beautés de l'antique, et qu'ils savoient les étudier avec fruit.[35]

It is tempting to believe that Seroux himself may have had a hand in formulating these
judgements.

Such instances—and many more could be quoted—hint clearly enough at Seroux
d'Agincourt's dependence on Gibbon for specific details, but his real debt is of another
order altogether. For he could find no guide to help him in the archaeological or art histori-
cal literature of the time. Winckelmann had ostentatiously neglected any art later than
that of the golden age, as he visualised it, while the innumerable local antiquarians, on
whose researches Seroux often relied, were, it is true, determined to push the chronological
boundaries of conventional study as far back as possible, but only so as to find ever more
precocious ancestors for the art of the Renaissance. If a painter of some distinction could
be found, in Pisa or Siena for example, who anticipated Cimabue or Giotto in the depiction
of the human form, such a discovery would enhance the reputation of either city at the
expense of Florence. It is partly for this reason that art historians today, especially in Italy,
have been keen to give credit to such local studies, and the undeniably valuable results
they achieved, to the detriment of Seroux d'Agincourt.[36] For Seroux, like Gibbon, and
like him alone, was interested in the process by which perfection disintegrated. Nothing
could make this point more clearly than the first plate with which he illustrated the section
of his book devoted to sculpture. The large folio page is divided into thirty-two miniature
reproductions to constitute a 'choix des plus beaux monumens de la sculpture antique'—the
Apollo Belvedere and the *Capitoline Venus*, the *Laocoön*, the *Agrippina*, the *Marcus Aurelius*,
the *Daughters of Niobe* and many more (Fig. 18). This absurdly unhistorical presentation,
so typical of an 'homme de goût', matches in its evocative power the opening chapters
of the *Decline and Fall* before the rot set in.

It is true that, as the book progressed, Seroux became increasingly fascinated by some
of the oddities he found; he came to scoff, and sometimes he paused to praise. But here,
too, he could find occasional precedents in Gibbon for such an attitude, and it is, I believe,
falsifying his overall design to pick out for admiration only such sympathetic responses.
If, here also resembling Gibbon, Seroux ends his book on an increasingly happy note—
indeed, in his case, the note is one of absolute triumph—it should never be forgotten that
he was concerned essentially with the process of decline.

It would, however, be wrong to make the relationship between them too schematic.
Living in Rome and a favourite of the ecclesiastical society of the city, Seroux shared none
of Gibbon's contempt for the development of Christianity—or, if he did, he was remark-
ably successful at concealing it. He goes out of his way to emphasise that the decadence
of art preceded the conversion of Constantine, and he gives what I believe to be the first
historical survey of the emotional impact exerted by Gothic architecture throughout the
ages. This friend of Voltaire lived to read—and to appreciate—the rhapsodies of
Chateaubriand.[37] Nonetheless, I hope that I have produced enough evidence to suggest
that, in a very real sense, Seroux d'Agincourt's fundamental book demonstrates the appli-
cation of Gibbonian interpretations to the study of art.

Fundamental—I use the word with some hesitation. We have seen that Seroux's book was almost exactly contemporary with that of Gibbon, whose influence on it was so strong, and that it was due to be published within a year or two of the *Decline and Fall*. The Revolution put an end to so elaborate and expensive a venture, and in fact it was not until 1810 that the first fascicules began to appear.[38] During the twenty-year interval between completion and publication, Seroux, impoverished now through the abrupt cessation of his income from France, tinkered relentlessly with his manuscripts, making repeated alterations, trying to keep abreast of new research, looking back nostalgically to the past. In the light of our present knowledge, it is impossible to follow the process with any confidence. Had the book indeed appeared at much the same time as the last volumes of Gibbon (the younger man of the two), the affiliation would inevitably have been noted, and the *Histoire de l'art* would have taken its rightful place in the world of scholarship as a sort of supplement to the *Decline and Fall*. Twenty years later everything had changed.

Seroux's researches had become well known—Goethe, for example, had commented on them during his visit to Rome—and many of his collaborators and friends had in the meantime published brief and valuable monographs on early art. In themselves these need no more have affected the grand design of Seroux's majestic volumes than the continuing flow of treatises on Roman commerce or clothing impinged on the *Decline and Fall*. Much more serious was the fact that the whole approach to the subject had changed by 1810. Two generations earlier, Gibbon himself had been aware that another attitude than his toward the decline of the Roman Empire was at least a possibility to be reckoned with. But he had dismissed it with scathing irony: 'They massacred their hostages, as well as their captives', he had written of Attila and his followers. 'Two hundred young maidens were tortured with exquisite and unrelenting rage; their bodies were torn asunder by wild horses, or their bones were crushed under the weight of rolling waggons; and their unburied limbs were abandoned on the public roads, as a prey to dogs and vultures. Such were those savage ancestors, whose imaginary virtues have sometimes excited the praise and envy of civilized ages!'[39] And, indeed, to a surprising extent his self-assured sense of values survived relatively intact until long after his death.

Seroux was less fortunate. Where he had picked his way with gingerly determination through centuries of decay, here and there holding up for cautious admiration the occasional Byzantine ivory or Lombard church or medieval fresco, his disciples, who belonged to a civilisation very different from that in which he had been brought up, began to reject his evolutionary approach to art and to admire 'primitive' artefacts for their own sake, with no concern for the direction in which they were moving, sometimes, indeed, with actual distaste for that direction. Seroux had written with genuine warmth of Giotto, praising his innovations, his expressive power and his composition, but the framework in which he had done so was still that evolved by Vasari and taken up by all subsequent writers who viewed the artist as having been great, 'considering the times in which he had lived', above all, because he had shown the way that led to still greater things. However, William Young Ottley, one of those who made illustrations for the *Histoire de l'art,* went so far as to claim that 'in respect of the three great requisites of *invention, composition,* and *expression,* and for the *folding of the draperies,* the best productions of these periods may even

28

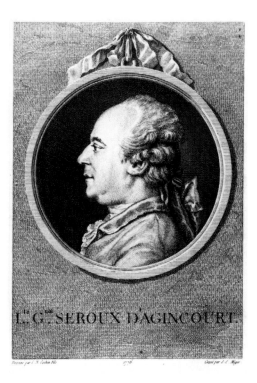

19. C. N. Cochin: *Portrait of Seroux d'Agincourt,*
from *Recueil de fragmens de sculpture antique en terre
cuite* (Paris, 1814)

now be studied with profit, and those of *Giotto,* especially ... abound in examples in
which, by the employment and ingenious distribution of the figures, the intended subject
is developed with a degree of perspicuity seldom equaled, and perhaps never surpassed,
by painters of later times.'[40]

It is true that a long period was to elapse before late Roman art—the *décadence,* rather
than the *renaissance* or the *renouvellement,* in Seroux's schematisation—was to be seen as
progress, but nonetheless the growing enthusiasm for early sculpture and painting led,
even in Seroux's own lifetime, to the whole balance of the book being disturbed. The
process has continued ever since, and the author has therefore been praised or blamed
according to whether he admired or neglected the art, whose serious 'rediscovery' began
only when he was in his seventies or eighties. Partly because he lacked Gibbon's supreme
literary skill and single-mindedness of vision, the *Histoire de l'art* has suffered in the eyes
of posterity far more seriously than the *Decline and Fall* has for even greater misjudgements,
such as—to take a notorious instance—that concerning the nature of Byzantine civilisation.

This was, for the most part, still in the future. But even before his book began to be
published, Seroux saw with alarm one effect of his researches. In what are for us today
surely the most moving pages in the whole *Decline and Fall,* Gibbon had asked 'with anxious
curiosity whether Europe is still threatened with a repetition of those calamities, which
formerly oppressed the arms and institutions of Rome'.[41] His answer was fairly reassuring,
but Seroux lived to see—partly, as he thought, through his own responsibility—the collapse
of an artistic culture which he cherished. As a young amateur, he had loved the art of
his rococo contemporaries Boucher and Fragonard; in middle age, he had been 'converted'
by the neo-classical admirers of Winckelmann; as he grew older, he could see artists (and
not merely connoisseurs) cultivate with fanatical zeal the 'primitive' he had brought to
their attention. In his last years he writes with something like remorse. Fortunate Winckel-

mann to have studied only Greek perfection and to have been able thereby to indicate to artists what they should imitate: 'Je leur montrerai ce qu'ils doivent fuire. C'est ainsi qu'à Sparte, l'ivresse mise sous les yeux des enfants, leur en inspirait l'horreur.'[42]

He renewed his warnings by writing, at the very end of his life, a little book on the antiquities of his own private collection.[43] This was a direct return to the practice which had been advocated and carried out by the Comte de Caylus when Seroux was a brilliant young man. Appropriately enough (though without his knowledge), when the book appeared after his death, there was published as a frontispiece the portrait of him that had been drawn by Cochin for Madame Geoffrin (Fig. 19), so that even in its physical appearance the book seems to constitute a return to a long-dead past. It was dedicated 'aux élèves des beaux arts, mes jeunes amis', and with deep feeling Seroux emphasises, 'Je reviens aujourd'hui à la plus parfaite manière d'instruire, aux leçons que présente la belle sculpture antique; je les chercherai dans les divers morceaux dont l'acquisition et la jouissance ont fait, pendant un long espace de temps, toute ma consolation.' The illustrations must suffice with commentary reduced to a minimum: 'Je ne me piquerai point d'une profonde érudition; ma tête, plus qu'octogénaire, n'en serait plus capable', and he insisted once more, for the last time, on the utility of his life's work, if only it were studied in the right spirit. 'Sachez-moi quelque gré du travail que je me suis imposé, pendant trente ans, pour réunir et mettre sous vos yeux un pareil amas d'examples qu'il vous importe d'éviter.'

If Gibbon had survived to see not merely the first stages but the irredeemable breakup of 'Europe as one great republic, whose various inhabitants have attracted almost the same level of politeness and cultivation',[44] and if he found real reasons for believing that the accounts he had given to the world of heresies and fanaticism, barbarian invasions and cruelty had actually been adopted as guides to conduct, he might have shared some of the feeling of his somewhat older French contemporary.

But, despite his qualms and despite many inadequacies of research, Seroux d'Agincourt had produced a work of fundamental importance. A final Gibbonian analogy is apt. Reviewing Milman's *History of Christianity*, Cardinal Newman was forced to observe: 'It is notorious that the English Church is destitute of an Ecclesiastical History; Gibbon is almost our sole authority for subjects as near the heart of a Christian as any can well be.'[45] For many years after Newman wrote these words, very similar sentiments could have been expressed about Seroux's labours by any student of the arts ranging between the third and the fifteenth centuries.

APPENDIX

Since writing this essay I have pursued the matter further and in an article entitled 'Cicognara eretico' (published in *Giuseppe Jappelli e il suo tempo*, ed. Giuliana Mazzi, 2 vols. (Padua, 1982)), I tried to demonstrate the impact of Gibbon on Leopoldo Cicognara, the great historian of Italian sculpture. In some ways this impact proved to be even more significant than that on Seroux, for—as the censors noted with alarm and indignation— Cicognara accepted Gibbon's religious sentiments as well as his scholarly conclusions.

3. The Baron d'Hancarville: An Adventurer and Art Historian in Eighteenth-Century Europe

AT THE VERY END of the eighteenth century and in the first years of the nineteenth, when the Imperial Republic of Venice had finally crumbled and the city itself was being handed backwards and forwards like a playing card between France and Austria, an exceedingly old Frenchman known as the Baron d'Hancarville used to enthral the guests who assembled regularly at the Salon, not far from the Rialto, of Isabella Teotochi Albrizzi, something of a blue-stocking, but above all one of the most famous society hostesses in Europe, at different times the friend of Byron, Foscolo and Canova.

'His penetrating, voracious eyes' (Fig. 20), she wrote of d'Hancarville, 'his flaring nostrils, his lips which barely touch each other are the outward signs of his longing to see everything; and then, having seen everything, having known everything, he wins you over with his learning and his prolific and imaginative way of speaking.'[1] A young visitor from Corfù was so struck by his conversation one evening that he decided on the spot to remain in Venice and not to return to his native island;[2] an Englishman was to recall that 'my mind was overwhelmed by a tumultuous tide of pleasure, admiration and surprise';[3] and the great art historian Leopoldo Cicognara conceded, after expressing some reservations, that 'it is one of those very singular cases, in which it can be more fascinating and instructive to spend one moment with someone who lives in a world of dreams or is delirious than never to leave the side of someone who is always wide-awake and rational'.[4]

With engravings spread out before him, d'Hancarville would talk to his absorbed listeners about Raphael's frescoes in the Vatican. In the *Liberation of St Peter,* for instance, he would explain, the artist had deliberately altered the traditionally accepted appearance of the Saint in order to make him look like Pope Julius II, thus adding a personal allusion to the titular church of S. Pietro in Carcere of that Pope when he had been a cardinal. Of the *Parnassus* he claimed that it had always been wrongly named and that the poets (whose features and activities he investigated at great length) were in fact assembled on Mount Helicon.[5]

It has to be assumed that his vivacious temperament and compelling voice made it more exciting to listen to d'Hancarville in the flesh than it is, nearly two centuries later, to read botched-up versions of his theories as recorded by his friends. Certainly those who did hear him were mesmerised. And d'Hancarville could also captivate them with first-hand accounts of an astonishing life—a life involving picaresque military adventures in Germany

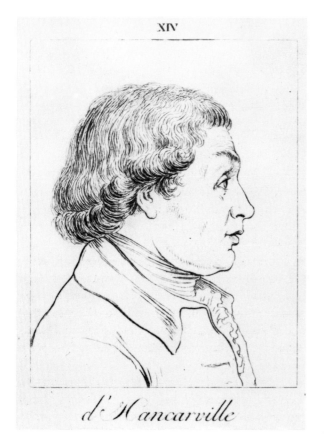

XIV

d' Hancarville

20. *Portrait of d'Hancarville*, from Isabella Teotochi Albrizzi, *Ritratti* (Padua, 1808), pl. 14

and debtors' prisons in most countries of Europe; brushes with the police over pornographic publications and collaboration with the great Winckelmann, murdered forty years earlier; close friendship with a President of the United States, lionisation by London society and participation with the crowd which had swarmed into the Bastille on 14 July 1789. He could also tell them the dozen or so false names under which he had passed at different times. The word 'adventurer', so familiar in the century of Casanova and Cagliostro, could have been coined for him, and it was freely used of him in his heyday. But now in his eighties he was respectable, even venerable—never, however, conventional. 'Delirious' theories about the frescoes of Raphael were only one indication that his strange, scholarly brain was still at work. He was also engaged in a far more surprising activity. He became one of the first men for centuries to enter the private chapel of the Scrovegni family in Padua and to study with extreme care the frescoes in it by Giotto, which had been barely mentioned even by Vasari and little referred to ever since. He then provided long, elaborate and far-fetched explanations of the allegorical Virtues and Vices round the base of the walls.[6] These explanations were hardly needed, as the frescoes concerned had been considerately inscribed by the artist and the imagery could be looked up in the standard iconographical textbooks, but once again the scholars were—as they always had been—bowled over by his arcane and original interpretations.

But these were to be his last—and they came too late to be published by him. Lying on his deathbed, he set the world one final mystery. Even to his confessor this man, with

so much on his conscience, refused—like some vain woman, in the words of a friend[7]—to confess his true age. In fact he was almost certainly more than eighty-six when he died in October 1805 and was buried in the little church of S. Niccolò in Padua. In the 1830s a French traveller came to look for his tomb and to try to find out from the parish archives what could be established about his final years.[8] Recently I did the same, but I do not think that many others had bothered much about him in the intervening century and a half.[9]

There is indeed something desperate, even ghoulish, in trying to resurrect forgotten art historians; but the opportunity to present to Harold Acton, from whom I have learned so much about Naples and Florence, a few pages devoted to a bizarre (though not always reputable) character who enlivened scholarship and society in both these cities during the second half of the eighteenth century is not the only reason why I have chosen to write about d'Hancarville in this volume. At a time when 'conventional' art history is under strong attack from those who deplore its lack of intellectual content, there may well be something to be gained from looking at the influence exerted by a man whose genuine passion for ideas only rarely met with that critical and yet sensitive response which is always necessary if the subject of art history is indeed once again to become truly significant.

'Baron d'Hancarville' was born Pierre François Hugues in Nancy in 1719,[10] the son of a bankrupt cloth merchant. He was something of a prodigy, for, to raise his standing in the world, he quickly mastered a very wide range of ancient and modern languages, as well as mathematics, history and various sciences. Perhaps he had the Church in mind; but he chose instead the army, the other road to success in the hieratical society of the *ancien régime,* and he was soon a captain in the service of Prince Ludwig of Mecklenburg. We come across traces of him in many parts of Germany, enthusiastically patronised by a number of ruling families: Lessing met him in Berlin,[11] Voltaire suggested that he should call on him in Potsdam, and Winckelmann was later to say that he spoke German perfectly.[12] In 1750 he was imprisoned for debt, but he was rescued by another German princeling, the Duke of Wurtemberg, himself a notorious gambler and spendthrift, and became involved with him in some farcical plot to buy up the island of Corsica.[13] Not surprisingly this came to nothing, and once again he seems to have been arrested—though not before having stolen the Duke's silver.[14] No doubt it was just this sort of episode that d'Hancarville was thinking of when, some years later, he wrote—melodramatically but a little vaguely—about 'those gloomy days, when, by the sport of capricious fortune, the low intrigues of Courtiers, and the ambitions of Princes, I saw, like Damocles, the fatal sword continually hanging over my head'.[15]

D'Hancarville also travelled in Spain and Portugal, and published a philosophical pamphlet apparently designed to demonstrate that morality was essentially a matter of political calculation. Although this was a matter on which he could speak with particular authority—Frederick the Great said that d'Hancarville was indeed an expert on the morality of stealing[16]—the main significance of the work, which was well received, was probably that it brought him into ever closer touch with the world of the 'philosophes' (Voltaire thought highly of his brain, though less so of his character)[17] and it needs to be emphasised that, for better or for worse, d'Hancarville was a man who came to art history from the

outside: not just from the barracks and the debtors' gaol, but from the world of philosophical speculation.

We first hear of him in connection with art in Florence in 1759. The circumstances are characteristic. 'When you show him your gems', wrote Winckelmann to Muzell-Stosch, nephew of the great antiquarian and inheritor of his collection, 'keep a very close look-out to see what he is doing with his hands.'[18] D'Hancarville was living on borrowed money under a series of assumed names, constantly on the run from the police. When life became too difficult he was forced to abandon his pregnant mistress, but that particular problem was solved by her running away with a monk.[19] Winckelmann, respectably installed as librarian to Cardinal Albani, was always to keep a distrustful, even scornful, eye on him—but was also to be much impressed by his talents.

It was not until several years later that those talents emerged in print—under somewhat mysterious circumstances. In November 1764 William Hamilton, then aged thirty-four, had been appointed British Envoy to Naples and had at once begun to pursue his astonishing career as art collector and dealer. Such activities were normal in the Foreign Office at the time, but Hamilton was most unusual in concentrating so much energy on the acquisition of ancient vases. It was only in the previous decade that this fashion had become at all widespread, and Hamilton was certainly among the very first to appreciate the intrinsic beauty as well as the historical interest of these antiquarian remains. The incredible speed with which he proceeded can be seen from the fact that within a year of his arrival he already owned a sufficient number—several hundred in fact—to warrant publishing a huge illustrated book on them. In some way, which is not yet clear, the job was entrusted to d'Hancarville.[20]

D'Hancarville thus has one claim to fame and to the gratitude of posterity which can surely never be disputed: he was a very great book designer. We know that Hamilton supplied the money and the vases, and left d'Hancarville to make all the practical arrangements. The volumes that resulted from this agreement are among the most beautiful of the eighteenth century—indeed, among the most beautiful of all time. The frontispieces and vignettes (Fig. 21) were, for the most part, drawn by Giuseppe Bracci (who is today almost totally forgotten, but who worked on the design of tapestries in Naples),[21] and in fantasy and brilliance of execution they are hardly inferior to the achievements of such elder masters as Piranesi and Tiepolo. Even more startling are the spectacular colour plates of the vases themselves (pl. 31). Hamilton had been particularly keen to improve modern English design by encouraging craftsmen to make a close study of antique forms, and for this purpose he insisted that carefully measured drawings should also be included. As the book was exceedingly expensive, the plates were often sold separately, and it is not surprising that Josiah Wedgwood should have been among those who acquired them—though the true extent of the influence exerted by these on English taste has been more frequently asserted than investigated.

Nonetheless, the beauty of the plates has been responsible for the four volumes being studied, if at all, by connoisseurs of neo-classical ceramics who have all been misled by the illustrations and by the title page: *Collection of Etruscan, Greek and Roman Antiquities from the Cabinet of the Hon.ble Wm. Hamilton, His Britannick Majesty's Envoy Extraordinary*

PRÉFACE.

Eſt à Monſieur Hamilton que le Public eſt redevable du beau recueil de deſſeins & de vaſes Etruſques, Grecs & Romains que nous lui donnons aujourd'hui. Conduit par un goût très éclairé ſur toutes les parties des Arts, dès longtemps il s'eſt fait un plaiſir de ramaſſer ces monuments précieux du génie des Anciens; & moins flatté de l'avantage de les poſſéder, que de celui de les rendre utiles aux Artiſtes, aux Gens de Lettres, &, par leur moyen, à tout le mon-

RECUEIL

D'Antiquités Etrusques, Grecques et Romaines.

CHAPITRE I.

De l'Origine des Etruſques, & de leurs Lettres.

Es commencemens des Anciens Peuples ſont preſque tous fabuleux, incertains ou totalement inconnus. On diroit que ſemblables aux ſources de ces fleuves, que leur petiteſſe ou leur trop grand éloignement dérobent à nos recherches, les Origines des Nations nous ſont cachées, ſoit qu'ayant eu des Principes trop foibles, ſoit qu'étant ſéparées de nous par un trop long intervalle de tems, elles reſtent confondues dans la

at the Court of Naples, Naples MDCCLXVI. In fact, the antiquities were only partly selected from Hamilton's collection, the book itself deals very little with vases, and for the most part it was not published in 1766.

In the first pages d'Hancarville paid lip service to the task with which he had been entrusted and from time to time he made spasmodic returns to it, prodded perhaps by Hamilton. He boasted of his knowledge of the technical procedures involved and explained how they could help contemporary craftsmen. He singled out for special praise the vase which is still thought to be the finest in the collection (Fig. 22) and which was given a prominent position in the portrait Sir Joshua Reynolds was later to paint of Hamilton (Fig. 23), and he made a few casual comments on the subjects represented in the vases. But he soon lost interest in this and launched into the first of his many investigations into the history of art in general. In these he demonstrates a phenomenal range of reading in classical literature and enters with some eagerness into one of the main disputes which had been rending Italy and intellectual Europe for some decades and which centred on the question as to which peoples had first cultivated the arts with complete success, the Etruscans or the Greeks. Artists and archaeologists, French and Italians, uncovered inscriptions, illustrated more and more evidence and fought bitterly over an issue which touched not only on sensitive local patriotisms but also on the best models to be followed by aspiring artists. The growing fame of the still almost unpublished temples at Paestum which were indubitably Greek and yet also very early in date did not in the slightest abash d'Hancarville,

21. Giuseppe Bracci (engraved Pignatari): Decorated pages from [D'Hancarville], *Collection of Etruscan, Greek and Roman Antiquities from the Cabinet of the Hon.ble Wm. Hamilton, His Britannick Majesty's Envoy Extraordinary at the Court of Naples*, I (Naples, 1766), pp. iii, 27; II (1770), pl. 4

who had at first come down on the side of the Etruscans. He had, he explained, been to Paestum and had found there the ruined remains of an even older Etruscan temple which had obviously been copied by Greek architects. On the other hand, he was among the first to agree with Winckelmann that the vases which were now being dug up in such large quantities near Naples as well as in Central Italy must in fact have been the work of Greek and not Etruscan artists.

Perhaps, indeed, he was a little intimidated by Winckelmann at this stage. Like many people who have decided to subdue their irregular sexual desires to the cause of respectability, Winckelmann was fascinated by bad behaviour in characters less cautious than himself and after d'Hancarville had written in very flattering terms about him the two men became friends, though they remained rather wary of each other.[22] D'Hancarville sent Winckelmann drawings of antiquities which had been discovered in Naples,[23] and in 1767 the great man came down to stay with him there. They climbed up Vesuvius with another friend, the Baron von Riedesel, their feet crunching the hot lava; and as they neared the crater they were held up by a minor eruption. They had to spend the night on the slopes, half naked, having removed their sweaty shirts to dry, and they ate pigeons cooked on an open fire—'just like the Cyclops', wrote Winckelmann with enthusiasm.[24] But by the time d'Hancarville's second volume appeared in 1770 Winckelmann had been murdered in Trieste. The text had already been completed, but d'Hancarville commemorated with a fine illustration the passing of the man from whom he had learned so much (Fig. 24).

22. Water-jar decorated by the 'Meidias painter' with scene of *Castor and Pollux carrying off the daughters of Leucippus*, as illustrated in [D'Hancarville], *Collection of . . . Antiquities from the Cabinet of the Hon.ble Wm. Hamilton*. The jar itself is in the British Museum.

The book had been intended to consist of two volumes, but d'Hancarville decided to enlarge it to four, because he now found that he had a great deal that he wanted to say. His patron, Sir William Hamilton, had been foolhardy enough to subsidise all the illustrations before the text had been completed (or even begun) and he soon paid for this rashness. Months, and then years, passed with no sign of the book being completed. D'Hancarville was soon once again in flight from his creditors, and in 1770 he was expelled from Naples on 'pain of death if he ever returned',[25] apparently for publishing the pornographic illustrations to which reference will be made below. Not long afterwards the 'idle adventurer', as Horace Mann described him in a letter to Walpole, arrived in Florence with a wild scheme to borrow money by supplying Tuscany with fresh fish.[26] He intended to combine this with the production of a catalogue of the works of art in the Uffizi—for he had by now much impressed the Grand Duke of Tuscany, thanks to whose generosity he was able to live in Florence 'en Prince'.[27] He was indeed, as Mann commented, 'a strange man [with talents] that only wanted common honesty to make him a brilliant figure'.[28] Meanwhile he pawned all the superb plates for the last two volumes and hid in a convent. When the enraged Hamilton arrived in hot pursuit a few months later, d'Hancarville was already in prison once again.[29]

The last two volumes eventually appeared in 1776. They are much more interesting than anything that he had yet published, but they are also prolix, badly composed, badly

23. Sir Joshua Reynolds (studio): *Sir William Hamilton*, 1777 (London, National Portrait Gallery). The folio is one of the volumes of d'Hancarville's publication; the water-jar is shown in Fig. 22.

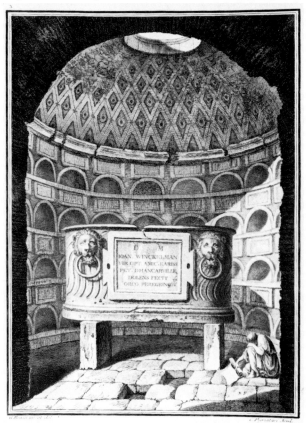

24. Giuseppe Bracci (engraved Pignatari): Mausoleum in honour of Winckelmann, from [D'Hancarville], *Collection of . . . Antiquities from the Cabinet of the Hon.ble Wm. Hamilton*, II (1770), pl. 3

written, pedantic, unreliable, dogmatic and credulous. And yet there are fleeting moments in these volumes during which we can grasp what it was about d'Hancarville that was at all times in his life to intoxicate those who came in touch with him—and to win their reluctant admiration even when it became all too clear that he was not the gentleman that he claimed to be.

Any indication of d'Hancarville's powers can only be suggested here by extreme over-simplification. It is broadly true to say that in the middle of the eighteenth century two distinctive, even though overlapping, groups of people were concerned with the arts of antiquity. On the one hand, there were those who were seeking in Greek and Graeco-Roman sculpture for an 'ideal beauty' with which to counter the changing, fashionable and—as they saw it—frivolous styles practised by the artists of their time. On the other hand, there were the antiquarians searching for clues which might throw light on ancient burial or wedding customs, myth or fable: and the more daring among these expected that their researches might even show that Christianity was not the unique, divine revelation that its orthodox supporters liked to claim, but merely one among many similar Mediterranean religions. D'Hancarville was concerned with both these issues and he discussed them both. But the questions he posed most rewardingly were different—and genuinely original. He was interested in why art existed at all, and why it took the various forms it did in different places and at different times.

The origins of the arts, he claimed, must be sought in popular religion—here (as quite often elsewhere) anticipating much Romantic theory: it is, he says, 'in representing the Gods that sculpture learnt to represent man'. But religious art had taken various forms: first of all, there were altars set up to the spirits of trees and rivers; then men built up piles of stones to indicate the presence, but not the appearance, of the gods—but this was too complicated to be understood by 'the people, which has always been the same in all times and all places'. And so the demand arose for some kind of representational sculpture. But, d'Hancarville argues, the history of sculpture consists of a continuous tension between two opposing forces, each of which has always hindered the other: the 'sign' and the 'figure'. In the many-breasted antique sculpture of *Diana of Ephesus* (Fig. 25) (known in a number of versions), for instance, the 'sign'—that is, the symbol of bounty or abundance—has produced a monstrosity in terms of art. And so the development of sculpture can be demonstrated by successive victories of the 'figure' over the 'sign', and these victories are achieved by turning the 'sign' into an 'attribute'. Attributes can take the form of exaggerated size or luxurious costume or some subsidiary feature which enables us to recognise the significance of what is shown without feeling that its 'figurative' quality has been destroyed.

D'Hancarville then proceded one stage further. Starting from the characteristically eighteenth-century notion that men are, and always have been, the same—a notion which he adumbrates in a surprisingly moving phrase, 'it is through the secret influence that they exert on the spirit that the centuries touch and draw close to each other despite the intervals of time which separate them'[30]—he suggests that even when great artists make 'figurative' sculptures, they quite deliberately retain the almost fetishistic magic of the earlier 'signs' that inspired their compositions. Thus, he claims that if one looks at two of the most famous

compositions surviving from antiquity, the so-called *Castor and Pollux* (Fig. 26) and the *Three Graces* (Fig. 27), one sees that the former is not only derived from, but is actually designed so as to recall its derivation from, two upright beams joined together by a kind of bolt; while the latter group has also been composed so as to remind those who look at it of the three piles of white stones which had originally been set up to pay homage to the Graces.[31] This issue of intention is crucial. D'Hancarville is not just arguing that complex figurative sculpture develops naturally from primitive forms: he is claiming that such complex figurative sculptures are effective precisely because they still retain the mythic power of non-figurative forms.

During the course of publishing Hamilton's Greek vases d'Hancarville had managed to insert (as indeed truth required him to do) some exceedingly erotic illustrations and it was probably this that gave him the idea, when in financial trouble once again, of making some money through the production of cheaper and more accessible books devoted to themes which he had as yet barely touched on. The precise time and place of publication are uncertain, but it was probably just before 1770 that he issued the first of two thin, illustrated volumes with the rather lurid titles of *Monumens de la vie privée des douze Césars* and *Monumens du culte secret des dames romaines* (Fig. 28).[32] Pornography did not bring out the best in d'Hancarville. His literary style—never his strong point—became coy and whimsical, and the supposedly antique gems which he used as illustrations were all modern forgeries. But, though moralists will deplore the fact, his exploitation of sexual fantasies, far from being useless to his scholarship, stimulated some of his most vivid influential and (conceivably) worthwhile ideas.

By the spring of 1777 d'Hancarville had drifted to London where 'he was in a Manner

25. *Diana of Ephesus* (Naples, Museo Nazionale)

26. *Castor and Pollux* (Madrid, Prado)

27. *The Three Graces* (Paris, Musée du Louvre)

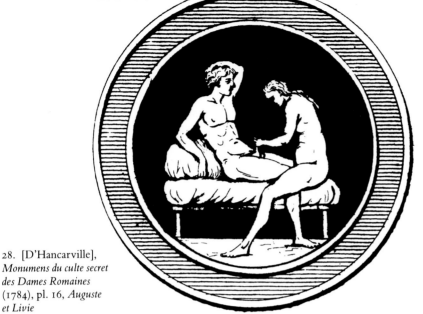

28. [D'Hancarville],
Monumens du culte secret
des Dames Romaines
(1784), pl. 16, *Auguste*
et Livie

Starving, Sculking about in the City, and Picking up Victuals in the meanest pot houses he could'. His arrival coincided with Sir William Hamilton's brief return to England and from this patron he was able to scrounge just enough help until he was picked up by Charles Townley.[33]

Townley, a Catholic gentleman from Lancashire, had spent much of his life in Italy and had devoted a great deal of time and expense to assembling one of the finest collections of antiquities to be seen in England: a famous picture by Zoffany (Fig. 29), painted in about 1781, gives a vivid though fanciful impression of the sculptures he had brought together in his house in Park Street, Westminster—and in that picture we can see d'Hancarville seated at the very centre, explaining, in an almost proprietary way, the antiquities which he had been called upon to catalogue.[34]

For d'Hancarville's conquest of Townley had (of course) been complete: he had at first (in Townley's words) spent summer and part of winter 'filling his belly frequently at my house with an occasional loan of 5 guineas', and during this time his disquisitions on ancient art had appeared to the collector to be 'more rational and more Satisfactory than all I had found in the absurd books of Antiquaries'.[35] But Townley, like Hamilton, also found that the burden of maintaining d'Hancarville was not an easy one ('£180 per annum . . . is much above what my income can afford'), and he wrote for advice to his friend and rival collector, Richard Payne Knight. Knight also found himself in a difficult situation ('the depreciation of property has rendered me so much poorer than I expected to be when I undertook the great Works I have been doing in Herefordshire, that my Finances are by no means in an agreeable State'), but he too was convinced that 'Dancarville's Work promises to be such an Acquisition to all lovers of Ancient Arts and History that he must at all events be enabled to complete it', and he agreed to help with the necessary subsidies.[36]

29. Johan Zoffany: *Charles
Townley in his Library*, 1781–3
(Burnley, Towneley Hall Art
Gallery). Townley
is seated to the right, and
D'Hancarville in the centre;
behind him are Charles Greville
and the antiquary Thomas Astle.

It was thus under the joint auspices of Townley and Knight that d'Hancarville was able to publish in London (but in French) the book that was to give him most notoriety. The long, elaborate title seemed innocuous—*Recherches sur l'origine, l'esprit et les progrès des arts de la Grèce; sur leurs connections avec les arts et la religion des plus anciens peuples connus; sur les monumens antiques de l'Inde, de la Perse, du reste de l'Asie, de l'Europe et de l'Egypte*[37]—but the contents of the two volumes were explosive. Appearing in 1785, it was a book that could not have been written even a few years earlier, for it took into account the first shock waves of a crucial and very recent intellectual discovery that was on the verge of transforming the consciousness of Europe: first-hand knowledge of the religions and literature of India and the Far East.[38] D'Hancarville was not particularly interested in Indian art and religion in themselves: he was, however, fascinated by the light that they could throw on the art of Greece, and he read carefully the theoretical works of those French writers who were delving into comparative mythology in order to prove that Moses and Bacchus and Osiris were no more than local variations of a single god, belief in whom had once spread over the entire world.[39] To these theories he added ideas of his own about the meaning of the images to be found on Greek vases which had first occurred to him during the last phase of his work on the Hamilton collection. And he suddenly claimed that anything at all strange could be interpreted as representing the initiation rites

into the secret mystery religions of antiquity, just as—he pointed out, in a revealing aside—artists in his own day were often required to paint for Freemasons images which they themselves could not understand. He studied all the illustrations (and occasional pieces) of Indian art he could lay his hands on, and the varying enthusiasms of his life now came together into a blindingly obvious whole, composed of pedantry, a passion for systems, pornography, an obsession with the religious origins of art, as well as bold (if unsubstantiated) flights of imagination, intelligence and learning. Everywhere he found the same image—the image of a bull, often breaking an egg (Fig. 30)—not only in Indian art, and on the coins of other exotic countries, but in Greek art also. Drawing on his extensive knowledge of languages, travel books and literature, he interpreted the Bull as symbolising the generative powers of the Creator. Thus the origin of all art was, as he had always thought, to be found in religion, but he now saw that this religion was one of sexuality—a tribute to fertility and the creative urge.

D'Hancarville did not spell out in print the full implications of his theories, which were in any case partly obscured by the almost impenetrably dense language in which he wrote about them: in private, however, he must certainly have explained exactly what was at stake, and (as is well known) two of his disciples caused considerable offence by demonstrating his views in lively and accessible prose. In 1780 Sir William Hamilton, his first great patron, discovered that in the little town of Isernia, less than fifty miles from Naples, the annual saints' day of Saints Cosmo and Damian was celebrated by a religious procession during the course of which waxen images of the male sexual organs were offered for sale. Beyond a small jibe that his discovery offered 'a fresh proof of the similitude of the Popish and pagan religion', Hamilton's report to the Society of Dilettanti (to which he had been elected a few years earlier) was laconic and reticent. But in 1786 another of d'Hancarville's patrons, Richard Payne Knight, took the whole matter much further, and in his *Discourse on the Worship of Priapus* (Fig. 31), he gave a witty, Voltairian, icy form to the more ponderous learning of his mentor.

30. Illustration from [D'Hancarville], *Recherches sur l'origine, l'esprit et les progrès des arts de la Grèce; sur leurs connections avec les arts et la religion des plus anciens peuples connus; sur les monumens antiques de l'Inde, de la Perse, du reste de l'Asie, de l'Europe et de l'Egypte* (London, 1785), I, pl. VIIIA

31. Richard Payne Knight, *Discourse on the Worship of Priapus* (London, 1786), frontispiece

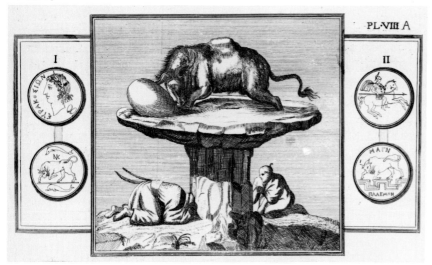

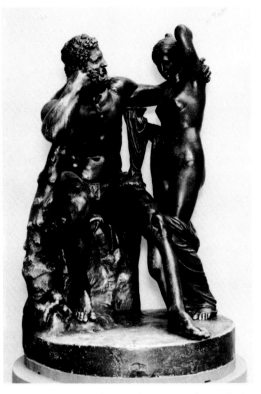

32. John Flaxman: *Hercules and Hebe* – imaginary reconstruction, in painted plaster, of Belvedere Torso (on loan to Victoria and Albert Museum, London)

Payne Knight knew exactly what he was doing. Religious subjects, he pointed out, being beyond the reach of sense or reason, are always embraced or rejected with violence and heat: 'men think they know because they are sure they feel'. He then set out to demonstrate with great vigour that the cult of fertility lay at the foundations of all religion, ancient and modern, Eastern and Western, Christian and heathen, and that this cult is expressed in innumerable varieties of religious symbolism. Almost everything that is described in common speech as 'Freudian' can be found in Payne Knight's brilliant little essay, and—as he acknowledged—he had derived his ideas from d'Hancarville, though he disagreed with him on a few complex linguistic points. And so it is through this essay, privately reprinted during the Victorian era (after Payne Knight himself had found it prudent to suppress it), that d'Hancarville's name has been kept tenuously alive as a purveyor of scholarly pornography. But, as has been seen, this aspect of his work (which certainly does exist) formed only one fragment of a far more systematic attempt to come to terms with every aspect of the visual arts.

D'Hancarville—how and when and whence he obtained his barony are still unsolved problems—interrupted the publication of his *Recherches* in London following a particularly damaging review, and (after nearly ten years in England) he went to Paris where he enjoyed an active social life, numbering among his friends Thomas Jefferson, at that time the American Minister to France, the English artist Maria Cosway, with whom Jefferson had fallen in love, and—above all—the leading painters of the day, especially David and his pupils.[40] His book on the Hamilton vases (or supposedly on the Hamilton vases) was reprinted in a less lavish edition, and as he grew older he acquired an international reputation as a man who could solve all iconographical problems.[41] Oddities about the imagery of Renaissance portraiture were referred to him for explanation;[42] and the English sculptor

John Flaxman attributed to d'Hancarville (rather than to Ennio Quirino Visconti, its true author) the notion that the Belvedere Torso in the Vatican was the only surviving fragment of a group that had once represented Hercules seated with Hebe standing on his left and made a plaster showing what it would have looked like (Fig. 32).[43]

In 1789 d'Hancarville—whose political sympathies were cautiously liberal—welcomed the fall of the Bastille and sent Townley an entertaining letter describing some of the scabrous documents which had been discovered in the fortress.[44] But soon the situation became uncomfortably oppressive and he fled to Rome, where he settled at some time in 1791, and then to Venice.[45] It was there that he dazzled his friends with theories about Raphael and Giotto, for he was not a man to rest on his laurels—*Cras ingens iterabimus aequor* he had quoted from Horace at the end of one of his volumes—and he was always on the look-out for something new to explore.

When d'Hancarville died in 1805 he left behind him an enormous mass of manuscripts, and the first concern of his friends was that these should be published. Most of them fell into the hands of an eccentric Fellow of Corpus Christi College, Oxford, Wolstenholme Parr, who despite much pressure did little more than print a very mutilated version of part of d'Hancarville's essay on Raphael.[46] Parr did, however, show his devotion to d'Hancarville's memory by giving in Padua a lecture, said to be based on the master's principles, on the significance of the word 'Oxford': there is no need to stress the bull symbolism he was able to find in the word, as well as the relics of Oriental religions that could be traced in the river Isis.[47]

Looking back, it is not difficult to see why d'Hancarville was able to exert so hypnotic an effect on so many people. He combined the love of the Encyclopaedists for the systematic search for a common origin, a single explanation, to account for all the varieties of artistic experience, with what we would think of as a typically Romantic preoccupation with the exotic, the irrational, the hidden springs of religion and creativity. His influence could survive only as long as those preoccupations were combined, as they were at the very end of the eighteenth century. The empirical, positivist art history of later years might seem to have disposed of him.

Soon after d'Hancarville's death a number of Italian archaeologists and art historians began to subject his work to fascinated but sceptical scrutiny.[48] It was Leopoldo Cicognara, the great historian of sculpture, who had the last word: 'In short [according to d'Hancarville] everything has a profound meaning, no doubt is ever possible, everything is related to ancient theology, nothing is given to chance, nothing to the skill or incompetence of the craftsmen; and this same excessively ingenious and strange way of interpreting is applied not only when the meaning really is in doubt, but in every other case. And this leads to the greatest intellectual danger possible, so that explanations are given of issues which arise out of pure chance and which do not in fact need any commentary'[49] Cicognara's summing up of d'Hancarville is uncannily relevant in some parts of the world today—but who would not also accept his conclusion that 'it can be more fascinating and instructive to spend one moment with someone who lives in a world of dreams or is delirious than never to leave the side of someone who is always wide-awake and rational'?[50]

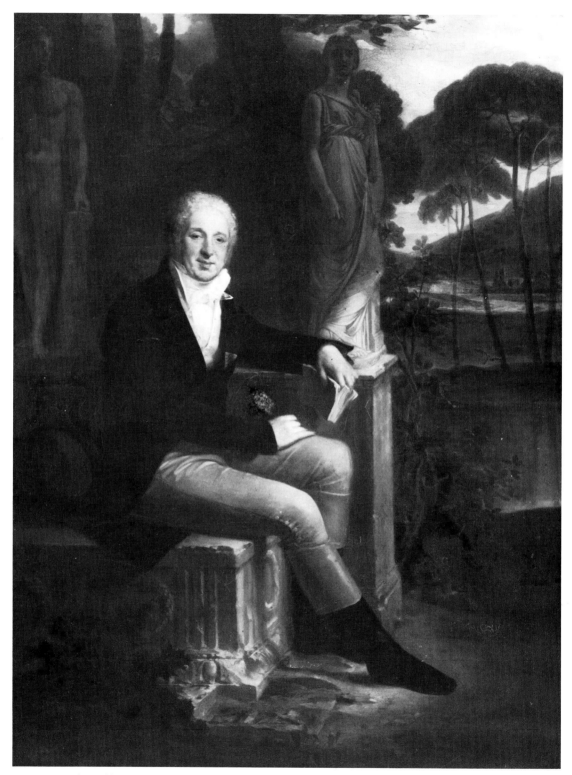

33. Pierre Paul Prud'hon: *Portrait en pied de M. de S*** [Sommariva] dans un fond de paysage* – Salon de 1814 (Milan, Brera)

4. An Italian Patron of French Neo-Classic Art

ALTHOUGH IT IS not a rule which can be applied universally, it is generally true that the more that lavish art patrons and art collectors recede in time, the more sympathetic they appear to posterity. Who now, when wandering through Florence, worries unduly about the misdeeds and crimes of the Medici, who have acquired an aureole from the beautiful objects that they commissioned? But the man who is subject of this essay, a man who has an unchallengeable claim to be considered the most munificent patron of the finest painters and sculptors of his day, died less than a hundred and fifty years ago; and when considering his strange life it will be difficult to forget the few but acid words with which a French authority has summed up his career. The power he exerted was marked 'by total immorality . . . and unscrupulous rapaciousness', and when he fell from power he made use of his splendid art collections in order to encourage people to forget the discreditable origins of his fortune.[1]

I first ran into Giovanni Battista Sommariva (Fig. 33) by what seemed like an accident, though—as will become apparent—this was exactly what he had planned. I was studying very carefully the Salon catalogues of nineteenth-century France, and I found that again and again during the first quarter of that century, the same name would turn up as the owner or purchaser of the more important pictures which were shown at these exhibitions. After this had happened several times, I began to wonder exactly who was this man, with an obviously Italian name, who seemed to be in such close touch with David, Girodet, Prud'hon and all the other best French artists of the time; who was in fact, beyond any doubt, the most significant patron in early nineteenth-century France outside the Emperor Napoleon and his immediate family: this was exactly what Sommariva had wanted me to wonder.

It soon became apparent that Sommariva was not only a passionate lover of French art—a fact which, by itself, would make him unique in the long history of Italian patronage—but also that this was acknowledged by his contemporaries who claimed that he 'appartient à la France par son goût, comme par ses affections'.[2] His two sons fought in Napoleon's armies from Russia to Spain, where one of them was killed, and although he himself was to spend much time, and eventually to die, in his native Italy, we will see that his whole life was dominated by French ideas, French arms, French politics and French culture.

But, although Sommariva is today largely forgotten or, when remembered, treated with

contempt, his career as a patron is one of considerable significance. We still know extra-ordinarily little about French—or even English—art patronage and collecting at the end of the eighteenth and the beginning of the nineteenth centuries, years pregnant with enor-mous changes in both countries, and any sociological theory of the arts and of taste can, I believe, only be based on the close study of very large numbers of individual case histories: it is one such that I want to present in this paper.

When the superb portrait of him by Prud'hon was exhibited at the Paris Salon in 1814,[3] Sommariva was just entering the most dazzling phase of his life. For many years he had been establishing himself as the most distinguished art patron in France, and until his death a dozen years later it was the aim of all art-loving visitors to Paris and to Italy to visit his five splendid houses filled with pictures and statues by contemporary and Old Masters.[4] For it was not just the professionals who were interested—the critics and the artists, all of whom naturally raved about his taste. We hear also of the young Balzac applying to gain admittance,[5] and of Stendhal overwhelmed by one of his sculptures,[6] of Samuel Rogers,[7] of Lord Lindsay[8] and—inevitably—of the effusive Lady Morgan[9] calling to see the collections. And there were innumerable others, all of whom seem to have been greeted with friendliness and hospitality.[10]

But this had not always been the case, and Sommariva's origins had been as dim and unpropitious as was to be his subsequent neglect by history.

Writing of him some time after his death one very grand French royalist said that he 'had surfaced from below ground'.[11] He was in fact born near Lodi in North Italy in 1760 and, so his enemies claimed, he started life as a barber's assistant.[12] With the support of the local nobility, however, he soon took to the law and became a successful barrister; the speed with which he began to make a fortune suggests that he was not altogether a scrupulous one. Be that as it may, when he came to Milan some time just before 1796, he had already done well for himself, though he was to go a long way further. The times were dangerous but full of opportunities for the talented, and the very words 'Milan in 1796' have a special resonance for lovers of French literature, for that is the name given by Stendhal to the first chapter of the *Chartreuse de Parme*. In it he evokes the few months after the battle of Lodi when Napoleon and his army descended into Italy and 'the miracles of bravura and genius which they performed awoke a sleeping population'.

Sommariva had not exactly been asleep during the previous years, but it is certainly true that the arrival of the French army gave him—like so many ambitious, intelligent and unscrupulous men of low birth all over Europe—opportunities which he could hardly have dreamt of before, and he seized them with both hands. It was, indeed, in his house that Napoleon first met Count Melzi who was to be the main architect of his policy in Italy and Sommariva's bitterest rival.[13] It would, however, be impossibly tedious to discuss here the swiftly varying fortunes of Napoleon's campaigns and policy in Italy: his playing off of the Jacobins against the moderates; his accommodation with his own government and then his defiance of it; his attempts to come to terms with the innumerable factions which were struggling for power in Milan and also to keep them under control so that he could achieve his principal aim of winning prestige for himself and extorting as much as he could from the population to finance his campaigns and keep his government in

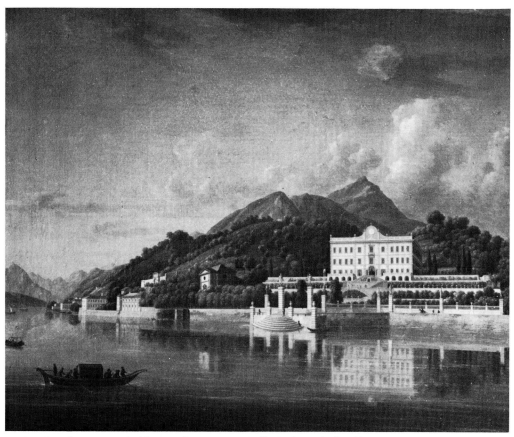

34. Jean Joseph Xavier Bidauld: *La Villa Sommariva* (Villa Carlotta, Cadenabbia)

Paris happy. All the various ins and outs of these events vitally affected Sommariva's career. By identifying himself with the French he found himself on top of the situation whenever they were in control, and then in trouble when they were driven out for more than a year by the counter-attacking Austrian and Russian armies. But even this had its advantages. Unlike those many other supporters of the French who were deported under appalling conditions to prison camps in Austria and Dalmatia, Sommariva fled to France, and the friendships that he made there with important politicians were to be of the greatest use to him in later years.[14] And in any case the advantages of being on top fully outweighed the temporary drawbacks that he was forced to suffer from time to time.

From 1800 to 1802, the lifespan of the second Cisalpine Republic proclaimed by Napoleon (now First Consul), Sommariva was virtual dictator of Milan. During these two years he made himself a gigantic fortune as well as a reputation for shady behaviour which it was to take him a decade of imaginative skill to live down. These, however, were his years of triumph. He showed his gratitude to Napoleon by proposing that Canova should be commissioned to carve for the centre of Milan what would have been the first monumental statue of him in Europe, though in fact his plans came to nothing.[15] It was now that Stendhal, a Frenchman in love with Milan, first came into contact with this Milanese in love with France. The writer, at this time a young lieutenant in the army of occupation, coolly recorded in his journal the exceedingly scabrous circumstances in which Sommariva was enjoying some of the privileges of power.[16] More important, it

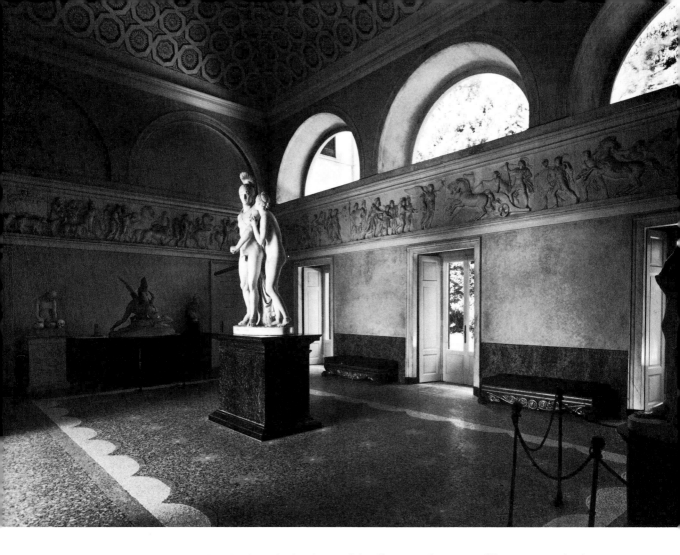

was now too that he bought his beautiful villa on Lake Como[17] (Fig. 34) which was to become famous throughout Europe.

But all this could not last. Though he was apparently an efficient administrator, his excessive taxation—which, to be fair, was forced upon him by the French—and his wild financial speculation—which was carried out entirely in his own interest—made him profoundly unpopular, and when in 1802 Napoleon proclaimed the Italian Republic, of which he himself was to be President, Sommariva's ambitions to be acting head of state were thwarted, and he was replaced by Count Melzi who had been introduced to Napoleon by himself. Sommariva did what he could to fight against the current. He offered a diamond necklace to Josephine, who turned it down, and an extremely expensive watch to Talleyrand, who accepted it. Neither gift did him any good.[18] He went to Paris again to intrigue with Melzi's enemies there, the ambitious Murat in particular, but he was soon reprimanded by Napoleon.

Sommariva was now aged forty; he was a very rich man, but he was a discredited, hated and ridiculous figure. It was at this stage that he began to call, as so many others have done in such circumstances, upon Art to save the situation. During his moment of glory he had bought his villa on Lake Como: now he began to turn it into a sort of temple to display works by all the leading sculptors of the day (Fig. 35). Of these, by

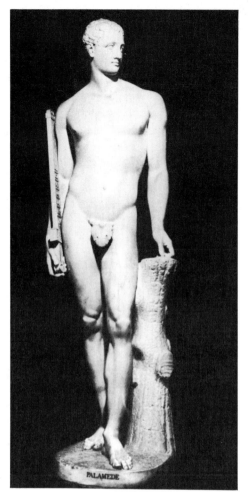

35. (far left) Cadenabbia, Villa Carlotta – sculpture room: Showing Thorwaldsen's frieze of the *Triumph of Alexander*, Luigi Acquisti's *Mars and Venus* and replicas of Canova's *Magdalene* and *Cupid and Psyche*

36. Canova: *Palamedes* (Cadenabbia, Villa Carlotta)

far the most famous, with a world-wide reputation, was Canova, and in 1803 Sommariva commissioned from him a statue (Fig. 36) which scarcely proved a happy augury for his future purchases, for hardly had it been completed in the studio than it suddenly fell to the ground, almost crushing the sculptor in the process. Sommariva's response reflects credit on his love of art rather than on his generosity. It was with the greatest difficulty that he could be persuaded to pay any of the expenses needed for the restoration, but he did at once order a picture (which was never in fact completed) which was to show the statue almost obliterating the wretched Canova.[19]

Other commissions followed, but though they were often splendid and important, and though Sommariva had bought other properties in Italy, he clearly felt that his political past made life uncomfortable for him in his native country, and that in any case it did not offer him enough scope.[20] Some time in about 1806 he moved to Paris, and bought a beautiful house in the most fashionable area of the city, not far from where Madame Récamier and other society figures lived—in a region which has today been replaced by the Boulevard des Capucines.[21] At much the same time he acquired a country house just outside Paris.

'He came to France', wrote someone who was in touch with him soon afterwards, 'to find a home where he would meet neither relations, nor friends, nor memories',[22] and

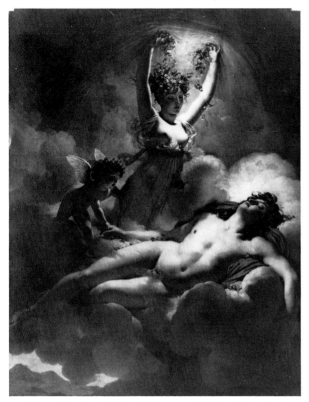

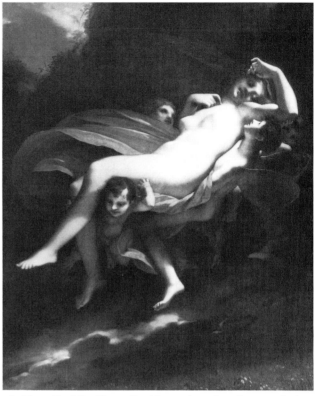

37. Pierre-Narcisse Guérin: *L'Aurore et Céphale* – Salon de 1810 (Paris, Musée du Louvre)

38. Pierre Paul Prud'hon: *Psyché exposée sur le rocher, est enlevée par les Zéphirs qui la transportent dans la demeure de l'Amour* – Salon de 1808 (Paris, Musée du Louvre)

39. Pierre Paul Prud'hon: *Jeune zéphir se balançant du-dessus de l'eau* – Salon de 1814 (Paris, Musée du Louvre)

40. Girodet: *Pygmalion amoureux de sa statue* – Salon de 1819 (Château de Dampierre)

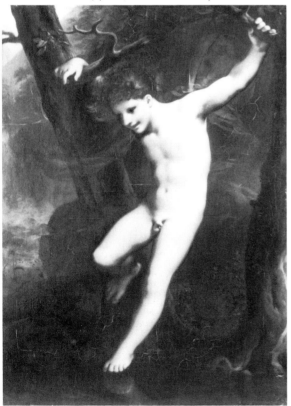

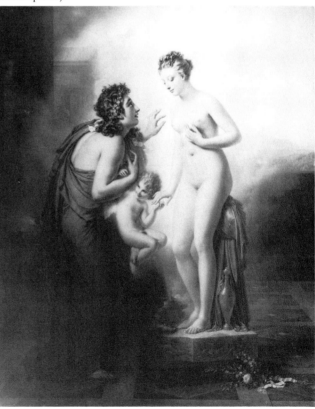

indeed no one in Paris seems to have known much about his past. On the way there he had managed to lose a wife and to gain a title—Count, Marquis, no one was quite sure which[23]—and he was to keep a careful (though anxious) eye on the forthcoming entry devoted to himself in a biographical dictionary which was published some years later.[24] In any case the past was soon obliterated by the splendid scale of his patronage.

It is not possible to examine this here in any real detail, but two things need to be said about it in general terms. First, that there was barely a single French or Italian artist of any distinction who did not at some time or another produce a major work for Sommariva; and, secondly, that, at a time when all the great French collections had been dispersed by the Revolution, he was among the very first men in Paris to start building up a gallery on the huge pre-Revolutionary scale. Virtually every writer of the time stressed how exceptional he was in this respect, and one of them went out of his way to gloat that his 'noble generosity' would not be understood in England where painters were only appreciated after their deaths.[25]

Let us look, first, at a very few of the more famous pictures that were painted for him (Figs. 37–8). It was by buying these two pictures in 1808 and 1810 that Sommariva first made his presence felt in the art world of Paris. The Prud'hon shows Psyche being carried to the realms of Love by young Zephyrs, and the Guérin depicts the moment told by Ovid when the saffron-robed Aurora falls desperately, but fruitlessly, in love with Cephalus

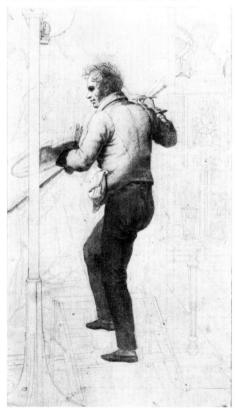

41. François-Louis Dejuinne: Drawing (in Louvre) for lost *Portrait de M. Girodet – Il travaille a son tableau de M. le comte de Sommariva et d'un de ses élèves* – exhibited in Salon de 1822

42. Adèle Chavassieu: Enamel copy of Dejuinne's lost *Portrait de M. Girodet* – see Fig. 41 (Milan, Galleria d'Arte Moderna)

(the sort of situation which, as we will see, was familiar to Sommariva from personal experience at this time). Sommariva went on buying pictures at a great rate, but it was a few years before he attracted as much attention again: this time with Prud'hon's *Young Zephyr* (Fig. 39) and not so much later with Girodet's *Pygmalion and Galatea* (Fig. 40)—a picture which was intended as a tribute to Canova, whose features are supposedly depicted in those of Pygmalion.[26]

This weird painting, in which the Nude is so coyly turning into the Naked, is today a source of embarrassment even to Girodet's most enthusiastic admirers. At the time it was greeted by most critics as the greatest masterpiece of the nineteenth century and Sommariva was so pleased with it that he commissioned a picture which was to portray himself in Girodet's studio while the artist was at work on it[27]—a picture that is now known only in a charming preliminary drawing (Fig. 41), and in a miniature copy (Fig. 42) recently discovered by Fernando Mazzocca.

Even from this brief glance it will be clear that all these are major pictures, based on mythological themes which had been popular in European art for over two centuries and which for the most part contained a strong element of eroticism to which I will have to return. All of them caused a great stir at the time, and critics fell over themselves to

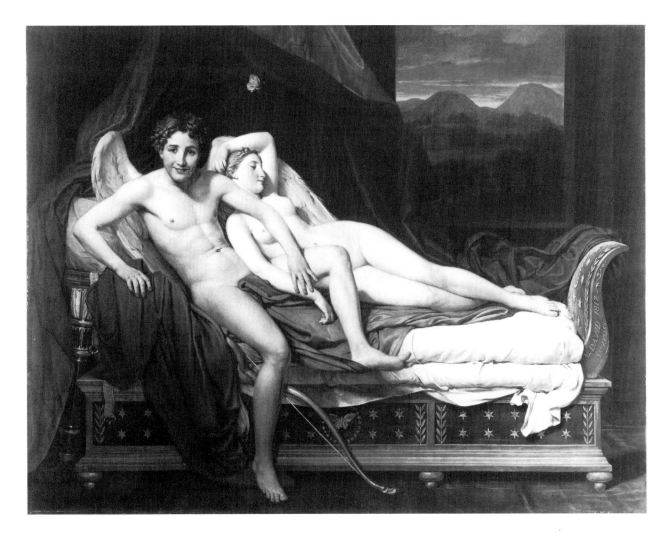

congratulate Sommariva on the extent and enlightenment of his patronage. He alone seemed to be supporting the great tradition of French art during a period of war, economic crisis and then national humiliation. Many years later a writer was to record that the way to Sommariva's house was as familiar to the people of Paris as the way to the Louvre.[28]

Sommariva survived the downfall of Napoleon, as he survived most things, and it was indeed under the restored monarchy that he was able to commission a picture from the most famous of all living French artists, Jacques-Louis David, then an exile in Brussels— once again a large-scale mythological work (Fig. 43), distinctly erotic in tone[29] and harping on the theme of Psyche which appealed so much to Sommariva and his contemporaries.[30]

But Sommariva's importance in the France of the first quarter of the nineteenth century did not lie only in the French paintings he commissioned—only a fraction of which have been mentioned here—but also in his propagation—in France—of Italian sculpture, especially the sculpture of Canova, to whom Girodet was shown paying tribute. Prud'hon's great portrait (Fig. 33) deliberately depicted Sommariva with two of his statues by Canova, the flawed *Palamedes* and the *Terpsichore* (Figs. 36 and 44). But the most famous object in his whole collection (though he had not actually commissioned it, but had bought it at second or third hand)[31] was Canova's *Magdalene* (Fig. 45) for which he built a little

43. (far left) Jacques-Louis David: *L'Amour et Psyché*, 1817 (Cleveland Museum of Art)

44. (left) Canova: *Terpsichore* (Cadenabbia, Villa Carlotta)

45. Canova: *Magdalene* (Genoa, Palazzo Bianco)

46. Façade of church of the Madeleine, Paris

altar described for us by a contemporary as half-chapel, half-boudoir, furnished in violet and lit only by an alabaster lamp hanging from the cupola[32]—an appropriate decor, we may feel, for a figure which so ingeniously combines pietism and worldliness.

It would be hard to exaggerate the importance that this piece of sculpture had for French taste and the really astonishing enthusiasm with which it was greeted by artists, critics and connoisseurs[33]—Stendhal was only one among many who thought of it as the greatest work of modern times[34]—and for well over a generation its impact could be detected in French art of all kinds,[35] for instance the figure of the Magdalene kneeling at Christ's feet in the pediment of the Madeleine in Paris (Fig. 46). As so often happens, the Sommariva Magdalene, as it was often called, came to be associated at least as much with the owner as with the artist.

'You will have heard of the death of our good Canova. Now the value of his works will be doubled.' The words come from a letter written by Sommariva to his son, Luigi, in 1822. It is perhaps a little unfair to quote from such a source. Were it not for the survival of these letters, published, for private circulation only, by his daughter-in-law a generation after his death,[36] Sommariva would have achieved his ambition and would have remained for those who bothered to remember him at all what he was for his French contemporaries: by far the greatest patron of his day and the sincerest of art lovers. But through these letters we can also see something else. We can see him systematically making use of his patronage and collection of art as an instrument of social prestige to establish himself in the best French and international company of the day. It was entirely through his art collection that the ex-barber's assistant, ex-revolutionary, ex-dictator of Milan, ex-Bonapartist now found himself, as the Marquis de Sommariva, receiving and visiting on equal terms

the Duke of Devonshire, the Duc de Montmorency, Count Anatole Demidoff and the Duc de Blacas, the blackest of royal reactionaries and friend of Joseph de Maistre. And he was aware of this. 'It is true', he wrote to his son, 'that it is an expensive business to cultivate the fine arts; but the capital always remains, and indeed sometimes increases. Besides, it does us a lot of honour. In fact I notice that abroad people talk about us even more favourably than they do at home.'[37] To make sure that his *éclat* as an art lover would reach a wider public than could actually call on him in Paris or Milan he encouraged the engraving of his pictures, to be accompanied by suitable dedications, of course, and even had them copied in the form of enamel miniatures which could be conveniently carried around with him.[38]

The theme that art collecting brings financial rewards and social prestige runs like a leit-motif through his correspondence. Of Thorwaldsen's marble frieze of the triumph of Alexander (Fig. 47) which had been commissioned by Napoleon and which Sommariva had been able to buy for his villa after the Emperor's downfall,[39] he wrote, 'I hope that this deal is the best that I have ever made in a matter of this kind, bearing in mind also the question of investment'[40]—and I will only refer to one other instance of this attitude. In 1824 he was having a furious quarrel[41] with a painter who was then well known but is now barely remembered, Gautherot, about a picture of which only the preliminary sketch has so far been traced (Fig. 48) illustrating an allegory of vaccination—a strange subject, but one that was being much debated in medical circles at the time. It is incidentally, worth stressing Sommariva's particular insistence on a mythological treatment even for so prosaic a theme, for both his own letters and his surprised contemporaries reveal how close a control he aimed to exert on the artists he employed.[42] This shows us that 'Aesculapius is about to prick Venus's arm below her bracelet, while Cupid supports her. Aesculapius has taken the vaccine which will preserve her beauty from Io, born of the gods, who has been changed into a cow through the jealousy of Juno.'[43] The very special—not to say eccentric—nature of Sommariva's patronage is brought out if we compare this with one of the fairly frequent genre treatments of the theme which were in vogue at the time such as Desbordes's *Une scène de vaccine* (Fig. 49). But at the moment we are

47. Bertel Thorwaldsen: *Triumph of Alexander* (detail) (Cadenabbia, Villa Carlotta)

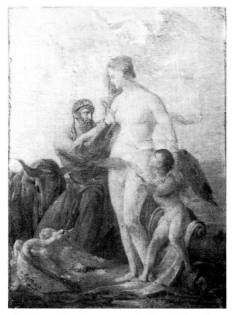

48. Pierre Gautherot: *La Vaccine* – Salon de 1819 (Angers, Musée des Beaux-Arts) – sketch for the lost *Vénus vaccinée par Esculape*, exhibited in Salon de 1824

49. Constant Desbordes: *Une scène de vaccine* – Salon de 1822 (Douai, Musée de la Chartreuse)

interested in this picture for another reason. It was exhibited, after years of delay, in the so-called English Salon of 1824, but Sommariva's name was not (as was usual in the circumstances) indicated in the catalogue as its owner. Had the printer slipped up, wondered his son. No, thought Sommariva, it was a deliberate and malicious plot on the part of the artist, and he concluded regretfully that 'it would not have been a bad thing if our name had been seen in the catalogue of the exhibition, as it has been missing for some years'.[44]

I have already mentioned that I was first moved to study Sommariva because of his systematic (and usually successful) attempts to draw attention to himself in just this way. But is that all there is to him—a one-time Jacobin who, like so many others, changed his skin, and a lavish patron of now little-known or little-admired artists who made use of his purchases as a form of social and financial investment? Let us look a shade more deeply at the character of his patronage, which we can approach once again through an episode in his private life.

Soon after his arrival in Paris, Sommariva met one of the neighbours of his country estate, Madame d'Houdetot (Fig. 50).[45] This sad, widowed and venerable old lady was now aged over seventy-five and largely forgotten except by a few friends as old as herself and the odd younger visitor who came to see her as a curious relic from a past that now seemed to belong to a wholly different world. For in her earlier days she had been one of the most famous women in Europe. She had been the friend of Diderot, Voltaire, Benjamin Franklin and all the Encyclopaedists; she had astonished everyone by living for more than fifty years both on good terms with her husband and as the faithful mistress of the Marquis de Saint-Lambert, himself a minor poet and philosopher; above all, she had inspired in Jean-Jacques Rousseau his one and only genuine passion—a passion that was returned only in the form of general benevolence—and in his *Confessions,* published

LE SALON DE LA COMTESSE D'HOUDETOT
À SANNOIS EN 1802
(D'après un tableau peint par le Comte Frédéric d'Houdetot)

50. Frédéric d'Houdetot (after): *Le Salon de la Comtesse d'Houdetot à Sannois en 1802* – heliograph reproduced from Hippolyte Buffenoir, *La Comtesse d'Houdetot* (Paris, 1905)

51. Le Barbier (engraved De Ghendt): *Jean-Jacques Rousseau et Madame d'Houdetot*, reproduced from Jean-Jacques Rousseau, *Les Confessions* (Paris, 1793)

and illustrated when she was still only aged fifty (Fig. 51), he had written pages of burning anguish to describe his feelings for her. Now Rousseau, her lover and her husband were all dead. The arrival of this dashing Milanese on the make inspired in her a final and over-whelming infatuation—an infatuation which inevitably recalls that of Madame du Deffand for the young Horace Walpole half a century earlier. She sent him flowers every day, and her last poems were addressed to him. Her friends were embarrassed, but (for the most part) they were ready to acknowledge in public that hers was like the love of a mother for her son—while expressing the matter rather differently among themselves.[46] It is pleasant to record that Sommariva (unlike Horace Walpole) responded magnificently to the situation, and it was in his arms, surrounded by her family, that she died in 1813.

The story is a touching one, but it is also significant—significant in that it consecrated the social success which Sommariva had sought for himself in France, and significant above all in that it throws real light on the nature of his contribution to French art at this period. For Madame d'Houdetot was one of the greatest surviving figures of the sentimental-erotic world of the eighteenth century in France, just before it collapsed with the *ancien régime*. And it is this very taste that is reflected in Sommariva's art patronage.

Few intellectual games are more enjoyable to play than the great 'ifs' which historians so disapprove of. What would have happened *if* Lenin had died when still a schoolboy, *if* the Archduke Franz-Ferdinand had not been assassinated, and so on. Sommariva, I suggest, allows us to glimpse an answer to a question which is of real interest: what would have happened to French—and European—art if the French Revolution and Napoleon had never occurred.

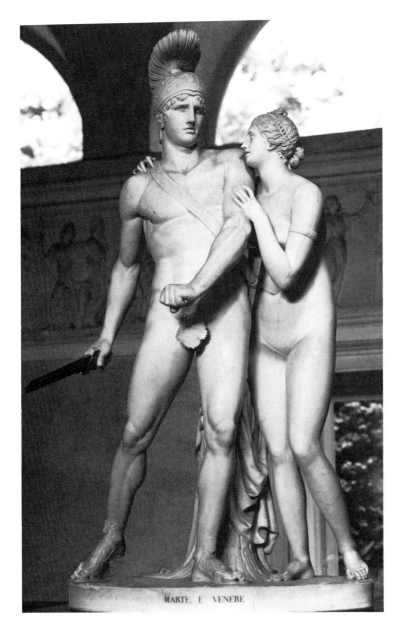

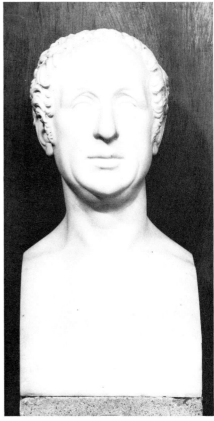

53. Bertel Thorwaldsen: *Portrait bust of Sommariva* (Copenhagen, Thorwaldsen Museum)

52. Luigi Acquisti: *Mars and Venus* (Cadenabbia, Villa Carlotta)

This is a paradox. Sommariva's fortunes were made, as we have seen, by the Revolution and by Napoleon. Yet his art patronage reflects an entirely different world. French and Italian art of the twenty-five years between 1789 and 1815 is inextricably linked in our minds with the dramatic events of the Revolution and the Napoleonic wars. But the tastes of Sommariva, whose sons both fought in Napoleon's armies, were very different. One of his earliest commissions, Luigi Acquisti's *Mars and Venus* (Fig. 52), shows us a trembling Venus holding back a ferocious-looking Mars, and again and again the pictures and sculptures that he ordered dwell on the theme of peace and its delights.[47] Guérin had barely painted *Napoleon forgiving the Insurgents of Cairo* for Napoleon before he was at work on *Cephalus and Aurora* (Fig. 37) for Sommariva. It may be significant that Gros, the artist most closely identified with the Romantic style of portraiture and the military aspects of

the Napoleonic epic, was never employed by him, despite the fact that his later work conforms to Sommariva's taste; and that Sommariva's own bust (Fig. 53), by the Danish sculptor Thorwaldsen, shows him in the ancient manner rather than in the modern costume which Napoleon and the upstart society around him had brought into vogue.

The *Amour et Psyché* that David painted for him in 1817 (Fig. 43) springs directly from the pictures that he had been painting for the French aristocracy on the eve of the Revolution (Fig. 54). It is, of course, true that David's style had evolved in the meantime. The picture for Sommariva is far harder, far more sensuous and shows a far bolder use of colour than the earlier work, whose freshness and innocence it lacks. But looking at them together who would guess that the twenty-five years that separate them had been marked by the artist voting for the execution of the brother of the man for whom he had painted the first of them, by his own imprisonment and perilous proximity to the guillotine, by his glorification of Napoleon and by his exile?

One must not exaggerate this. While it is certainly true that between the creation of these two pictures every worthwhile artist on the continent of Europe was in one way or another caught up in the Napoleonic epic, it is not absolutely true to claim that Sommariva was the only patron to encourage an alternative mode of painting. Well before the *Cupid and Psyche,* David had in 1809—that is at the height of the Empire—produced for a Russian grand seigneur of the *ancien régime,* Prince Yusupoff, another rather similar erotic picture—a *Sappho and Phaon* (Fig. 55)—also derived from antique subject matter, and indeed we know from many sources that Yusupoff shared with Sommariva a taste for many other artists and themes.[48] Various other observers, well before myself, have noted the nostalgia for the eighteenth century that can be said to begin almost before the century is over. Nonetheless, the fact remains that Sommariva's taste was by far the most consistent, his purse by far the widest, his enthusiasm by far the greatest, of the exceedingly few private citizens who, during this rather barren period between the Revolution and the very last years of the Restoration, were really keen to buy large-scale contemporary history paintings. This gives him the importance which warrants our considering his career with some attention. But there is one final issue that must be mentioned.

54. Jacques-Louis David: *Les Amours de Pâris et d'Hélène* (Paris, Musée du Louvre)

55. Jacques-Louis David: *Sappho and Phaon*, 1809 (Leningrad, Hermitage Museum)

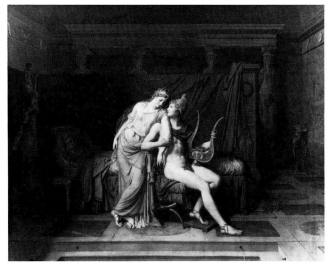

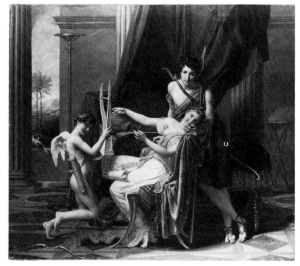

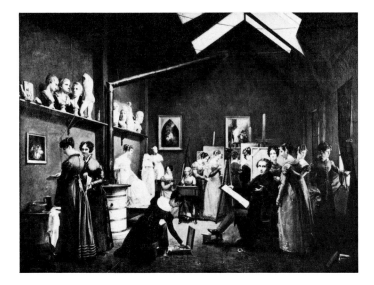

56. Adrienne Grandpierre:
Intérieur d'atelier de peinture [*of Abel de Pujol*] – Salon de 1822
(Paris, Musée Marmottan)

No cliché is so frequently repeated, and yet in the whole history of art perhaps none has been so little investigated, as that which claims that the change in social status of art patrons that followed the French Revolution was in a large measure responsible for the downfall of classical art and the rise to prominence of genre, landscape, anecdotal history and portraiture. Not one of these branches of painting was encouraged by Sommariva, although he liked having represented the studios of those artists who worked for him—of which an attractive example is provided by Adrienne Grandpierre's *Intérieur d'atelier de peinture* [*of Abel de Pujol*] (Fig. 56).[49] This nouveau-riche barber's apprentice and lawyer from Milan played a greater part than any other patron in Europe in prolonging the classical art of the last half of the eighteenth century into the era of Romanticism. Of course one example proves little enough. Was Sommariva typical or was he exceptional? We will not know until we have studied the careers of other patrons of the period. Meanwhile it might be worth giving the cliché at least a temporary respite, and noting that the taste of this parvenu was more 'aristocratic' than that of any aristocrat.

The consequences of Sommariva's preferences were predictable. In 1826 he died; some of his collection seems to have been taken by his adored son Luigi to the villa on Lake Como, and indeed Luigi added to it one of the attractions which his father had commissioned but had not lived to see and which proved most popular with the visitors who still flocked there to admire treasures that were by now world-famous,[50] Tadolini's copy of Canova's *Cupid and Psyche* (Fig. 57).[51] Moreover, these visitors, many of whom have left their impressions of both father and son,[52] could also see the monument by Marchesi (Fig. 58) which shows the classically garbed Sommariva bidding farewell to Luigi, as the angel of Death draws him away from the world that he had enjoyed so much. Luigi himself died twelve years later, and most of the pictures and sculptures remaining in Paris were sold by his widow.

The sale was a major event, so crowded that it was difficult to get in.[53] It was also a fiasco. Everyone wanted to see the dispersal of a collection whose Old Masters were considered to be at least as important as its works by contemporary artists—for, like many other millionaires before and since his day, Sommariva claimed to own the original of the *Mona Lisa*. Their disappointment was correspondingly great. Canova's *Magdalene* and

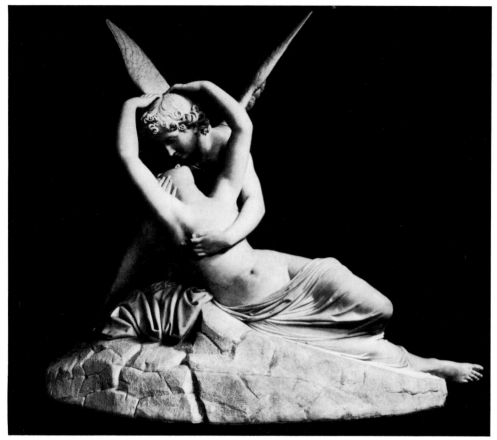

57. Adamo Tadolini: Replica of Canova's *Cupid and Psyche* (Cadenabbia, Villa Carlotta)

58. Pompeo Marchesi: *Giovanni Battista Sommariva takes leave of his Son Luigi* (Cadenabbia, Oratorio of Villa Carlotta)

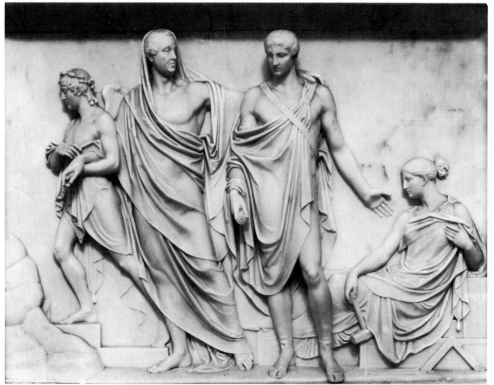

the pictures by Prud'hon aroused real enthusiasm; the rest—in the age of Delacroix and the fully developed Ingres—already seemed to belong not so much to history as to a fashion that was just sufficiently out-of-date as to be both boring and ridiculous. Sommariva's name was forgotten and has barely been mentioned again until now.[54]

<div align="center">APPENDIX</div>

Since bringing to light that remarkable but unscrupulous patron Giambattista Sommariva in 1972,[*] I have come across a number of other references to his collections, but none of these adds very significantly to what I then wrote. However, in an exhibition catalogue (*Neoclassico e troubadour nelle miniature di Giambattista Gigola* (Milan, 1978–9)) and a long and very interesting article ('G. B. Sommariva o il borghese mecenate: il "cabinet" neoclassico di Parigi, la galleria romantica di Tremezzo', in *Itinerari*, ii (1981), pp. 145–293) Fernando Mazzocca has made such important contributions to our knowledge of Sommariva (and especially of the pictures he kept in Italy) that anyone interested in his personality and his place in the history of patronage will have to study them carefully: I must admit, however, that I myself feel that my original interpretation of the issues raised by personality and patronage alike have been modified rather than seriously altered by Mazzocca's rather different approach.

Mazzocca has made two major discoveries. In the first place he has found (in the reserve section of the Galleria d'Arte Moderna in Milan) an almost complete set of the miniature copies commissioned by Sommariva of the pictures in his collection. Although many of the pictures themselves are known, in some cases these miniatures give us our only indication of the appearance of lost originals. One of these is of exceptional fascination, for it reproduces Dejuinne's *Portrait de M. Girodet: il travaille à son tableau de Pigmalion et Galathée en présence de M. le Comte de Sommariva et un de ses élèves* (from the Salon of 1822), of which I knew only the preliminary drawing which does little more than show the artist on his own. The complete composition now available to us gives us perhaps the most evocative impression anywhere of a 'Romantic' studio in the 1820s.

In the second place Mazzocca has published an extensive exchange of letters between Sommariva and Canova, as well as some other relevant correspondence. These letters add to, rather than alter, our existing knowledge—but they do so in the most vivid (and often hilarious) way; and they also demonstrate once again that great sculptor's unenviable capacity for bringing out an appalling strain of whimsy in those who were in touch with him— Sommariva, for instance, liked to think of himself as married to Canova's *Terpsichore* and would therefore address him as 'father-in-law'.

[*] Besides this essay I also wrote an article about him, 'More about Sommariva', in the *Burlington Magazine* (October 1972), pp. 691–5, which I have decided not to reprint here because, although it contains some additional material, it would involve too much repetition.

5. Art and the Language of Politics

'SMIRKE CALLED. He spoke of the "*Catalogue Raisonné*" and approved the remark in it that there had been a *virulence of Criticism* on the pictures painted by *Turner*, such as should be reserved for Crime, but wholly disproportioned to a subject of painting however much disapproved.'[1]

Every student of nineteenth-century art will be familiar with the wider implications of this conversation reported by the painter and diarist Joseph Farington in 1815, for the extreme hostility that was encountered by the early works of almost all those painters who are today esteemed most highly has become a legend enshrined in countless popular biographies. The situation was not wholly new, and the tradition of neglect (rather than of hostility) was, of course, a long-standing one. Nonetheless, the 'virulence' did reach quite unexpected heights and greeted Constable and Turner, Delacroix, Courbet, Manet, the Impressionists, Matisse, Picasso and many other familiar names.

Most of these artists also had their staunch supporters, and in almost every case received opinion needs to be considerably modified before we can understand the true critical background. Nor can any one explanation be offered for the very different forms taken by hostility at different times and in different countries between 1800 and 1945. It does, however, seem reasonable to suggest that '*virulence of Criticism* . . . such as should be reserved for Crime' was not aroused exclusively by aesthetic concern, and that one contributory factor may have been an association, not always conscious, of artistic with political change.

That artistic quality reflects the social, moral, political or religious health of society (however these values are determined) is a very old notion which antedates by centuries its vigorous and familiar propagation by Pugin, Ruskin and William Morris. I am not here concerned with the merits of this case, or even with its influence, but rather with its emergence in one particular context: that of language, because it is here that its effects may be most influential and least detectable. Michael Baxandall's *Giotto and the Orators*[2] investigates the terminology available to fifteenth-century Italian humanist writers on the arts and the conditioned responses that this could arouse in them. All of us still respond, sometimes even against our wills, to metaphors that are clearly misleading in any serious critical sense: we need, for instance, only consider the most common of all the analogies that have ever been used in the discussion of art—the analogy of its childhood, adolescence, maturity and decrepitude—to realise this; and (to return to the basic theme of my argument) I can recall, from personal experience, that the first art criticism I ever heard was

that Picasso was a 'bolshevik', made many years before the artist had shown any interest in the Communist party.

Although the two can never be altogether separated, it goes without saying that what I will be talking about will be political terminology applied to developments which seem to us to be non-political. I will not therefore be touching on the many people who attacked or welcomed as revolutionary such painters as David, Courbet or Picasso *after* they appeared to be associated with political causes, though even here I will have to make a qualification, for in 1819 Géricault gives us an entertaining and satirical account of how easily reasoned political reactions can be adapted to apparently stylistic issues. Writing to a friend about the reception of the *Raft of the Medusa* (a picture which, of course, *did* carry strong and deliberate political allusions, for the shipwreck was alleged to have been caused by government negligence), he says that 'vous entendez un article libéral vanter dans un tel ouvrage un pinceau vraiment patriotique, une touche nationale. Le même ouvrage jugé par l'ultra ne sera plus qu'une composition révolutionnaire où regne une teinte générale de sédition.'[3]

It is naturally only after the general politicisation of life that followed the French Revolution that certain terms still in use today, such as 'avant-garde', 'reactionary' or 'anarchist', became widely available to the writer on the arts. But thereafter the equation between style and politics was developed very rapidly. When discussing which pictures should be publicly exhibited in the newly created National Museum in Paris, an official report was submitted as early as 1794 to the Committee of Public Education saying that 'les pinceaux efféminés de pareils maîtres (Boucher, Van Loo, etc.) ne sauraient inspirer ce style mâle et nerveux qui doit caracteriser les exploits révolutionnaires des enfants de la Liberté, défenseurs de l'Egalité. Pour peindre l'énergie d'un peuple qui, en brisant ses fers, a voté la liberté du genre humain, il faut des couleurs fières, un style nerveux, un pinceau hardi, un génie volcanique.'[4] In fact no painter then active in France really fulfilled these criteria, which were not fully in evidence until Delacroix's *Liberty on the Barricades* (Louvre) of 1831 celebrated a very different revolution; and it is striking that David, the most famous artist associated with the first Revolution, should in 1800 have accused his pupils of constituting 'un véritable tribunal révolutionnaire de la peinture' because they denounced his *style* as being too rococo, too Pompadour.[5]

Analogies to this sort of approach to painting can, however, certainly be found in earlier centuries, and I want first to touch very briefly on some of these. Did the great quarrel between the champions of Rubens and those of Poussin that bitterly divided French artistic circles at the end of the seventeenth century throw up accusations of, say, republicanism or sedition? I feel pretty certain that anyone with the patience and strength of mind to struggle through the enormous amount of literature thrown up by that controversy would find some examples of this sort of charge, but I confess that I have not yet made the effort.

There is, however, in mid-seventeenth-century Naples one very close parallel with what I am trying to investigate: we are told that the classicising painter Francesco di Maria (Fig. 59), affronted by what he considered to be the colouristic excesses of Luca Giordano, his rival (Fig. 60), would refer to him and his pupils as 'that school of heretics which, with their damnable liberty of conscience, is leading people away from the straight and narrow path'.[6] Rembrandt, also, was sometimes referred to as 'the first heretic',[7] and there

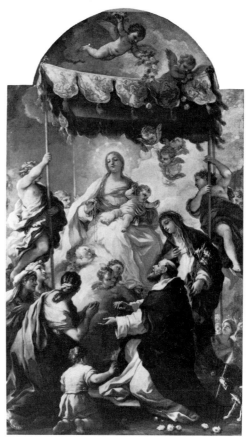

59. Francesco di Maria: *The Maries and St John at the Crucifixion* (Naples, S. Giuseppe a Pontecorvo)

60. Luca Giordano: *Madonna of the Canopy* (Naples, Museo di Capodimonte)

were many references to the 'libertinage' of Michelangelo, because of his infringement of classical rules.[8] All these phrases are, within the context of seventeenth-century religious dogmatism, exactly analogous to later charges of Bolshevik or anarchist. Moreover, all these instances refer to questions of style, treatment and decorum rather than of subject matter. It may be felt that I am exaggerating the importance of a perfectly banal linguistic point, and that what writers referred to as heresy, free thinking, etc., is merely an obvious way of stigmatising any infringement of the ordinarily accepted conventions of the day. To some extent this is certainly true, but it is also evident that we can read a little more into it than that. Despite the case of Michelangelo, the 'heretics' are nearly always those who, in the great and ceaseless war between the colourists and the draughtsmen, stand for the supremacy of colour; it thus became possible to claim that the *style,* as well as the actual survival, of Venetian painting was associated with freedom and national independence.

After the downfall of the Venetian Republic, however, things looked very different. From being a bulwark of liberty the history of Venice was retrospectively viewed as having constituted a régime of brutal oppression, and in the 1830s the French political philosopher Edgar Quinet was struck by the insuperable problem of how to reconcile the art and the politics of the city.

Ce qui frappe d'abord c'est que la sombre sévérité du régime politique de Venise ne s'est jamais communiquée à sa peinture. Si vous ne considerez que le gouvernement, vous vous figurez que toute cette société a été conduite sans relâche par la terreur, et que les imaginations ont dû se couvrir d'un voile lugubre. Si, au contraire, vous examinez l'art, vous supposez que ces hommes ont vécu dans une fête perpetuelle, et que des imaginations aussi fougueuses appartiennent à un régime de liberté excessive.[9]

Although it now seems so obvious, I do not think that such spilling over into art of expressions derived from political and religious conflicts was at all common before the Romantic period. We can, however, as I have already mentioned, trace back much further in time the closely related but by no means identical claim, that the *quality* of art produced in any given society is directly conditioned by the moral (or political) nature of that society. Diderot—as far as I can make out—never actually made use of social or political *metaphors* in his art criticism, though again and again he seems on the brink of doing so. In 1767, for instance, when discussing what is meant by 'mannered' art, he writes that 'la manière est dans les arts ce qu'est la corruption de moeurs chez un peuple',[10] in this echoing many earlier writers. But like them, and like most other critics of the eighteenth and nineteenth centuries in England and France, Diderot was essentially concerned with morals, and it is a fact (though perhaps a sad one) that to say of art that it is evil or corrupt probably makes less of an impact than to say that it is heretical or (nowadays) Establishment.

Nevertheless, after the Revolution, observers certainly read back into the *ancien régime* political implications in the artistic situation that, as far as I know, had never been made at the time. In 1818, for instance, the liberal Lady Morgan wrote of the musical controversies that stirred up such passions in eighteenth-century France: 'The privileged class cried out against innovation, even in crotchets, and quavers; and the noble and the rich, the women and the court, clung to the monotonous discords of Lulli, Rameau, and Mandonville, as belonging to the ancient and established order of things.'[11] It seems unlikely that a sociological analysis would bear out this interpretation of the quarrel, but radical quavers and reactionary discords really form the main theme of this paper, for the *reductio ad absurdam* of the issue is so much more evident in music than in any other of the arts.

It was, in fact, in the second quarter of the nineteenth century that the practice of applying political and social metaphors to art criticism first became really widespread. I do not know who first used the word 'revolutionary' of a picture, but in 1825 Louis Vitet announced that 'le goût, en France, attend son 14 Juillet';[12] a year before this Stendhal began his criticism of the famous Salon of 1824 by announcing stridently that 'mes opinions, en peinture, sont celles de *l'extrême gauche*',[13] and significantly he goes out of his way to dissociate these from his political views which, so he says, are *'centre gauche, comme celles de l'immense majorité'*. Indeed, of all writers, Stendhal is the one who most enjoys toying with political concepts in his artistic analyses: 'Le beau idéal antique est un peu républicain', although, he adds teasingly, 'Je supplie qu'à ce mot l'on ne me prenne pas pour un coquin de libéral'.[14] The implications of this are somewhat surprising to us, because in more recent years a form of art closely inspired by Classical canons of beauty has come to be thought of as particularly authoritarian, even 'fascist'.

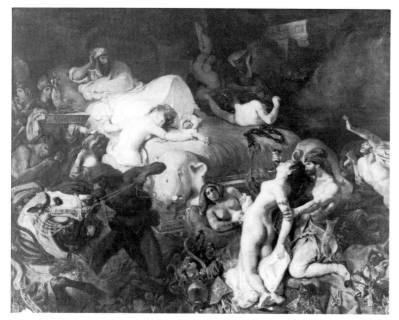

61. Eugène Delacroix: *Mort de Sardanapale* – Salon de 1827 (Paris, Musée du Louvre)

62. Jean-François de Troy: *The Rape of the Sabines*, 1729 (Neuchâtel, Musée d'Art et d'Histoire)

Indeed, Stendhal's friend Delécluze, also a liberal in politics though a strong anti-modernist in art, referred with disapproval to Delacroix and the other Romantics as constituting 'l'extrême gauche en peinture',[15] while in the same year, 1827, another critic, Jal, talked of the contemporary revival of neo-classicism as 'l'ancien régime des beaux-arts'.[16] This last example raises once again a very important and interesting issue. I have already pointed out that in the seventeenth and eighteenth centuries whatever was thought about the desirability of a type of painting which appeared to emphasise colour at the expense of line, it seemed on the whole to be agreed that it was the outcome of freedom. From this it might perhaps be assumed that political metaphors were applied consistently so that we could build up certain theories: colour, for instance, to be associated with freedom, and line with tyranny. To a very limited extent it is possible to argue in this way, but in the nineteenth century the categories break down far too often for it to be fruitful. For Jal, neo-classicism represents 'l'ancien régime des beaux-arts'; for Stendhal, it is 'somewhat republican'.

We can carry the paradox even further. In this very same year, 1827, yet another writer who strongly defended the Davidian standards of classicism maintained that it was Delacroix and the Romantics who, far from being 'progressive', were in fact promoting a counter-revolution by appearing to return to the colouristic, painterly, 'unfinished' style of the eighteenth century (Figs. 61–2).[17] In 1849 Delécluze made much the same point when he commented bitterly on the expanding vogue for the art of the eighteenth century.

Quant à moi, qui depuis 1830, observe la marée toujours montante de l'océan démocratique, je n'ai pas encore pu me rendre compte de ce qui peut avoir causé le mélange monstrueux des opinions républicaines avec le retour du goût pour les ouvrages de Watteau et de Boucher . . . En 1789 jusqu'en 1797, au moins fut-on conséquent et

70

63. Paul Delaroche: *Le Cardinal de Richelieu* – Salon de 1831 (London, Wallace Collection)

64. Pierre Révoil: *Un tournoi au XIVᵉ siècle* – Salon de 1812 (Lyons, Musée des Beaux-Arts)

l'on vit le goût qui régnait dans les arts s'accorder avec les idées politiques que l'on professait alors ... Or, par un contre-sens inexplicable, je le répète, ce sont nos plus fiers républicains de la veille qui, depuis vingt ans tout à l'heure, ont préconisé avec une espèce de fureur le goût et les ouvrages de Watteau, de Lancret, et de Boucher.[18]

From the 1820s onwards the use of political metaphor in art criticism becomes so frequent that examples could be multiplied indefinitely. They are interesting to the student of taste, and it would certainly be worth while and rewarding to pursue them in order to see just who were the artists attacked or championed in these terms, and what it was about their art that invited such metaphors. I will touch on this later, but at the moment I only want to stress that in the early stages of their adoption, say from 1820 to 1848, they are less important than they become later, just because their authors were aware of the novelty of what they were doing, and consequently imply that the expressions they use need not be taken too seriously. We have seen, for instance, how self-consciously Stendhal dis-

tinguishes between his political *views* and his political *metaphors*. But there is at least one example of a political phrase applied to art which has confused the issue from the very beginning.

It was on 31 January 1831 that Louis Philippe made his famous speech in which he announced that 'Nous cherchons à nous tenir dans un *juste milieu* également éloigné des excès du pouvoir populaire et des abus du pouvoir royal',[19] thus giving the Salon critics of that year a few months during which to ponder over a new and potentially valuable addition to their critical vocabulary.

Actually the term 'juste milieu' had been used well before this,[20] and Diderot in his Salon criticism of 1767 had specifically advocated it as a guide to happiness, while rejecting it for the artist: 'Se jeter dans les extrémes, voilà la règle du poète; garder en tout un juste milieu, violà la règle du bonheur.[21] But it was Louis Philippe's pronouncement that gave it political currency and that set it on a long lease of muddled and misleading cultural life. Different critics used the term 'juste milieu' in different ways, and very occasionally it could throw real light on certain tendencies in the art of the 1830s. But the over-all result of its adoption by so many contemporaries and later historians is that most people now think that Delaroche and certain other artists managed to paint pictures mid-way between those of Delacroix and those of the classicising followers of David, pictures that combined 'Romantic' imagery with a highly 'finished' technique (Fig. 63). This may contain a particle of truth, but the political metaphor wholly distorts the historical reality, because such pictures were painted by Révoil (Fig. 64), Richard and others well *before* Delacroix and the Romantics. In fact, if one is going to apply political metaphor to art historical discussion, it would be much more accurate to describe these pictures as 'revolutionary' rather than as 'juste milieu'.

A generation or so later the whole political and artistic problem is given a further dimension of unreality through the use of the term 'juste milieu' as one of unqualified social *praise* by no less tendentious a writer than Proudhon in his rapturous account of Courbet's *Paysans de Flagey* (Fig. 65), in which, so he claims and elaborates at some length, 'tout le monde, à son point de vue, dans le cercle de ses idées et de ses intérêts, peut se dire partisan du juste milieu'.[22] It is true that Proudhon goes on to point out that 'Sans doute nous ne sommes pas aujourd'hui, à Paris surtout, tels que j'ai essayé, pour expliquer le tableau de Courbet, de nous dépeindre. Notre juste milieu politique a abouti à une honteuse destitution. Cette estime de la médiocrité qui distinguait nos pères a fait place aux impatiences de l'industrialisme', but this qualification only emphasises the absurdity of such critical terminology.

Art history may not matter all that much, but art does. The danger of political analogies is that they so often tend to take on a life of their own which becomes more and more detached from the subjects that they were originally intended to illuminate. It was harmless enough to talk of the 'left wing of art' as long as emphasis was given (as it was by Stendhal) as much to the art as to the left wing. But as time went on this was not always the case. In 1848 an opposition journalist approached Corot and asked him, 'Comment se fait-il, M. Corot, que vous, un révolutionnaire en art, vous ne soyez pas avec nous en politique?'[23] This journalist had, in other words, become so used to hearing a political metaphor applied

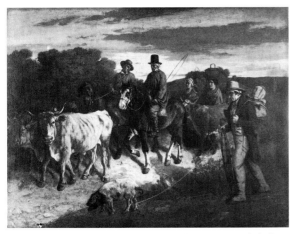

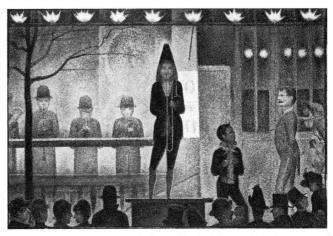

65. Gustave Courbet: *Les Paysans de Flagey revenant de la foire, Ornans*, 1855 (Besançon, Musée des Beaux-Arts)

66. Georges Seurat: *La Parade* (New York, Metropolitan Museum of Art)

to painting that the transition back again from painting to politics seemed to him to be a perfectly natural one.

Later in the nineteenth century this confusion was to become absolutely commonplace. Again and again the Impressionists were described as being 'Communards',[24] which was not at all a helpful label to be saddled with in the 1870s. It distorted not only the critical response to their work, but more sadly their own personal relations. 'Le public n'aime pas ce qui sent la politique', wrote Renoir in 1882, 'et je ne veux pas, moi, à mon âge, être révolutionnaire. Rester avec l'israélite Pissarro, c'est la révolution.'[25] Pissarro's politics were indeed anarchist, but it is by no means easy to relate his politics to his pictures at this period of his life. At its most extreme this approach to art could lead to a demand in the French Chamber of Deputies in 1912 from a *Socialist* deputy that the Cubists should be prevented from exhibiting at the Salon d'Automne on the grounds that their art was 'anti-national'.[26] I need hardly stress the fact that Braque is now monotonously acclaimed as a typically 'French' painter—the only one, I believe, to have been granted a state funeral.

We sometimes come across examples of the equation between political views and artistic styles which are as bizarre as this but which are made by the artists themselves. In an astonishing article in the anarchist paper *La Révolte*,[27] the artist Paul Signac claimed that he and his friend Seurat and the other neo-Impressionists were revolutionary in their artistic as well as their political attitudes just because they chose a style and technique—that of divisionism—which rendered them totally unacceptable to conventional bourgeois opinion (Fig. 66). This, in his view, was wholly as subversive as any choice of straightforward political subject matter of the kind that had been demanded by left-wing critics of an earlier day. It is a peculiar argument but one whose implications have been amply pondered by later authoritarian régimes.

'Les intransigeants de l'art donnant la main aux intransigeants de la politique, il n'y a rien là d'ailleurs que de très naturel', wrote one newspaper indignantly after a tolerably favourable review of the Impressionist Exhibition of 1876 in a left-wing journal.[28] But those who, like myself, deplore the straightforward assumption that an artistic style carries with it political associations which may be deeply repugnant to us can take a certain amount of comfort in recalling that almost from the first writers and artists have strongly protested

against the notion. The first instance of such a disclaimer that I have come across occurs in an English source—a long poem, with elaborate notes, written in 1809 by the portrait painter, and later President of the Royal Academy, Sir Martin Archer Shee. The poem, *The Elements of Art,* is not in itself a great literary masterpiece, though it is certainly of higher quality than anything written by Shee's fellow academician Turner, but to those interested in the subject of this paper it is intensely fascinating: 'Free-thinking is philosophy in Taste' runs one neo-Popian line, qualified by the comment that 'The professed votaries of Virtù will, perhaps, consider this, a licentious sentiment; and may be disposed, in this place, and in some other passages of his work, where similar opinions are advanced, to look upon the Author as a kind of factious innovator, who would disturb the calm of criticism, and shake the foundations of authority'.[29] Almost every word in this footnote would repay investigation and would reveal the political tensions that followed the French Revolution and the prevailing confusion as regards absolute or relative standards of taste. In this context I want only to stress one other comment made by Shee, because it is one that we will find echoed again and again by men who could not conceivably have known his poems: 'Our scholars indeed, though sometimes Whig in politics, have always been Tories in taste: they may be Roundheads occasionally, in religion, but they are proud to be Cavaliers in criticism.'[30] Let us move on more than half a century, and here in 1867 is Manet complaining of Théodore Duret who will later become one of his greatest champions: 'C'est curieux comme les républicains sont réactionnaires quand ils parlent d'art',[31] a paradox that had already been emphasised by Baudelaire in his great essay on Wagner:

> Possédé du desir suprême de voir l'idéal dans l'art dominer définitivement la routine, il a pu (c'est une illusion essentiellement humaine) espérer que des révolutions dans l'ordre politique favoriseraient la cause de la révolution dans l'art. Le succès de Wagner lui-même a donné tort à ses prévisions et à ses espérances; car il a fallu en France l'ordre d'un *despote* [i.e. Napoleon III] pour faire exécuter l'oeuvre d'un révolutionnaire. Ainsi, nous avons déjà vu à Paris l'évolution romantique favorisée par la monarchie, pendant que les libéraux et les républicains restaient opiniâtrement attachés aux routines de la littérature dite classique.[32]

Baudelaire wrote as an ironical observer. Let me end with two men deeply involved with art and politics. There was, first of all, the great revolutionary Henri Rochefort, the passionate opponent of Napoleon III, a figure so involved with the Commune that he was exiled to the South Sea Islands from which he made a sensational escape, a man whose very name was used as a shorthand term for extremism of every kind, so that—for instance—Gauguin could refer to himself as 'un Rochefort dans l'art'.[33] Yet such is the irony of artistic tastes that Rochefort, who was a keen and sensitive art lover, viewed with the utmost contempt all those painters who looked upon themselves as outcasts and consequently identified themselves as much with him, as they did with such fictional heroes as Victor Hugo's Jean Valjean. In an extraordinary outburst denouncing contemporary art, he wrote: 'If Cézanne is right, then all those great brushes (of Rembrandt, Velázquez, Rubens and Goya) were wrong . . . We have often averred that there were pro-Dreyfusards

long before the Dreyfus case. All the diseased minds, the topsy-turvy souls, the shady and the disabled, were ripe for the coming of the Messiah of Treason.'[34] Cézanne, that most timid and clerical of *bienpensants*, a Dreyfusard!! To such madness can intelligent men—for Rochefort was intelligent—be led by the identification of political and artistic ideas.

Let me give finally an example from the other end of the political spectrum. Throughout most of the nineteenth century the overwhelming majority of innovating painters were, however different from each other, moving away from the doctrines of neo-classicism to a whole variety of less 'finished', less 'idealised' styles. From the artistic point of view, Géricault, Constable, Turner, Delacroix, Courbet, Manet, Cézanne, Gauguin and so on were *metaphorically* on the left—i.e. were artistically 'progressive'. But in actual, historical fact, it was the real, and not the metaphorical, Left which was associated in many people's minds with a highly 'finished' neo-classical painting. This probably sounds far fetched as well as confusing, but there is an extremely interesting passage in the memoirs of the great art dealer Paul Durand-Ruel which suggests that such considerations may well have played their part in forming people's reactions to contemporary art. Durand-Ruel, as well as being the most heroic champion of the Impressionists at a time when their pictures were reviled as being grotesquely 'modern' in the worst sense of the word, was in politics an extreme royalist reactionary who may well have been involved in monarchist plots against the Third Republic. Writing of the early days of the firm, his son tells us that 'mon père s'était établi, en effet, au moment des luttes ardentes entre l'Ecole néo-antique, née avec le développement des idées Jacobines de la Révolution et representée par David, et tout un groupe de jeunes peintres et de littérateurs dont le talent et les tendances s'affirmaient sous l'influence des oeuvres de Gros, de Géricault, de Prud'hon, de Delacroix, de Bonington, de Constable et d'autres artistes français et anglais.'[35] In other words, Durand-Ruel (and others too, perhaps) was able to convince himself of the futility of too simple a metaphorical equation: for him, the right wing in art appeared to enshrine left-wing politics, whereas—he must have hoped—the 'artistic left' (which he so gallantly championed) might correspond to a political right or at least, to use his own word, an élite.

In this brief paper I have barely scratched the surface of a deep, complex and important subject—I have not, for instance, even mentioned the 'social' word *bourgeois* or the 'military' phrase *avant-garde* which were of such immense significance in nineteenth and early twentieth-century criticism—but I hope that I have at least indicated that the political metaphors which we use in our discussions of art can affect the ways we look at it.

APPENDIX

Since the appearance of this essay the most interesting contribution to the subject that I have come across has been made in the field of musical history: William Weber's very stimulating article '*La Musique ancienne* in the Waning of the Ancien Régime' published in the *Journal of Modern History* (March 1984), pp. 58–88.

6. The Manufacture of the Past in Nineteenth-Century Painting

'IN ONE OF THE TWILIT, sombre rooms of Whitehall, the coffin of the decapitated king stands on dark-red velvet, and before it a man, who lifts the lid with steady hand, and quietly gazes at the corpse. That man stands there all alone . . . What a great, what a general grief the painter has here expressed with a few touches.' This is Heine writing for his German readers an account of one of the most popular pictures in the Paris Salon of 1831,[1] *Cromwell et Charles I^er* by Paul Delaroche (Fig. 67). I am quoting at this stage only a few lines of his long panegyric to show that there was a time when this sort of evocation of the past, which to later critics has seemed so banal that the whole concept of historical painting has been dismissed as futile, could carry the utmost significance for the most sensitive observers. No kind of art was more influential during the first half of the nineteenth century and none has now so hopelessly retreated beyond the frontiers of our appreciation. Most of the great French painters of the time, Ingres, Delacroix and many more, attempted such reconstructions of historical scenes, and in our eyes almost none of them has escaped some measure of absurdity—that same feeling of absurdity that strikes us when we look at fashions that have not yet had time to become nostalgic or picturesque. Because of this, almost no attention has been paid to a problem that is one of the most fascinating in the history of art from any number of different points of view: that is, the attempts made by artists all over Europe (though I will be talking almost exclusively about France) to look back into their national histories in order to be able to express their feelings about their own times.

These nineteenth-century costume pieces, which ransacked the melodramatic episodes of medieval, Renaissance and later European history, have generally been looked upon as among the more misguided fruits of the Romantic imagination. I want to suggest, on the contrary, that they very often represented a quite conscious search for a repertory of scenes that should be more meaningful to their contemporaries than was the iconography of Greece and Rome which had hitherto reigned supreme. This is hard for us to understand today because we so often accuse the Romantics of having looked on the past merely as a colourful pageant of detached episodes with no relevance to themselves beyond that of stimulating jaded nerves. But it is worth making an effort to understand how significant some of the episodes chosen by them could appear to a public very much concerned with balancing the new world of the nineteenth century against that of the past. The pictures

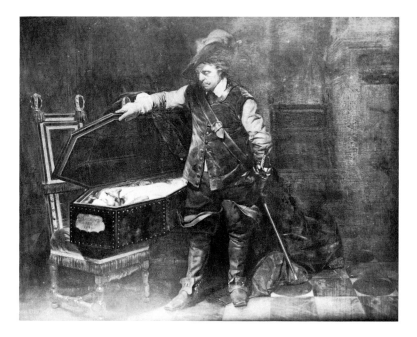

67. Paul Delaroche:
Cromwell et Charles I –
Salon de 1831 (Nîmes,
Musée des Beaux-Arts)

with which we will be concerned are fascinating also from another point of view: in them
we can watch painters having to struggle in different ways with problems which were
quite new to them and which often presented almost insuperable difficulties.

During the second half of the eighteenth century, both in England and in France, a
number of artists began to broaden the range of their subject matter so as to include episodes
from Renaissance and seventeenth-century history, and in fact it is in London, some
fifty years before Delaroche, that we first come across a picture dealing with the life of
Charles I, *Charles I demanding in the House of Commons the Five Impeached Members* (now
in the Boston Public Library), painted between 1781 and 1795 by Copley (Fig. 68), one
of that group of American artists who, because they were not brought up on the rigidly
classical curriculum of European painters, were often ready to experiment in new fields.
But the portrayal of this episode from Charles I's reign was far from fortuitous, and was
in fact intended to allude directly to contemporary controversies about the power of the
Crown. The allusion was apparent to everyone. 'You have chosen, Mr. Copley, a most
unfortunate subject for the exercise of your pencil', was the Queen's comment when she
was shown the picture.[2]

At first sight nothing could be more remote from this dramatic historical scene, still
composed according to the principles of the High Renaissance and the Baroque, and
the brooding, private, psychological moment depicted by Delaroche. But dead or alive
Charles I always carried with him a massive weight of political allusion. 'Do you not
think, sir, that the guillotine is a great improvement?' Heine reports hearing from an
Englishman standing just behind him at the exhibition, and indeed everyone realised that
the beheaded Charles referred to the beheaded Louis. But what of Cromwell? Heine tells
us that some people had suggested that he was supposed to represent Napoleon, who by
having himself crowned had betrayed both the Revolution and the true monarchists. 'In
the life of Cromwell there is a stain of blood; in that of Napoleon, a stain of oil', and,

'haunted by his crime, he would wander all night through the great halls of the Tuileries, a storm in his breast, fury in his mouth'. There was good reason to make such an analogy, for only four years earlier the young Victor Hugo had published his *Cromwell,* in which the English dictator was clearly intended to allude to Napoleon—though the scene shown here by Delaroche does not occur in that play, but in Chateaubriand's almost contemporary *Les Quatre Stuarts*.[3]

But the parallel was, of course, not an exact one, and there was another nearer to hand which was much more compelling. Louis Philippe had just been made king, and his father, Philippe Egalité, had indeed voted for the execution of Louis XVI. His reign was thus as blood-stained in its origins and as doubtful in its legitimacy as that of Cromwell. It is not clear to what extent this parallel was intended or understood. Certainly Louis Philippe himself was reported to have been offended by the picture and to have delayed naming the artist an officer of the Légion d'honneur as a result of it. But the story that it had actually belonged to the Duchesse de Berry, the widowed daughter-in-law of the deposed Charles X, and that she presented it to the city of Nîmes in gratitude for its support of the legitimist revolution she tried to foster appears to be a much later invention.[4]

No amount of historical explanation will turn a mediocre picture into a good one, but

68. John Singleton Copley: *Charles I demanding in the House of Commons the Five Impeached Members* (Boston Public Library)

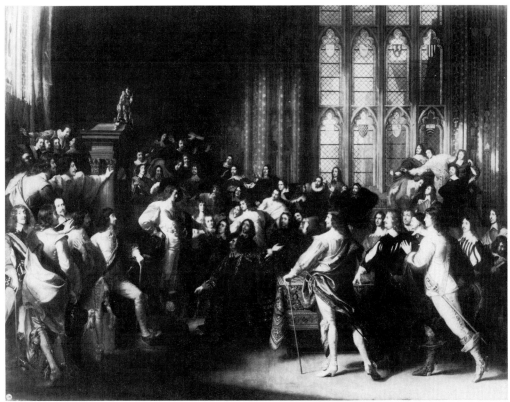

I do believe that our appreciation that this picture, and most of the others I will be discussing, is charged with passionate political meaning, and is not merely a historical melodrama, does make us look at it in a different spirit, a spirit akin to that with which we appraise the similarly charged classical pictures of the late eighteenth century.

If Napoleon was not the direct inspirer of Cromwell in the Delaroche, he was, I believe, the principal instigator of the whole genre of historical paintings which filled the exhibition rooms of London, Paris and elsewhere throughout the first half of the nineteenth century—and even later. It is true that there had been tentative moves in this direction well before his time, but—in France, at any rate—these vanished almost entirely during the revolutionary period in favour of classical analogies. But upstart emperors, as much as upstart revolutionaries, have always needed to find ancestors, and Napoleon could hardly look to the leaders of republican Rome for his. Indeed, Napoleonic imagery runs entirely against the current of revived antiquity, and from the moment he was crowned he did everything he could to link his reign with that of earlier French kings—that of Charlemagne, above all. An entertaining insight into this process has recently come to light.[5] In 1806 Jean François Mérimée, father of the novelist, was asked to make a secret report to the Ministry of the Interior on the astonishing picture of the Emperor which had just been painted by Ingres (Fig. 69).

> I have been to see the picture by M. Ingre [*sic*] and I have seen that it contains much of great beauty, but unfortunately it is a kind of beauty likely to be appreciated only by other artists, and I do not think that the picture will have any success at court. As far as I can remember the Emperor's features—and I have not seen him for three years—M. Ingres's portrait is in no way a good likeness, and in the eyes of the public, resemblance is an essential quality which makes up for many shortcomings, and the lack of which is not compensated for by beauty. Though it is certainly a good idea to have painted a portrait which avoids anything capable of recalling the portraits of our modern sovereigns, the idea has been carried too far. By adopting the type of representations of Charlemagne the artist has actually gone so far as to try to imitate the style of this period. A few artists who do not admire the simple and grand style of our earliest painters will praise him for having dared to paint a picture of the fourteenth century [*sic*]: *les gens du monde le trouveront gothique et barbare.*

This was one peril to which the artist exposed himself when trying to assimilate Napoleon to Charlemagne, and I think it is quite reasonable to assume that Ingres did have such a source in mind (Fig. 70); an even greater problem is exemplified in the commission that was given to Gros in 1812 to decorate the dome of the Panthéon (which Napoleon re-established as a church after it had been secularised during the revolutionary period) with the figures of Clovis, the first king of the Franks, Charlemagne, St Louis and Napoleon himself, all surrounding Ste Geneviève, the patron saint of Paris. This would indeed have proclaimed his legitimacy to the historically minded, but the work was not to come to fruition as planned because of the intervention of politics.[6] After Elba, Gros was summoned by the royal minister and told that Louis XVIII was to be substituted for Napoleon. Came the Hundred Days and Napoleon found time to countermand the order, and the wretched

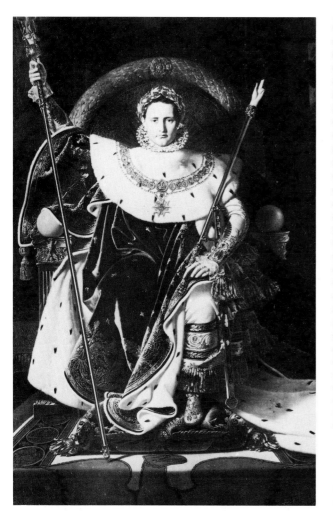

70. *Charlemagne*, reproduced from Bernard de Montfaucon, *Les Monumens de la monarchie françoise* (1729), I, pl. 20 (detail)

69. (left) Jean-Auguste-Dominique Ingres: *Sa Majesté l'Empereur sur son trône* –Salon de 1806 (Paris, Musée de l'Armée)

Gros set to work again, only to have it near completion at about the time of Waterloo, after which once again Louis XVIII had to be inserted. Even more trying than these political difficulties was the problem of how to represent on a monumental scale heroes from the Dark and Middle Ages who had left behind virtually no authentic visual records or recognised styles. When, in the eighteenth century, artists had occasionally had to paint Clovis they had not bothered too much and had turned him into a standard rococo figure from antiquity. Gros, however, made a bold attempt to introduce some 'local colour' (the phrase itself dates from this time) in the flowing locks of hair, leather belt and so on (Fig. 71), though when he came to Charlemagne he adopted a far more stylised manner, clearly based on reminiscences of Michelangelo.

But though Gros never had the chance to bring together Charlemagne and Napoleon, as originally intended, he was able to compare the Emperor to another hero of French history, and the picture that he produced gives us a fascinating insight into the origin and development of these costume pieces. After the final defeat of Austria at the battle of Austerlitz, when Napoleon was already planning to marry the Habsburg princess Marie Louise, Gros was commissioned to paint the meeting, and implied reconciliation, of the two Emperors on the field of battle (Fig. 72). The picture is one of his least successful,

80

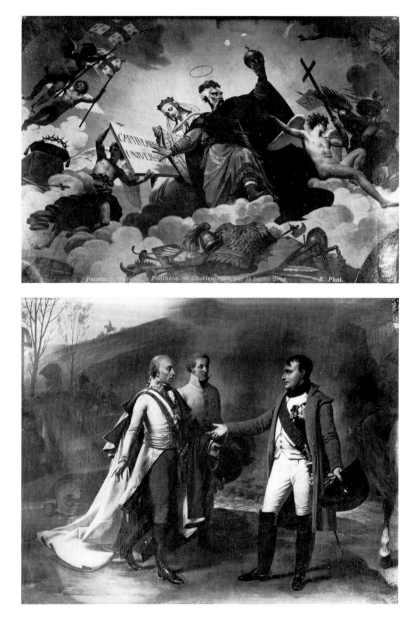

71. Antoine-Jean
Gros: Detail from
cupola of Panthéon in
Paris, showing
Charlemagne

72. Antoine-Jean
Gros: *Entrevue de LL
MM l'Empereur des
Français et l'Empereur
d'Autriche en Moravie –
Salon de 1812* (Musée
de Versailles)

stiff, empty and theatrical. But soon after, he had the chance of recording the same event in what was evidently a far more congenial manner; for in 1812 he was one of a number of artists who received commissions to paint pictures to decorate the reconsecrated sacristy of St Denis, where the French kings had been buried, and for this he painted the moment when in 1540 François I had, as Napoleon was to do nearly three centuries later, briefly reconciled himself with his Habsburg enemy, in this case the Holy Roman Emperor, Charles V, and had welcomed him to the Abbey of St Denis (Fig. 73). In both cases a king of France greets his principal enemy with feudal courtesy, but—paradoxically—in the historical picture the whole episode is painted with far more feeling than in the modern one. To that extent—but only to that extent—Gros can be looked upon as the ancestor

of all those many nineteenth-century artists who felt themselves more at home in the past than in the present, and the picture is a precursor also in its almost Hollywood concentration on prominent figures of the time: among those watching the ceremony are Amyot, the translator of Plutarch, Jean Goujon, the great sculptor, Clément Marot, Rabelais, Diane de Poitiers and many more familiar figures. But there is more to the picture than that. On Sunday, 20 October 1793, marauding soldiers had uncovered the vault of François I and his immediate family: 'all the corpses were in a state of liquid putrefaction and gave out an unbearable stench', as they were ignominiously dragged from their tombs. Now—and how splendidly and with what grandeur—François I returned to St Denis.

What were the sources available to Gros when painting a picture of this kind? Curiously enough there does actually exist in Italy a sixteenth-century fresco depicting the meeting between François I and Charles V,[7] but he seems to have paid no attention to this and to have turned instead to a later century—the seventeenth—and a later artist—Rubens—for the mechanism, so to speak, of his picture. The principal source, however, of most of the pictures that interest us was to be found in the museum founded by one energetic man in 1792. At a time when revolutionary fanaticism was engaged in destroying many

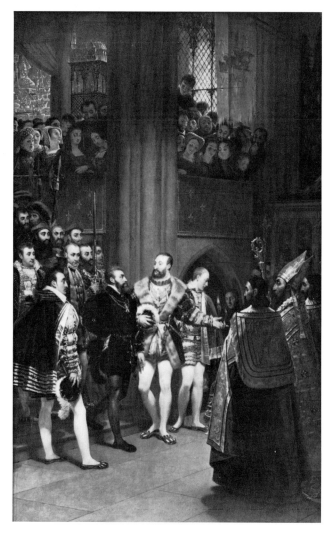

73. Antoine-Jean Gros: *Charles-Quint venant visiter l'église de Saint-Denis, où il est reçu par François Ier, accompagné de ses fils et des premiers de sa cour* – Salon de 1812 (Paris, Musée du Louvre)

74. J. E. Biet (engraved Normand): *Quatrième vue de la salle du XVe siècle*, reproduced from *Souvenirs du Musée des Monumens Français*

of the great monuments in the French churches, Alexandre Lenoir managed to have as many of them as possible rescued and placed in the deconsecrated Convent of the Augustinians (the site of the present Ecole de Beaux-Arts). There, he hoped, they would be studied 'objectively', untainted, as it were, by any association with the original motives behind their construction. This Musée des Monuments Français, the first of its kind in the world, was soon filled with treasures, arranged in more or less chronological order, from churches and palaces all over France, including incidentally the tomb of Louis XII (Fig. 74), which Gros just indicates in his picture. Very soon these objects began to attract considerable attention. Starting off as rather an esoteric enterprise, appealing only to scholars, it soon struck the public imagination and attracted large numbers of artists and writers. Many years later Michelet was to describe the effect of the museum on his generation:

> The eternal continuity of the nation was reproduced there. France at last could see herself, her own development; from century to century, from man to man and from tomb to tomb, she could in some way examine her own conscience . . . How many there were to catch the first spark of history in the Museum—the interest that can be aroused by the memory of great events, the vague desire to climb back through the ages! I remember still the emotion which even now lives for me as powerfully as ever and which made my heart flutter when, as a little boy, I used to enter those dark vaults and gaze at those pale faces, when, full of ardour, curiosity and fear, I would wander and search from room to room and age to age. Of what was I thinking? I hardly know. The life of those epochs, no doubt, and the spirit of the times. I was not quite sure that they were not still alive, those marble sleepers stretched out on their tombs; and when from the sumptuous and glowing alabaster monuments of the sixteenth century I went to the lower hall of the Merovingians, which contained the cross of Dagobert, I was not sure that I would not see Chilperic and Frédégonde suddenly sit up.[8]

Of course, the Musée des Monuments Français no more 'caused' the rise of romantic historicism than the earlier discoveries at Pompeii and Herculaneum had 'caused' the rise of neo-classicism. But there is no doubt that the concentration of so much material in one place played an immensely important role in stimulating the imaginations of artists, and if nineteenth-century art is ever studied with the same seriousness as that of the Renaissance, scholars will devote as much attention to it as they do to the ancient sarcophagi and classical figures excavated during the fifteenth and sixteenth centuries.

One man, however, though he recognised the value of saving these monuments, deplored the fact that (as had been the intention) for him at least 'they no longer have anything to say to the heart or the imagination'.[9] In trying to make good this lack Chateaubriand also encouraged the creation of the pictures that interest us. His *Génie du Christianisme*, published in 1802, was, he said, intended to be filled 'with memories of our antique customs, of the glories and monuments of our kings . . . it breathed the spirit of the ancient monarchy. Frenchmen learned to look back on the past with regret.' Chateaubriand helped to undermine respect for antiquity—'the Romans were always a horrible people'—and dazzled his readers with colourful impressions of the Middle Ages:

'an old castle, a wide hearth, tournaments, jousts, hunts, the sound of the horn, the clash of arms . . .' The age of chivalry, he said, was the only poetical time of French history, and he lingered over the names of Du Guesclin, the Chevalier Bayard, Montmorency, who were soon to be filling the canvases of history paintings.[10] This mood of nostalgia for the *ancien régime* and of fervent patriotism was actively encouraged by Napoleon, who hoped to give it a particular slant. In 1806 a government official suggested that subjects for sculptures on the fountains which were being built in Paris should be taken from the history 'of the Emperor, the history of the Revolution and the history of France. In general no opportunity should be missed of humiliating the Russians and the English. On these monuments one could, for instance, honour William the Conqueror and Duguesclin.'[11] Hence an increasing number of these pictures, which tended to combine sentimentality and patriotism, showed, for instance, subjects such as Agnès Sorel saying farewell to her lover Charles VII as he went off to fight the English.

It is not surprising that the patrons and collectors who most encouraged such pictures should have been just those men who were most anxious to call attention to the aristocratic, feudal past—that is to say, either figures of the *ancien régime* who had survived the Revolution, or members of the upstart nobility which Napoleon was busily creating. Josephine herself and her son by her first marriage, Eugène de Beauharnais, commissioned a whole series and it was for the Duc de Blacas, one of the most extreme royalists, that—just after the Restoration—Ingres painted *Henri IV jouant avec ses enfans, au moment où l'ambassadeur d'Espagne est admis en sa présence* (Fig. 75). A few statistics will give some indication of the popularity of pictures showing scenes from French history: in 1801 and 1802 there were two at each of the Salons; in 1804, six; in 1806, eighteen; in 1808, twenty-one; in 1810, twenty-five; in 1812, thirty-seven; in 1814, eighty-six; and thereafter they become too numerous to count.

75. Jean-Auguste-Dominique Ingres: *Henri IV jouant avec ses enfans, au moment où l'ambassadeur d'Espagne est admis en sa présence* – Salon de 1824 (Paris, Musée du Petit Palaias)

76. Fleury Richard: *Valentine de Milan, pleurant son époux assassiné en 1407, par Jean, duc de Bourgogne* – Salon de 1802 (now lost), reproduced from C. P. Landon, *Annales du Musée*, IV (1803)

77. J. E. Biet (engraved C. Normand): *Troisième vue de la Galerie conduisant aux salles des XIV^e et XV^e siècles*, reproduced from *Souvenirs du Musée des Monumens Français*

Interestingly enough we know something about the principal artists who specialised in the production of these pictures, much to the dismay of David, whose classical themes they seemed to be undermining in popularity. There were four of them, Révoil, Fleury Richard, Granet and the Comte de Forbin, and all were pupils of his. In his studio they

78. Jacques-Louis David: *Les Sabines*, 1799 (Paris, Musée du Louvre)

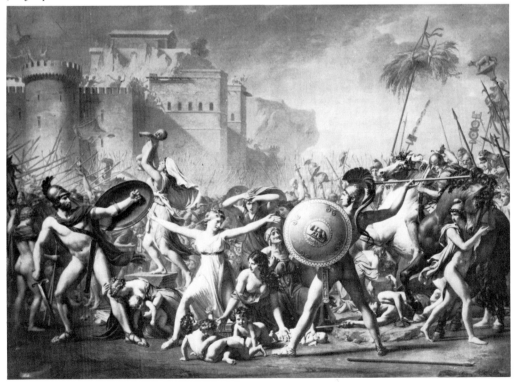

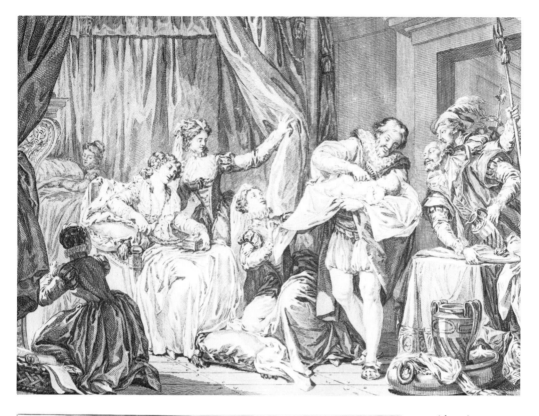

79. (above)
Anonymous engraver
of eighteenth century:
Birth of Henri IV

80. Moreau le Jeune
(engraved F. Janinet):
*Projet d'un monument à
eriger pour le Roi*, 1790

were all considered to be 'aristocratic', and all were practising Catholics at a time when this was rare among artists. An early example of such works is provided by Fleury Richard's *Valentine de Milan, pleurant son époux assassiné en 1407, par Jean duc de Bourgogne* (Fig. 76), exhibited in 1802 and now known only through preliminary studies, a copy and an engraving. This picture is of particular interest because we know that the artist got the idea for it from the tomb of Valentine de Milan which was in the Musée des Monuments Français (Fig. 77); and the assassination of Valentine's husband had set off a train of disasters culminating in civil war. The picture, in other words, can be thought of as a plea for national reconciliation of much the same kind as David himself had painted three years earlier in a classical context showing the Sabine Women intervening in the conflict between their menfolk and the Romans (Fig. 78). Though we can judge little of its quality from the line engraving, a critic of the time pointed out that 'the costume of the character, which is the exact one of her century, the arms of her family painted on the window, and the style of the architecture characterise a subject which will be new to most spectators and for which the artist has had to use every particular detail possible'.[12]

If the same theme could be treated by the 'new' as well as ancient iconography, it is also true that certain French historical characters could serve a multitude of suppliants. Let us look briefly at a few of the innumerable versions of that eternal standby, Henri IV. In an eighteenth-century print we see him born into a rococo world, quite devoid of 'local colour' or modern allusions (Fig. 79), but in 1790—in the design for a monument which could not be erected in time (Fig. 80)—he is giving a helping hand to Louis XVI who commented that 'Je suis en bonne Compagnie';[13] and then, after only a brief eclipse, he re-emerges during the Empire[14] to enjoy quite unprecedented success under the restored monarchy. In 1817 the painter Gérard, his brushes still wet, so to speak, from portraits of Napoleon and the Imperial family, painted *L'Entrée d'Henri IV, dans la ville de Paris,*

81. François Gérard: *L'Entrée d'Henri IV, dans la ville de Paris, en 1594* – Salon de 1817 (Musée de Versailles)

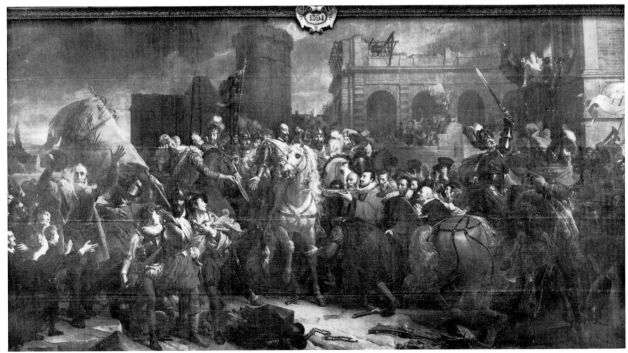

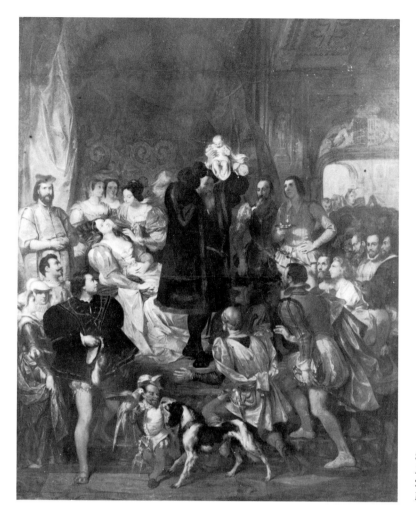

82. Eugène Deveria:
Naissance de Henri IV —
Salon de 1827 (Paris,
Musée du Louvre)

en 1594 (Fig. 81) to celebrate the return of the Bourbons—a picture which inspired Chateaubriand to write: 'Our ancient history is about to live again: love of our ancestors increases love of our fatherland . . . Henri IV has won a second immortality through the brushes of M. Gérard.'[15] In 1827, when Charles X was becoming increasingly unpopular and was soon to be driven into exile, Dévéria painted the *Naissance de Henri IV* (Fig. 82), now in the Louvre, which was for many years considered to be one of the greatest of all Romantic pictures, and in 1846 when Louis Philippe, the last king of France, was beginning to face the trouble that would soon topple him from *his* throne, the same artist returned to the theme in rather a feeble documentary picture (at Versailles) which records the King's son, the Duc de Montpensier, presiding over the inauguration of yet another statue of Henri IV.

The greatest attempt to 'codify' French history painting of this kind was, in fact, made by Louis Philippe when in 1833 he decided to restore Versailles and turn it into a museum dedicated 'to all the glories of France'. Like Napoleon he was anxious to impress on his subjects the essential continuity of French history culminating in his own reign. Portraits, trophies and so on were collected, but it was soon realised that there would not be enough to fill the enormous number of rooms assigned to the project, and as from 1833 artists

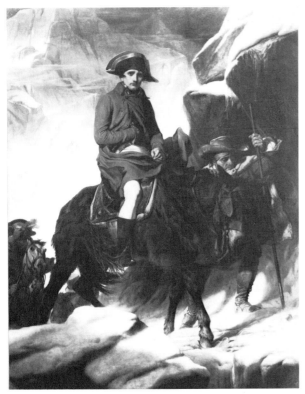

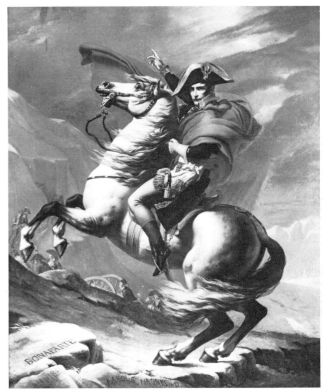

83. Paul Delaroche: *Bonaparte franchissant les Alpes*, 1850
(Liverpool, Walker Art Gallery)

84. Jacques-Louis David: *Bonaparte au Mont Saint-Bernard*, 1800
(Musée de Versailles)

all over France were busily engaged in churning out pictures of the Baptism of Clovis, the glories of Pépin and Dagobert, etc. The King's taste was very uncertain, to say the least, and few of the pictures commissioned by him with the most passionate interest and devotion have any real claims to be considered masterpieces. This did not worry Louis Philippe so much as the more embarrassing problem of what to do as history began to catch up with the present. The Revolution had to be treated very gingerly, as the King particularly objected to the idea that that event had involved any sign of 'disorder'. On the whole it was decided that it was better to stick to French military victories abroad, and the downfall of the monarchy was tactfully omitted. There were long discussions as to what should be done about Napoleon, and though it was finally decided that he could not be altogether omitted, no new pictures of his rule were commissioned, and—to the considerable advantage of the gallery—he was represented by the great contemporary pictures by Gros and others which had hitherto been rolled up and kept in storage.

And yet pictures of Napoleon were painted during the reign of Louis Philippe, and as I claimed that it was Napoleon who gave the principal impulse to the revival of French history which we have been exploring, so it seems fitting to end with Napoleon, himself by now a historical character. In about 1847 Delaroche painted a picture (of which Fig. 83 shows a slightly later version) depicting Napoleon crossing the Mont St Bernard. In this he quite deliberately echoed—parodied, one is almost tempted to say—the famous painting of the same subject by David (Fig. 84) which had constituted that artist's response to Napoleon's commission for a picture of himself 'calm on a fiery steed'. David's masterpiece

is the first picture of Napoleon, painted in 1800 even before he became Emperor, that made (in the inscription on the rocks) the fatefully influential comparison with Charlemagne. We have looked very briefly at some of the progeny which resulted from this type of allusion. But, when we come to the Delaroche, we see that the whole concept of 'history' has changed. Bleak though this is as a work of art, it is one of the first indications in painting that a new era has dawned, and that even the artist is trying to follow Ranke and 'see things as they really happened'.

APPENDIX

This essay has probably suffered more than any of the others collected in this volume from the rapid and powerful revival of interest in historical painting of the nineteenth century, and my own copy of it is barely legible under the annotations I have scribbled all over it. It is clearly no longer true that 'no kind of art . . . has now so hopelessly retreated beyond the frontiers of our appreciation', for pictures of this kind have been much exhibited during the last few years, and in 1982 the Louvre acquired a slightly earlier version of the painting of *Napoleon crossing the Alps* with which I ended my essay (and which has been discussed in a most interesting article by Edward Morris in the *Bulletin of the Walker Art Gallery* (Liverpool), v (1974–5), pp. 65–83). In a very enthusiastic, informative and thorough analysis of the painting now in the Louvre Elizabeth Foucart-Walter (*La Revue du Louvre,* v–vi (1984), pp. 367–84) sets it within the context of other representations of Napoleonic themes and explains the use made by Delaroche of Thiers's *Histoire du Consulat et de l'Empire,* the first truly scholarly work on the period. She also demonstrates that although the (obvious) contrast with David's picture of the same subject was made from the first, there is as yet no direct evidence that Delaroche's painting was specifically conceived of as a 'realistic' reply to David's more rhetorical treatment of the crossing of the Alps. The publication of Norman D. Ziff's thesis on Delaroche has enabled me to correct an important mistake I had made about the artist's *Cromwell and Charles I.*

Of the extensive literature devoted to historicising painting during the first half of the nineteenth century two books should be singled out: François Pupil's *Le Style troubadour* (Nancy, 1985) (which is much broader in scope than Marie-Claude Chaudonneret's *Fleury Richard et Pierre Révoil: la peinture troubadour* of 1980) and Thomas W. Gaehtgens's *Versailles: de la résidence royale au musée historique* (Antwerp, Fonds Mercator, 1984). There are now many articles directly relevant to my essay, of which I mention only two: Ruth Kaufmann, 'François Gerard's "Entry of Henry IV into Paris": The Iconography of Constitutional Monarchy', *Burlington Magazine* (1975), pp. 790–802, and Josette Bottineau, 'Le Décor de tableaux à la sacristie de l'ancienne abbatiale de Saint-Denis, 1811–1823', *Bulletin de la Société de l'Histoire de l'Art Français* (1973), pp. 255–81. Some English eighteenth-century precedents for the politicised historical painting investigated here are discussed by John Sunderland in 'Mortimer, Pine and some Political Aspects of English History Painting', *Burlington Magazine* (1974), pp. 317–26, to which there is a reply by Edward Morris, *ibid.,* p. 672. Pre-Revolutionary French treatment of national history is discussed in the catalogue *De David à Delacroix: la peinture française de 1774 à 1830* (Paris, 1974–5).

7. The Old Masters
in Nineteenth-Century French Painting

AMONG THE MORE curious and attractive reflections of the new attitude to the past which we find in painting towards the end of the eighteenth century and during the first half of the nineteenth is the very large number of pictures devoted to the lives and works of earlier artists: *Raphael and the Fornarina, Salvator Rosa among the Bandits,* etc. So many and varied are the artists whose activities are depicted during this period that a list of the titles of such pictures reads almost like a series of chapter headings for an illustrated Thieme–Becker, though the standards of accuracy are, alas, less exacting. Who, for instance, would not like to know more about the occasion on which Bramante introduced Raphael to Leonardo as he was at work on his portrait of the Mona Lisa, or Rembrandt with biting cynicism repelled the friendly homage of Rubens—scenes that were recorded by Mme Brune and E. Wallays in pictures of 1845 and 1842? But the fact that we do not turn to paintings of this kind for scholarly information about their subjects does not mean that they are without considerable historical interest of an altogether different kind.[1]

It is true that to isolate scenes such as these from the general mass of paintings concerned with episodes from modern (as opposed to antique) European history necessarily involves some falsification of the evidence, for it can certainly be argued that pictures devoted to the persecution of Tasso or Galileo—to take two instances of popular subjects—were felt to be as relevant to the position of the artist in the nineteenth century as were themes more specifically concerned with the pictorial arts themselves. It would therefore be a mistake to construct over-ingenious theories to account for the phenomenon which is to be discussed, without remembering that it forms only a small fraction of the much wider field of historicism as a whole. Nevertheless, it seems reasonable to assume that the choice by a painter of a subject which offered such very obvious possibilities of self-identification as was the biography of one of his predecessors can be more revealing about current attitudes to art than those innumerable other pictures which deal with poets, philosophers, kings and men of action.

The exploration of these themes has another fascination for the historian, for this is one of the rather rare cases in which his range of material is definitely circumscribed in time. Year by year we can watch the birth, flowering and decay (in statistical rather than aesthetic terms) of pictures dealing with the lives of earlier artists, and in many cases the vogue for such works can be related to social and intellectual phenomena of great importance.

It is, of course, perfectly true that there are precedents to the fashion of treating such themes, which reached its peak in the forties and fifties of the nineteenth century. Classical antiquity and the early Church had given the world at least two painters, Apelles and St Luke, whose activities had inspired artists throughout the medieval, Renaissance and Baroque ages and were to continue to do so long after more attention was being paid to painters whose work was rather better documented. And reference must also be made to Dibutade, the Corinthian maid, who discovered the art of drawing by tracing on a wall the shadow cast by her lover.[2]

During the sixteenth and seventeenth centuries we can also find a few works, usually designed by relatives or disciples, to celebrate the careers of certain illustrious masters of an earlier age. Such, for instance, are the drawings by Federigo Zuccaro illustrating scenes from the life of his brother, Taddeo,[3] and—much more important—the astonishing series of paintings recording events in the life of Michelangelo which were commissioned in the early years of the seventeenth century by his great-nephew, Michelangelo Buonarroti the Younger.[4] Cycles such as these constituted a highly imaginative variation on the conventional monuments in honour of artists which had from time to time been erected ever since the late years of the fifteenth century.

Yet another aspect of this pre-history of the subject can be found in those tributes to artistic patronage to be seen in such decorations as those by Vasari in the Sala di Cosimo il Vecchio in the Palazzo Vecchio, which show Cosimo with Donatello, Filippo Lippi, Luca della Robbia, Ghiberti, Brunelleschi, Fra Angelico and other artists; and by Ottavio Vanini in the Palazzo Pitti, which portray Lorenzo also surrounded by the artists of his day, including Michelangelo.[5]

However, what is certainly the most striking of all these early tributes from one artist to a predecessor is Luca Giordano's *Rubens painting the Allegory of Peace* in the Prado, a picture in which the relationship between fiction and reality is of positively Pirandellian complexity and which was created in circumstances that are unfortunately unknown.[6] Yet despite all these and a few other precedents, there can be no doubt that the last quarter of the eighteenth century witnessed the invention of what was essentially a new artistic subject: the anecdotal picture devoted to the life of an earlier master.

The first indications of what was to come are found in England in a number of drawings and engravings by John Hamilton Mortimer, produced in 1776 and the years immediately following, of Salvator Rosa and Gérard de Lairesse. Mortimer was frequently referred to as 'the English Salvator', and there can be little doubt that his representation of that artist implied a considerable degree of self-identification, while it has been suggested that the Lairesse was intended as a tribute to Sir Joshua Reynolds, to whom Mortimer had dedicated his series of prints.[7] It also seems possible that some contrast between Nature and Learning was intended, though the works themselves provide little warrant for any allegorical interpretation. Whatever their true meaning Mortimer's *Rosa* and *Lairesse* are exceptional and left behind no successors, for—as will be seen—they stand in strong contrast to virtually the whole tradition that is to be studied by concentrating on the artist as an isolated being rather than as a social figure.

In 1778, the very same year in which Mortimer produced these strange prints, Angelica

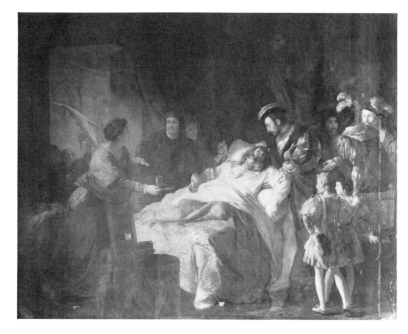

85. François
Guillaume Ménageot:
*Léonard de Vincy,
mourant dans les bras de
François Premier* – Salon
de 1781 (Amboise,
Musée de l'Hôtel de
Ville)

Kauffmann exhibited at the Royal Academy a picture, which cannot now be traced, of the *Death of Leonardo da Vinci in the Arms of Francis I,* and in the following years a number of other versions of the same subject were produced in England, France and Italy, of which the most famous is Ménageot's *Léonard de Vincy, mourant dans les bras de François Premier,* exhibited at the Salon of 1781 (Fig. 85). Although, as Robert Rosenblum has pointed out,[8] deathbed scenes were extremely popular at this date and all derived from Poussin's *Death of Germanicus,* the general composition of which was retained whoever the protagonist, Ménageot's picture differs from the others of its kind in one crucial respect: the chief

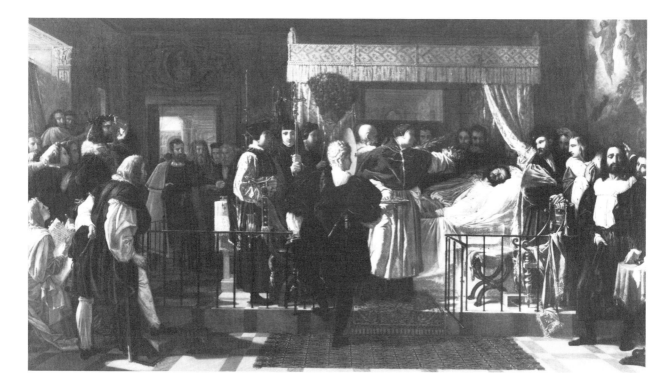

mourner, François I, is of greater importance than the man he mourns. This is made plain not only by the composition itself, but also by the lines devoted to it which Ménageot inserted in the Salon catalogue: they discuss at some length the King's generosity to Leonardo and then explain that Leonardo, 'voulant se soulever pour lui témoigner sa reconnaissance, tomba en foiblesse, le Roi voulut le soutenir, et cet Artiste expira dans ses bras'. Diderot, in his warm but critical welcome,[9] curiously fails to discuss the novelty of the subject, but devotes more attention to the King and his retinue than to Leonardo; and when, some years later, Girodet wrote some verses to discuss the theme as a suitable one for artists, the very rhythm of his lines shows where he thought the emphasis should lie:

> Que je puisse admirer dans une heureuse image
> L'illustre Léonard comblé de gloire et d'âge
> Dans les bras de François satisfait de mourir,
> Le grand homme au grand roi rend son dernier soupir.[10]

Ménageot's picture, in fact, was a celebration of royal patronage more than of artistic genius. Significantly, it was painted for Louis XVI, just as, many years later, it was Napoleon who bought Bergeret's *Honneurs rendus à Raphaël après sa mort* of 1806 (Fig. 86), shortly to be discussed; and thematically it is more closely related to the growing fashion for pictures recording episodes from the careers of the Chevalier Bayard, Du Guesclin

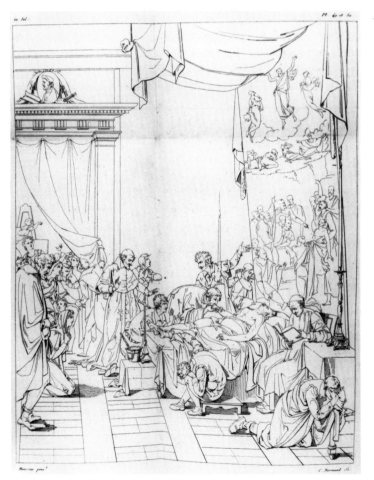

87. Nicolas-André Monsiau: *La Mort de Raphaël* – Salon de 1804, reproduced from C. P. Landon, *Annales du Musée*, X (1805)

86. (far left) Pierre-Nolasque Bergeret: *Honneurs rendus à Raphaël après sa mort* – Salon de 1806 (Oberlin College, Allen Memorial Art Museum)

and other heroes of French history than to later representations of the artistic life. Indeed, so little was the artist conceived of as an individual and so closely was talent linked to patronage in people's minds that, despite the fact that genre subjects were popular during the Revolutionary period, no paintings of artists' lives were exhibited in France for the next twenty years; and when such subjects turned up again in 1804 Ménageot's picture was completely forgotten and the critics referred to Monsiau's *La Mort de Raphaël* (Fig. 87) as inaugurating a completely new type of subject matter.[11] Thereafter, however, the taste for them remained constant, and there is, in fact, not a single Salon until 1886 which did not include at least one example. A few statistics will give some indication of their popularity. Between 1804 and 1817 an average of two or three were to be found at every exhibition. With the return of the Bourbons their numbers increased considerably, and in the 1820s there were often as many as ten in each Salon. During the next thirty years or so it was not unusual for this figure to climb to nearly twenty, but from the end of the 1860s onwards, with the decline of historical pictures generally, numbers began to dwindle to an average of four or five a year, only dying out altogether a generation later. Though such statistical evidence can only be assembled about pictures actually recorded in exhibitions, the numbers of those which can be traced from other sources confirms this trend.

These paintings can be discussed from many points of view, and in this brief article it is proposed only to indicate some of the more interesting approaches. There is, first of all, the insight that the actual choice of artists can give us into the history of taste. It is not surprising that during the first half of the nineteenth century Raphael appears more frequently than any other painter, and in fact the vogue for treating episodes from his life (which played so important a role in the career of Ingres despite the fact that he never completed his intended series)[12] was given a blessing by the most influential of the artist's early nineteenth-century biographers and apologists, Quatremère de Quincy, whose own book on Raphael, first published in 1824, was often used as a source for artists in search of material.[13]

In the introduction to this, Quatremère de Quincy specifically refers to the decoration of the Casa Buonarroti in Florence and welcomes the creation of similar pictures in honour of Raphael. He shows great enthusiasm for those which have already been produced, in particular the paintings of Monsiau and Bergeret, whose styles he contrasts; but in comparing them he directly contradicts the opinions of earlier critics of these two artists. For Chaussard (*Le Pausanias français*) writing in 1808, in Monsiau's painting, excellent though it was, 'on voyait une scène peut-être trop bien arrangée, une scène peinte en France';[14] whereas in Bergeret's 'c'est le désordre du moment. En général, la vérité de l'action est telle, qu'elle semble avoir été peinte à l'instant même et dans le lieu où elle s'est passée, par un Elève de Raphaël qui aurait assisté à ce funèbre et touchant spectacle.' Quatremère de Quincy, however, thought that Monsiau's subject was treated 'avec la seule fidélité du lieu, des accessories et des usages du pays', while Bergeret's contained 'la licence que la poésie de la peinture permet de porter dans les sujets dont on veut proportionner l'image à la grandeur des idées et des affections qu'ils rappellent'. Such debates as to how reality could best be achieved in historical painting were naturally common at the time, but they

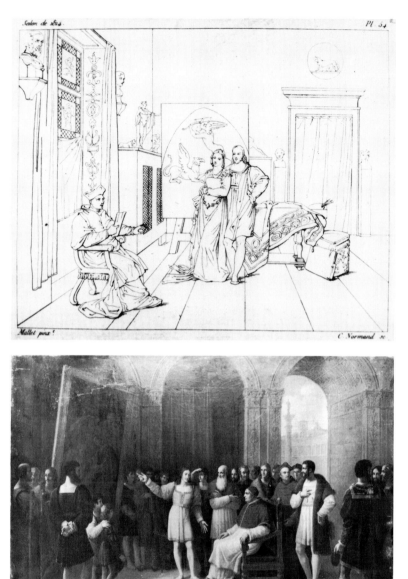

88. Jean–Baptiste
Mallet: *Interieur de
l'atelier de Raphaël* –
Salon de 1814,
reproduced from C. P.
Landon, *Annales du
Musée (Salon de 1814)*

89. Jean Henri Marlet
[Marlay]: *Raphaël dans
son atelier* – Salon de
1812 (Dijon, Musée des
Beaux-Arts)

acquired special significance in the treatment of subjects such as these, where the artist being depicted had himself been associated with a particular style. In view of the endless debates that were later to oppose Raphael to Rubens, line to colour, it is therefore interesting to note that Chaussard in 1808 can give almost equal praise to two representations of Raphael, one of which (by Monsiau) 'se recommandait par l'élégance du dessin, la noblesse des personnages et des airs de tête; l'arrangement des draperies et le parti qu'il avait tiré du costume'; while the other (by Bergeret) was superior 'sous le rapport du Coloris, de l'entente du clairobscur, de l'ordonnance, et sur-tout du caractère historique'.

Although it is proposed to discuss later the nature of the actual scenes chosen for representation and to suggest that these can to a large extent be accounted for by considering the

circumstances of their authors, a few points can be made here about the changing iconography of Raphael, because the problem was raised very early in the history of the subject. When in 1814 Landon came to discuss Mallet's *Intérieur de l'atelier de Raphaël* (Fig. 88),[15] he pointed out that such a title might have led the spectator to expect a large-scale picture showing Raphael surrounded by his pupils, as had in fact already been painted by Marlet (Fig. 89); instead he was confronted with a small anecdotal scene, which showed Cardinal Bibbiena reading one of his comedies to the artist and his mistress. Such a scene, adds Landon, might appear to be lacking in dignity, despite the fact that we know that Agostino Chigi encouraged the artist to keep his mistress with him while engaged on work. Landon's extended gloss on this episode and on Cardinal Bibbiena's friendship with Raphael proves, however, that he must have been aware of what was presumably Mallet's intention when choosing such an invented episode: to demonstrate that so intimate was Raphael's relationship with the great that he could afford to take licences which would hardly have been possible for other artists. In other words this picture also, however trivial in conception, was designed to stress the social status of the Renaissance artist.

It remains true, however, that—as with most themes in the history of art—these pictures, which had originally been inspired by a serious social and didactic purpose, were rapidly transformed into something far less significant. It is curious that even Ingres should have paid so much more attention to Raphael's relationship with the Fornarina than with his work, though admittedly in his many versions of the scene the artist is always portrayed turning away from the former to the latter, from Nature to Art (Fig. 90). Coupin de la Couperie's *Raphaël ajustant la coiffure de la Fornarina avant de la peindre*, commissioned by the Duchesse de Raguse in 1824, is known to us only through an engaging print (Fig. 91),[16] but the younger Fragonard's *Raphaël rectifiant la position d'un modèle pour son tableau 'La Vierge à l'Enfant'* (Fig. 92) shows us that even potentially religious subjects could be converted into delightful and frivolous genre.

Pictures of this kind—and there were a great many of them—spring to mind when we read of Lady Glencora Pallisser's reveries in Trollope's *Can You Forgive Her,* of 1864:

> She had a little water-coloured drawing called Raphael and Fornarina, and she was infantine enough to tell herself that the so-called Raphael was like her Burgo—no, not her Burgo, but the Burgo that was not hers. At any rate, all the romance of the picture she might have enjoyed had they allowed her to dispose as she had wished of her own hand. She might have sat in marble balconies, while the vines clustered over her head, and he would have been at her knee, hardly speaking to her, but making his presence felt by the halo of its divinity. He would have called upon her for no hard replies. With him near her she would have enjoyed the soft air, and would have sat happy, without trouble, lapped in the delight of loving. It was thus that Fornarina sat. And why should not such a lot have been hers? Her Raphael would have loved her, let them say what they would about his cruelty.[17]

And so, by mid-Victorian times yet one more theme which had been welcomed by the critics as symbolising the glories of the artistic life was now available to feed day-dreams about romance and adultery.

90. Jean-Auguste-Dominique Ingres: *Raphaël et la Fornarina* (Cambridge, Mass., Fogg Art Museum)

91. Marie-Philippe Coupin de la Couperie: *Raphaël ajustant la coiffure de la Fornarina avant de la peindre* – Salon de 1824, reproduced from C. P. Landon, *Annales du Musée, (Salon de 1824)*, II

92. Alexandre Evariste Fragonard: *Raphaël rectifiant la position d'un modèle pour son tableau 'La Vierge à l'Enfant'*, c. 1820 (Grasse, Musée Fragonard)

Immediately after the Restoration Michelangelo began to be seen at the Salons. Apart from an improbable appearance at Raphael's deathbed (in 1806), we first come across him in 1817, and thereafter he became increasingly popular. Despite his adoption by the Romantics, Michelangelo was in fact also enrolled into the classicist camp, for in these early renderings he is nearly always shown pointing out for admiration some great work of classical antiquity.[18] It was not until 1833 that his rivalry with Raphael was brought to the fore in the once notorious picture by Horace Vernet, *Raphaël au Vatican* (Fig. 93),[19] which depicted the moment, reported most recently by Quatremère de Quincy when the two men exchanged insults: '"Vous marchez entouré d'une suite nombreuse, ainsi qu'un général." "Et vous," répondit Raphaël au peintre du Jugement dernier, "vous allez seul comme le bourreau."' The picture was rightly ridiculed by contemporary critics for its composition,[20] but its actual implications are not altogether clear. Laviron and Galbaccio said that it was a subject 'destiné à salir la réputation de ces grands maîtres', but in fact we know that Vernet had vehemently disapproved of Thiers's plan to have the *Loggia* and *Stanze* copied for the benefit of French art students,[21] and it may well be, therefore, that, despite his own love of brilliant society, he was intending to side with the *farouche* Michelangelo. Certainly Overbeck, whose loyalties to Raphael are not in doubt, is reported to have thought that the picture must have been the work of a madman.[22]

In general, however, the Michelangelo whom we find in nineteenth-century pictures is not the *terribile* figure so beloved of earlier tradition, but the kindly old man who sits at the deathbed of his devoted servant—a theme frequently painted by Robert-Fleury (Fig. 95). Only Delacroix (who in the Salon of 1831 had exhibited a *Raphaël méditant dans son atelier*) attempted (between 1849 and 1852) to probe the nature of Michelangelo's solitude and the reasons for his failure to finish so many of his works—and in so doing he not only produced what is probably the single masterpiece of the whole genre here being discussed (Fig. 94)[23] but also threw moving light on the agonies of his own creative process: 'Je me le figure à une heure avancée de la nuit, pris de peur lui-même au spectacle

de ses créations, jouissant le premier de la terreur secrète qu'il voulait éveiller dans les âmes',
he had written some twenty years earlier; but it is interesting that much later he copied
into his Journal a passage from Clément which noted that 'malgré les travers qu'on lui
a reprochés, la violence de son caractère, son esprit irritable, sarcastique, son amour presque
maladif de la solitude ... Michel-Ange fut lié avec les hommes les plus célèbres de son
temps'.[24] And this was the Michelangelo who was painted by most of Delacroix's fellow
artists.

It would be tedious in the extreme to discuss in detail the innumerable artists from Albani
to Zurbarán who turn up in the paintings of the nineteenth century, but it is worth giving
some broad survey by schools. The masters of the Florentine and Roman High Renaissance
and the French seventeenth-century classicists—Leonardo, Raphael, Michelangelo, Poussin,
Le Sueur—were all popular during the first half of the century, with rather less attention
being paid to the Venetians, who later, however, decisively out-stripped Raphael. But
two of the greatest of all Salon successes were won by Titian and Tintoretto: the former's
funeral by Hesse, in 1833 (Fig. 96),[25] and the latter painting his dead daughter by Cogniet
ten years later (Fig. 97). Indeed, Maria Tintoretto was a popular figure in her own right,
and was often enough shown in her studio or in the company of her father.[26]

Giorgiones were rare, but Thoré describes as 'excellent' Baron's painting of 1844, *Gior-
gione Barbarelli faisant le portrait de Gaston de Foix,* and this verdict is surely confirmed by
the delightful lithograph (Fig. 99), even though the portrait in the Louvre on which it

93. Horace Vernet: *Raphaël au Vatican* – Salon de 1833
(Paris, Musée du Louvre)

94. Eugène Delacroix: *Michel Ange dans son atelier,*
1849–50 (Montpellier, Musée Fabre)

is based is now thought not to be of Gaston de Foix and is universally attributed to Savoldo.[27] Correggio does little other than die, not mourned by kings and popes, but feverish after a day's tramping in the sun and comforted only by his family. Vasari attributes his premature end to his excessive miserliness, but to the nineteenth century he was a symbol of the starving and neglected artist, and it is not surprising, therefore, that the most moving interpretation of the subject was painted (in 1834) by Tassaert (Fig. 98), who was obsessed by misery and constantly compared by the critics to Correggio.[28]

The Bolognese masters (with the strange exception of Guido Reni) were also popular, and Rubens had been among the very first to be painted, but it was not until the 1830s and 1840s that Rembrandt and the other Dutch and Flemish masters came into their own. The flowering of landscapes and marine pictures during these decades was responsible for a large number of Potters and Van de Veldes, many of them the work of a single painter, Eugène Lepoittevin (Fig. 100), who also established a monopoly of Backhuysen.

It is curious that, for all the many revaluations of earlier reputations which took place during the nineteenth century, so few 'rediscovered' artists found their way into the standard repertoire. There were no Botticellis or El Grecos, Le Nains or Vermeers, despite the fact that all these had their champions in France while the supply of anecdotal pictures was still plentiful. Even the more familiar 'primitives' were few and far between. The subject of Cimabue discovering the talents of the young Giotto was naturally an exception to this general tendency, and by 1844 Paul Mantz could claim (with some exaggeration) that 'tous les ans l'exposition offre à notre curiosité émoussée sur ce sujet une demi-douzaine de *Giotto surpris dessinant ses chèvres par Cimabue, peintre florentin* . . . Peindre ce sujet, c'est déjà montrer un sentiment élevé, un véritable amour de l'art, un bon instinct de la poésie pittoresque.'[29]

Masaccio was the first of the fifteenth-century masters to be celebrated, and as early as 1817 Couder showed him dying—oddly enough of poison and in the Brancacci chapel—just before being able to complete the frescoes in S. Clemente now attributed to Masolino (Fig. 101).[30] Perugino earned his place in the Salon on a few occasions as the master of

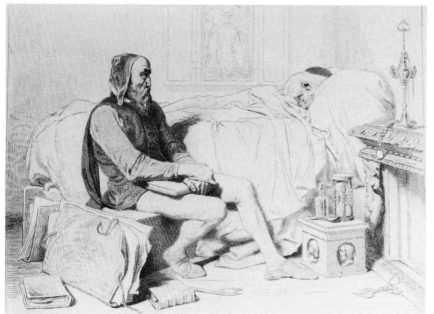

95. Joseph-Nicolas Robert-Fleury: *Michel-Ange donnant des soins à son domestique malade* – Salon de 1841, reproduced from *Album du Salon de 1841*

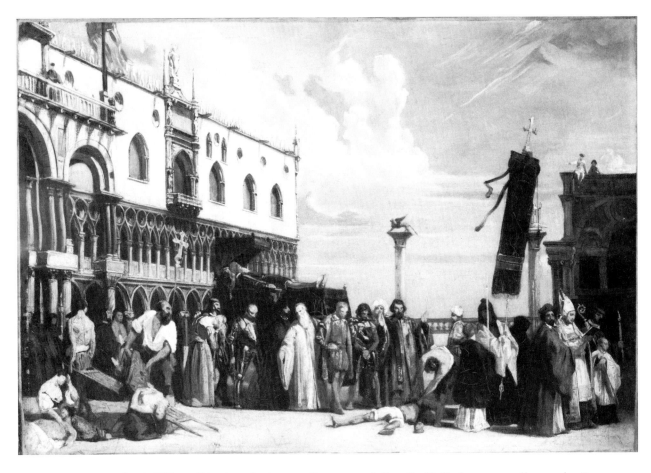

Raphael, Filippo Lippi as the lover of a nun and Gentile Bellini as a traveller to the East. But, apart from these and one or two others, the Quattrocento was largely neglected, and the only artist of the period who was popular in his own right was Fra Angelico—above all with the followers of Ingres.[31] He also returned to fashion during the Catholic revival of the 1870s and 1880s, and, as a result, he was one of the very last painters still capable of attracting attention as a subject of art. As late as 1885 Maurice Denis could write in his *Journal,* 'Oui, je travaillerai pour la gloire de celui que j'aime quand je peindrai l'apothéose de Fra Angelico, cette oeuvre qui doit briller à mon premier Salon, cette oeuvre qui est mon espérance, mon rêve, mon but; cette oeuvre qui me fera connaître par le puissant intermédiaire du Beato!'[32]

Both Ribera and Velázquez (or, rather, his 'slave' Juan de Pareja) had appeared in the Salons of the 1820s, but naturally enough it was the opening of Louis Philippe's *Galerie Espagnole* in 1838 that gave the main impetus to scenes from the lives of Spanish artists, and such scenes continued to be painted for the next thirty years, reaching a climax in Ribot's horrific *Supplice d'Alonzo Cano* of 1867 (Fig. 102).[33]

Despite the considerable, if not widespread, admiration for the eighteenth-century French masters throughout the Romantic period, the only representation of one of these during the 1820s was the obviously exceptional tribute to the courage of Joseph Vernet paid by his grandson Horace in 1822 (Fig. 103).[34] However, Watteau and Pater appeared together in 1845, and during the Second Empire especially there was a fairly large number

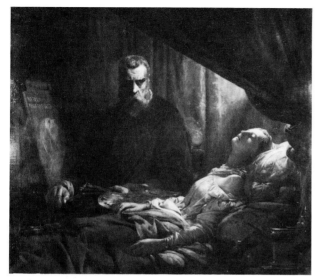

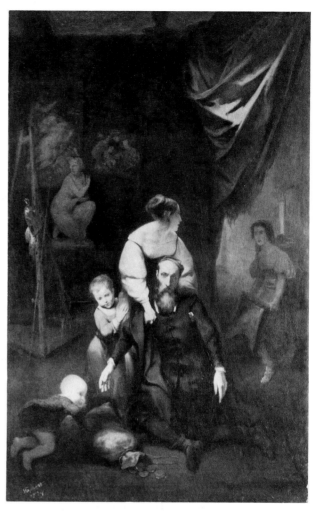

97. Léon Cogniet: *Le Tintoret et sa fille* – Salon de 1843
(Bordeaux, Musée des Beaux-Arts)

98. (right) Octave Tassaert: *La Mort du Corrège* – Salon de 1834
(Leningrad, Hermitage Museum)

96. (left) Alexandre Hesse: Sketch for *Honneurs funèbres rendus au
Titien, mort à Venise pendant la peste de 1576* – Salon de 1833
(Philadelphia Museum of Art. The Henry P. McIlhenny Collec-
tion in Memory of Frances P. McIlhenny)

99. (below) Henry Baron: *Giorgione Barbarelli faisant le portrait
de Gaston de Foix, duc de Nemours* – Salon de 1844, reproduced
from *Album du Salon de 1844*

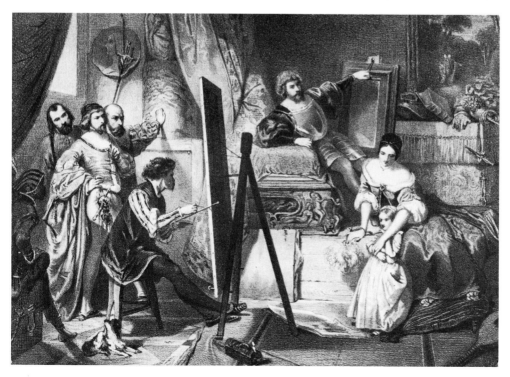

of pictures devoted to Rococo painters and especially to Prud'hon. Many of these were clearly designed as much as a gesture to the Empress Eugénie as to the artists themselves, for we now find Mme de Pompadour and Marie Antoinette offering the same patronage to Boucher and Vigée-Lebrun as Charles V had once held out to Titian.

Even this brief survey of some of the principal artists depicted in nineteenth-century Salon pictures will have indicated how varied were the themes that could be chosen, and it may appear at first sight that their authors did little more than ransack Vasari and other sources for the most picturesque episodes that could be found. Closer inspection, however, shows that this was certainly not the case and that, whether by conscious intent or not, the vast majority of these paintings propagate a consistent view of the artistic vocation. 'On riait encore au théâtre, à cette époque [1825], quand un père disait à l'amoureux de sa fille: "Quelle est votre fortune?"—"Je suis peintre . . ."—"C'est-à-dire que vous n'avez rien."'[35] So we learn from Amaury-Duval, but almost every picture of the kind that we have been looking at would have told a different story: in the past, at least, they proclaim almost unanimously, the painter had everything—fame, fortune, family, love and friends.

The fact that in so many of them the artist is shown on his deathbed should not mislead us into thinking that tragic implications were intended. On the contrary, by well-

100. Eugène Modeste Edmond Lepoittevin: *Paul Potter dessinant d'après nature dans les environs de La Haye* – Salon de 1843, reproduced from *Album du Salon de 1843*

102. Théodule Ribot: *Le Supplice des coins* (or *Le Supplice d'Alonzo Cano*) – Salon de 1867 (Rouen, Musée des Beaux-Arts)

101. Louis-Charles-Auguste Couder: *La Mort de Masaccio* (Leningrad, Hermitage Museum) – reduced version of the picture exhibited in the Salon of 1817

established tradition a deathbed offered the most conspicuous opportunities for displaying the homage that the great ones of the world were ready to pay to talent,[36] and in any case quite soon we find such tributes being paid during the artist's lifetime as well. Popes, kings, poets and duchesses flock into his studio. The overwhelming importance of this aspect of these pictures may be gauged from the fact that even the life of Benvenuto Cellini, which offered such unrivalled opportunities for a 'romantic' interpretation of the artistic temperament, interested nineteenth-century artists almost exclusively because he was visited by François I.[37] And although (as will be seen later) the life of Van Dyck included an attractive love story, there can be little doubt that his great popularity at certain periods— in the Salon of 1847 there were five pictures depicting him—was due to his close and well-rewarded contacts with royalty and the aristocracy.

Poverty and other misfortunes associated with the artist's life, which were frequent enough in the nineteenth century and which already had a long literary tradition behind them, play an extraordinarily limited role in this dream world. The contrary case of Correggio has already been mentioned, but in other realms of art even he sometimes enjoyed happier circumstances than those recorded by Tassaert: when in Frankfurt in 1840, David Wilkie saw a play called *Correggio,* in which 'the great painter was represented in his troubles of obscurity and poverty discovered and relieved by Giulio Romano and Michael Angelo'.[38] Bernard Palissy is the only other artist whose poverty is insisted on, except for Wouwerman, who injects the single note of despair into an otherwise buoyant profession: he was sometimes shown on his deathbed destroying his drawings so as to discourage his sons from entering so unprofitable a profession.

For most other artists even misfortune had its compensations. Granet's *Stella* (Fig. 104), for instance, exhibited in 1810 and much admired by Canova,[39] shows that French artist, who has been imprisoned in Rome as the result of a series of intrigues, drawing on the

wall of his dungeon a Virgin and Child, which fills with admiration his fellow prisoners and jailer. And Salvator Rosa's detention by brigands offered him unparalleled opportunities for studying congenial material at first hand (Fig. 105).

The independence of the artist, so much vaunted during the nineteenth century by even the most conformist of painters, is but rarely treated: perhaps Callot declining for patriotic reasons to engrave for Richelieu the French capture of his native Nancy[40] and Palissy refusing to abjure his Protestantism under pressure from Henri III are the only examples. Indeed the most notable feature of nearly all these pictures is the idyllic relationship between artists and patrons that they manage to convey. Queen Christina of Sweden, who seizes the hand of Guercino and exclaims, 'Je veux toucher cette main qui fait de si belles choses',[41] speaks for most of the European sovereigns.

If artists' lives were prosperous enough, this good fortune was clearly well earned, for nothing in these pictures is more striking than the warmth of their relationships and the kindness they all show to each other. Few episodes are more familiar from a reading of Vasari and other early historians than the moment when the aging master becomes so jealous of the talents of his more gifted student that he throws him out of his studio. This is a scene that is never represented in these nineteenth-century pictures. On the contrary: Cimabue is touchingly solicitous of Giotto, Ghirlandaio spurs on Michelangelo, Rubens is always ready to give a helping hand to Teniers or Van Dyck; Quentin Varin is delighted to help Poussin, who in turn solves Le Sueur's problems for him. The close relationship between master and pupil is idealised into one of paternal affection, seen perhaps at its most touching in the picture by Rubio (Fig. 106)—apparently not exhibited at the Salon— which shows Rubens dragging a reluctant Van Dyck away from the pretty girl at Saftleven with whom he had fallen in love, so that he can go to Italy to pursue his studies.

103. Horace Vernet: *Joseph Vernet* – Salon de 1822 (Avignon, Musée Calvet)

105. Adrien Guignet: *Salvator Rosa chez les brigands* – Salon de 1844, reproduced from *Album du Salon de 1844*

104. (left) François-Marius Granet: *Stella* – Salon de 1810 (Moscow, Pushkin Museum)

Occasionally there are scenes of rivalry, but even they are happily resolved in most cases. The Cavaliere d'Arpino challenges to a duel Annibale Carracci, who had spoken harshly of his work, but the latter merely points to his brushes and explains that 'C'est avec ces armes que je vous défie et que je veux avoir affaire de vous'.[42] Even the critics are included in this atmosphere of general good will: Ingres and others painted the moment when Tintoretto frightened Aretino with his pistol for having spoken badly of him, but the Salon catalogue is careful to point out that they afterwards became firm friends.[43]

In fact, if one had to sum up all these pictures under a single heading one could say that they represented a sort of counter-attack on the whole tradition, never more flourishing than during the nineteenth century, which represented painters as disreputable bohemians, quarrelsome and crippled by poverty. It is true that a concession is made to one popular conception in the many pictures devoted to Raphael and the Fornarina, and in Delaroche's delightful *Filippo Lippi* of 1824 (Fig. 107), but in the context of the genre taken as a whole such works are quite exceptional. From Giotto to Pajou the great artists of Europe are seen as loyal members of the Institut.

It is an improbable view, of course, but no more absurd intrinsically than the opposite one—now fostered by those cinematic biographies which are the modern equivalent of the pictures under discussion—that the great masters were all misunderstood geniuses who starved in garrets when not drinking themselves to death. And it is an interpretation of the past for which several explanations can be suggested. In part it can be accounted for when we look more closely at the nature of the artists who specialised in such scenes. And in part it was due to the highly placed patronage that they themselves received. It has already been pointed out that the kings and emperors of the nineteenth century were only too happy to see themselves in the role of Lorenzo de' Medici, Pope Leo X

or Charles V, and this naturally encouraged a rosy view of the relationship between patron and artist: the Duchesse de Berry, Count Demidoff and other leading collectors were among those who bought and commissioned these pictures.

There is also the fact that such idealised scenes from the lives of the Old Masters were considered to be particularly suitable for decorating the great number of public museums and galleries that were being founded all over Europe. During the Restoration the Louvre was lavishly painted with scenes illustrating the patronage of earlier French kings, from *Le Pérugin faisant le portrait de Charles VIII* (by Heim) to Eugène Devéria's much ridiculed *Le Puget présentant le groupe de Milon de Crotone à Louis XIV, dans les jardins de Versailles, en présence de la Reine et de quelques personnages les plus distingués de l'époque*.[44] Other museums in other countries followed suit, understandably enough giving a distinctly nationalist interpretation of European art: De Keyser's version of *Denis Calvaert, of Antwerp, with his Pupils Guido, Albano and Domenichino* (Fig. 108), painted for the Antwerp Museum, shows that artist exerting an apparent influence over the attentive Guido Reni, Albani and Domenichino, which even then cannot have been considered very plausible by historians.

But social considerations, however predominant, are not the only feature that emerges from a study of these paintings. In the 1830s a new theme begins to appear: suddenly artists are discovered to have had childhoods. Among the first, improbably enough, was Pietro de Cortona, who in a picture by Charpentier in 1834 was shown amazing the ladies of the Sacchetti household by the precocity of his talents. Thereafter, the idea became

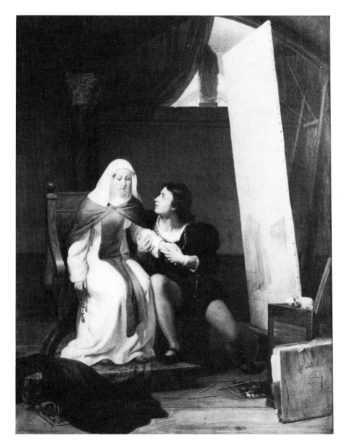

106. (far left) Luigi Rubio: *Van Dyck being led away from his Fiancée by Rubens* (Leningrad, Hermitage Museum)

107. Paul Delaroche: *Philippo Lippi, chargé de peindre un tableau pour un couvent devient amoureux de la religieuse qui lui servait de modèle* – Salon de 1822 (Dijon, Musée Magnin)

increasingly popular. Young Masaccios and Rembrandts, Carraccis, Murillos and Poussins—even a baby Thomas Lawrence[45]—these now began to outnumber the deathbed scenes. Indeed, Le Sueur, who had previously only died, was in 1861 resuscitated, as it were, to emerge as a healthy young lad. Some artists, in particular Callot, were portrayed almost exclusively as children (Fig. 109).

The phenomenon is an interesting one and clearly reflects contemporary developments in biography, as well as the sentimentalisation of material which is characteristic of the late Romantic period generally. It is worth comparing with Ruskin's magnificent evocation of the boyhoods of Giorgione and Turner (*Modern Painters,* V, 1860) and the great attention that Champfleury pays to the childhood of Le Nain in his *Documents positifs sur la vie des frères Le Nain* (1865).[46] It marks, in fact, the climax of the idea of the 'innocent eye' as an explanation of genius—Baudelaire's 'l'enfance retrouvée à volonté, l'enfance douée maintenant, pour s'exprimer, d'organes virils et de l'esprit analytique qui lui permet d'ordonner la somme de matériaux involontairement amassée' (*Le Peintre de la vie moderne,* 1863).

Indeed, if we do not press the point too hard, we may say that this concentration by artists of the middle years of the nineteenth century on the part played by childhood impressions on the later development of talent constitutes the only contribution made by them to the theory of creation that still carries any conviction. For perhaps nothing is more surprising when we look at these pictures than to observe how much they must have contradicted the experiences even of their authors, let alone their heroes. The assumption

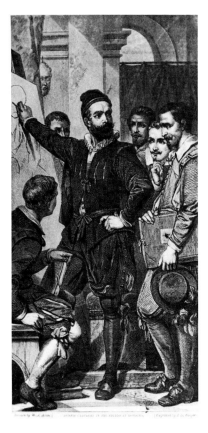

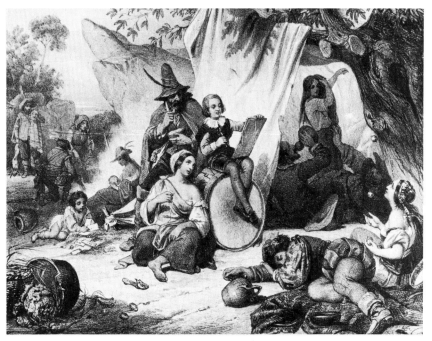

109. Alexandre Debacq: *Enfance de Callot* – Salon de 1844, reproduced from *Album du Salon de 1844*

108. (left) Nicaise de Keyser: *Denis Calvaert, of Antwerp, with his Pupils Guido, Albano and Domenichino*, reproduced in the *Art Journal* from one of a series of murals in the Royal Museum, Antwerp, illustrating the history of Flemish art

behind them is one of almost unadulterated naturalism in its loosest sense: the painter records what he sees (often by accident) and nothing more. Richard Verdi has acutely pointed out that Benouville's *Poussin sur les bords du Tibre, trouvant la composition de son 'Moïse sauvé des eaux'* implies that the great painter 'sifted carefully the material he observed in nature to meet his own artistic ends'.[47] Such sophistication was, however, rare enough, and in general the Old Masters are considered to have been fortunate enough to come across their groups of figures and compositions almost ready made—a point brought out by Gombrich in his discussion of Hopfgarten's lithograph of *Raphael painting the Madonna della Sedia*.[48]

As the vogue for pictures showing earlier artists at work reached its peak at a time when the Barbizon artists were at last beginning to win recognition, it is not surprising that so many artists (including even Raphael, in a picture by Colin of 1857)[49] should have been shown sketching and painting in the open air, though Lepoittevin's *Van de Velde dessine un combat naval d'après nature* of 1843 (Fig. 110) does somewhat strain the imagination. Still more curious is the way in which even such stylised figures as the putti of Correggio and Albano are always assumed to have been inspired by the artist's family.[50] The notion of inspiration from a source outside the artist's control, so fundamental to most nineteenth-century thinking on creation, is only very rarely explored. It is, indeed, almost confined to Fra Angelico, though Boisselat exhibited in 1841 a *Rêve de Raphaël Sanzio* in which an angel showed him a vision of the Virgin with Christ and the infant St John.

In part, of course, 'naturalism' of the kind that has been indicated was implicit in the very nature of the genre itself. When an artist was shown at work—an occurrence that

was much less frequent than his childhood or his deathbed—it was almost inevitable that the spectator should expect to see him copying a motif that was familiar to him from his knowledge of the finished composition. At most the model could be allowed to shift her position slightly, as in Nicaise de Keyser's *Le Titien peignant sa Vénus [of Urbino] en présence de ses deux amis, Pietro Aretino et Sansovino* (Fig. 111).[51]

For the same reason a painter who chose to paint pictures of this kind would be likely to try to imitate the style of the master whose life he was portraying. This, however, was not always the case. As Thoré commented sarcastically on Gérôme's *Rembrandt faisant mordre une planche à l'eau forte* (Fig. 112): 'C'est le dernier degré de Willem Mieris! Et quelle étonnante perversion d'aller chercher Mieris pour peindre Rembrandt!'[52] A far more astonishing disparity between the subject of a picture and the style in which it was represented is to be found in Dyce's *Titian preparing for his First Essay in Colouring* (Fig. 113), about which Thoré remarked appositely, though without any hostility (indeed, he recalled the picture as being '*délicieux*'), that 'certains morceaux se rapprochent vraiment de Van Eyck ou de Memling'.[53] But works of this kind were obviously exceptional.

To some extent the paradoxes that have been discussed above can be explained if we consider the nature of the artists who tended to exploit the genre. Although it is true that a few controversial painters—Ingres, Delacroix and even Manet (in his *Scène d'atelier espagnol* or *Vélasquez peignant*) (Fig. 114)[54]—painted pictures of this kind, it must be admitted that on the whole they were produced by minor figures, nearly all of whom were much admired by the orthodox critics and the public of their times. Like so many innovations, this one also seems to have originated largely in the studio of David, though Monsiau, whose *Mort de Raphaël* of 1804 and *Le Poussin reconduisant le Cardinal Massimo* of 1806 inaugurated the nineteenth-century vogue, was in fact a pupil of Peyron. It is interesting that he painted anecdotes from classical as well as from modern history, and in 1806 he exhibited an *Aspasie s'entretenant avec les hommes les plus illustres d'Athènes,* which portrayed (among others) Pericles, Socrates, Alcibiades, Plato, Xenophon, Sophocles and Phidias. The famous '*école de Lyon,*' which is usually credited with the introduction of 'troubadour painting,' played only a very minor role in this particular area, and Pierre Révoil, the head of the school, seems to have painted no more than two pictures of the kind—an early *Michel-Ange aveugle* and a *Giotto enfant,* exhibited in 1841, the year before his death at the age of sixty-five.

The main impulse to the production of these pictures was given by two pupils of David, both of whom were friends of Ingres: Pierre-Nolasque Bergeret (1782–1863) and the much better known (and much more distinguished) François-Marius Granet (1775–1849). Delécluze tells us that Bergeret was one of those who worked with Ingres and Bartolini in the former Couvent des Capucines, and who formed a sort of 'Académie à part'.[55] He designed the compositions for the bas-reliefs of the Colonne Vendôme, and although he enjoyed a highly successful official career he wrote a book in 1848 to complain about the administration of the arts. From his *Honneurs rendus à Raphaël après sa mort* of 1806, which was bought by the Emperor and was a great critical success, until his *Rembrandt dans son atelier, entouré de sa famille, gravant le portrait du bourgmestre Six, son ami* of thirty years later, he turned out a large number of pictures devoted to the lives of the Old

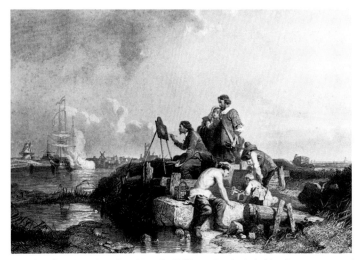

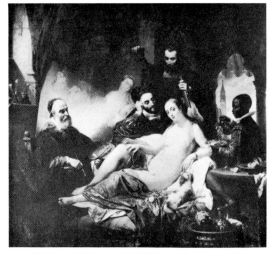

110. Eugène Lepoittevin: *Van de Velde, qui suivait habituellement son ami Ruyter dans les campagnes maritimes, dessine un combat naval d'après nature* – Salon de 1843 (lithographic reproduction)

111. Nicaise de Keyser: *Le Titien peignant sa Vénus en présence de ses deux amis, Pietro Aretino et Sansovino*, c. 1843 (Whereabouts unknown)

Masters—Raphael, Titian, Michelangelo, Filippo Lippi, Poussin, Tintoretto, Claude and Rembrandt—not all of which were exhibited in the Salons. The theme of every one of them echoed his life, if not the theories expressed in his book: painting was a profitable and socially advantageous profession; and he managed to show Titian in the company both of Charles V and, more fancifully, of François I.[56]

Granet's career was clearly much more complex. Although he, too, devoted a great deal of his energies to representing the lives of the Old Masters, he often proceeded no farther than the beautiful and expressive drawings which, together with his landscapes, constitute his most significant achievement. Yet even among his completed pictures the range of artists represented is extraordinarily wide, for it includes Sodoma, Domenichino, Strozzi and Andrea Pozzo as well as his masterpiece in this field, *Le Poussin, avant d'expirer, reçoit les soins du cardinal Massimo et les secours de la religion* (Fig. 115). By the time this was exhibited, in 1834, Granet was well established and successful and had hardened into a dogmatic conservative as far as the younger generation was concerned. Yet as a young man, so familiar to us through Ingres's magnificent portrait, he had suffered from poverty and neglect, and there is a certain satisfaction in knowing that his first great success had come in 1810 through his picture of Jacques Stella in prison (already discussed), which was apparently bought by the ex-Empress Josephine for Malmaison.[57]

Although there was a steady production of these pictures throughout the 1820s and 1830s, no single figure stands out as a specialist, apart from Bergeret and Granet of the older generation. The year 1839, however, saw the first public venture into the genre of the painter who, more than any other, was to make his name by recording the 'grandeurs et misères' (but mostly the 'grandeurs') of the Old Masters. It would be difficult to establish just how many Michelangelos, Titians and Rembrandts—exhibited and unexhibited—were turned out by Joseph-Nicolas Robert-Fleury, who was born of French émigré parents in Cologne in 1797 and who survived until 1890.[58] A pupil of Horace Vernet, Girodet and Gros, he was credited in old age with having been one of the lonely and heroic pioneers of Romanticism. But, though it is true that he made his first appearance at the famous 'Romantic salon' of 1824 (where he won a medal and a state commission), his pleasing,

though minor, talent was rapidly acclaimed, and even Baudelaire spoke of him with great warmth throughout his career, although of his *Atelier de Rembrandt* (1845) he commented significantly: 'pastiche très curieux, mais il faut prendre garde à ce genre d'exercice. On risque parfois d'y perdre ce qu'on a.'[59] But Robert-Fleury seems to have neither gained nor lost much in talent, and he had little to complain of.

One other specialist emerged at much the same time, Eugène Lepoittevin, who painted a long series of pictures throughout the 1840s inspired by the lives of the Dutch landscape painters, but for him the anecdote was of little importance and served mainly as a pretext for his attractive marines.

In the following generation the theme was principally adopted by the many foreign artists who exhibited at the Salon and who sometimes introduced a relatively exotic note into the standard repertoire. The Belgians had always been keen to exploit their past glories, and they were now joined by the Spaniards and, above all, by an Italian pupil of Ingres and Cogniet, Richard-Cavaro, who throughout the 1860s outproduced all his rivals in the depiction of the Old Masters.

Though none of the painters so far referred to has been much studied (and there are countless more about whom still less is known), enough has been said about some of the more typical practitioners of the genre to suggest that no strikingly new interpretation of the artistic life was likely to be produced by them. On the whole they tended to be minor figures on the fringes of the Romantic movement, who were rightly admired and appreciated by their contemporaries even though they have been neglected by posterity.

112. Jean-Léon Gérôme: *Rembrandt faisant mordre une planche à l'eau-forte* – Salon de 1861 (Whereabouts unknown)

113. William Dyce: *Titian preparing for his first Essay in Colouring*, 1856–7 (Aberdeen Art Gallery)

It is also characteristic of many of these artists that they themselves were often collectors of Old Masters (such as Granet) or even museum curators (such as Clérian and Dauban).

The question of sources remains to be considered. The visual ones have already been referred to. After the vogue for deathbed scenes based on Poussin's *Death of Germanicus* and its eighteenth-century derivatives, one of the most common practices was to split some famous composition by the Old Master concerned into its individual components and to turn a great picture into a *tableau vivant*. For obvious reasons the *Fornarina* in Rome, now variously attributed to Raphael and to Giulio Romano, was constantly fitted into pictures recording the life of Raphael. Similarly, Cogniet's head of Tintoretto (which was enormously admired)[60] in *Le Tintoret et sa fille* was copied from that artist's *Self-Portrait* in the Louvre, and painters depicting some episode from the life of Titian often made a point of introducing somewhere into the scene an adaptation of his so-called 'Portrait of his Daughter with a Bowl of Fruit' in Berlin. And many other 'quotations' of this sort could be indicated.

For those less historically minded the Dutch masters of the seventeenth century and also Greuze offered a starting-point for compositions which did not, of course, differ in any essential way from other nineteenth-century paintings devoted to quite different subjects of the most varying periods.

To pursue the question of literary sources could inspire a great deal of very involved

114. Edouard Manet: *Scene d'atelier espagnol* (or *Vélasquez peignant*), 1860 (Paris, Galerie Lorenceau)

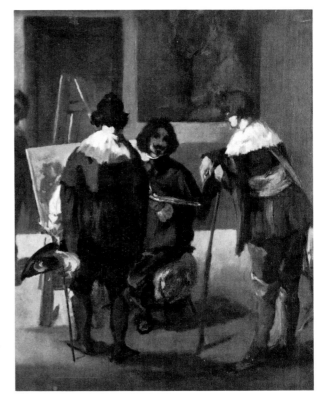

115. (far right) François-Marius Granet: *Le Poussin, avant d'expirer, reçoit les soins du cardinal Massimo et les secours de la religion* – Salon de 1834 (Aix-en-Provence, Musée Granet)

research, mostly to little purpose. The vast majority of the anecdotes recorded by artists of the nineteenth century can be traced back ultimately to some passage in the more obvious biographical compilations—Vasari, Ridolfi, Félibien and Descamps, to name only a few. It is perfectly true that it was not until 1842 that the first French translation of Vasari was completed (with commentaries by Jeanron, who was himself later to paint scenes from the lives of Raphael, Fra Bartolommeo and Tintoretto), but there was absolutely no reason why painters should have had to turn back to these original sources for the information they needed. A vast amount of popularisation at every level took place during the first half of the nineteenth century, and Landon's *Vies et oeuvres des peintres les plus célèbres,* Stendhal's *Histoire de la peinture en Italie,* Gault de Saint-Germain's *Guide des amateurs de tableaux pour les écoles allemande, flamande et hollandaise,* Viardot's *Les Musées d'Espagne,* Quatremère de Quincy's *Histoire de la vie et des ouvrages de Raphaël,* not to mention less serious publications such as Lady Morgan's *Life and Times of Salvator Rosa,* which enjoyed a European reputation, provided a fund of stories for those artists who were unable to cope with Italian, Dutch, German or Spanish.

For those who found even these modern books beyond their reach, the artistic and other journals of the day, such as *L'Artiste* (inaugurated in 1831) and *Le Magasin Pittoresque* (inaugurated in 1833), regularly contained short biographical and critical accounts of the Old Masters in easily digestible form, which plagiarised both the sources and secondary liter-

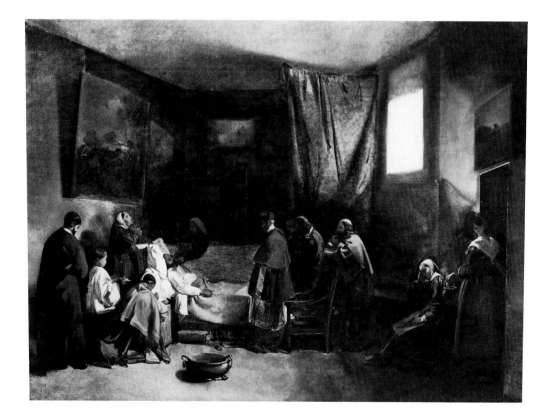

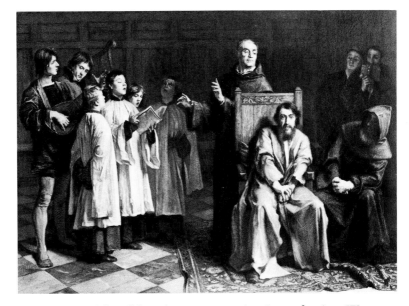

116. Emile-Charles
Wauters: *Hughes van
der Goes au couvent de
Rouge-Cloître*
(Brussells, Musées
Royaux des
Beaux-Arts)

ature and provided adequate material for all but the most conscientious of artists. We must remember, too, that many of these painters had themselves spent some years at the Académie de France in Rome, and when visiting the churches and public collections there they doubtless heard from their guides much the same anecdotes as are still related to visitors today.

Sometimes it seems possible to be more precise. Though there had been a few pictures devoted to Bernard Palissy before 1855, the enormous increase in scenes from his life subsequently was certainly due to the publication in that year of Lamartine's *Vie des grands hommes,* which included the artist in the company of Homer, Caesar, Joan of Arc, Columbus and other figures of similar stature. Or, again, the sudden appearance in the Salon of 1863 of three pictures depicting the young Prud'hon—a painter never hitherto portrayed—must surely be related to the Goncourts' essay on him, which was published two years earlier.

But if all these books, articles and funds of traditional lore provided a repertory of 'facts', which could be—and were—exploited by artists, playwrights and opera composers (with or without acknowledgements), the spirit of some of their paintings is more easily paralleled in the deliberately romanticised and fictional biographies which were equally popular. Of all these, only a very few, such as Balzac's *Le Chef-d'oeuvre inconnu* (which itself first appeared in *L'Artiste* in 1831) and some of the stories of Hoffman, have survived their period. But Balzac's *conte,* with its fantastic plot involving Poussin and Pourbus as well as the invented Frenhofer, is exceptional only because of its genius and its philosophical implications, which have fascinated artists ever since its first publication: the genre to which it belonged was widely accepted, and many other examples could be given. Of them all, the most popular with artists was Musset's delightful story *Le Fils de Titien* (1841), which frequently attracted the Salon painters.

No doubt a thorough reading of the works of Samuel-Henri Berthoud, a Balzacian journalistic figure who turns up editing, or writing for, most of the illustrated journals of the first half of the nineteenth century and whose huge and varied output ranged from

novels and plays to scientific popularisation and artistic fantasies, would bring to light many more stories the origins of which are still uncertain. And he, too, was only one among many, who can themselves now scarcely be identified. But we should not fall into that pedantic error which refuses to allow the artist himself any imagination, and it is on the artist that any discussion of art should concentrate.

For the pictures that have been discussed are not of interest only for the sociological or historical information they can impart. Many of them are attractive works in their own right, and though their painters are now often wholly forgotten, so that it is at present virtually impossible to reconstruct their *oeuvres,* it does appear likely (on the minute evidence available) that the pictures they painted of the earlier masters were often their own best works. Even if they could hardly hope to attain the height of their models, the devotion of Baron and Robert-Fleury to Giorgione and Titian was perhaps rewarded by a touch of the spirit of these great men, and, as tributes go, an attractive genre picture is perhaps more sympathetic to their ghosts than many an unreadable volume. This is to tread on dangerously whimsical ground, but it may be permissible to end with one example of such a work which clearly carried a powerful meaning for one of the greatest of nineteenth-century painters. In October 1888, when waiting in Arles for the arrival of Gauguin, Van Gogh wrote to his brother Theo: 'Once again I am reduced to a state of madness like that of Hugo van der Goes in the painting by Emile Wauters (Fig. 116). And if it were not that I have a kind of split personality, being both something of a monk and a painter, I would have been completely reduced to the same condition long ago.'[61]

APPENDIX

Representations of individual artists in art have been studied quite frequently in recent years and have been used to supplement literary texts in examinations of their critical fortunes. The quattrocentenary celebrations of Raphael's birth in 1983 gave a notable impulse to such studies—see the exhibition catalogue devoted to *Raffaello: elementi di un mito* held in the Biblioteca Laurenziana in Florence in 1984 and of *Raphael et l'art français* in the Grand Palais in Paris in 1983–4. In an article ('Bergeret's "Honors Rendered to Raphael on his Deathbed"') in the *Bulletin of the Allen Memorial Art Museum* (Oberlin College), xlii, no. 1 (1984–5), pp. 2–15, Martin Rosenberg has shown that the original version of the picture acquired by Napoleon is now at Oberlin, while the one at Malmaison (reproduced by me when this essay first appeared) is a later autograph replica. A short general survey of the whole phenomenon is to be found in *The Painter Depicted: Painters as a Subject in Painting* by Michael Levey (Walter Neurath Lecture, 1981, published by Thames & Hudson) and the theme is most interestingly explored in relation to all other aspects of *La Peinture dans la peinture* in the catalogue (edited by Pierre Georgel and Anne-Marie Lecoq) for the exhibition of that title held in the Musée des Beaux-Arts in Dijon in 1982–3. The classic *Legend, Myth and Magic in the Image of the Artist* by Ernst Kris and Otto Kurz (English edition—New Haven and London, 1979) provides the essential context within which all these studies need to be considered.

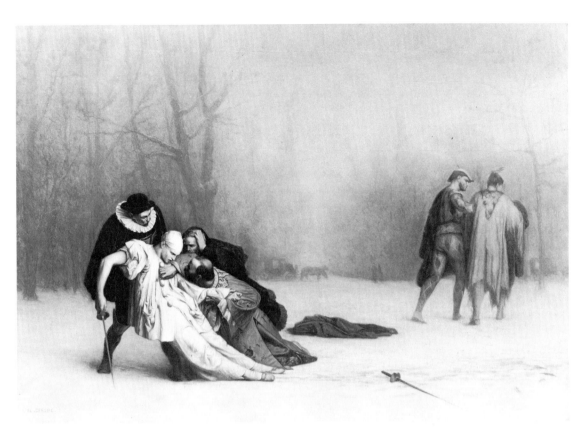

117. Jean-Léon Gérôme: *Sortie du bal masqué* (Baltimore, Walters Art Gallery) – version of the painting (now in Chantilly) exhibited in the Salon de 1857

118. Thomas Couture: *The Duel after the Masked Ball* (London, Wallace Collection)

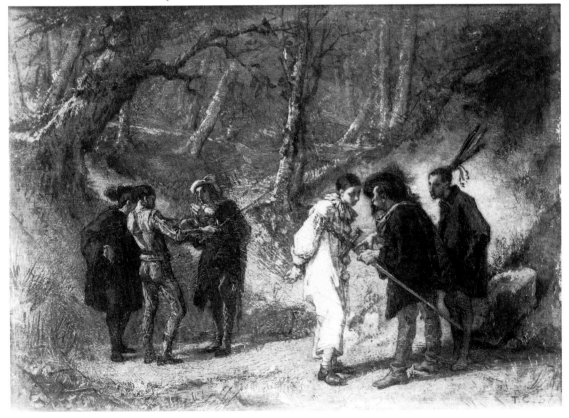

8. The Sad Clown:
Some Notes on a Nineteenth-Century Myth

EARLY IN 1858 Gérôme's *Duel aprés le bal masqué* (see Fig. 117) was exhibited in London. Such a combination of the picturesque, of gaudy colours and of slick painting was bound to be a success, and the press was able to point out that 'a finer moral lesson than this of M. Gérôme's has not been taught since Hogarth's time'.[1] For what really made the fortunes of the picture was the fact that while it was being exhibited in London, a much publicised duel—murderous assault would be a better definition—took place in Paris after a journalist had made a very mild joke at the expense of the army.[2] 'Title and subject', wrote *The Times*, 'together furnish a startling comment on the late murderous duel in Paris, where for a jest as light as that which may have set these men, hot from the mad folly of the masquerade, face to face in deadly combat, Monsieur de Péne now lies at death's door.' And even when the picture had been shown in Paris a year before this, critics had suggested that Gérôme was commenting on the many frivolous duels that had been taking place among members of high society.[3] This may, indeed have been the case; but in none of these, as far as I am aware, had the protagonists been dressed in theatrical costume,[4] and here I am interested in a different problem: the suffering clown, of whom *The Times* observed that 'We have never seen a figure in every line of which death was written in characters so true and legible as that of the mortally wounded Pierrot'.

Dead clowns, sad clowns—they have played a significant role in French painting from Gérôme's dueller (is he the first?) to the tragic figures of Rouault and, above all, Picasso (Fig. 119). Why are they so sad and why did the theme first make its appearance in the 1850s? Indeed, in the same year that Gérôme painted his duel, a very much finer artist painted the same subject (Fig. 118), though at a slightly different stage of the story, and there were the inevitable discussions as to who had thought of the idea first.[5] We shall shortly see that both these pictures can probably be related to a literary text, but first we must embark on a fairly long detour.

The very words Sad Clown necessarily conjure up for us the most beautiful and evocative image of the theme ever painted (Fig. 120). But were Watteau's scenes from the Commedia dell'Arte in fact intended to be looked at in this light? There is, as far as I know, not a single trace of evidence dating from the eighteenth century itself to suggest that they were.[6] On the contrary, every one of his early biographies, all written by men who had known him personally, points to the contrast between the restless pessimism of his character

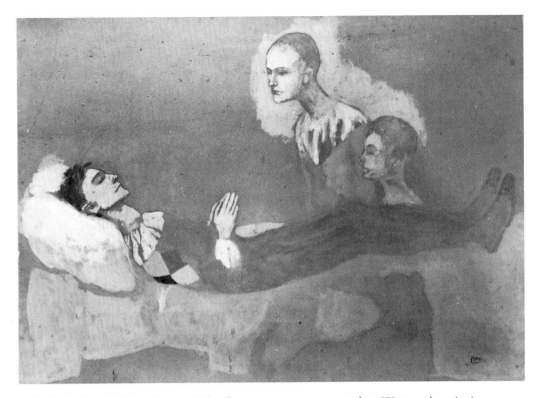

and the 'gaiety' of his pictures. The first person to suggest that Watteau's paintings were implicity melancholy seems to have been Emile Deroy, the painter friend of Baudelaire, who drew attention to this aspect of his art in the 1840s.[7] Very soon the idea was taken up by Gérard de Nerval, Banville and others until it became a commonplace, but never until much later was this point made about the *Gilles*, a picture which was almost totally neglected even by the Goncourts. As late as 1867 that most sensitive of critics and passionate admirer of Vermeer and Watteau, Thoré, wrote of this picture, 'Regardez-le, comme il est gentil et narquois, de grandeur naturelle, tout en blanc, et si gai.'[8] Only one man, as far as I know, saw something different in this picture. Writing in 1863, four years before Thoré, Jules Michelet said of the *Gilles*, 'Au dernier triomphe, écrasé de succès, de cris et de fleurs, revenu devant le public, humble et la tête basse, le pauvre Pierrot un moment a oublié la salle; en pleine foule, il rêve (combien de choses! la vie dans un éclair), il rêve, il est comme abimé . . . Morituri te salutant. Salut, peuple, je vais mourir.'[9]

In fact, as we now know thanks to the researches of Mrs Panofsky,[10] Watteau is here showing us, in very imaginative terms, a *parade*—that is to say not an actual performance by the Italian Comedians, but the free advertisement for such a performance which took place on a raised platform outside the theatre in order to attract the public, of a form which survived well into the age of Seurat and which can be occasionally seen even now in country fairs and circuses. This particular *parade* is one of a farcical series called 'A laver la tête d'un âne on perd sa lessive'—hence the donkey. These *parades* always involved Gilles, who wore the same costume and had the same character as Pierrot—a fearful, coarse, stupid valet, who was generally pushed around and unsuccessful in everything he undertook. He was a farcical creature, not a tragic or a sensitive one, and the somewhat forlorn features

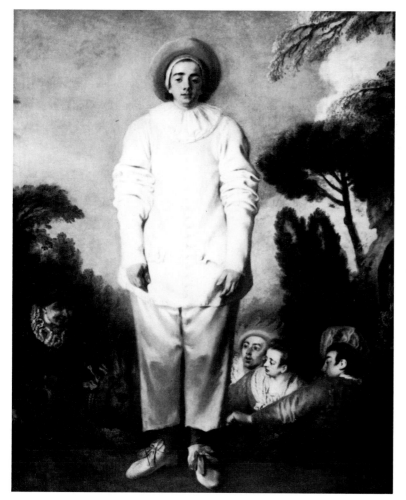

119. (far left) Pablo
Picasso: *Death of
Harlequin*, 1905 –
gouache on cardboard
(Upperville, Virginia,
Mr and Mrs Paul
Mellon collection)

120. Antoine
Watteau: *Gilles* (Paris,
Musée du Louvre)

that Watteau shows us bear no relation to the part he is acting, nor do they appear to represent a portrait of some particularly famous clown of the day. It is, however, hard for us to resist the conclusion that the consumptive Watteau has invested the figure of Gilles with some degree of self-identification, and Mrs Panofsky has also pointed out that on many other occasions when painting Pierrot figures Watteau not only gave them a predominance which was absolutely not justified by the nature of the parts they were called upon to act, but may even have hinted at something Christ-like in their role. So great and so original an artist was Watteau that his interpretation of Pierrot has, since the late nineteenth century, affected everyone who has ever thought about the nature of clowns—and everyone includes art historians. Whether such an identification of Pierrot and Christ could conceivably have occurred to Watteau on either the conscious or even the unconscious level, or whether we ourselves are not influenced by certain later artists and writers about whom I will be talking, must therefore remain an open question.

The interpretation of Watteau thus plays a decisive, but somewhat late, role in the notion of the Sad Clown, but his imagery leads us directly into the heart of our problem. That imagery centres on the strange and now vanished world of the Commedia dell'Arte, those

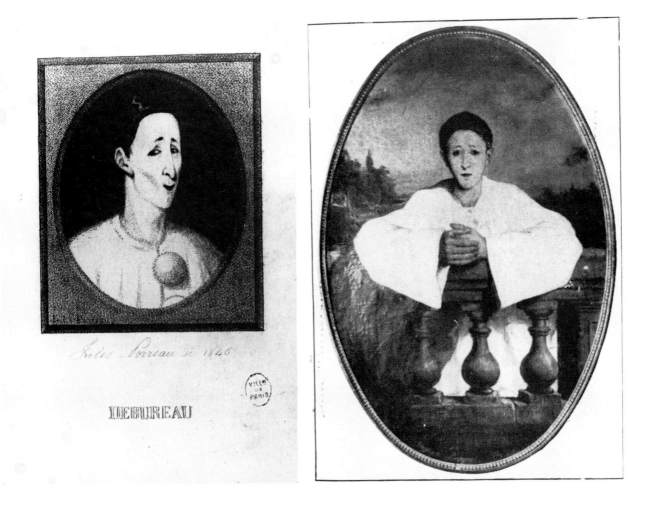

DEBUREAU

touring companies of Italian actors with a cast of standardised characters—the Doctor, the Captain, Pantaloon, Harlequin and so on—who relied on improvisation for the effects of their farces. Appearing first in the early sixteenth century they soon spread all over Europe and enjoyed particular success in France a century or so later; and ever since, despite their virtual disappearance even before the Revolution, they have—as we will see—haunted the imaginations of artists and poets. For many of these, indeed, the world of the Commedia dell'Arte came to represent a sort of alternative to the long-established tradition of classical mythology, whose gods and goddesses had acquired over the years different, sometimes even conflicting, layers of meaning. In just the same way, Harlequin and Pierrot and Gilles absorbed characteristics from each other and often changed their natures as they were interpreted by one great actor or another. 'Perhaps', Théophile Gautier once said, 'there are as many Pierrots as there were Jupiters or Hercules's',[11] and we urgently need a *Survivance des comédiens antiques* to add to Professor Seznec's *Survivance des dieux antiques* on our bookshelves.[12] But fortunately for us nineteenth-century painters were not as learned as their Renaissance predecessors, and if I am somewhat vague in my discussion of the various characters involved, so—I can plead in my defence—were the artists whose works I am considering.

For all their crudity of plot and vulgarity of theme the farces of the Commedia dell'Arte

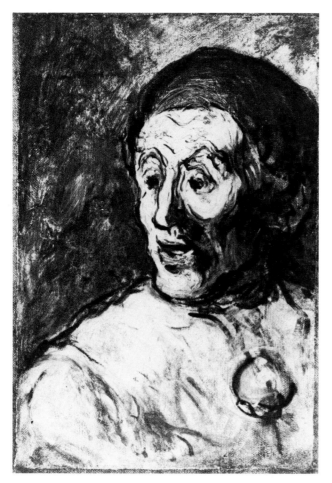

121. Jules Porreau: *Deburau* (Paris, Musée Carnavalet)

122. Bouquet: *Le Pierrot à la balustrade: J. G. Deburau* (Paris, private collection)

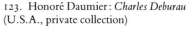

123. Honoré Daumier: *Charles Deburau* (U.S.A., private collection)

had from the first been an aristocratic form of entertainment with leading companies being raised and maintained by kings and princes. But towards the end of the eighteenth century, as the aristocracy sought diversions elsewhere, the improvised pantomimes and harlequinades which French acrobats and actors took over from the Italians became an increasingly plebeian form of entertainment, despised or ignored by the regular theatre-going public, and playing as often as not on casual stages in fairgrounds or in the more proletarian areas of Paris. No doubt the world of Pierrot would have vanished altogether— and Watteau's *Gilles* would have seemed as remote to us as one of the fantasies of Bosch or Piero di Cosimo—had there not appeared an actor of genius to interpret the role during the early years of the nineteenth century. The accounts that we have of Jean-Gaspard Deburau (Figs. 121–2) are by no means entirely consistent, but his greatness seems to have been recognised by all who saw him.[13] From the late twenties onwards, a few writers, poets and artists began to penetrate to the squalid Théâtre des Funambules in which he appeared and in 1832 he became a celebrity thanks to a book by that most fashionable of critics, Jules Janin. 'There is no longer a Théâtre-Français; only the Funambules . . . In the old days dramatic art was called Molé or Talma: today, it is just Deburau . . . Let us write the history of this art as it is, filthy, beggarly and drunken, inspiring a filthy, beggarly and drunken audience. Since Deburau has become the king of this world, let

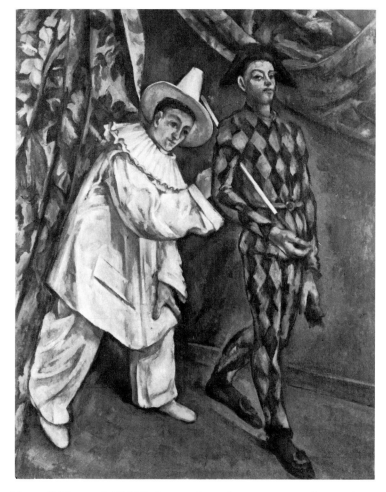

124. Paul Cézanne:
Pierrot and Harlequin
(Mardi Gras) (Moscow,
Pushkin Museum)

us celebrate Deburau the king of this world.'[14] Today we have become so used to writers such as Max Beerbohm glorifying the music hall of the 1890s or, more recently, music critics telling us that the Beatles are the greatest composers since Beethoven, that we are liable to forget how surprising such highbrow interest in urban, popular art once was. Janin's book is, I think, the ancestor of the whole genre and it has the same rather self-conscious 'camp' attitude to its subject, revealing the critic's self-satisfied daring in shocking conventional opinion which characterises all later examples. It caused a furore of indignation and it turned Deburau into an idol of the young. Writers such as Charles Nodier, who had always admired him, were now joined by Gérard de Nerval, Théophile Gautier, Banville and many more. The cult of the pantomime was born.

The interesting thing for us about all this is that Deburau's own performances were not, as far as we can tell, by any means tragic in implication or even sentimental.[15] Though Janin's book was illustrated by lithographs, one at least of which (Fig. 122) suggests that the artist had some acquaintance with Watteau's *Gilles*, Gautier tells us that, wonderful though his acting was—'he is the greatest mime in the world'[16]—Deburau's interpretation of the part of Pierrot was technically incorrect because 'Pierrot assumed the airs of a master and an aplomb unsuited to the character; he no longer received kicks—he gave them . . .

Cassandra would think twice before daring to box his ears.'[17] In all this Deburau was no doubt revealing facets of his own not very attractive character. Something of an illiterate lout,[18] he once accidentally killed a young boy who was taunting him, and though he was acquitted at the trial—partly, it is said, through the intervention of George Sand—it was impossible thereafter for the audience not to see an ironical link between the parts he was called upon to play and his own personality.

Deburau's place in the history of acting is a very great one; in our story it is essential, but also somewhat incidental. His talent attracted the intellectuals to a virtually forgotten and unexplored theatrical genre, and the intellectuals then proceeded to change the nature of that genre. As anthropology does today, so in the 1830s and 1840s the popular entertainment of the pantomime was made to support a whole philosophy of life. Gautier himself wrote pantomimes[19] and produced casual but influential theories about them. He professed to see in the stereotyped figures of the Commedia dell'Arte a microcosm of the human condition,[20] and in so doing he almost imperceptibly softened the outlines of the very performances by Deburau which he himself had seen. For Janin, Deburau had been 'the people, in turn happy, sad, ill, well, beating, being beaten, the poet, but always poor as the people . . . He is Molière's Misanthrope.' Gautier adapted this very significantly as follows: 'Pierrot, pallid, slender, dressed in sad colours, always hungry and always beaten, is the ancient slave, the modern proletarian, the pariah, the passive and disinherited being, who, glum and sly, witnesses the orgies and follies of his masters.'[21] One result of all this attention was that a new scholarly interest began to develop in the popular theatre and the Commedia dell'Arte. Rather apologetically at first, historians of the Roman stage suggested that Deburau could actually throw light on the practice of antiquity,[22] and in 1860 Maurice, the son of George Sand, wrote the first serious modern study of the Commedia dell'Arte.[23]

Well before this, however, the most important step had been taken in the creation of the myth that interests us. In 1843 Jules Champfleury, then aged twenty-two and still living in the provincial town of Laon under his real name, Jules Husson, made his first visit to Paris, and 'not by chance' went at once to the Funambules.[24] The acting of Deburau was a revelation to him—though he had already seen a pantomime 'in the English style', *Mother Goose*, which he classed with his 'memories of Molière, Swift and Hoffmann'. His experience of Deburau, of mime, of popular art, influenced him far more profoundly, and as I believe far more fruitfully, than the Realism for which he is remembered today. For, despite a very few years of political opposition, of 'realist novels', of championship of the brothers Le Nain and of Courbet, it is as an investigator of caricature, myth and folklore that he made his major—and still wholly neglected—contribution to French culture.

In 1846 Deburau died. How? It is from Champfleury that we have the most vivid, if not the most clinically accurate, account.[25] Deburau, he tells us, had for years been racked by asthma; the doctors forbade him to act, but—mindful only of his faithful public—he returned to the stage, where, overcome by his enthusiastic reception, 'a tear ran down the flour which covered his face. A real tear in the theatre is so rare . . . A few days later he died.' And so, we may add in a gloss of our own, a clown has wept for the first time: the father of an innumerable progeny.

It was for Deburau's successors, his son Charles and another great mime, Paul Legrand, that Champfleury himself now began—just before 1848—to write a series of pantomimes which aimed to retain all the 'popular' ingredients of the genre, but which would also have a philosophical content. The first of these was *Pierrot, valet de la mort*, which aroused the enthusiasm of Gérard de Nerval, Gautier and Baudelaire. After a series of grotesque adventures in which Pierrot is accidentally killed by his doctor, he is released by Death on the one condition that when he returns to life he will, in his place, send Harlequin to Death as his servant. Pierrot agrees to the arrangement, and as soon as he gets back to the world he challenges Harlequin to a duel. The result is inconclusive, but eventually Pierrot breaks his pact with Death (who is himself killed by Polichinelle), and then magnanimously blesses the marriage of his rival Harlequin to Colombine, the girl whom he himself has loved. This sudden return to virtue and triumph over Death was criticised by Gautier as being too abrupt, and Champfleury himself later explained that he had been inspired by the sentimental optimism which prevailed before 1848.[26] The details are by no means correct, but do we not find some reflection of this curious pantomime in the pictures by Gérôme and Couture with which I began this paper? One good reason for believing that this is indeed the case is that we hear from a later source that Paul Legrand, who acted the part of Pierrot in Champfleury's pantomime, kept a photograph of Gérôme's picture on the wall of one of the rooms in his house.[27] And so, just as Gautier claimed that the old pantomime was being swept away by vaudeville and comic opera, because 'the crowd has lost the meaning of these high symbols and profound mysteries which make the poet and the philosopher dream',[28] Pierrot, Harlequin and the other denizens of the Commedia dell'Arte began to take on a new lease of life in the world of high culture. Their literary appearances are familiar enough,[29] and it is not very long before we find a trickle of artists as different as Couture and Meissonier, Manet, Cézanne and many more taking an interest in themes from the Commedia dell'Arte. These are nearly always treated in a vein of melancholy, often with strongly symbolic overtones (Fig. 124).[30] Many of the writers of the 1840s had at least hinted at the melancholy inherent in the parts played by Deburau, but it was, I believe, Champfleury who gave Pierrot his metaphysical content, who was—dare I make an absurd analogy?—the Marsilio Ficino of the Commedia dell'Arte, lending weight to the theme and suggesting to artists (in whose work he himself was possibly not much interested) how the crude, stock characters of a vanished world could, like Venus or Pan during the Renaissance, be made to carry meanings relevant to the second half of the nineteenth century. The iconography of so influential a painter as Couture would, I feel certain, repay investigation along these lines.[31]

The metaphysical sadness of the clown represents, however, only one aspect of our theme; the other is the plight of the actual performer himself. These two aspects are closely linked both in time and in artistic milieu. Champfleury's friend Daumier painted only one true portrait in his whole career, and this significantly enough was of Charles Deburau (Fig. 123).[32] Thus, even if we lacked other evidence, we would know that he was an admirer of the Sad Clown, as it had been developed since the death of Jean-Gaspard Deburau by his son Charles. But Daumier scarcely touched the theme from this point of view. In the way that had perhaps inspired Watteau, and that was certainly to be taken

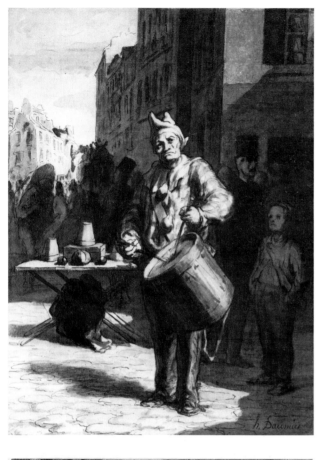

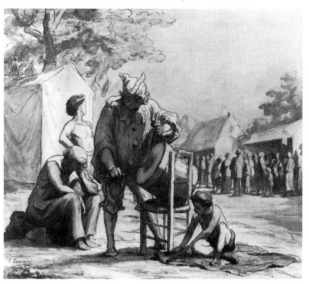

125. Honoré Daumier: *Saltimbanque jouant du tambour* – pen and watercolour, heightened with gouache (London, British Museum)

126. Honoré Daumier: *Les Saltimbanques* – pen and watercolour (London, Victoria and Albert Museum)

127. Antoine Watteau (engraved Jacob): *Le Départ des comédiens italiens en 1697*

128. (right) Honoré Daumier: *Le Déplacement des Saltimbanques* – charcoal, crayon and stump and pen and wash, heightened with red chalk and watercolour (Hartford, Conn., Wadsworth Atheneum)

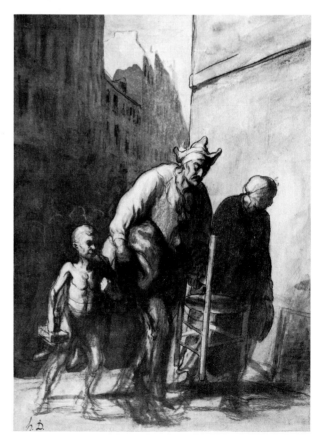

up again by other artists at the end of the century, Daumier's wonderful drawings and watercolours of clowns, dating mainly from the 1850s and 1860s, are more 'realistic' in inspiration. I use the word with extreme reluctance because, although it is always applied to Daumier, it seems to me that he, like Champfleury, was one of the greatest myth creators of the nineteenth century, one of the only artists, for instance, who was able to interpret the Bible and imaginative literature of the past in a truly successful manner. What I mean by 'realism' in this context is that Daumier's Sad Clowns are usually shown with convincing reasons for their sadness and that these derive not from any conceptions of their role, but from their failure to attract a public (Figs. 125–6). There is a rational explanation for the sour features of the Harlequins, which contrast so frighteningly with their garish costumes. They are old and hungry and the public is no longer interested in what they have to offer.[33] It is impossible not to think of Baudelaire's *Vieux saltimbanque*, first published in 1861, 'la misère absolue, la misère affublèe, pour comble d'horreur, de haillons comiques, où la nécessité, bien plus que l'art, avait introduit le contraste'.[34] And much later Henry James was to be struck by Daumier's drawings of this kind: 'the crowd doesn't come, and the battered tumblers, with their furrowed cheeks, go through their pranks in the void. The whole thing is symbolic and full of grimness, imagination and pity.'[35]

In *Le Déplacement des saltimbanques* (Fig. 128) Daumier shows us another motif: the homelessness of the clown, forced to be always on the move from one unappreciative public to the next, driven out perhaps by the civic authorities. The Goncourts wrote about this in these same years, though in a more light-hearted spirit,[36] and the subject had been treated by Watteau (in collaboration perhaps with his master Gillot) in a picture that is now known only through an engraving, *Le Départ des comédiens italiens* (Fig. 127), and that refers to the expulsion of the Italian Commedia dell'Arte from Paris in 1697 at the behest, apparently, of Madame de Maintenon. But a far more compelling juxtaposition and one that shows us the concept of the Sad Clown developing under our eyes is provided by an anonymous lithograph clearly dating from a few years before Daumier's drawing (Fig. 129). Compared to this rather homely scene, Daumier's treatment of the subject gives his clowns all the legendary and tragic power of that other myth which so fascinated Champfleury, that of the Wandering Jew.[37]

Thus during the 1850s two distinct, but closely associated, contributions were made to the concept of the Sad Clown by a number of artists and writers. When interest in the pantomime revived nearly half a century later these contributions merged and Pierrot was already a symbol of despair ripe for exploitation. The revivalists of the late 1880s, above all Felix Larcher and Paul Margueritte,[38] looked back to one of the few surviving poets of the great generation which had actually seen Deburau on the stage, Théodore de Banville. 'Rien qu'à vous parler de Deburau, qui fut le Napoléon de cet art, nous en aurions pour sept ans!' he told them and 'L'histoire de la pantomime!!! Mais alors, mon cher monsieur, c'est l'histoire de l'humanité que vous voulez faire.'[39] Far from it, in fact. The revival was an artificial one, just because it lacked humanity, because there was no Deburau to give it true vitality, because Pierrot was turned into an entirely symbolic character who could be shaped at will by the beliefs of a new generation of writers. To take one example among many, for the anti-Semites he could represent 'a simple Christian

129. Anonymous French lithographer: *Déplacement des Saltimbanques*

130. Adolphe Willette: *Au clair de la lune*

soul being constantly duped by the Jews';[40] and there were endless variations popularised by Adolphe Willette of the concept of Pierrot 'pessimiste et macabre' (Fig. 130). The Sad Clown acquired more substance when he was transferred from the pantomime to the more vital art of the circus and he gained a new dimension through the vogue for English spectacles, in which (as we learn from many writers, including Baudelaire and Edmond de Goncourt, whose circus novel *Les Fréres Zemganno* was partly set in England)[41] the clowns were particularly violent, brooding and sinister.

Thus for the greatest exponent of the theme of the Sad Clown, Picasso, a rich and varied symbolism was already traditional. He could portray the clown as the artist himself, as we know from innumerable drawings early and late in his career; the clown as metaphysical hero with overt religious analogies, which had perhaps just been hinted at by Watteau, and which was certainly emphasised in a deliberately ironical context by the painter Anatole Bazoche in the Goncourts' *Manette Salomon*;[42] and the clown as a forlorn wanderer in the spirit of Daumier.

It is easy enough to see why this theme should have appealed so much to nineteenth and twentieth-century poets, artists and, perhaps, above all art historical lecturers who were able to project on to it their own feelings about being forced to please a public which responded with indifference or even hostility, but I want to conclude by considering for one moment the wider implications of the myth. Essentially, it is concerned with the paradox that someone who ought to be laughing is in fact weeping. The close relationship

between these two activities has been recognised ever since antiquity, but towards the end of the eighteenth century and the beginning of the nineteenth it became an intensely popular theme. Samuel Richardson, Horace Walpole, Beaumarchais and Byron are only a few of the writers who explored in different ways the paradox 'And if I laugh at any mortal thing, / 'Tis that I may not weep!'[43] This sort of paradox lies at the basis of many other nineteenth-century mythologies, and even earlier ones, for the concept of the Noble Savage itself has some of the same quality. We find it exemplified in the Prostitute with the Heart of Gold who was born in the 1830s shortly before the Sad Clown, and in that belief, so cherished by Dostoievsky and certain *fin-de-siècle* Catholic writers, that the Greater the Sinner the Greater the Saint. It would not do, of course, to press all these different themes into an identical mould, but they do, I believe, help to throw a little light on the continuing vitality of the subject that I have, very tentatively, been trying to explore. A clown by Rouault thus carries us beyond tired clichés, beyond the 'rational' explanation provided by countless popular novels and operas such as Leoncavallo's *Pagliacci*, beyond the private meaning it may have had for the disheartened artist, beyond even the obvious analogies with Christianity. A great actor, a forgotten pantomime by a distinctly muddled thinker, and a few poets and painters of genius have helped to make us aware of certain strange processes of the unconscious which lie buried deep in all of us.

APPENDIX

Since the first appearance of this article the literature on Watteau (led by Donald Posner's 'Watteau mélancolique: la formation d'un mythe', *Bulletin de la Société de l'Histoire de l'Art Français* (1973), pp. 345–61) has increasingly argued that the 'melancholy' detected in his pictures is to be related more to the romanticism of his nineteenth-century admirers than to Watteau's own intentions. Meanwhile, representations of the Commedia dell'Arte and its impact on French art of the nineteenth and twentieth centuries have been much studied— see, for instance, Albert Boime, *Thomas Couture and the Eclectic Vision* (New Haven and London, 1980), and E. A. Carmean, Jr, *Picasso: The Saltimbanques* (National Gallery of Art, Washington, 1980).

9. Doré's London

ARCADIA, for the Romantic imagination, must be peopled with criminals and hints of terror rather than with shepherd girls and the promise of innocent recreation, and for many of the great (and lesser) French Romantic artists of the nineteenth century—Géricault (Fig. 131), Henry Monnier, Eugène Lami, Gavarni (Fig. 132), Constantin Guys and Gustave Doré among them—the streets of London constituted a more sophisticated alternative to the Roman Campagna with its picturesque bandits or the pashas and exotic tortures of the East. The sinister aspects of life in Paris were explored by countless writers, but it was the abject misery of London that especially impressed most of the French authors and artists who visited it—misery which they saw wherever they looked, and then pursued with insatiable fascination. This approach distinguishes their work from the more casual and detached curiosity of natives such as Hogarth, the pioneer in this field, or even Cruikshank, their contemporary, whom they much admired.

The historian who examines the illustrations of these Frenchmen in the hope of finding some overall picture of mid-century London is at once faced with serious difficulties: a thousand details will convince him of the essential accuracy of what has been recorded, and yet the principal feature that seems to characterise what was then the greatest commercial centre of the world is one that we associate largely with rural, and essentially feudal, communities: the rigid juxtaposition of extreme wealth and crippling poverty, with none of the intervening stages which even then must have been the lot of most of the city's inhabitants.

The London of the Romantics was a city of black and white in every sense of the term: it was recorded in etchings and wood engravings rather than in paintings, and it portrayed a universe of Manichean extremes with few transitions between a box at Covent Garden and starvation in a doss house. It is worth remembering that both Gavarni and Doré delighted in the contrasts between their frequent excursions into the life of the court and society and their expeditions into the East End.

To turn the pages of Doré's *London* is, even now, to conjure up for oneself the most inflammatory of revolutionary situations. Yet, for all the alarms, there was no revolution in nineteenth-century London while there were plenty in Paris. Despite the terrible truths that are illustrated in these pages, truths that are familiar to us from so many sources from Blake to Morris, it is hard not to feel that artists from elsewhere tended to project onto the English capital many of their fears about life at home. Gavarni was in London when

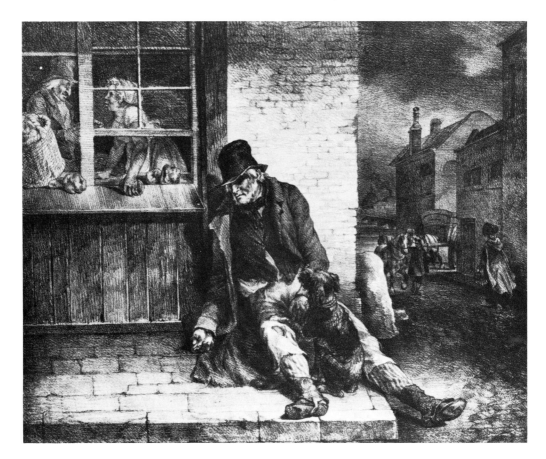

he heard, with the most profound distaste, of the upheavals of 1848—'Ah! vous prenez
la populace pour le peuple! . . . C'est parce que je suis du peuple que je hais la populace
. . .'; meanwhile Doré, who had just come to Paris for the first time, watched those
upheavals with growing alarm. Later, as we will see, he was to complete his drawings
of London after having been a horrified witness of the Commune from the vantage point
of Versailles. The London revealed by these men was all too real, but it had about it also
many of the properties of a myth.

It is tempting to look back with hindsight and see Doré's entire earlier life as a prelude
for the elaboration of this myth: for it is he who has given it its most powerful embodiment.
He was born in Strasbourg in 1832, the son of an engineer, but almost the only records
that have come down to us about his father (who died in 1848) concern his disapproval
of art as a career. Doré's mother, on the other hand, remained by far the most important
figure in his life until her death in 1881—a shock from which he never recovered and
survived by less than two years. 'Since I was born I had never ceased to live at the side
of that tenderest, most devoted, and generous of mothers', he wrote in reply to a letter
of sympathy, and we learn from a friend that when he was well into his forties she 'followed
every footstep of the illustrious son (as much a boy to her then as when he tripped home
daily from the Lycée Charlemagne)'. The brooding, Rembrandtesque portraits that he
made of her are (to judge from photographs) his only real masterpieces in oils. His early
biographers made discreet and mysterious references to forlorn passions and broken engage-
ments, but there is much in his work and reported comments to suggest that he never

131. (far left) Théodore Géricault: *Pity the sorrows of a poor old man!* — lithograph

132. (left) Gavarni (engraved Vizetelly): *The Street Beggar* — illustration to Emile de la Bédollière, *Londres et les anglais* (Paris, 1862)

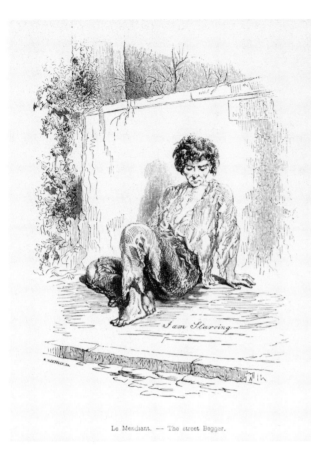

Le Mendiant. — The street Beggar.

133. Gustave Doré: *La Piscine dans le refuge de Field lane — pauvres se lavant —* pen and ink, reproduced from Blanchard Jerrold, *Life of Gustave Doré* (London, 1891)

felt at ease in the society of women and was never seriously attracted by them. Everyone commented on his boyishness—Gautier described him as 'un gamin de génie'—and his moods tended to alternate with great suddenness from wild gaiety to nervous melancholia.

Almost immediately after his arrival in Paris he began to make a name for himself as an illustrator for the popular magazines, and his first published book—a series of burlesque *Labours of Hercules*—appeared when he was fifteen. In this one can trace the influences of Daumier, Grandville and other popular artists of the day, and the first, unsteady, indications of that macabre fantasy which never left him. Doré was among the most prolific artists who have ever lived, and though the estimate of 40,000 drawings in fifteen years must be an exaggeration, even the contemporaries of Dumas and Balzac were amazed by his output. He was at one time considered to be the richest artist in France, and though he was by nature extravagant, it is obvious that work became an obsession for him, a means of evading loneliness and fears. 'The life of Gustave Doré was, on the whole, a very happy one; for his day-dreams never ceased, and he never lost the power of working them out, until he lay cold in death'; with this revealing phrase his closest friend began his biography: but those dreams were often nightmares. The list of volumes that he illustrated with such phenomenal success reads like some introductory course to the Great Masterpieces of the World: Balzac, Rabelais, Dante, Cervantes, Milton, La Fontaine, Ariosto, Tennyson, the Bible, and 'My Shakespeare! My Shakespeare!' he cried on his deathbed. 'I must get up quickly to finish it!' These were the peaks, but there were innumerable others. His imaginative fertility was prodigious, and though there is a close family resem-

blance between his treatment of the characters and episodes in all these dissimilar works he rarely repeated himself. But contemporary critics noted, often with disapproval, the grotesque pessimism that runs through them all. 'He was a caricaturist who seldom raised a laugh. Indescribable grimness and hardness appear in his comic drawings.' His essential timidity and childishness emerge in the enormous size of the figures he loved to draw. Again and again (and not merely when the story demanded it), they tower above us, gaunt, thin and ragged, like tramps who have terrified a little boy who has got lost on his way home from school. And often even they are dwarfed by the giant coiling serpents which seem to have haunted his imagination, so that even the roots and branches of his trees writhe and twist like claws ready to clutch at the unwary passer-by. For all his deficiencies as a draughtsman he was able to invest the standard imagery of Romanticism with the obsessive power generated by deeply felt personal fears.

The principal books illustrated by Doré have little in common beyond their 'sublimity', and, like the traditional clown who yearns to play Hamlet (or like that truly great artist and contemporary Daumier), he was dissatisfied with being an illustrator and caricaturist and wished to achieve immortality as a painter and sculptor. For all their obtuseness—and often for the wrong reasons—the French critics were able to recognise that he had no genius and little talent in these fields (though one of them compared him favourably to Michelangelo), and like other French failures he came to London where he enjoyed an overwhelming success—as is testified by a specially constituted Doré gallery to show his works. In second-hand bookshops one can still often come across hefty volumes of insensitive wood engravings after his would-be religious masterpieces: they are interesting only as testimonies to his unsuccessful longings to escape from a world of grovelling humanity to austere regions of colourless dignity.

> The work on London, which was the joint production of Gustave Doré and the present writer, was undertaken at the suggestion of the latter, when the artist was staying with him in Jermyn Street, and was busy establishing his gallery of paintings in Bond Street. The idea as described to Doré, was of far greater importance than that which was realized.

Thus the journalist Blanchard Jerrold begins his account of the joint venture, which seems to have been planned in the middle of 1868. In his biography of the artist Jerrold published the original outline of the intended volume, and it is very revealing of Doré's mentality to compare this with the book that eventually appeared. It was to have been a real encyclopaedia, including not only commercial statistics but also details of life in the city, the great shops and banks, the press, parliament and clergy, as well as excursions to Hampstead, Richmond and the residential suburbs. But from the first it was intended to differ from the ordinary run of books on a famous capital by concentrating on daily life rather than on monuments or cultural activities. Westminster Hall and Westminster Abbey are almost the only significant buildings singled out for treatment: there is no mention of the National Gallery or any other museum. And even in outline the emphasis was strongly polarised between the very rich and, especially, the very poor. Out of forty-three chapters, ten were to cover 'La Saison à Londres' and related activities, while eighteen were to be devoted to 'Les Travailleurs de Londres; et les pauvres' and 'Comment vivent, et sont secouries

ceux qui ne peuvent pas travailler. Les Charités de Londres : les Soup-kitchens, Refuges, Orphelinats, etc. Ceux qui ne veulent pas travailler. Les mendicants, voleurs : leurs garnis, thieves' kitchens, etc.'

It was characteristically with these 'eccentric quarters' (to use Jerrold's words) that Doré began, visiting Whitechapel, the docks, the night refuges, the opium dens, accompanied by two policemen in plain clothes. In his published biography Jerrold points out repeatedly how 'bewildered and horrified' Doré was by what he saw in the more gruesome slums; but William Michael Rossetti, in private notes made at the time, recorded merely that 'Sala has been escorting Doré through the *mauvais lieux* of London : Doré was much pleased with the squalid cellar-shops in the Seven Dials district. He is an agreeable companion—the reverse of mealy-mouthed.' Was it fear or a sense of intrusion that prevented him from making drawings on the spot? Whatever the cause, he only made the briefest of shorthand notes (Fig. 133), hiding his little book whenever a stranger appeared. He and Jerrold described themselves as 'pilgrims', and the word must serve to sum up an obsessed, but distant, fascination with the life around them—for it was a fascination that involved no contact, no conversation except with the escorting policemen, though doubtless matters were very different when, with paradoxically far less success, he recorded the gay garden parties at Holland House or the audiences at Covent Garden, in whose company he loved to bask. His method of work meant that he had to complete his drawings and turn them into

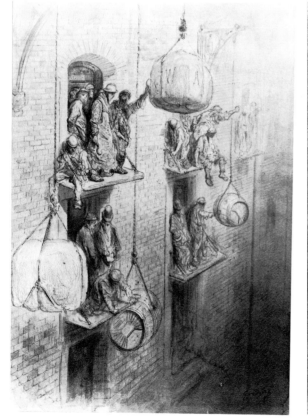

134. Gustave Doré: Preliminary drawing for *Warehousing in the City* – see fig. 135 (London, Victoria and Albert Museum)

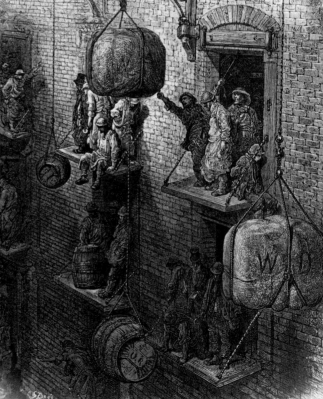

135. Gustave Doré (wood-engraving after): *Warehousing in the City*, reproduced from Gustave Doré and Blanchard Jerrold, *London : A Pilgrimage* (London, 1872)

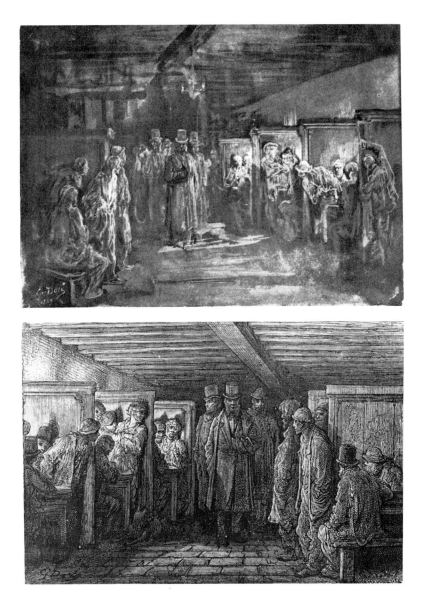

136. Gustave Doré:
Preliminary drawing
for *Whitechapel and
Thereabouts* – see
fig. 137 (Leningrad,
Hermitage Museum)

137. Gustave Doré
(wood-engraving
after): *Whitechapel
and Thereabouts*,
reproduced from Doré
and Jerrold, *London*

finished compositions back in his studio, relying on his memory, which—as critics pointed out—was sometimes at fault: more important was the fact that his imagination had time to intensify his first impressions made on the spot, and the process could be carried still further when the drawings were being prepared for the block. Miss Millicent Rose has acutely pointed out how much more precarious are the positions of the men (and cataclysmic the general effect) in the published version of *Warehousing in the City* than in the drawing he made of the scene (Figs. 134–5).[2] Similarly, the lowering of the ceiling, and even the absence of the flaring gaslight, makes the illustration which heralds the chapter on Whitechapel even more oppressive than the original gouache (Figs. 136–7). Though the drawing of some of his figures owes a good deal to those of the vastly superior Gavarni, what distinguishes Doré's treatment of London squalor lies just in this feeling of the oppress-

ive. Gavarni's beggars live in a vacuum, but towering brick walls bear relentlessly down on the poor recorded by Doré—even the rich rarely see the sky because of the giant trees in their gardens—and he puts this feeling to frightening effect in the most famous image that he ever produced, *Newgate Exercise Yard*, which was transformed by Van Gogh, in a mood of pessimism, into a terrible symbol of the human condition as a whole (Figs. 138–9). In his illustrations of the masterpieces of earlier literature it was the phenomena of nature—craggy mountains, dark forests, black storm clouds—that threatened man; in the *London* the identical sensation of terror is induced by rickety tenement houses, foggy alleys and smoky chimneys (Fig. 140)—the title 'der industrialisierte Romantiker' given to him recently by a German writer[3] is an appropriate one. How closely fantasy and reality were related in his mind can be seen by the conspicuous similarities between *Ludgate Hill* (Fig. 141) (can it ever have been quite as crowded as this?) and a rather later drawing for the *Orlando Furioso* (Fig. 142).

Work on the *London* extended over a period of four years, and it is particularly sad that we do not know the exact stages of its development, because during the course of these years Doré underwent a traumatic experience. In 1870 he was on a visit to Paris when his return to London was prevented by the outbreak of war. He endured the siege ('I have witnessed many dramas and episodes of ruin, in which, despite the gloom of the theme, you would, I think, be interested. I could furnish you with many vivid scenes and descriptions to which you could add the colouring of romance') and fled to Versailles—where he showed his infinite contempt for the politicians in a series of caricatures which

138. Gustave Doré (wood-engraving after): *Newgate—Exercise Yard*, reproduced from Doré and Jerrold, *London*

139. Vincent Van Gogh: *In the Prison Courtyard* (Moscow, Pushkin Museum)

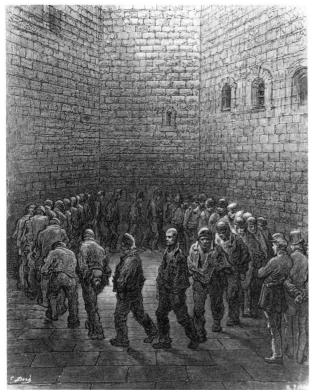

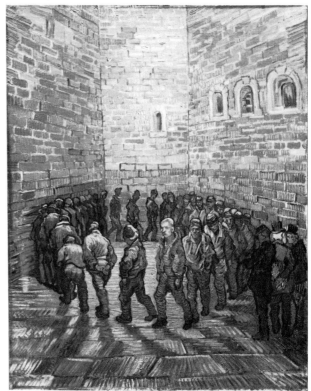

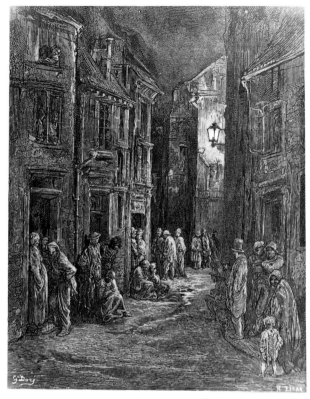

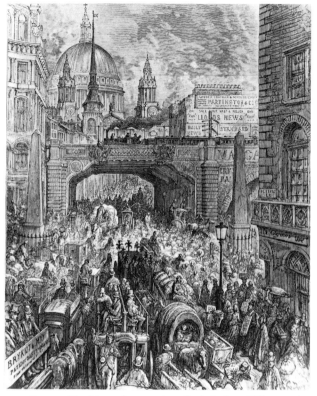

140. Gustave Doré (wood-engraving after): *Bluegate Fields*, reproduced from Doré and Jerrold, *London*

141. Gustave Doré (wood-engraving after): *Ludgate Hill*, reproduced from Doré and Jerrold, *London*

were only published after his death—at the time of the Commune ('In the whole history of the world, I don't think there is a parallel instance of so sanguinary a drama, and of such ruin'). The poor, whose fortunes in London had so 'bewildered and horrified' or 'pleased' him (depending on whose evidence one chooses to rely), had shown that they could rise and occupy a great capital, and when in July 1871 he reluctantly resumed work on the drawings, Jerrold remarked on the change that had come over him. 'His sensitiveness was now morbid . . . he was in a state of profound dejection, from which we could, with difficulty, rouse him at intervals.' His biographer reports one revealing episode. When they were presented to 'the strongest woman in Shadwell', 'That is not a type, ' I said to Doré, as we turned away, 'but a monster.' 'She is the ideal of ferocious animalism—a hideous excrescence of civilisation. The latent brute beast in humanity has burst out into this hideous spectacle. Yes, she is a type—of the wild human animal.' His general fears of women are here surely combined with memories of the *pétroleuses*—those devilish termagants, much in the minds of the Versaillais, who had deliberately set fire to bourgeois property . . .

Yet, though our inability to date the drawings precisely makes it impossible to say which of them were influenced by such fears, it is noticeable that Doré's poor are not usually threatening—except in so far as there are too many of them. On the contrary, they are so abject, so cringing, that one is tempted to feel that (desperate though we know their conditions to have been in reality) Doré has, so to speak, taken his revenge on them (Fig. 143). Can the wronged ever have been quite so subdued as those that listen to the

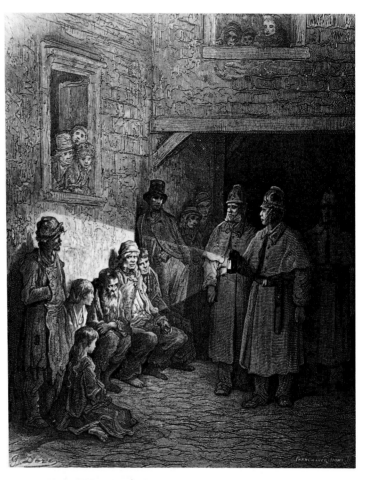

142. Gustave Doré (wood-engraving after): Illustration from Canto V of Ariosto, *Orlando Furioso*, 1879

143. Gustave Doré (wood-engraving after): *The Bull's Eye*, reproduced from Doré and Jerrold, *London*

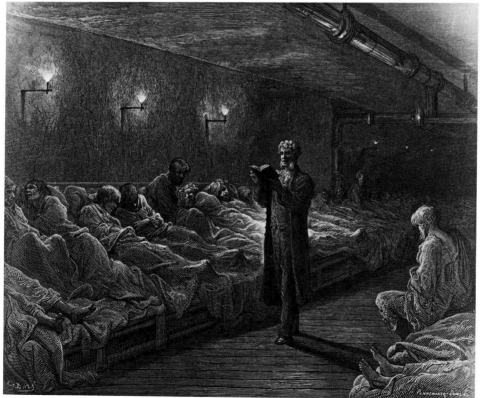

144. (left) Gustave Doré (wood-engraving after): *Scripture Reader in a Night Refuge*, reproduced from Doré and Jerrold, *London*

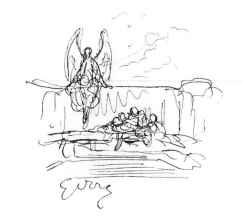

145. (left) Gustave Doré: Sketch for *London Bridge* — pen and ink, reproduced from Doré and Jerrold, *London*, and exhibited Hazlitt, Gooden and Fox, London, 1983

147. (right) Gustave Doré (wood-engraving after): *The New Zealander*, reproduced from Doré and Jerrold, *London*

146. (below) Gustave Doré (wood-engraving after): *Over London by Rail*, reproduced from Doré and Jerrold, *London*

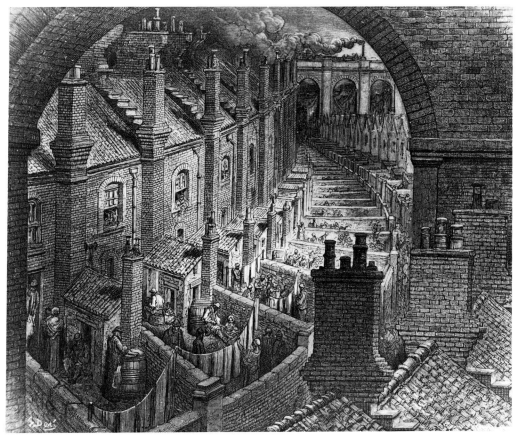

Scripture Reader in a Night Refuge (Fig. 144)?—surely, to modern eyes, the most terrifying of all his terrifying images, and terrifying, like so many of the others, just because of the docility with which men are shown to face intolerable conditions. Here, indeed, are outcasts who know their place—and, in these circumstances, it is perfectly possible to sympathise with them, for there is no reason whatsoever to doubt his natural benevolence. One scene above all preoccupied him so much that 'he never appeared to tire of it', and recorded it in drawings, prints and paintings: a group of ragged women and children huddled together at midnight on London Bridge. In his drawings of this (though not in the illustra-

tion to his book) he placed above them a protective angel (Fig. 145). But this was the only comforting thought he allowed himself.

The *London* began to appear in parts in January 1872, and it was published as a book later in that year. Doré worked on its final stages with increasing distaste—he was partly concerned that it would prejudice the public against his paintings—and there were repeated difficulties with the blockmakers and publishers. It was because of this that only twenty-one out of the projected forty-three chapters were written and that the more balanced picture of the city as a whole which had been intended was so seriously distorted. Even the climate

added to the element of melodrama inherent in the treatment; while the sun never fails to shine on the rich, the East End is always seen by night or in the fog.

Gavarni had lost popularity because of his concentration on the seamy side of London, but Doré's work was well received, though there were criticisms of inaccuracies in the boat-race drawings and he was reproached for his failure to distinguish between the physiognomies of the English and the French. Yet he failed to sell the original set of drawings (for which he asked £1,000) and eventually he gave them away to his friends so that they have now been dispersed.

Jerrold's intolerably turgid prose, while acknowledging a debt to Dickens and to pioneers such as Knight and Mayhew, constantly stressed the accuracy and modernity of Doré's outlook, and it is certainly true that the magnificently powerful *London* projected by him will continue to haunt the imagination long after the last of the slums has vanished—meanwhile a train journey out of Liverpool Street is sufficient to demonstrate how vividly he has caught the essence of this grim district (Fig. 146); though his scenes from high life contain none of the nostalgia or graceful charm of those by Lami or Gavarni, for his make-up lacked any trace of aristocratic sensitivity. But for all the horrible reality behind it, the vision is still that of the Romantics, who first 'discovered' London much earlier in the century. Nothing is more indicative of the doom-laden atmosphere which pervades the whole book than the eagerness with which Jerrold and Doré have seized on Macaulay's colourful aside on the Catholic Church—'And she may still exist in undiminished vigour when some traveller from New Zealand shall, in the midst of a vast solitude, take his stand on a broken arch of London Bridge to sketch the ruins of St Paul's'—and transformed it into an image worthy of Piranesi—or John Martin (Fig. 147). The intense particularity of observation, the concentration on 'types', the eye that is so ready to be amazed or horrified—all these were soon to give way to an entirely new interpretation of life in a great town. Already the Impressionists were at work, recording, with careful neutrality, the anonymous bustle; soon Seurat would investigate the melancholy silence of the suburbs. Doré was terrified by crowds; a new generation was to shudder at isolation.

APPENDIX

Part of the argument advanced in this essay concerning Doré's response to London depends on his having made some of his most impressive drawings of scenes in the city only after he had witnessed the effects of the Commune in Paris. Unfortunately the chronology of his work on the book is still not clear. The most recent study known to me—a thoughtful article by Ira Bruce Nadel, '"London in the Quick": Blanchard Jerrold and the text of *London: A Pilgrimage*', *London Journal*, ii, no. 1 (May 1976), pp. 51–66—claims only that 'most of the engravings had been completed by late 1869 when the two men tried to get the volume issued'. We do know, however, from Jerrold's biography, that Doré was still making some drawings as late as 1872, the year in which *London* was finally published, at first apparently in separate parts, and then as a single volume.

10. Giorgione's *Concert champêtre* and its Admirers

ART HISTORIANS generally concern themselves with the processes of creation. Who painted such and such a picture? When was it painted? What does it represent? What does its style tell us about influences on the artist? Sometimes they venture into wider fields. How important for the painter were the political, the social or the religious circumstances of the time? What about the patron who commissioned the picture? Did his specific instructions or his generalised tastes play their part in the shaping of the picture as we now see it? All these and many other questions are ones that are rightly asked—and sometimes answered—by virtually everyone who writes about the history of art. But once the picture is completed the historian usually loses interest. What it may have meant to the man who ordered and paid for it, to the artist's contemporaries and successors, to the critics and historians of the time or later—all this tends to be neglected, except in a few cases where the influence of a painting has been so overwhelming on later artists that it too must be thought of as playing an essential part in the process of artistic creation.

Such neglect is not altogether surprising. Until comparatively recently—and indeed even today—the language of art appreciation has been extraordinarily barren and unrewarding. To say of a picture that the 'figures are so lifelike that they look as if they could breathe'—this was the cliché that was handed down for decades and served generations of art lovers as a convenient tool for expressing unqualified admiration. Though we must read the fifteenth and sixteenth-century theorists if we are to try to understand fully the nature of Renaissance art, we must also admit that when we do so it is very rare indeed that we feel that we are making contact with an individual art lover in our sense of the word. Then, in 1677, the great French critic Roger de Piles wrote that in front of a picture we admire, as in front of a woman, our first reaction should always be the exclamation 'Ha, voilà qui est beau!' As a comment it hardly seems very enlightening at first sight, though in fact its implications were of vast importance, but for one second it carries us back across the centuries and puts us in touch with someone we feel we know. It is, surely, the very sort of exclamation that seems entirely appropriate when we first see in the Louvre the *Concert champêtre* which, for some three hundred years, was attributed to Giorgione (Fig. 148). It so happens that Roger de Piles recommended that our initial response to great art should be of a purely emotional character just at the time when we first hear of the existence of this very painting. But although he himself owned what he claimed to be a Giorgione,[2] it was actually the work of another artist that he had in mind when he made his exhortation.

When choosing to explore the 'posthumous' history of this picture, I realised from the first that half my title at least was controversial. Many people would now deny that the artist who created it was in fact Giorgione—over the last ten years or so more and more scholars have come round to the view that it is an early picture by Titian,[3] and among the officials of the Louvre, where it hangs, this opinion has hardened into near certainty: we shall see later that such changes in attribution do affect our way of looking at art. And by calling it *Concert champêtre* I have accepted a name which has been conventional for about 170 years, but which would have meant nothing to the lucky man (or woman—it has sometimes been conjectured) who commissioned the picture, and which may well give us a misleading impression about what it actually represents. We shall also see later that these questions about subject matter can affect our way of looking at pictures. For the moment let us confine ourselves to Roger de Piles's advice, and merely repeat 'Ha, voilà qui est beau!'

I did, however, believe that on the question of its admirers I was on stronger ground. I was aware, it is perfectly true, of the fact that nobody knew anything about the early history of this picture, which must have been painted in about 1510 (and I was hardly optimistic enough to think that I would be able to solve this problem), but I was ready to accept without question the information about its later provenance which is to be found in every catalogue or book which refers to it. At some time, we are invariably told, it formed part of the magnificent art collection accumulated by the Gonzaga family, the lords of Mantua. In 1627, or thereabouts, it was acquired with the rest of that collection by Charles I, and it thus remained for some twenty years in London, where it must have glittered even in the staggering company that surrounded it. With the downfall of Charles I, so tradition continues, the *Concert champêtre* was sold by the Commonwealth, and was bought by the great German-born collector Everard Jabach who had settled in Paris. After a further twenty years Jabach ran into financial difficulties, and this was among the many wonderful paintings, and still more drawings, that he was compelled to sell at a derisory price to Louis XIV. Ever since then it has remained in France, being taken over by the State, along with all the other royal pictures, at the time of the Revolution.

Every researcher, in every field, will recognise the feeling of panic as well as of exhilaration that comes over one as information that one has always taken for granted begins to dissolve, and one is left standing on thin air, so to speak. To challenge a tradition that has been upheld for more than two hundred years; that is to be found in books and articles written by scholars of every nationality—German, Italian, French, American and English; a tradition, moreover, that is so grandiose and exemplary in the panorama it offers us of European collecting—Italian princes, the most romantic of English kings, the first of the self-made businessmen collectors; to challenge all this is a daunting and foolhardy experience, but the fact remains that there appears to be no solid evidence whatsoever to back up this tradition. The picture is not mentioned in the inventory of the Gonzaga pictures in Mantua; still more surprising it is not mentioned in the extremely thorough inventory of the pictures belonging to Charles I. Can so striking a painting—in quality and in subject matter—just have been overlooked?

Let us see what we do know about it, leaving aside all preconceptions. In the second

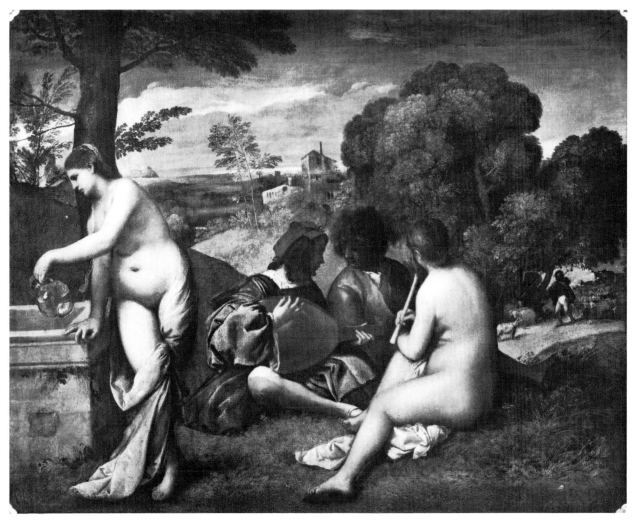

148. Giorgione (or Titian): *Concert champêtre* (Paris, Musée du Louvre)

half of the seventeenth century at least three copies were made of the *Concert champêtre*. Two are excellent pen and ink drawings with wash (Figs. 149–50) and the one now in Leiden is dated 16 January 1668. On grounds of style these can be securely attributed to Jan de Bisschop, the Dutch artist who lived between 1628 and 1671 and who made something of a speciality of copying the Old Masters and antique sculpture in this medium and through engraving. The drawings are by no means identical, but both are faithful enough to the original, though there are variations in each case.[4] The third copy is a print (Fig. 151) and, as is normal, the composition is reversed. Here too the copy is not exact— look, for instance, at the trunkless tree behind the main figures, the hair style of the woman with her back to us, the stream that has been added in front of what was originally a shepherd with his flock, and a fairly large number of other details. On the other hand, it is as different from the drawings by Jan de Bisschop as it is from the picture itself, and this suggests that the print and the drawing are not directly related. It is signed A. Blooteling, the name of a Dutch engraver who was born in 1640 and died in 1690, and who spent the years between 1672 and 1676 in England.

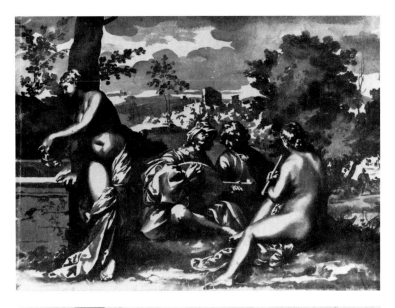

144

149. Jan de Bisschop:
Copy in pen and ink of
Giorgione (or Titian),
Concert champêtre (Paris,
Fondation Custodia,
Institut Néerlandais)

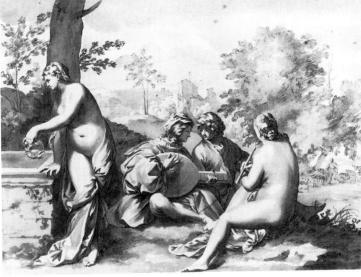

150. Jan de Bisschop:
Copy in pen and ink of
Giorgione (or Titian),
Concert champêtre (Leiden,
Rijksuniversiteit
Prentenkabinet)

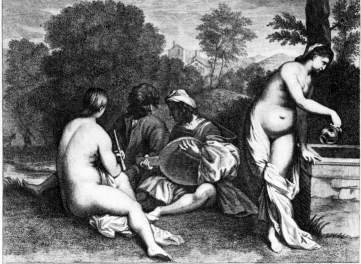

151. Abraham
Blooteling: Engraving of
Giorgione (or Titian),
Concert champêtre (Oxford,
Christ Church Gallery)

What can we deduce from all this? Did our two Dutch artists see the picture, and, if so, where? Though Jan de Bisschop certainly went to Italy in the middle 1650s, he is not known ever to have visited Paris; nor is Blooteling, who, you will have noticed, came to London long after the dispersal of Charles I's pictures. Kenneth Clark once rightly pointed out that art historians are exceedingly reluctant to allow artists to travel without their permission, and we must therefore admit that it is perfectly possible that both men did in fact make the journey and saw the picture when it belonged to Jabach or Louis XIV. We can also demonstrate that Jan de Bisschop frequently reproduced works of art which he had never seen and which were known to him only in the form of copies made by other artists. On the other hand, the fact that the only recorded copies of this great painting made in the seventeenth century should have been by Dutch artists cannot help make us wonder whether it too, like so many others, did not at some stage in its career pass through Holland.

The query is not just a pedantic one. This painting is the greatest and most poetic example that was then accessible of that quintessentially Venetian invention of 'figures in a landscape'. What admirers may it not have had in Holland of all places!—for though we know that many great Giorgionesque pictures were in Holland during the seventeenth century,[5] none was of quite this quality or style. All art historians have stressed the affinity between the young Vermeer and Giorgione; Kenneth Clark has emphasised how much Rembrandt owed to him, and there are many lesser Dutch artists who developed aspects of the theme so marvellously explored in the *Concert champêtre*. The thought that some of them may actually have seen this particular picture is therefore an intoxicating one —and one which would surely repay investigation if only we knew more about its history.

If only—all this is speculation. I have already suggested that Jan de Bisschop and Blooteling may have visited Paris; or their versions could have been based on some copy which is now lost rather than on the original picture—the fact, for instance, that in 1684, when we know the *Concert champêtre* to have been in Paris, a painting attributed to Giorgione and described as 'Lute Players and Ladies, very artistic and outstandingly fine', said to have come from the Arundel collection, turned up on the Amsterdam art market, hints that copies were around.[6] And even if my speculations should prove to be correct, they do not altogether dispose of the theory, first propounded I believe in the 1720s, that the *Concert champêtre* had once belonged to Charles I. But combined with the startling fact that it is not recorded in his inventory, all this should make us think again, and—in these days especially—wonder just what masterpieces of Venetian sixteenth-century painting have been allowed to leave this country.

One more speculation about this problem before we return to history. There exist certain paintings in the museums of Dijon and Dôle (Fig. 152) by a Flemish artist, Frans Wouters, which—it has been claimed—reveal the impact of our picture:[7] they are in no way copies, but the combination of music in a landscape and naked and clothed figures does suggest that this artist could have seen the Giorgione. Where? Wouters was a pupil of Rubens who in fact lived in England from 1636 to 1641, during the last two years of which he was painter to the Prince of Wales. If you accept the theory (which is to me by no means

146

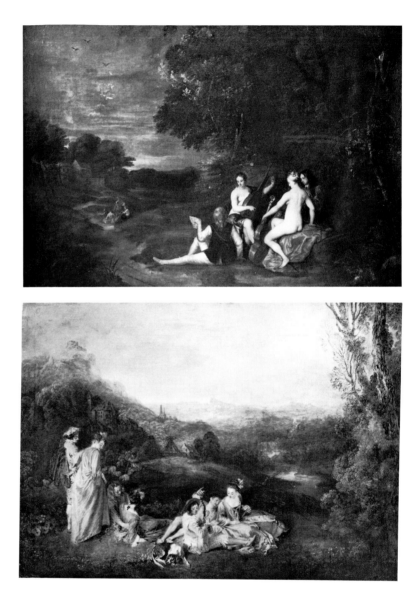

152. Frans Wouters:
Concert champêtre
(Dôle, Musée
Municipal)

153. Antoine
Watteau: *Fête galante*
(Berlin, Dahlem
Museum)

conclusive) that his paintings were inspired by the *Concert champêtre*, that would at least point to the picture having once belonged to Charles I.[8]

From so much vagueness let us return to fact—our first fact. The picture is first mentioned in an inventory of Louis XIV's collection drawn up by his court painter Charles Lebrun in 1683, and the reference is an interesting one. It represents, he says, a Pastoral, and he then gives an accurate description of the figures in it. This, as far as I know, is the first time that the word Pastoral, which was familiar enough in a literary context, had ever been applied to a picture,[9] and the link that Lebrun implies with pastoral poetry of the period is still a valid one. What seems to be the earliest certain appreciation as opposed to description of the picture comes, curiously enough, from an Englishman, though one could wish that it were a little more sensitive and expressive. At some time before 1722

the connoisseur Jonathan Richardson junior passed through Paris, and noted that he had seen in the Louvre: 'Giorgion: Four Figures, Bright manner, well preserved.'[10] With this laconic phrase criticism begins of one of the world's great masterpieces.

By then, however, it had presumably attracted the attention of a far more appreciative interpreter. Everyone who has ever looked at certain paintings by Watteau, in particular the so-called *Festival of Cupid* in Dresden and the *Fête galante* in Berlin (Fig. 153), has always felt the affinity between him and Giorgione, and as this picture was almost certainly accessible to him, it is hard to believe that the influence was not a direct one: the evocative colours; the ravishing and somehow melancholy relationship between the music-playing figures and the landscape; the dreamlike atmosphere. No drawing survives by Watteau after any of the figures in our painting, though he did frequently copy the Old Masters; and the connection between the two artists is essentially one of feeling.[11] And yet how different is Watteau's view of the world! One of the most remarkable features of the Giorgione—to which I shall have to return—is the complete absence of communication between the men and the women. They seem to exist, quite literally, in different worlds. In Watteau on the other hand, music is always the food of love; in all his pictures the poignancy comes from human contacts—sometimes deep, sometimes fragile, usually tender and always lyrical.

As the eighteenth century advanced, critics, as well as artists, began to admire the *Pastorale*, as it was always called, but to be increasingly puzzled by what appeared to them to be its lack of decorum: the combination of fully clothed men and naked women.[12] In itself, the combination is, of course, not unusual. Certain subjects specifically demand it: Actaeon, for instance, the hunter who was torn to pieces by his own dogs after accidentally stumbling on the bathing Diana and her handmaidens; or—in a far more peaceful episode—the three goddesses who displayed their charms to the shepherd Paris.

In all such cases, however, the combination of clothed and unclothed was sanctioned by mythology, and it was recognised that both man and woman belonged to a different world from that of the spectator and the artist himself. What increasingly worried critics, and by the nineteenth century positively angered them as moral criteria moved into what had hitherto been the province of aesthetic judgements, was the fact that in our picture this 'distancing' is impossible.[13] Although everyone's behaviour is impeccable, the scene was conceived of as being indecent by its very nature, and many people while recognising the quality of the picture deplored its content.

Not everyone. When the pictures from the royal collection were arranged in the State museum in the Louvre, it naturally became easier for the public to see the *Concert champêtre*, as it now came to be called, and it is gratifying—even if not altogether surprising—to find that (as far as I can make out) the first man to give the picture his unqualified admiration should have been Stendhal, who tells us that he 'never grew tired of looking at it'.[14]

Nevertheless, writers generally felt themselves uneasy, and it was left to artists to express their homage—in the way that came easiest to them—by copying the picture.

One of the first to do so was Turner in a little sketch (too pale, unfortunately, for reproduction) that he made on his visit to Paris during the peace of Amiens in 1802, though even he found himself somewhat embarrassed by what he took to be 'Spanish figures with

two naked females'.[15] Thereafter, the number of copyists becomes innumerable. I shall refer to only a few of these, and illustrate still fewer, because, although copies by great artists of Old Masters are among the most fascinating of pictures, in photography everything that gives them value and interest disappears.

For the Romantics Giorgione's picture was especially appealing because, like the works of Rubens which they also passionately admired, it gave them the opportunity to study glowing colours and warm, living flesh after the more arid models which had been pressed upon them by their neo-classical teachers. Delacroix was among the first to see this, and in 1824, while still at the beginning of his career, he made a copy of the *Concert champêtre* (which he referred to casually as 'the naked women in the countryside').[16] The copy has now disappeared, but I wonder whether he may not have remembered it when, eight years later, he painted a scene which he had witnessed on his visit to North Africa, his *Femmes d'Alger* in the Louvre (Fig. 155). If we reverse the composition, and substitute men for women in the centre, there are certain similarities in the general disposition of the figures, though I would not like to press this point too far. Other artists in Delacroix's circle copied our picture, as did his English acquaintance and nearest equivalent, William Etty, who braved the Revolution of 1830 to study the Venetian paintings in the Louvre.[17]

But as Romanticism waned, and French painters became increasingly interested in depicting reality, so Giorgione's picture came to appeal to them just because it appeared to be a sort of 'tranche de vie' from the Renaissance, one of the few that had survived, uncluttered by 'all those boring allegories' that Manet complained about in Italian art.[18] The extent to which far more complex pictures than the *Concert champêtre* could be interpreted naturalistically is shown by the fact that when Giorgione's still mysterious *Tempesta* in the Accademia (Fig. 154) first came to light in the 1850s, after more than three centuries of neglect, it was known as 'The Painter's Family', and guidebooks solemnly explained that it represented Giorgione himself with his mistress and newborn child.[19]

That being so it is not really surprising that our picture should have appeared to represent little more than a couple of jaunty students out with their girl friends for a day in the country. The country was as important as the girls for many artists of the period. At its most touching we find this reflected in a story about Millet, whose own interpretations of rural life were to be so very different. We are told that as a young painter in Paris, with an overwhelming nostalgia for the country life he had known as a child, he cheered himself up one afternoon by painting a copy of the *Concert champêtre* 'which at least gave him the impression of reviving himself with a walk in natural surroundings'.[20] Corot also was an enthusiastic admirer of Giorgione,[21] in particular (presumably) of the *Concert champêtre*.

But the main attraction was a different one. Kenneth Clark has pointed out that the seated nude 'is painted with an unprejudiced sensuality as if she were a peach or a pear. In this she is the forerunner of Courbet, Etty, Renoir and of those life studies which were the chief product of art schools through the nineteenth century',[22] and it is true that we seem to find reflections of her plump and apparently artless pose in the works of innumerable painters of this period. This is no mere coincidence. The records tell us that the picture

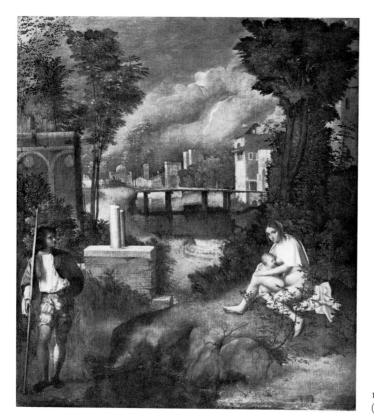

154. Giorgione: *La Tempesta*
(Venice, Accademia)

was copied again and again by Fantin-Latour, by Bonnat, by Cabanel, by Degas, by Cézanne and by many more.[23]

The most famous and most discussed of all such derivations is, of course, the *Déjeuner sur l'herbe* by Manet (Fig. 156). Watching some figures bathing one day, Manet is reported to have exclaimed: 'People tell me that I ought to paint a nude. Well, I'll do one for them. When we were at the studio, I copied Giorgione's women, the women with musicians. But the picture is dark. The colours have sunk. I'll do it over again with figures in the open air like those we see over there.'[24] There is no need for me to talk about the resulting masterpiece in any detail. The actual composition was taken from a print by Giulio Romano after Raphael, but the Giorgionesque inspiration is obvious and it is interesting that Manet also owned a copy of the *Concert champêtre* painted by Fantin-Latour. Even the fact that the two men are talking to each other, rather than paying direct attention to the girls, reveals the source of his picture, although everyone has pointed out that the brazen attitude of the principal nude directly contradicts the impression made by Giorgione's picture. What is of interest to us today is not so much Manet's *Déjeuner sur l'herbe* as the consequence it had for our interpretation of the original Giorgione. By bringing up to date an assumption that had been widely, but more or less tacitly, held about the *Concert champêtre*, Manet aroused a storm of protest. To deflect this he, and his friend Zola, invented an exceedingly ingenious defence which (I am inclined to believe) had little bearing on his original intentions, but which was to be of profound importance for later aesthetic theory. Forget the subject and its implications, ran their argument. Look at this as an abstract

150

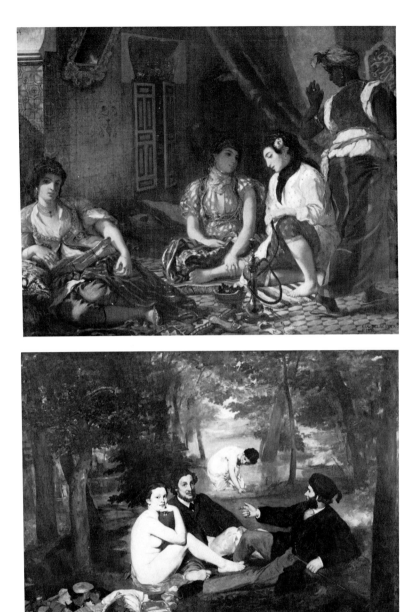

155. Eugène
Delacroix: *Femmes
d'Alger dans leur
appartement* – Salon de
1834 (Paris, Musée du
Louvre)

156. Edouard Manet:
Le Déjeuner sur l'herbe
(Paris, Musée du
Louvre)

composition, a combination of colours, of light and dark, a mere pretext for the painting
of flesh and costumes. Zola's famous article to this effect appeared on 1 January 1867.[25]
Within a few months Théophile Gautier, who had little sympathy with Manet, found
himself having to write about the Giorgione in the Louvre, and when doing so he used
the identical arguments. Giorgione, he claims, 'with that supreme moral indifference of
the artist who dreams only of beauty, has been inspired here merely by the felicitous contrast
between beautiful materials and beautiful flesh . . . that is all there is in this picture . . .

which is quite devoid of subject and anecdote'.[26] I can think of no more striking instance of the manner in which we interpret the past through the contemporary, and so was launched the still widely held theory of Giorgione as a 'pure painter', totally uninterested in subject matter.

Meanwhile across the channel, the *Concert champêtre* had also been acquiring fame— though of a very different kind. In 1849 Dante Gabriel Rossetti, then aged twenty-one, paid his first and only visit to the Louvre. Apart from Ingres and a few 'primitives', he found almost everything to be 'slosh', but he made one curious exception for the 'pastoral— at least, a kind of pastoral—by Giorgione which is so intensely fine that I condescended to sit down before it and write a sonnet'.[27] The sonnet was published a year later in the Pre-Raphaelite journal *The Germ*, and in its final form, after extensive revision, it ran:

> Water, for anguish of the solstice:—nay,
> But dip the vessel slowly,—nay, but lean
> And hark how at its verge the wave sighs in
> Reluctant. Hush! beyond all depth away
> The heat lies silent at the brink of day:
> Now the hand trails upon the viol-string
> That sobs, and the brown faces cease to sing,
> Sad with the whole of pleasure. Whither stray
> Her eyes now, from whose mouth the slim pipes creep
> And leave it pouting, while the shadowed grass
> Is cool against her naked side? Let be:—
> Say nothing now unto her lest she weep,
> Nor name this ever. Be it as it was,—
> Life touching lips with Immortality.[28]

Even within Rossetti's own circle, there was some doubt as to the exact meaning of part of this sonnet, but its plangent, melancholy tone, so different from the more down-to-earth French approach, had the effect of introducing Giorgione's *Concert champêtre* into the select Pantheon of pictures admired by the Pre-Raphaelites, along with those of Botticelli and a few other very different painters. In 1861, for instance, the young Swinburne went to Paris for the first time, and especially picked out that 'stunner above stunners, that Giorgione party with the music in the grass and the water drawer . . . that Gabriel made such a sonnet on'.[29] And, as happened so frequently at this time, from Rossetti and Swinburne the torch was handed on to Pater, to John Addington Symonds[30] and to the 'aesthetic movement' generally, including Oscar Wilde in *The Critic as Artist*.

But meanwhile a great blow had fallen. During the 1860s the picture was scrutinised by the two great connoisseurs Joseph Archer Crowe and Giovanni Battista Cavalcaselle, who for the first time put the subject of art history on to a serious basis and who in particular cut through the almost impenetrable jungle of hundreds of pictures of every kind which had hitherto been attributed to Giorgione. They found it sadly lacking in quality: 'slovenly design, fluid substance, and uniform thickness of texture; plump, seductive, but un-aristocratic, shape'.[31] I was at first inclined to attribute this distaste to the prudish prejudices

157. Giovanni Battista Cavalcaselle: Copy in pen and ink of Giorgione (or Titian), *Concert champêtre* (Venice, Biblioteca Marciana)

of the Englishman Crowe, especially as he adds that though 'there is no conscious indelicacy, yet we stand on the verge of the indelicate'; but a vigorous drawing by his Italian colleague Cavalcaselle (Fig. 157), now in the Marciana in Venice, shows that he too dismissed the picture, for—as can be seen from his notes—he has given it to the very minor artist Morto da Feltre.[32]

The march of professional art history was inexorable. Pater, who wrote such a marvellous essay on Giorgione (*All art constantly aspires towards the condition of music*), and with whom this picture was a favourite, was cautious after it had been given such a drubbing by the experts—though, in fact, it was rapidly reattributed to Giorgione by other authorities. In France also doubts spread as to its authorship, though they always remained more

generous. 'People now claim that it is by Titian', said the painter Henner in 1878[33]—and, as I have already mentioned, this problem has remained unsolved.

So too has the question of its subject. Could it be the Prodigal Son, suggested someone to Henner, amusing himself with women? Not noticing, apparently, that this is in fact just what the two young men are not doing. Any explanation of it must take into account the total indifference of the men to the women, and in recent years many have tried to do so.[34] None has been wholly satisfactory, though to my mind the most convincing is the one put forward by Professor Fehl, who suggests that the two women are nymphs, who are invisible to the young men, and have been attracted by their music making.[35]

Does any of this matter? I have shamefully (and perhaps cunningly) left myself no time to answer what is perhaps the only significant question raised by this talk. The *Concert champêtre* has (with only one or two exceptions) always been loved; it is not one of those paintings whose critical fortunes have varied dramatically at different times. Does not de Piles's 'Ha, voilà qui est beau!' still sum up all that we feel we can, perhaps should, say in front of it? Yet that reaction was intended to be only the immediate response, however essential, before closer inspection brought to light deeper beauties and more hidden meanings. And every time we try and analyse those meanings we bring to the attempt assumptions about the nature of art which are conditioned and complicated by extraneous factors. We have seen that even the quintessentially unliterary approach which explains the picture in abstract terms as a combination of radiant colours and forms is one determined by specific issues which originally had nothing to do with Giorgione himself. The 'innocent eye', in fact, is as impossible a goal for the beholder as for the artist. Whether or not we are aware of their existence, the Dutch copyists of the seventeenth century, Watteau, Manet, Rossetti, Crowe and Cavalcaselle, Pater and all the other artists and writers I have mentioned as well as many I have ignored, have in different ways affected our approach—and, I would claim, enriched it—as we gaze at what remains one of art's most supreme masterpieces.

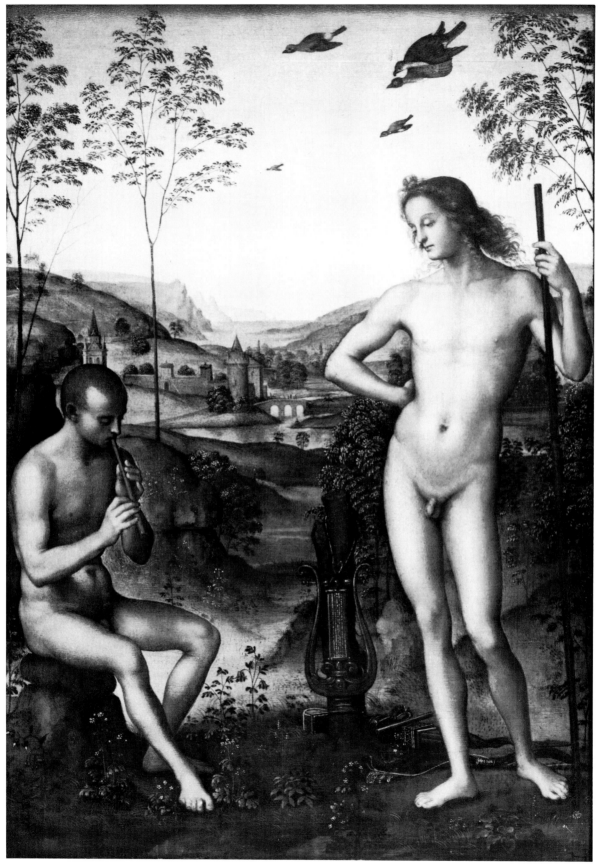

158. Perugino: *Apollo and Marsyas* (Paris, Musée du Louvre)

11. A Martyr of Attributionism: Morris Moore and the Louvre *Apollo and Marsyas*

LATE IN THE YEAR 1849 Mr Francis Isaac Duroveray, a City merchant and publisher of illustrated classics, died in Brunswick Place, London, and a few months later his executors sent for sale the large accumulation of books, bronzes, engravings, drawings and pictures that he had amassed.[1] Most of these appear to have been of fairly mediocre quality, and Duroveray himself does not seem to have taken them very seriously.[2] However, Christie's the auctioneers were sufficiently impressed by a few of his pictures to single them out for special attention, and among them was an *Apollo and Marsyas* (Fig. 158) which—it was claimed—had once belonged to a well-known collector, John Barnard.[3]

Duroveray had himself been particularly attached to this very appealing picture, but had not apparently shown any interest in who had painted it. Christie's, however, then (as now) did not like selling anonymous pictures, and at the very last minute had given it the name of Mantegna.[4] Nothing could have been more unfortunate from their point of view, for in the very same sale was another picture also attributed to Mantegna (Fig. 159). Although this was of feeble quality, it was sufficiently Mantegnesque in style to make the attribution of the *Apollo and Marsyas* untenable, and it thus reverted, as it were, to anonymity.[5]

Because Duroveray's prints were of high quality nearly all the leading London dealers attended the sale, and so also did Charles Lock Eastlake, who had recently resigned as Keeper of the National Gallery, but who was still very influential in its counsels. The *Apollo and Marsyas* was the last item to be sold on 2 March 1850 and it fetched 70 guineas. From that moment onwards it became the most controversial Old Master of the second half of the nineteenth century, arousing violent passions in London, Paris, Dresden, Vienna, Berlin, Milan, Venice and Rome. Every connoisseur and expert became involved in the debate; every available method and technique was employed to determine its authorship. Names, from the greatest to the most insignificant, were suggested on all sides. The whole modern history of attributionism can be studied through a close analysis of the fortunes of this one picture.

The *Apollo and Marsyas* was bought by a dealer called Emerson on behalf of a client who had (apparently) already tried to acquire it privately from Duroveray in earlier years.[6] Even in an age when bad temper and obstinacy were very frequent, Morris Moore—nicknamed 'Taste' by his friends[7]—impressed his contemporaries through his quite excep-

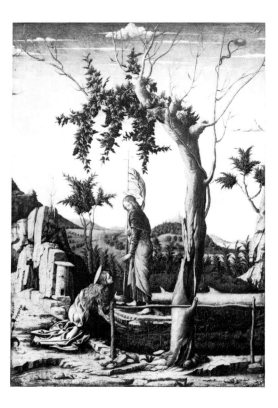

159. Mantegna (imitator of): *Noli me tangere* (London, National Gallery)

tional talents in these respects. He had been born in 1811 in a fortress in Lorraine, of English parents who had been interned in France during the Napoleonic wars.[8] As a very young man he had, after being destined for the Church, joined the navy, and then—fired by the example of Byron—taken part in the Greek war of independence. For many years he studied art in Italy, and for a time he shared a studio in Rome with the sculptor Alfred Stevens who in 1840 painted a fine portrait of him in the Venetian style (Fig. 160). On his return to London in the middle of the 1840s he began to launch a series of ferocious attacks on the National Gallery which concentrated essentially on two issues: the failure of the Gallery to buy masterpieces of the Italian Renaissance as opposed to later works by Carracci, Guido Reni and so on; and the ruthless 'cleaning' to which the pictures were subjected. He reprinted these letters to the newspapers, which appeared under the pseudonym 'Verax', in the first of the numerous savage pamphlets which were to punctuate his career at frequent intervals.[9] The pamphlet attracted a great deal of attention and won him a number of friends and admirers, but his unrelenting hatred of the National Gallery and especially of Eastlake, who was later to become its greatest director, had the most far-reaching effects on his career. At one time he evidently hoped to become director himself, and his inevitable failure to do so only soured his character still more.[10] In 1848 he turned to dealing,[11] and when, two years later, he acquired the *Apollo and Marsyas* he probably did so in order to sell it quickly for a profit. In fact he was to retain it almost until his dying day.

Accounts differ as to what exactly happened at the sale. One version has Eastlake looking at the picture rather nonchalantly and merely commenting: 'It's curious.'[12] According

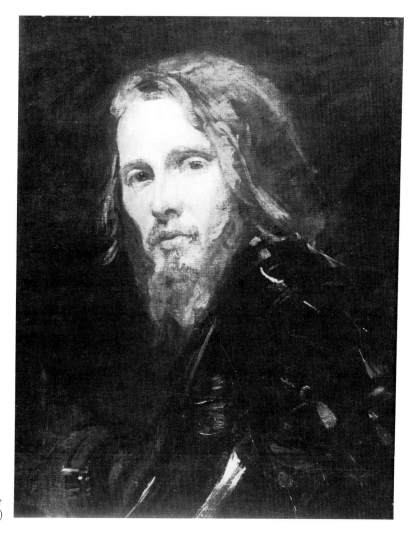

160. Alfred Stevens:
Portrait of Morris Moore
(London, Tate Gallery)

to another source, he put his head in his hands, and moaned: 'It was a Raphael, and we lost it.'[13]

Moore himself had no doubts. He carried the picture home, and—to the astonishment of his wife, who thought he had gone mad—he shut himself up in his room, lit all the candles, and spent the whole night gazing at it.[14] The effect on him was as dramatic as the vision on the road to Damascus had been to St Paul. He owned a Raphael—and the rest of his life was to be spent in trying to prove it.

A year later, when the first phase of the storm was at its height, the *Art-Journal* commented with weary, but justified, irony: discoveries of lost Raphaels were so frequent that 'we are enabled to foretell the date of their occurrence as surely as the reappearance of a comet, the return of the cholera, or the outbreak of a French revolution'.[15] This case, however, was not to disappear as quickly as some of its predecessors (or successors), and in view of the conflicting opinions it was to give rise to, it is fortunate that we know the reasoning by which Moore, in these early days, established its claim to be a Raphael.[16]

'Reasoning' is, perhaps, not the right word. He starts from the assumption that the picture is by Raphael, and then proceeds to compare details in it with those in other of the master's works dating from all periods—a procedure which he justifies on the grounds that Raphael was always prepared to copy himself. Thus the landscape recalls that of the *Vision of a Knight* in the National Gallery; the general treatment is similar to that of the *Sposalizio* in the Brera; the figure of Apollo is very close to that of St John in the tapestry cartoon of the *Healing of the Lame Man . . .* Such reckless juggling with chronology makes it difficult for Moore to date the picture by comparison with other works by Raphael. But he argues that the strong element of the antique in the figure of Apollo and the firm draughtsmanship and strength of simplicity show that it must have been painted after Raphael had been to Florence. On the other hand, the touches of gold on the lyre and bow, and even on parts of the foliage, and the Peruginesque slenderness of Apollo's legs show the work to be relatively immature. He concludes that it must date from about 1504, and—though showing no interest whatsoever in its provenance—he wonders whether it might not possibly have been painted in gratitude to Giovanna della Rovere who had given Raphael a letter of introduction to the Gonfaloniere Soderini in Florence.

Once he had satisfied himself that he owned a Raphael, Moore's first move was to show it to one of his closest allies in his campaign against the National Gallery; and then (very reluctantly), at his insistence, to get in touch with the National Gallery itself. One of the trustees was impressed, and a campaign began to be organised to buy it for the Gallery as being a work 'of great national importance'. A large number of artists, collectors and men of letters spoke enthusiastically about the picture,[17] but the campaign never really got off the ground, because Moore was now dealt a very heavy blow.

The recognised authority on Raphael was, of course, Johann David Passavant, whose *Rafael von Urbino und sein Vater Giovanni Santi,* published eleven years earlier, in 1839, was recognised throughout Europe as marking a milestone in art historical studies: for the first time, a scholar had tried to combine the biography of a painter with an accuracy of scholarship and attention to detail which had hitherto been used only in discussions of medals and prints. Moreover, Passavant had inaugurated the practice of including a catalogue raisonné of all those pictures which he considered to be authentic as well as an account of variants, copies and so on. Passavant's opinion was therefore of paramount importance. He was in Brussels at the time of the sale, and the sources conflict as to whether he hurried to London at Morris Moore's special invitation or took the initiative himself and came of his own accord. Anyway, he did come, he stayed with the Eastlakes, and on Friday, 24 May, he called on Moore, and said that a glance was sufficient to give him 'the unalterable opinion' that the picture was by Francesco Francia. Three days later, on Monday, 27 May, the two men met again in the print room of the British Museum, and Passavant said that he now thought that the picture might be by Timoteo Viti.[18] Morris Moore was not pleased by either verdict and wrote some bitter letters to the press, as did his friends,[19] and indeed, in view of the rumours that he had actually behaved with violence, a special letter had to be sent to the *Morning Post* by someone who was present at the meeting to point out that Moore had conducted himself with 'extreme politeness and even indulgence' towards the German art historian.[20]

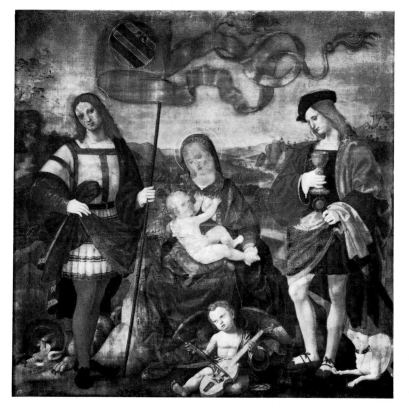

161. Timoteo Viti:
*Madonna and Child with
Saints Crescens and
Vitale* (Milan,
Pinacoteca di Brera)

The alteration, at such speed, of an 'unalterable opinion' laid Passavant open to some ridicule[21]—but the encounter can be seen as having a certain symbolic significance. It marks the first triumph of the art historian over the policy of unprofessional museum trustees (the question of buying the picture for the National Gallery virtually ended at this stage) and it inaugurates repeated clashes between empirical English connoisseurship and German scholarship.

In fact, however, German scholarship was as yet hardly involved, for it was not until many years later that Passavant made any attempt to justify his attributions. Nonetheless, we can try to reconstruct his probable reasoning. Timoteo Viti played a much greater role in Raphael's life for his nineteenth-century biographers than he does today, as he was generally held to have been the great man's teacher for a time, as well as one of his closest friends; moreover, Viti was believed—partly on the basis of forged documents—to have been the beloved pupil of Francia, who in turn was also a friend of Raphael.

Thus a case could be argued for attributing to either man potentially Raphaelesque pictures which were held to be not quite worthy of Raphael himself. The reputation of Francia was at its peak, and the paintings of Viti had the great advantage of being rapturously praised in the little available literature and wholly unfamiliar to almost everyone[22]— Passavant was later to claim that he had been struck by stylistic resemblances between the *Apollo and Marsyas* and a tempera by Viti in the Brera of the Virgin and Saints (Fig. 161). But why did Passavant not suggest the more obvious name of Perugino? Here he, and those who followed him, were being ingenious. There was in the middle of the nineteenth

century a strongly held belief, based on some real evidence, that Raphael had not only been influenced by the elder Francia and Viti, but that he had in turn influenced them; with Perugino, on the other hand, the relationship was purely that of a pupil who was infinitely more gifted than his master. Hence an attribution to Francia or Viti could imply that a work either derived from Raphael or led up to him. Even more important was a psychological consideration. The magic of the picture was held to reside in its youthfulness: it corresponded exactly to the mid-nineteenth-century view of 'the spring time of the Renaissance'; but the antique inspiration of the figure of Apollo seemed to make a date of before about 1504 wholly unacceptable. Had Perugino been the author, he would then have been a very old man—and no one could believe that the picture had been painted by anyone other than a youth.

Moore's position was now strengthened by two discoveries. On the border of the quiver at the feet of Apollo, he claimed—eight months after having acquired the picture[24]—to be able to detect Raphael's monogram R.V. picked out in gold dots, though he himself (unlike some of his supporters) usually played down the importance of this[25] and it was never shown in the engravings made of the picture (nor, indeed, is it visible today). Above all, a preparatory drawing came to light.

In 1822 the Austrian authorities enabled the Accademia in Venice to buy the great collection of drawings which had been assembled many years earlier by the Milanese neo-classical painter Giuseppe Bossi. Among these was the famous 'Raphael sketchbook', which for

162. Benedetto Montagna: *Apollo and Marsyas* – engraving (Oxford, Ashmolean Museum)

163. Perugino: *Apollo and Marsyas* – drawing in pen and ink with white lead (Venice, Accademia)

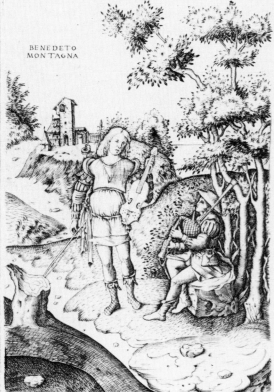
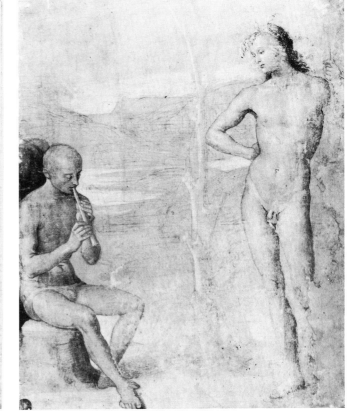

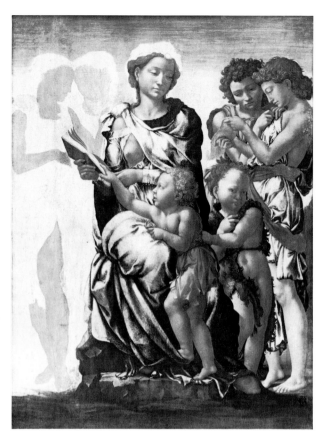

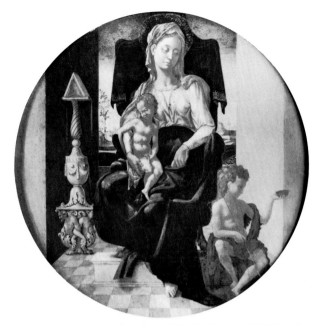

165. Antonio Mini (attributed to): *The Madonna and Child with St John the Baptist* (Vienna, Akademie der Bildenden Kunste)

164. (left) Michelangelo (ascribed to): *Madonna and Child with the Infant St John the Baptist and Angels* (The Manchester Madonna) (London, National Gallery)

generation after generation played so central and confusing a role in all studies of the artist, and many other drawings of varying quality. One of these (Fig. 163) was clearly of direct relevance to the *Apollo and Marsyas,* despite some very obvious differences which were to prove crucial in refuting the opinions of those who were to claim that the drawing had been made *after* the picture.[26]

It was not quite clear who was the anonymous friend of Moore who drew his attention to the drawing in about 1852.[27] Passavant later claimed that he had seen it in 1835, had thought of it as a Timoteo Viti[28] and had at once associated it with the *Apollo and Marsyas* which was then still in the Duroveray collection. But Morris Moore effectively demolished that claim.[29] In fact, only one person is known to have studied it for certain. Following a stormy political career, Count Leopoldo Cicognara, the historian of Italian sculpture, had, after the downfall of Napoleon, been appointed director of the Accademia, and had made a preliminary attempt to sort out the drawings, some of which were kept on perma‐ nent view in the galleries. On the mount of this one he had written the name 'Montagna'. It seems unlikely that such a distinguished connoisseur who was more familiar with Italian fifteenth-century art (especially in the Veneto) than anyone else in Europe actually believed that this drawing was by Montagna, and when, some twenty years after Cicognara's death the controversy was at its height, it was suggested—very plausibly, I believe—that he had written the name in order to remind himself of the engraving of the same *subject* (Fig. 162) by Benedetto Montagna, son of the well-known painter Bartolomeo.[30] Whether or not

this was the case it is hardly necessary to emphasise how much confusion was created by the attribution of picture and drawing to Mantegna or to one of the two Montagnas.

Moore and his friends were naturally eager to see the drawing and to obtain some sort of reproduction of it, but—so they claimed—Eastlake, alarmed by so unexpected a discovery, hurried to Venice to persuade the director of the Accademia, Pietro Selvatico, to remove it from public view, and it was accordingly taken to his private room and rendered totally inaccessible.[31] Revenge came in 1853. In that year a Committee was appointed to look into the affairs of the National Gallery, and Moore was called upon to give evidence. He did not spare his enemies, and in particular he made one charge that was to be of much importance for the future: he claimed that the Gallery had failed to buy a painting by Michelangelo, despite the fact that it was cheap and easily available, because they had failed to recognise that it was by him (Fig. 164).[32]

Moore himself had, in 1851, made just such a purchase (Fig. 165) or so he believed—and once again we can follow his reasoning in some detail: the lower part of the figure, he suggested, 'strongly resembles in design the celebrated figure of Lorenzo dei Medici, called "Il Pensiero" . . . the shaft and base [of the book stand] remind one of the candelabrum designed and sculpted by M.Angelo for the altar of the Cappella dei Medici'.[33] The argument hardly seems very persuasive, especially in view of the fact that Moore dated his picture to about the year 1495, but he was on stronger ground in suggesting that the so-called Manchester Madonna was by Michelangelo,[34] and he was to derive immense prestige—especially in France—from having been the first to identify a new work by the great artist. It proved easy enough to assume that a man who had discovered a Michelangelo could also have discovered a Raphael.[35]

Meanwhile the attempts to get a reproduction of the Venice drawing continued unabated—and unsuccessfully. In 1854 Selvatico published a catalogue in which he claimed that the drawing was indeed by Raphael and he even rather grudgingly related it to Moore's picture,[36] but although he finally allowed the making of 'a feeble copy by hand',[37] he and others made a series of excuses why no photograph could be supplied: the drawing was too indistinct,[38] the paper was red tinted,[39] the photographer was unable to manage.[40] A series of English friends were called in to help, the English consul tried in vain to intercede. Nothing could be done for three years until Moore went in person to Vienna to persuade the Austrian authorities to intervene.[41]

Moore's frustration will be understood by all too many readers of this paper, but the episode is not merely significant in revealing the unchanging characteristics of (some) museum directors. For many years there had been theoretical discussions in the art press about the part that could be played by photography in settling problems of attribution: this—as far as I know—is the first instance when someone actually tried to take advantage of the new technology for this purpose. It is one of a number of cases (to some of which I will refer later) in which Moore proved himself to be a pioneer in the history of attributionism.

Moore himself had first published his picture through the medium of a wood-engraving (Fig. 166) which was made for him by a radical printmaker, W. J. Linton, and which appeared in a very left-wing paper, *The Leader*.[42] It was later suggested that some of the

controversy aroused by the *Apollo and Marsyas* was due to political passions 'with radicals declaring for Raphael and Tories asserting the picture to be the work of a minor artist',[43] and although this is difficult to prove, it is worth pointing out that considerations of this kind may play a greater part in affecting taste and attribution than most scholars or connoisseurs would willingly admit. It is also worth pointing out that advanced politics did not—in nineteenth-century England—go hand in hand with sexual liberation: Apollo has been provided with a fig leaf, but the editor was careful to point out that separate impressions on better quality paper could be acquired showing the god 'before the alteration was made'.

The issue of reproductions was in these years coming to be seen as supremely important in questions of attribution and it had yet to reach a climax as far as Moore was concerned. Between 1857 and 1859 the brothers Alinari (then only at the very beginning of their careers) produced for the Florentine publisher Luigi Bardi a very large corpus of drawings by Raphael and certain other masters taken from the collections of Florence, Venice and Vienna, which appeared in English, French and Italian editions[44]—this was probably the most spectacular commercial venture in the field of art reproductions that had yet been undertaken anywhere. Bardi announced that the attributions would be those of the institutions concerned, thus (he must innocently have hoped) avoiding controversy. In the case

166. Perugino (engraved W. J. Linton, in *The Leader*, 7 September 1850): *Apollo and Marsyas*

167. Perugino (engraved C. V. Normand, in *Gazette des Beaux-Arts*, 1859): *Apollo and Marsyas*

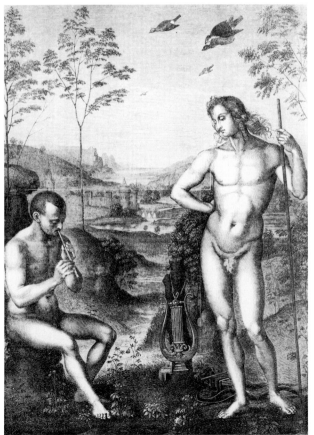

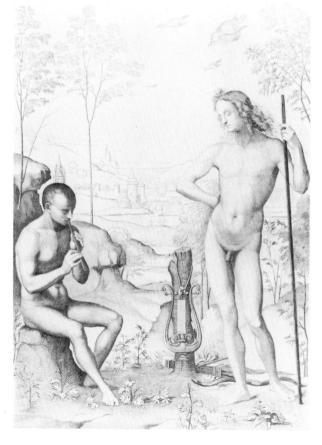

of the Accademia this was from Selvatico's catalogue of a few years earlier which had finally acknowledged that the *Apollo and Marsyas* really was by Raphael and had related it to Moore's picture. But on the mount of the photograph Moore was horrified to discover that, although his own painting was still mentioned, the drawing was described as being 'attributed by some people to Mantegna', thus once again implying that his picture might be by that artist. In a rage he called on the publisher, Signor Bardi himself, who was visiting Paris and staying at the Hôtel Byron in the Rue Laffitte. Faced with Moore's vigorous protests, he acknowledged that the name Mantegna had been inserted at the specific request of the patron of the whole venture, Prince Albert,[45] who was at that time doing everything in his power to promote the scholarly study of Raphael and who did not want to cause embarrassment to his friend and protégé Eastlake.[46] Moore replied that this was a 'mole-like conspiracy' organised by the Germans.[47]

He had indeed already experienced considerable German hostility, for, apart from Passavant, the other great expert on Raphael was Gustav Waagen, director of the Berlin Gallery and one of the most influential figures in the artistic life of England as well as of Prussia. In 1851 Waagen had agreed to look at the picture only on condition that he would not be required to make an attribution[48]—a most unusual request for a man so used to attributing pictures of every artistic school, but one that shows that he was familiar with Moore's quarrelsome nature. However, Moore not only rejected the proposal with contempt but also set off for Berlin late in 1856 in order to discredit Waagen on his home ground.[49] He was immediately arrested and spent an uncomfortable night in prison, accusing his German antagonist of trying to make use of the police in order to silence him. Disputes over attribution can arouse extreme virulence, but in this instance Moore's troubles were due to political rather than to artistic causes: he was accused of carrying letters from German political refugees in London to subversives in Berlin—almost certainly these must have come from Linton, the engraver of the *Apollo and Marsyas,* who did indeed keep in close touch with revolutionaries throughout Europe.[50]

Early in 1858 Moore took another step which marks a landmark in art historical studies. He decided to exhibit his controversial picture in the main capitals of Europe and thus—as he hoped—break through the constraints imposed by an Anglo-German conspiracy and inadequate methods of reproduction. Old Master exhibitions had been held before, though only in England were they a regular feature of social and cultural life, but never had a single picture been carried across so many frontiers in an attempt to win recognition. Not surprisingly, the venture aroused much curiosity, comment and debate.

In February he arrived in Paris—his first stop. He had hoped to show the *Apollo and Marsyas* in a room in the Palais de l'Institut, but when permission was refused, it and the hard-won photograph of the Accademia drawing were briefly exhibited in the Salon Carré of the Louvre[51] and thereafter in an artist's studio in the Rue de Grenelle.[52] The occasion was an outstanding success and it is entirely due to this success that the picture is in the Louvre today. Celebrities of all kind were enthusiastic; at Napoleon III's request it was shown at the Tuileries; and the Comtesse de Boigne who was ill was granted a private view of the picture in her *hôtel* in the Rue d'Anjou. Artists, writers and critics were almost unanimous in admiring it and accepting its authenticity: Ingres, Flandrin, Mérimée,

Delécluze, Charles Blanc among many others. The most interesting response it aroused was made by Delacroix, who was given a photograph of the picture by Moore and who wrote very perceptively about it in his diary on 23 February:

> Voilà un ouvrage admirable et dont les regards ne peuvent se détacher. C'est un chef d'oeuvre sans doute, mais le chef d'oeuvre d'un art qui n'est pas arrivé à sa perfection. On y trouve la perfection d'un talent particulier avec l'ignorance, résultat du moment où il a été produit. L'Apollon est collé au fond: ce fond avec ses petites fabriques est puéril; la naïveté de l'imitation l'excuse et le peu de connaissance qu'on avait alors de la perspective aérienne. L'Apollon a les jambes grêles: elles sont d'un modelé faible; les pieds ont l'air de petites planches emmanchées au bout des jambes: le cou et les clavicules sont manqués, ou plutôt ne sont pas sentis. Il en est à peu près de même du bras gauche qui tient un bâton: je le répète: le sentiment individuel, le charme particulier au talent le plus rare, forment l'attrait de ce tableau.

To Moore's fury occasional doubts about authenticity did find their way into print. An anonymous article in *L'Artiste* (said to be by Reiset, 'a trafficker . . . in works of art', as Moore characteristically called him)[53] once again raised the name of Francia, and this was repeated elsewhere. But, in general, the attribution to Raphael was not questioned, and two extremely important articles gave the picture the first serious examination it had yet received.

Henri Delaborde, then aged forty-seven, had started life as an artist. He had joined the Cabinet des Estampes as Conservateur-adjoint in 1855 and three years later he was promoted to being Conservateur en chef. He had spent some years of his life in Florence and he had a very thorough knowledge of Italian art: 'il avait trois admirations: son maître Paul Delaroche, Ingres et son école, les Primitifs italiens'.[54] In the *Revue des Deux-Mondes* of 15 July he published a striking article called 'Les PréRaphaélites à propos d'un tableau de Raphaël', which combined a scathing attack on the theories of Ruskin and on contemporary English painting with an unqualified affirmation of the authenticity of the *Apollo and Marsyas*. His argument was based essentially on quality and style—'cette tête d'Apollon, exquise de caractère et d'exécution, est en quelque sorte la signature même de Raphaël, elle seule prouverait l'authenticité du tableau'—but however much Delaborde may have loved the real primitives in general, he (like many of his contemporaries) was sufficiently disturbed by those whom he thought of as their modern imitators to feel some doubts about them when contemplating the impact that they had made.[55] In the context of an article on Ruskin and modern English art these doubts rose to the surface. Francia, he felt, was 'un peu trop en faveur aujourd'hui'; the talent of Perugino was 'foncièrement monotone'; only the young Raphael was capable of painting such a beautiful picture which should be dated between 1504 ad 1507. Delaborde paid no attention to the presumed signature, but it was perhaps he who first tried to give some documentary backing to the attribution to Raphael. Vasari, he pointed out, had said that during his second visit to Florence Raphael had painted and given to Taddeo Taddei 'due quadri, che tengono della maniera prima di Pietro [Perugino] e dell'altra che poi studiando apprese, molto

migliore, come si dirà'. Could the *Apollo and Marsyas* be one of these? As Vasari had not indicated the subject of either picture, such evidence was not very cogent, but Delaborde raised the question only in the most speculative and tentative manner. It was soon to be pursued more thoroughly and to harden into dogma.

Among authors especially praised by Delaborde was a young colleague, François-Anatole Gruyer (1825–1909), who had, until quite recently, been trained for a scientific career. What seems to have been a late-flowering interest in art had inspired a visit to Italy and a book on the *Stanze*. In 1859 he was persuaded by Charles Blanc, editor of the newly founded *Gazette des Beaux-Arts* with which he himself was closely associated, to publish an article on the *Apollo and Marsyas*.[56] A fine new engraving was specially made by Normand from a drawing by Chevignard (Fig. 167), and the merest glance is needed to appreciate how very great are the differences between this and the wood-engraving by Linton, and how precarious was a style criticism based on such unsatisfactory visual data. Like Delaborde, Gruyer pays no attention to the 'signature', and he bases his argument in support of Raphael's authorship principally on quality, with observations that are indeed very closely based on those of Delaborde. After an impressive survey of the various artists to whom the picture had by now been atrributed, he concludes, 'mais non, ce n'est ni Pietro Vannucci, ni aucun Florentin, ni Timoteo delle Vite, ni Francia, ni Mantegna, qu'il faut nommer ici: c'est Raphaël lui-même, car il est là tout entier'. He relates the picture to the *Three Graces* (then in Lord Ward's collection, now at Chantilly), and he carries Delaborde's 'documentary' evidence one stage further. One of the Taddei Raphaels, referred to but not alas described by Vasari, was known to be the *Madonna del Giardino* in Vienna (Fig. 168); could not the *Apollo and Marsyas* be the other, which had already left the Taddei collection by the seventeenth century according to Baldinucci, and which had later been sold in London according to a rumour recorded by Bottari?

The articles by Delaborde and Gruyer were sensitive and thoughtful contributions to the problem of attributing the picture. It is sad to have to believe that Moore may have been more impressed by an absurd and aggressive pamphlet published by a journalist called Léon Batté. Its tone makes it clear beyond doubt that this was inspired (if not actually dictated) by Moore himself, and it recalls all his feuds with Eastlake, Passavant, Waagen and others. Its arguments for the attribution read like a parody of those first advanced by Moore: similarities are detected with virtually every single known work by Raphael, including the *Disputa* (in which 'la même expression typique [of the Apollo] se trouve au moins douze fois aussi facilement lisible'), the Farnesina frescoes, etc., etc. Much emphasis is laid on the signature, and the Taddei provenance is almost taken for granted. Batté (*alias* Moore?) has no doubts at all: 'Le Raphaël de M. Morris-Moore est une des oeuvres les plus puissantes et les plus exquises de l'Art moderne, et de plus un tableau *unique* dans l'oeuvre de chevalet de Raphaël.'[57]

It is unfair to associate the admirable articles by Delaborde and Gruyer with Batté's ludicrous outpourings, but what must strike today's reader is that, however genuine their search for truth, *all* historians started from the (perhaps unconscious) assumption that the picture must be by Raphael, and then proceeded to dismiss alternative hypotheses. This can be demonstrated very simply: not a single author, as far as I know, ever suggested

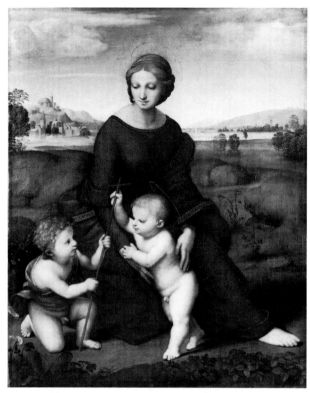

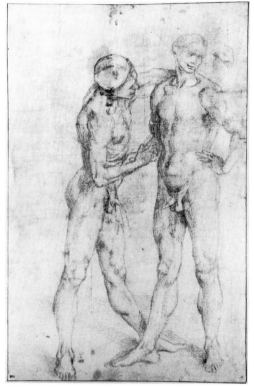

168. Raphael: *Madonna of the Meadow (Madonna del Giardino)* (Vienna, Kunsthistorisches Museum)

169. Luca Signorelli: *Two Male Nudes* (Paris, Musée du Louvre – Cabinet des Dessins)

that the picture might have been painted before about 1504. There was absolutely no extrinsic evidence for so late a date, but to have postulated an earlier one would have made Raphael's authorship of the picture almost impossible.

Moore was delighted with his reception in Paris—so different from what he had encountered in London and Berlin. The affair moved beyond the world of experts, museum officials and artists, and even the chroniclers took up his cause: a spirited piece by Edmond About mocked the English and commented that 'les amateurs et les experts se laisseraient tous égorger plutôt que de naturaliser un chef d'oeuvre qu'ils n'ont pas inventé. Le préjudice serait trop grand pour leur amour-propre et surtout pour leur intérêt.'[58] As we will shortly see, Moore never forgot French enthusiasm for his picture: for the moment he contented himself with presenting a fine Signorelli drawing to the Louvre (Fig. 169). In December 1859 he left Paris, first for Munich and then for Dresden, exhibiting his picture for nine days in each city to widespread acclaim, except from those he describes as Eastlake's agents. Early in 1860 (the year in which the second, French, edition of Passavant's *Raphael* was published in Paris, reaffirming that 'ce tableau, qui est à coup sûr de l'école de Francesco Francia, nous semble devoir être attribué à Timoteo Viti'),[59] the picture was shown in Vienna, in Venice and, shortly afterwards, in Milan.[60] Here Nemesis lay in wait, though Moore could hardly be expected to recognise this. Giovanni Morelli had as yet published nothing on art and although his gifts were recognised by a limited circle of acquaintances he was so little known generally that Moore could airily dismiss him as 'un certo Signor Morell [*sic*] di Bergamo, intrinseco dell'Eastlake'.[61] But his opinion that the picture was not by Raphael spread rapidly, and although at this stage he was credited with attributing

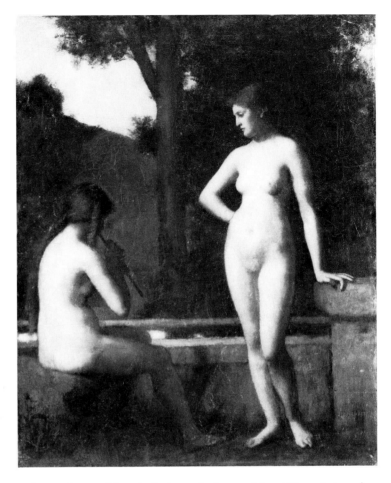

170. Jean-Jacques Henner:
Idylle (La Fontaine) (Paris,
Musée du Louvre)

it to Costa and was frequently to change his mind about it, it was Morelli's opinion that
was eventually to prove decisive.

In June 1860 Moore arrived in Rome. He at once carried his picture to the tomb of
Raphael in the Pantheon,[62] and thereafter he and the *Apollo and Marsyas* remained in the
city for a quarter of a century. Although the story is fascinating, if macabre, a full account
of his stay in Rome would be too long to give here. The 'Raffaelometer in General', as
Rossetti nicknamed him,[63] did not mellow with age, but there is some pathos in the quarrel-
some old man living in the Via Cavour, pouncing on visitors to persuade them of the
authenticity of his picture, pouring out his venom about the English and the Germans,
fighting the battles all over again with grim intensity, so that when he was afflicted with
the first of his many strokes, the doctors attributed it 'to injustice and consequent mental
distress suffered'.[64] Certainly no art lover has ever campaigned with such tenacity and
vigour for an attribution, and it was everywhere acknowledged that he did so out of a
love for the truth, as he saw it, and not for financial gain.

There were many compensations. It was still natural for painters to be consulted as experts
on attributions, and now—as always—painters were almost unanimous in accepting
Raphael's authorship. All the members of the Accademia di S. Luca gave public and fawn-
ing expression to their belief in Moore's attribution, and so did Overbeck, Cornelius and

Hippolyte Flandrin.[65] A more lighthearted indication of artistic admiration was the Giorgionesque pastiche exhibited by Jean-Jacques Henner at the Salon of 1873 (Fig. 170), but presumably based on sketches made when he was living in Rome between 1859 and 1864. Moore made a substantial contribution to the purchase of Raphael's birthplace by the city of Urbino, and on a visit there in 1873 he was welcomed in triumph.

Much more important, the greatest authorities on Raphael of the second half of the nineteenth century—Eugène Müntz in 1881[66] and Crowe and Cavalcaselle a year later[67]—accepted the picture as being by Raphael. Cavalcaselle, who had closely studied it not long after its purchase,[68] suggested that the picture had been painted soon after the *Three Graces,* 'at Perugia, under the influence of a temporary visit to the Tuscan capital', and this endorsement was (for a short time) influential. Meanwhile potential purchasers became increasingly interested. Even the English felt that a mistake had perhaps been made, and the director of the National Gallery called—anonymously—to inspect the picture.[69] And it was now that the French saw their opportunity.

By 1882 Delaborde and Gruyer, who early in their careers had so vigorously championed the *Apollo and Marsyas,* were men of great power, and were related by marriage. Delaborde had been Conservateur en chef of the Cabinet des Estampes for twenty-four years and Secrétaire perpétuel of the Académie des Beaux-Arts since 1874. He had kept in touch with Moore intermittently since Moore's stay in Paris and had consistently flattered him and his picture.[70] Gruyer, with a long list of publications on Raphael to his credit, was Conservateur des peintures at the Musée du Louvre. These were the two men who now began secret negotiations to acquire the 'Raphael' and the 'Michelangelo' for the Louvre.

The negotiations were prolonged and difficult, interrupted by ministerial crises and by lack of funds[71]—the 'Michelangelo' was eventually sold to the Prince of Liechtenstein, but although other foreigners were offering high prices for the *Apollo and Marsyas,* Moore was desperately keen that it should end up in the Louvre,[72] and finally, early in April 1883, Gruyer set out for Rome to see once again, after twenty-five years, the picture he had so much admired and which had been at the centre of so many controversies. The story of his reactions can be told in some detail and it is of extraordinary fascination. Before leaving for Italy Gruyer wrote to the director of the Louvre in order to put down on paper his views on the subject as a whole. He reviewed the whole saga, saying of Moore, quite fairly, that 'ceux-là même qui partageaient sa manière de voir, pour peu qu'ils n'eussent pas son intolérance, s'exposaient à ses invectives'. The Louvre, he said, could have acquired the picture in 1858 had the authorities been prepared to call it a Raphael. They had refused.

A mon avis, on eut tort. Celui qui vend et ceux qui achètent disparaissent. L'oeuvre seule reste, et c'est là l'essentiel. Le tableau d'*Apollon et Marsyas* est admirable, cela ne peut être nié par personne. Eh bien, portons les choses au pire : mettons que nous nous trompions et qu'on vienne un jour à nous démontrer que ce tableau est l'oeuvre d'un artiste qu'on ne soupçonnait pas encore. Nous n'en aurons pas moins enrichi le Louvre d'un chef d'oeuvre de plus, et nous aurons en outre doté notre musée d'un peintre dont on ignorait complètement la valeur, d'un peintre tellement fort qu'on peut à l'occasion le confondre avec le plus grand des maîtres.'[73]

It is worth pausing for a moment over this remarkable and moving passage. There can be no doubt that by now Gruyer had serious doubts about the attribution to Raphael; he knew, however, that, should he reveal those doubts, two consequences would follow: the government would refuse to put up the funds to buy the picture, and Morris Moore would refuse to sell it. He went into the transaction therefore prepared to suppress what he suspected would be the truth in order to obtain a beautiful painting. This is an important episode in the social history of attributionism and it should be recorded.

Gruyer arrived at Morris Moore's rooms in Rome on 24 April 1883: 'J'ai trouvé cet homme, jadis si terrible, terrassé maintenant par la maladie; mais j'ai senti toujours vibrer en lui la passion, l'idée fixe de sa vie. Ce tableau est quelque chose comme son oeuvre à lui. C'est lui qui l'a decouvert et il a épuisé toute son existence à combattre pour la plus haute des attributions.'[74] As for the picture, Gruyer found that his doubts about it were confirmed in its presence: 'On m'apporterait la preuve que l'*Apollon et Marsyas* n'est pas de Raphaël, que je ne me troublerais nullement.'[75] Nonetheless, he was as impressed as he had ever been by its supreme beauty, he consulted Delaborde, and he bought it for the 200,000 francs that had been agreed (more than a hundred times the price that Moore had paid for it). On 2 May he signed a contract declaring that in the ensuing catalogue of the Louvre it would be described as follows: 'ce tableau est connu depuis 1850 sous cette dénomination, *le Raphaël de M. Morris-Moore*'.[76] Although in fact the picture was labelled Raphael on the frame, the authors of later catalogues were only very half-hearted in observing the terms of this agreement, despite protests from Moore and—as late as 1921—from his son.[77]

Three weeks later the *Apollo and Marsyas* hung in the Salon Carré. Delaborde and Gruyer wrote about it enthusiastically to Moore; Jules Ferry, then Minister of the Arts, paid a special visit to see it. A question was asked about it in the House of Commons (this was the third time that the issue of the picture had been raised in Parliament) and there was a leading article in *The Times*.[78] Meanwhile, from Tours, in 1885, a man wrote to Eastlake (who had in fact been dead for some twenty years) offering to have it stolen from the Louvre in return for £5,000 so as to save the National Gallery the embarrassment it must be feeling. The letter is annotated laconically: 'Acknowledge receipt and say director has no reply to make.'[79]

But in fact the National Gallery was not feeling all that embarrassed. The renewed interest in the picture aroused by its sale to the Louvre had once again stimulated an intensive debate about the attribution, and gradually the name of Raphael came to be discarded—even in France. 'Nous sommes étonnés du silence gardé par les "autorités" françaises au sujet de l'oeuvre contesté', wrote Alfred de Lostalot as early as January 1884; 'nous comptons, parmi les fonctionnaires de nos musées, divers écrivains dont la compétence n'est pas discutable; chacun d'eux prétend reconnaître le nom de l'auteur, mais, quand on les interroge, ils sourient d'un air entendu et restent muets; jusqu'à ce jour il nous a été impossible de leur arracher leur secret. Quel est donc ce mystère?'[80]

The answer was that Giovanni Morelli had now openly intervened in the controversy, and Morelli was by far the most famous connoisseur of the day. We are told that 'no book of the like modest dimensions [as his *Die Werke italienischer Meister in den Galerien*

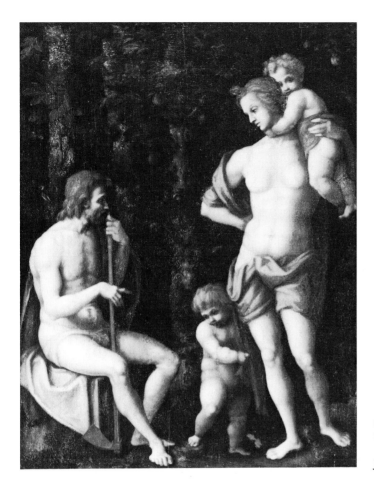

171. Bacchiacca (Francesco Ubertini): *Adam and Eve with Two Children* (Philadelphia, John G. Johnson Collection)

von München, Dresden und Berlin of 1860] has made so profound a sensation in the world of art and art criticism as did this brilliant and aggressive production'.[81] Yet Morelli was far from being brilliant and aggressive in this instance. He had had his doubts about the picture from the first and (in a quite uncharacteristic way) he constantly showed himself more ready to follow than to guide the opinion of others.

When the picture was exhibited in Milan in 1860, he was, as we have seen, reported as believing it to be by Costa[82]—partly because that had been the opinion of Otto Mündler. Later he denied having thought this, and claimed that he had assigned it to Marco Melloni.[83] For some time thereafter he accepted Passavant's attribution to Timoteo Viti, and then (without ever having seen the picture again) he changed his mind once more. He was shown by a dealer a small painting of *Adam and Eve* (Fig. 171) in which the figures were very closely related to those of the *Apollo and Marsyas*. The picture was said to be by Giulio Romano, but Morelli immediately reattributed it to Bacchiacca. He then deduced that Bacchiacca must have derived his compositon from the famous cartoon in Venice; and as Bacchiacca's master had been Perugino, therefore the cartoon (and hence Morris Moore's picture) must be by Perugino.[84] However persuasive the attribution, the argument by which he claimed to have reached it was not in itself very convincing: and although reasons of chronology make it impossible to accept in full the rebuttal made by one of

Moore's more loyal and combative supporters that 'unless it be supposed that Raphael carefully locked up his works in a drawer as soon as they were executed, Perugino's scholar, Bacchiacca, might just as well have plagiarised his fellow pupils as his master's work',[85] the principles behind his reasoning hardly seem less valid.

Indeed, Morelli's attribution, which has survived (more or less intact) to this day, was reached, after an extraordinary amount of hesitation, by most unMorellian methods, and he himself claimed to be doing little more than aligning himself with current opinion. In part this was true. His disciple Gustavo Frizzoni (who later acquired the Bacchiacca for his own private collection) had already made a far more ostensibly Morellian analysis of the picture than had Morelli himself, and in a remarkable (and unpublished) letter to Cavalcaselle he tried—in vain—to persuade him, entirely on stylistic grounds, that the picture was in fact by Perugino. He had, he explained, at first been so won over by its beauty that he had accepted the attribution to Raphael. Then came doubts—provoked essentially by the limbs of the figures. 'Nelle pitture autentiche di Raffaello giovane noi vediamo sempre ch'egli dà una rotondità e pastosità tutta sua caratteristica al nudo.'[86] In Moore's picture, on the other hand, 'entrambe le figure sono piuttosto scarne e per lo meno non cosi molli, e coi muscoli più rigidi e più tesi: La differenza già in questo punto mi parve cosi sensibile che dentro di me dovetti senz'altro escludere Raffaello.' Only Perugino—and it is striking that Frizzoni should have considered no one else—seemed to be a possible candidate. And so Frizzoni went to Florence to study Perugino. There he found the same slender elongated limbs—in the polyptich from the Accademia; and an almost identical landscape— in the *Agony in the Garden* (now in the Pitti). Parallels could also be found with the *Tobias and the Angel* in London. 'Insomma tutto, compreso il modo di dipingere, mi riconduce al Perugino.'

Cavalcaselle's answer was polite, but brief and basically uncompromising: 'Ella ha *perfettamente ragione* dicendo che il quadro del Sr. Moore mostra tutta l'impronta delle opere di Pietro Perugino: *Ma vi è qualche cosa di più per me, perchè in quella tavoletta ci vedo la mano del giovane Raffaello.'* No further argument was necessary—but, when commenting to Crowe on the exchange of opinions, he took Frizzoni's suggestions more seriously. Again and again he acknowledged the similarities with Perugino, but ultimately he could not avoid what was for him, as it had been for so many others, the main stumbling block: 'con tutta quella squisita esecuzione, ferma e diligente esecuzione in tutti i dettagli, caratteristica della mano d'un giovane'. And so he stuck to Raphael, fortified no doubt by his belief (which was surely correct) that Frizzoni could only have written his letter 'd'accordo Morelli'—the hated adversary.

In England, Martin Conway, another Morellian, pointed to 'the right foot of Marsyas and the wide division between the great toe and the rest' and said that such feet could be found in Perugino's *Combat of Love and Chastity* in the Louvre, but in no work by Raphael. And, even more important than such close observation, was his challenging of what by now amounted to a taboo: 'It is not the work of a struggling youth, but of a skilled and mature painter.'[87]

Morris Moore lived long enough to read about—and to assail with all the vitriolic indignation that might be expected of him—the beginnings of this renewed debate.[88] He

died on 18 December 1885. Four years later Gruyer finally broke his public silence. 'Il fut un temps—il y a de cela plus de trente années—où ce mystère n'existait pas pour nous. Nous étions dans l'âge des affirmations faciles. Depuis lors, il a beaucoup neigé sur nous, et nous en sommes maintenant à ce point de la vie où l'on dit *peut-être* plus volontiers que *certainement* . . . Nous avons beau nous raisonner, nous ne sommes plus absolument convaincus.'[89] Gruyer loved the picture as much as ever, and he had absolutely no regrets about having bought it for the Louvre. Once again he went over the old arguments and the old names: he dismissed the 'signature', and was properly sceptical about the Taddei provenance. None of the proposed artists fitted, and his sensitive discussion of Perugino provides a beautiful instance of old-style descriptive connoisseurship as opposed to Morellian 'science': 'Jamais Pérugin n'a donné pareille preuve d'intelligence en présence de l'antique. Remarquable dans ses vierges et ses tableaux religieux il a toujours été insuffisant dans ses interprétations de la Fable et faible aussi devant les nudités de la nature. Jamais un marbre antique ne lui a inspiré une figure comparable à celle d'Apollon; jamais un modèle vivant ne lui a permis de peindre une figure analogue à celle de Marsyas. Pérugin est un poète mystique, mais c'est un pauvre humaniste et un naturaliste insuffisant.' He could only conclude with a question mark: 'On le discutera sans cesse et on l'admirera toujours . . . Si l'on n'y reconnait pas Raphaël, qui faut-il y voir? . . . Voilà la question qu'on se posera longtemps encore et peut'être toujours.'

Gruyer was right. Although Morelli's attribution to Perugino has won very wide (if not universal) acceptance, this has perhaps been due more to quiescence than to absolute conviction: interest in the Quattrocento has much diminished since the nineteenth century. It would be rash to claim that the mystery surrounding the authorship of this lovely and poetical picture has been finally solved. Part of the trouble has indeed lain in its special quality. As Gruyer—and many others—pointed out, 'ceux qui reconnaissent ici l'esprit et la main de Raphaël s'appuient avant tout sur l'exceptionelle beauté de l'oeuvre elle-même. Cette beauté suffit à elle seule pour les convaincre. Toute autre démonstration leur semble superflue.'[90] The *Apollo and Marsyas* had so many of the features that connoisseurs of Italian painting looked for after the religious dogmatism of Rio and Lord Lindsay had begun to lose its hold, to be gradually replaced by the neo-paganism of Walter Pater (who spoke of it with special feeling)[91] and others. It was 'innocent' but not pietistic, and its very weakness—of anatomy and of construction—were the weaknesses of youth. And youth was synonymous with Raphael—or, rather, with the early Raphael. In support of, or against, these preconceived ideas, new technologies—photography and exhibitions made possible by modern transport—and new men—art historians—fought with varying success. These preconceived ideas can themselves only be reconstructed with difficulty. I have tried in this article to lay bare the reasoning behind the many attributions given to this picture, but I am of course aware that reasoning, however much it is later elaborated, plays only a small part in such issues. The flash of insight, the brilliant (or faulty) memory—these crucial elements inevitably escape our investigations.

And there is more to the problem than that, so much more that it is tempting to express it in terms of a paradox: the case of the *Apollo and Marsyas*—a controversial picture exposed to closer analysis than any before in history—is typical just because it is so exceptional.

It is exceptional because Morris Moore was such an extraordinarily difficult man—even by the standards of art collectors. His paranoia, his pathological hatreds, his invective, his mania for publicity necessarily brought into the open issues that are normally suppressed in discussion of this kind: and yet no observer of the art world can honestly deny that they are influential—and typical. Nationalism, personal feelings, unwillingness to acknowledge mistakes, financial considerations *do* play a part in the attribution of paintings, even when there is no question of conscious dishonesty. The endless fascination of the subject lies in the recognition that a straightforward answer is theoretically possible—someone *did* paint the picture—combined with an awareness that the most irrational, as well as the most rational, factors are going to obscure (or reveal) the truth. In no case is this complexity more convincingly demonstrated than in the story of the half-mad Englishman and his beautiful picture which is now in the Louvre because it was acquired by an imaginative director who had the sense not only to prefer quality to attributions but also to deny that very fact in public. It is a story that deserves to be remembered.

APPENDIX

This picture has recently been discussed (as a Perugino) by Sylvie Béguin in the catalogue of the exhibition *Raphaël dans les collections françaises* held at the Grand Palais (Paris, 1983–4), pp. 133–6. Mme Béguin appears to accept the recent and powerfully argued suggestion by Carlo del Bravo (' "Etica o poesia e mecenatismo": Cosimo il Vecchio, Lorenzo e alcuni dipinti', *Gli Uffizi, quattro secoli di una galleria,* Convegno internazionale di studi (Florence, 1983), pp. 201–16) that the subject represents not *Apollo and Marsyas* but *Apollo and Daphnis.*

12. A Turk and his Pictures in Nineteenth-Century Paris

THE NAME OF Khalil Bey will be at least vaguely familiar to anyone who has examined the careers of Ingres and (especially) Courbet, but the great collection of pictures which he built up in Second Empire Paris—'the first ever to be formed by a child of Islam', in the words of Théophile Gautier—has been little studied as a whole, and he himself has remained a tantalisingly elusive figure. His French contemporaries were intrigued by him, but they were also somewhat condescending, and were we to rely only on them for information—as has hitherto been the case—our judgement of him would be seriously distorted as well as inaccurate. In fact it is worth trying to reconstruct his career today not so much because it is of special fascination at a time when contacts between very rich Orientals and European art are frequently in the news, as because he was a highly cultivated (as well as dissolute and frivolous) art collector who may have played a significant role in the creation of one of the more mysterious paintings of the nineteenth century.

Khalil Bey was born in Egypt in 1831, his father having emigrated there from Constantinople to serve as a captain for Mehemet Ali, whose struggle for independence from the Ottoman Empire caused such military and diplomatic excitement in the West during the first half of the nineteenth century; and Khalil Bey was himself partly educated in an Egyptian school in Paris—one of the main sources through which Western ideas and culture were filtered to the East. His first public post was as Commissioner to the International Exhibition held in Paris in 1855; the following year he entered the Ottoman diplomatic service, and he was one of the plenipotentiaries engaged in signing the peace treaty which put an end to the Crimean War. Thereafter, he served as ambassador, first in Athens, and then in St Petersburg, where he made himself extremely popular in Russian society. 'In the entrance hall of Khalil Bey's palace at Foundoukli, on the Bosphorus', we are told in a contemporary account of him, 'is to be seen a stuffed bear of enormous size that was shot by the Emperor Alexander's own hand, and presented to Khalil Bey as a mark of His Majesty's esteem and friendship.' Disliking the cold of St Petersburg, however, he retired to Paris in a private capacity (his father had made a vast fortune in Egypt), and settled in expensive rooms in the Rue Taitbout (near the present Opéra), which he leased from Lord Hertford, the founder of the Wallace Collection.

Once in Paris Khalil Bey (Fig. 172) rapidly attracted attention as a spectacular gambler. 'He is', wrote an American journalist, 'one of the most imperturbable of the card players

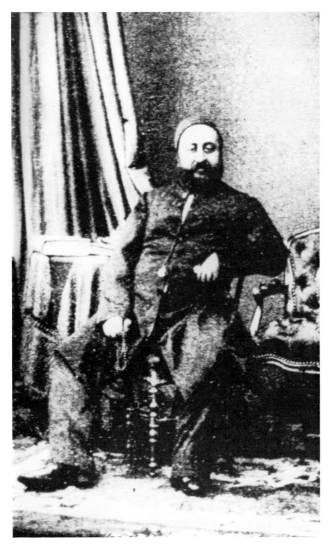

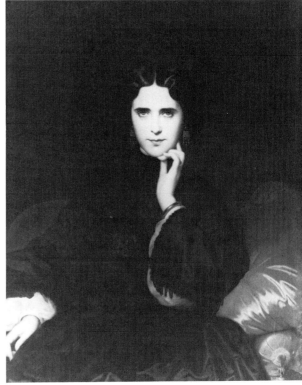

173. Eugène-Emmanuel Amaury-Duval: *Portrait de Madame* ★★★ [*Jeanne de Tourbey, comtesse de Loynes*] – Salon de 1863 (Paris, Musée du Louvre)

172. (left) Khalil Bey – photograph reproduced from *Bulletin de la Société des Amis de Gustave Courbet*, 1964

of the *grand monde*. He loses with the same impassible countenance with which he wins fabulous sums', and a few years later a French gossip writer commented that he was 'a prince from an Oriental tale . . . who remained Turkish through his lavish generosity and taste for women and gambling, but became Parisian through his wit, his elegance, his love of the theatre and the arts'. Rumours spread that he was as short-sighted as he was lustful, and that slave traders had several times sold him superannuated sultanas for his harem, but in fact he could see well enough to select as his mistress one of the most beautiful, as well as one of the most notorious, women in Paris, whose features are known to us through the intriguingly mannered portrait of her painted by Amaury-Duval (Fig. 173) just before their liaison began.

Jeanne de Tourbey is of particular interest to us in this context because it is through her that Khalil Bey made his close contacts with the leading writers and artists of the time. She had begun her sensational career some ten years earlier as a small part actress from the provinces, who became the mistress of a successful journalist and playwright, Marc Fournier, and from then on she never looked back. To list and describe her admirers could

in itself constitute a sizeable article—indeed, at least two have been largely devoted to the subject—and as Fournier, who had launched her, found his own career being advanced by her great social success, everyone remained satisfied. In time Jeanne de Tourbey was taken up by the Prince Napoléon, the Emperor's republican, ambitious, intelligent and cultivated cousin who apparently decided that to do him justice as a hostess she needed a little more intellectual polish than she had yet received. Sainte-Beuve was entrusted with the task, and he carried it out with great eagerness and success. It was now—in about 1864–5—that Flaubert, Renan and other leading French writers entered her orbit. How exactly she came into contact with Khalil Bey is not quite clear, but it may have been through the intervention of the shadiest of all nineteenth-century intermediaries between the worlds of Islam and the West, François Bravay, a crooked speculator who was to be used by Alphonse Daudet as the protagonist of his *roman-à-clef, Le Nabab*. But the very fact that Jeanne de Tourbey—'*la dame aux violettes*'—who seems to have calculated every step she took in her adventurous life should have decided that a rich Turk was a better bet than the Emperor's cousin shows us the position Khalil Bey had assumed in Paris society almost immediately after his arrival. It was not long before he was entertaining, and being entertained by, many of the leading writers, politicians and artists of the day.

Among the friends of Sainte-Beuve at this time was Courbet, and when Khalil Bey decided to form a collection of pictures, it seems likely that it was Sainte-Beuve who recommended a visit to Courbet's studio. Hanging there was a picture which is now known only through a photograph (Fig. 174) (taken when it had already been somewhat altered) and a later variant (which radically altered the original composition). The subject was *Vénus poursuivant Psyché de sa jalousie*, and the picture had been rejected by the Salon jury on the grounds of indecency. This makes it clear that the lesbian overtones implicit in the painting were immediately recognised; but in fact the story of the jealousy felt by Venus (Aphrodite) at the admiration aroused by Psyche's beauty had a reputable source in Greek mythology; and if we look at the record of Courbet's first treatment of it, we can accord some justice to his claim that, 'If this picture is immoral, all the museums of Italy, France and Spain ought to be closed down'.

Khalil Bey was not worried by such considerations and immediately wished to buy it, but was told that it had already been sold to a private client. Khalil Bey then commissioned from Courbet either a copy or another picture. News of this transaction rapidly reached Courbet's home town in the provinces, where a local newspaper managed to get hold of a garbled version of the story, which nonetheless gives us an idea of the impact of Khalil Bey on the artistic life of France: 'The famous picture of the *Two Naked Women* which was refused at the last but one exhibition has been sold by M. Courbet to a Turkish diplomat. Our painter is at this moment painting a pendant to the picture. No need to tell you that it's just as indecent as the first. After all it's for a Turk!'

The picture that Courbet painted for Khalil Bey was *Les Dormeuses* (Fig. 175), and to this I will return at some length later in this article. That it was a success is proved by the fact that Khalil Bey bought a number of other pictures by him, including the beautiful *Bathing Nude* (Metropolitan Museum, New York), *Les Braconniers* (Galleria Nazionale d'Arte Moderna, Rome) and, most notoriously, the nude described by Maxime Du Camp

in which 'through an extraordinary lapse of memory the artist, who had studied his model from the life, failed to represent the feet, the legs, the thighs, the belly, the hips, the chest, the hands, the arms, the shoulders, the neck and the head'. This was apparently kept locked up behind a panel on which was painted a village church under snow.

Apart from special cases of this kind, Khalil Bey acquired nearly all his hundred-odd pictures, modern and Old Masters, from dealers—mostly from Durand-Ruel. Among French painters of the first half of the nineteenth century virtually every famous name is included and some were represented by major works. The six pictures by Delacroix, for instance, included *L'Assassinat de L'Evêque de Liège* (Fig. 177), for which Khalil Bey had to pay 40,000 francs instead of the 1,500 it had cost the Duc d'Orléans, as well as *Tasso in the Hospital of St Anna, Ferrara* (Bührle Collection, Zurich) and *Tam O'Shanter pursued by Witches* (Castle Museum, Nottingham). With one very important exception

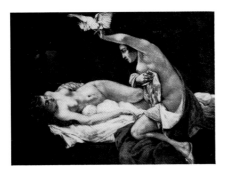

174. Gustave Courbet: *Vénus poursuivant Psyché de sa jalousie* (Whereabouts unknown)

175. (below) Gustave Courbet: *Le Sommeil (Les Dormeuses)* (Paris, Musée du Petit Palais)

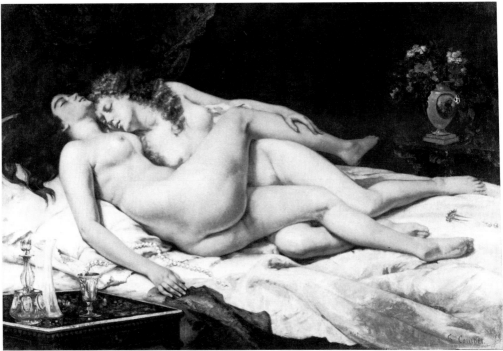

176. Théodore
Rousseau: *L'Allée des
Châtaigniers* (Paris,
Musée du Louvre)

177. Eugène
Delacroix: *L'Assasinat
de l'Evêque de Liège
(Guillaume de la Marck,
surnommé le Sanglier des
Ardennes)* – Salon de
1831 (Paris, Musée du
Louvre)

to be discussed later, his pictures by Ingres can no longer be traced and the Barbizon land-scapes are difficult to identify with certainty, but they included Théodore Rousseau's most admired masterpiece *L'Allée des Châtaigniers* (Fig. 176), which the State had made a vain attempt to purchase many years earlier.

Most of these would inevitably have to be included in any serious anthology of the finest French pictures of the nineteenth century. Indeed Khalil Bey's collection acquired its coherence not through any particularity of taste but through sheer quality—and that quality was, it must be admitted, to a large extent determined by his superior purchasing power and his access to the best dealers. By the time of the International Exhibition of 1867, when visitors from all over the world—including the Sultan of Turkey—flocked to Paris, Khalil Bey's was looked upon as one of the finest private collections in the city.

And yet there are certain pictures in that collection which must surely have had more

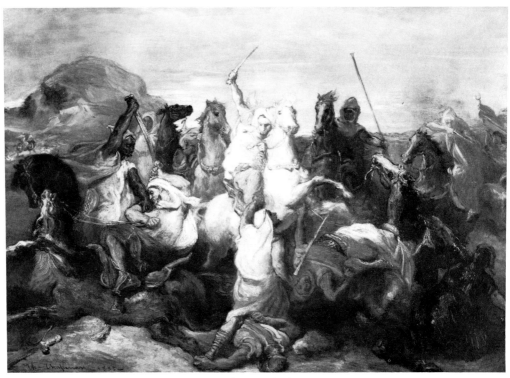

178. Théodore Chassériau: *Combat de cavaliers arabes* (Cambridge, Mass., Fogg Art Museum)

resonance for him than did similar works belonging to the bankers and industrialists, successful doctors and upstart aristocrats who were his main rivals in the dealers' galleries. For Khalil Bey owned a significant number of works by those French painters who turned out 'Oriental' subjects. Of these the finest was certainly Chassériau's *Combat de cavaliers arabes* (Fig. 178), and there were several of Fromentin's Arab scenes. It is unlikely that many of these could have recalled specific memories, but it would be interesting to know whether Marilhat's *Une rue du Caire* brought back to him the dusty, picturesque town of his childhood—he himself was born nearby in the very year that Marilhat visited the city, and his father could even have witnessed the massacre of the Mamluks that had fascinated Horace Vernet and other Romantic painters. Sitting in Second Empire Paris, surrounded by such pictures of an unfamiliar East, Khalil Bey naturally caught the imagination of his visitors. Perhaps, however, he himself was immune to the charms of a world that had grown strange and distasteful to him. Perhaps his schooling in France encouraged him to be more fascinated by such pictures as Gérôme's *Louis XIV and Molière* (Fig. 179), one of his most famous and expensive possessions. Did he, like Théophile Gautier, examine the expressions of the princes of the blood horrified by the familiarity of the King inviting a playwright to a meal? Alas, we do not have enough evidence to allow us to gauge the reactions to his pictures, whether of European or Oriental fantasies, of this Turk who was so at home in Parisian society.

Above all, we would like to know more about the exact circumstances that led to the acquisition of what is today considered to have been the most important picture in his collection, Ingres's *Bain Turc* (Fig. 180), though it is easy enough to guess why it should

have appealed to him. Recent research has, unfortunately, shown that he did not, as used to be thought, buy the *Bain Turc* from Ingres after it had been returned to the artist by its original owner, the Prince Napoléon: it would, after all, be pleasant to think that Khalil Bey's mistress, and masterpiece, both came from the same source. In fact, the two men owned different (but similar) pictures of the same subject, and we know only that Khalil Bey acquired his version in 1865.

Two years later in December 1867, at a private view before the sale of his pictures, the Goncourt brothers saw it and Courbet's *Les Dormeuses* hanging together. The *Journal* bitingly records their impression: 'And so, at the two extremes of art, these two popular idiots have both betrayed female nudity.' Reading these words, no one interested in French art of the nineteenth century can fail to be reminded of what Baudelaire described as the 'enormous paradox' that Courbet and Ingres had certain points in common: their war against the imagination. In that war, suggested Baudelaire, 'they are obedient to different motives; but their two opposing varieties of fanaticism (the *ideal* of Ingres and the *real* of Courbet) lead them to the same immolation'. Baudelaire never saw either of these two pictures; but, with his words in mind, as well as those of the Goncourts, and knowing that they both belonged to the same man, dare one suggest that they might in fact have been related? The picture by Ingres is the culmination of a whole series of similar composi-tions that go back for decades through his career. Moreover, the seraglio dominated the erotic imagination of the West for centuries. When the Sultan came to Paris in 1867 the question as to whether he would bring his harem with him and thus offend the chaste morals of Napoleon III and his court assumed notable importance. To Ingres, who had lived on this dream for much of his life, the *Bain Turc* would no doubt have been far more familiar than to Khalil Bey himself, and it is inconceivable that Khalil Bey can have

179. Jean-Léon Gérôme: *Louis XIV and Molière* (Malden Public Library, Massachusetts)

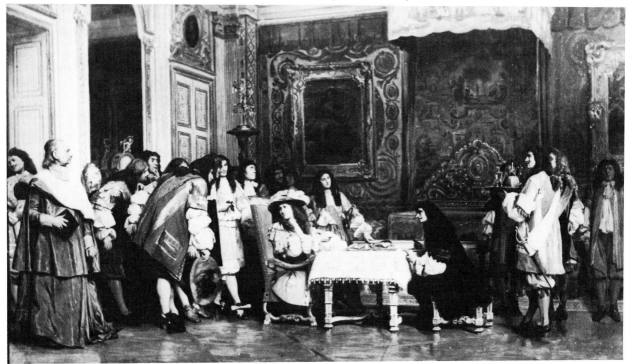

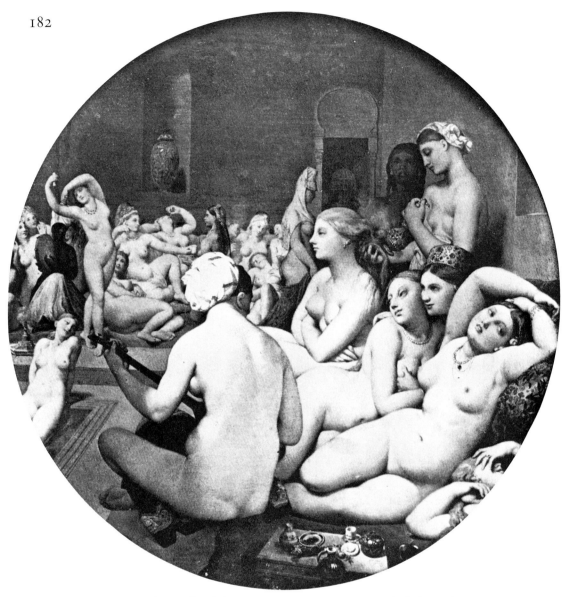

180. Jean-August-Dominique Ingres: *Le Bain Turc* (Paris, Musée du Louvre)

had any influence, direct or indirect, on the nature of the picture. It is, however, extremely tempting to suggest (but quite impossible to substantiate) that Khalil Bey told Courbet about the purchase, perhaps showed him the picture, and then suggested that the great 'realist' should paint a modern counterpart to this Oriental fantasy—in the light of our current knowledge, it seems that chronologically this hypothesis is just tenable. From other points of view it has much to recommend it.

That Courbet showed an interest in the art of Ingres and, on occasion, responded to it, has often been pointed out, and that this particular painting by Ingres might have particularly fascinated him, as well as Khalil Bey, seems likely enough. The muted lesbian under-

tones in *Vénus poursuivant Psyché* have already been mentioned, but the nudes in the right foreground of the *Bain Turc* are in many ways more provocatively posed than those to be found in that picture by Courbet which—it will be remembered—had so appealed to Khalil Bey. *Les Dormeuses*—though, of course, quite unlike the *Bain Turc* in composition—explores one of its underlying themes with a blatancy, a vulgarity even, that would have horrified Ingres, but which could nevertheless have been suggested by his picture. It is, in any case, worth pointing out that Courbet has rejected his earlier mythological subject in favour of one that is intended to be strictly contemporary; and if the above hypothesis—and it can be no more than the most tenuous hypothesis—as to its origin is accepted, this might well be because he felt that a challenge to Ingres could be made most successfully on the ground he had made his own.

Khalil Bey's expenditure on Jeanne de Tourbey; on his lodgings in the Rue Taitbout; on his pictures by Ingres and Delacroix, Courbet and Rousseau, Corot, Troyon and Daubigny, Meissonier and Gérôme; on the writers who flocked to his dinner parties—all this was considerable. But it was his gambling which brought him down. Towards the end of 1867 rumours began to fly through Paris of a forthcoming sale, and we are told that nothing else was talked of in the artistic world. In January 1868 the sale took place. 'Khalil Bey', announced *L'Artiste*, 'has collected a magnificent gallery of pictures despite the law of the Prophet which forbids the representation of figures ... now he has had the entirely Oriental fantasy of sending his collection along to the auction rooms.' Théophile Gautier was commissioned to write the preface to the catalogue and to puff it in the press. 'Everything', he claimed, 'has been carefully selected, and in this casket of paintings there are among the precious stones no bits of rubbish, no false pearls. Every artist is represented by one of his purest diamonds. A sure taste, a perfect sense of quality, a sincere passion for the beautiful have guided the owner of this rare collection.' That being the case, it was distinctly unfortunate that two paintings by Fromentin had to be hurriedly withdrawn from the sale when they were denounced as fakes; nor is it easy to understand how Gautier could have given his blanket enthusiasm to a collection which claimed to own the original of Watteau's *Le Voyage à Cythère* 'oeuvre capitale qui a toujours été citée comme le chef-d'oeuvre du maître': it was, continued the catalogue, only the sketch for this picture which Watteau had presented to the Académie.

In fact, the Old Masters in the collection seem to have included a number of rather dubious pictures, and only a very few of real quality, such as Terborch's beautiful *Officer dictating a Letter while a Trumpeter waits*, now in the National Gallery in London. Khalil Bey may have been the first child of Islam to have formed a gallery of European pictures; he was certainly not the last to be cheated by European dealers. Nevertheless, the sale went very well, and when it was over, Khalil Bey commented to the auctioneer: 'Life is really very strange. Women have deceived me, gambling has let me down, and my pictures have brought me money.'

In fact, we now know what most of his friends and mistresses did not know, and that is that Khalil Bey was far more than a spendthrift and philanderer with a love of art. While in Paris he had been planning the extreme liberal reforms which he felt had to be put into effect if the Ottoman Empire was to be preserved, and early in 1867 he made

a brief visit to Constantinople in order to have circulated there a pamphlet arguing the need for a constitution and an egalitarian régime in Turkey to save it from foreign intervention; while there he found the time to write some touching letters to Jeanne de Tourbey.

Courbet, Sainte-Beuve, Emile Ollivier, the Prince Napoléon—his liberal Parisian friendships take on a certain consistency if we realise (as his French contemporaries did not) that he was in his own way interested in importing some of their ideas into his native country: when he got back there he did, incidentally, sponsor the first production in Turkey of a modern play written in Turkish.

Khalil Bey left Paris to become Ottoman ambassador in Vienna, and then returned to Constantinople where he married the beautiful daughter of one of the most prominent of the reformers among the leading Turkish statesmen, and for a short time he himself became foreign minister. Meanwhile the Paris he knew disintegrated under the pressure of famine, German victory parades and the Commune. Madame de Tourbey, however, landed on her feet as easily as ever. Recovering with remarkable speed from any grief she may have felt at the departure of her Oriental lover, she soon married a rich count and presided over a smart salon which attracted some of the most extreme right-wing nationalists, emerging in time as one of the leading figures in the anti-Dreyfusard compaign.

And Khalil Bey himself? If we were to follow only contemporary French sources, we would indeed get the impression that he was like some figure from the Arabian Nights—vanishing first into thin air, and then suddenly appearing in several different places at once. People even describe his death in towns separated by hundreds of miles. A journalist who claims to have known him well in his heyday, met him some years after the Franco-Prussian war, much impoverished but still a compulsive gambler. With the odd duke or two he settled down to a game of baccarat with ten francs as the highest stake. Winning a few francs, he dreamt that his luck had turned and that he would be able to recover his fortune: a few days later he was reported dead. But, some years after this is supposed to have happened, another journalist claimed to have seen him in 1877 at the inauguration of the Paris Salon.

In fact he did come back to Paris for a few months in 1877 as Ottoman ambassador, and it must have been on this occasion—and not under the Second Empire, as has been said—that when presenting his letters of credence to the head of state and being asked by him, 'Well, Mr Ambassador, you must find things here very different from back at home?' he answered with his habitual insouciance, 'Not at all, we are just as backward as you are.'

The company he had known had vanished: Sainte-Beuve and Gautier were dead; Courbet, Emile Ollivier and the Prince Napoléon were all in exile; and, in any case, he himself soon returned, a very ill man, to Constantinople. Early in 1879 rumours reached Paris that he was dying: dull, unseeing eyes, a listless body suddenly shaken by such frenzied violence that a straight-jacket would have been needed to keep him under control. Some said that it was the thought of his lost millions, others that it was the effect of the syphilis he had picked up in Russia. He died soon after, and the obituaries, which failed to realise the role he had played in the modernisation of Turkey, were callous: 'he was witty enough

for a Turk, but not enough for a Parisian; subtle enough for a bourgeois, but not enough for a diplomat; he was really only fit to be a millionaire'.

It is hoped that the above notes on his collection have demonstrated how superficial, as well as condescending, were the opinions of those journalists who commented in this way. Perhaps the real significance of Khalil Bey lies in the fact that his picture gallery could not in essence be distinguished from that of any other rich man living in Paris at the time. To appreciate the full measure of his importance we need to see him against the background of those frivolous *turqueries* or ferocious barbarians who had conditioned the European vision of his country for centuries, and then to recall that this 'child of Islam' was perhaps the first such to be able to talk on equal terms with the most brilliant representatives of one of the most brilliant societies Western Europe has known; he helped to dispose of a picturesque but by now threadbare mythology, and emerged—for better or for worse—a 'modern man', and if for the journalists he still served as a symbol to tickle the jaded imaginations of the West, that was due more to their blindness than to his behaviour. For the career of Khalil Bey demonstrates what can today be verified by a visit to any auction room or art dealer in London, Paris or New York: European art for rich Islam cannot easily be distinguished from European art for rich Europe or America. And, when looking at some of the most remarkable pictures in the Louvre, the Petit Palais and other museums it is worth recalling the man in whose rooms they once hung.

APPENDIX

After the publication of this article Mr Michael Rogers of the British Museum kindly drew my attention to an article by Roderic H. Davison, 'Halil Şerif Paşa, Ottoman Diplomat and Statesman', *Journal of Ottoman Studies* (Istanbul), xi (1981), pp. 203–21. This adds a good deal of information to my very tentative biographical sketch and makes it clear that Khalil Bey was a figure of greater political significance than I had estimated. Mr Davison concludes that he was 'a cultured individual, although much more, it seems, in an occidental than in Ottoman fashion . . . Undoubtedly he was too westernized an individual for Istanbul of his time.' He died of a brain disease on 12 January 1879.

13. The Benjamin Altman Bequest

WHEN BENJAMIN ALTMAN (Fig. 181), founder of the New York department store that still
bears his name, died on 7 October 1913, leaving some $35 million to philanthropic institu-
tions in the city and to the Metropolitan Museum the greatest bequest it had ever received,
the *New York Times* commented that 'he was probably the most retiring man in New
York. Avoidance of personal notice of any kind was almost an obsession with him . . .
Could there be better evidence of the privacy with which he surrounded himself than
the fact that no newspaper has been able to procure and publish a portrait of Mr. Altman?'[1]
It is therefore hardly surprising that his personality has been so little studied in the now
flourishing literature, both scholarly and popular, that has been devoted to the formation
of the major American collections.[2] Wherever we look, we find indications of his reticence.
If too much publicity were likely to follow his purchase of a Velázquez or a Rembrandt,
he warned Henry Duveen, he would prefer to give up the picture altogether.[3] When nego-
tiating with the Museum about his bequest, he complained with indignation that rumours
of his intention had already begun to circulate.[4]

 On one occcasion Altman gave a rational explanation for the secrecy that he was so
concerned to maintain about his collecting: 'people, learning of the great amount of money
involved in the two transactions, are given to idle talk to the effect that the money must
be obtained, and that the prices of goods in the store will be advanced, or as customers
have previously expressed themselves: "Mr. Altman, I see, has just bought a new picture;
I suppose that is the reason things are so high."'[5] After his death, on the other hand, his
bewildering attitude was attributed by those who knew him to 'a desire to avoid even
the appearance of using his devotion to art as an advertisement of his business'.[6] There
is no direct conflict of evidence here, but both explanations are in any case too superficial.
Whatever the reasons—and we do not even know enough about these to speculate—
discretion was too deeply ingrained in his character to be accounted for purely by business
preoccupations. It finds expression even in his use of language. On one occasion he received
a cable from Henry Duveen: 'Rug I purchased yesterday is greatest finest have ever seen.
Will give me greatest pleasure submit it to you on my arrival.'[7] Five days later Altman
wrote him a brief letter that, after disposing of various matters, ended: 'Your cable regard-
ing the rug has been received for which I thank you. It evidently is a very fine rug.'[8]

 This same tone is revealed in the nature of most (though not all) of his collection of
paintings. While other millionaires of his day were amassing glamourised portraits of the

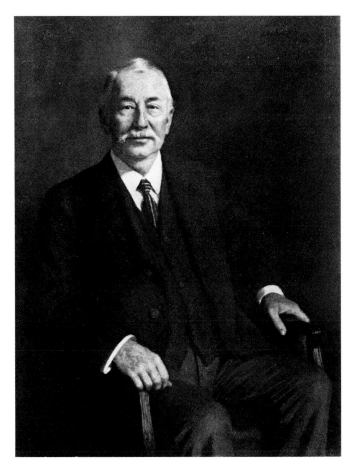

181. Ellen Emmet Rand: *Portrait of Benjamin Altman*, 1914 (New York, Metropolitan Museum of Art)

English aristocracy, Altman concentrated boldly on the severe, tight-lipped bankers and merchants of the Low Countries and Germany. It is when looking at Memling's *Tommaso Portinari* (Fig. 182) and *Portrait of an Old Man*, Dieric Bouts's *Portrait of a Man*, and, above all, Hans Maler zu Schwaz's *Ulrich Fugger of Augsburg* (Fig. 183) (for can one think of any reason apart from spiritual kinship for the purchase of this bleak, almost abstract, portrait?) that we seem to come closest to the inner core of Benjamin Altman. Here is the gallery of ancestors that *he* built up for himself.

Altman was, in fact, the son of Bavarian Jews who had come to New York in about 1835.[9] He was born in 1840, and, in the words of a rather condescending writer in *The Times* (of London), 'it will always remain a mystery to those who met him in his later years how this mild mannered little man could have built up so vast a business as that which bears his name'. *Little* is not the adjective that springs to mind when one looks at the benign but rather austere features that are so striking in the few surviving photographs, but mild mannered he certainly was towards the end of his life; it remains, however, truer than ever that his early activities are shrouded in mystery. His father ran a small dry-goods store, and Altman's education was brief—to the end of his life his grammar and spelling were inclined to be erratic. We know that he helped his father in the store and that in about 1863 he and his brother Morris set up business in partnership. Together

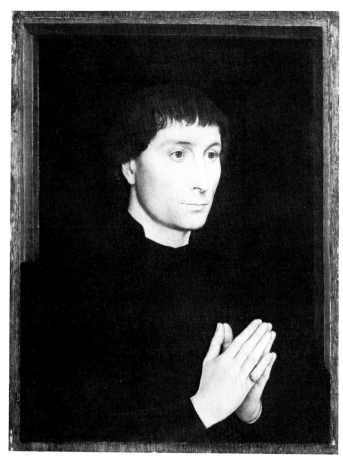

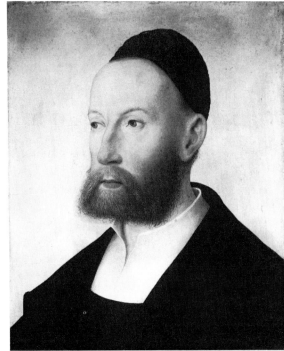

183. Hans Maler zu Schwaz: *Ulrich Fugger of Augsburg* (New York, Metropolitan Museum of Art – Benjamin Altman Bequest)

182. (left) Memling: *Tommaso Portinari* (New York, Metropolitan Museum of Art – Benjamin Altman Bequest)

they made something of a success, though the scale was still modest. Morris, apparently, campaigned to shorten the working hours of clerks in the dry-goods business, and in later years, when he himself was prosperous, Benjamin was among the first to provide luncheon, rest and medical services for his employees. It is not quite clear how long the association between the two brothers continued, but in 1876, when Morris died, Benjamin took over his interests and moved from Third Avenue to Sixth Avenue between Eighteenth and Nineteenth Streets. It was then that his enterprise began to develop with very great rapidity. He was obviously an extremely thorough worker, and, as will be seen from our examination of his activities as a collector, he would fully master every aspect of anything that interested him. All the same, the attribution of his fantastic success merely to 'hard work' must leave open a number of questions that as yet remain without an answer. After thirty years he established his store, by then vastly expanded, in its present location on Fifth Avenue at Thirty-fourth Street, thus pioneering the move of big business uptown. He never married, and although he expressed warm appreciation of his associates and employees, very little is known of any close friends. He died of kidney disease at the age of seventy-three.

No one can now say what first moved Altman to collect works of art. Was he merely following a fashion that was already current among the rich businessmen of his day? If so, he was unique in that, far from using his collection as a tool for rising higher in the

social scale, he did everything possible to avoid drawing attention to it. Was he already—for there can be no doubt about his later feelings—moved by an insatiable love of the beautiful? If so, it is strange that he scarcely ever visited Europe and showed little, if any, interest in the museums of his own town. These questions must remain unanswered. What seems certain is that in 1882 he visited a small exhibition of Chinese art that had been arranged by the young Dutchman Henry Duveen, who had settled in America five years earlier, and bought from him a pair of Chinese enamel vases.[10] From then until the very end of his life Chinese ceramics of all kinds remained one of his keenest interests, culminating in a collection of exceptional quality and importance.

In 1889 and again in 1890 he at last travelled extensively in Europe (and elsewhere in the world), but thereafter he only once left the United States. We know very little indeed of his other purchases during these first two decades of activity beyond the fact that they included a number of American paintings (which he later disposed of) and some good Barbizon pictures (several of which came to the Metropolitan Museum) as well as a number of very fine rock crystals and other examples of 'applied art'.[11] None of this distinguishes him much from many other collectors of his time.

With the beginning of the new century we first begin to hear of his interest in the Old Masters. It is true that after thinking over the matter for some time he turned down Hoppner's portrait of Lady Louisa Manners, for which Duveen paid a record price at auction in 1901,[12] and that two years later he rejected a Hobbema that Agnew's sent him on approval from London;[13] but (although it is likely that he already owned some Dutch pictures, which he subsequently got rid of) in 1905 he acquired, through Gimpel and Wildenstein, the first two of his pictures which still remain in his collection, the *Man with a Steel Gorget* (attributed to Rembrandt) and Hals's so-called *Yonker Ramp and his Sweetheart*.[14] In this same year he moved into a large new residence at 626 Fifth Avenue, which he began to fill with Oriental rugs, eighteenth-century furniture, and other sumptuous adornments.[15]

The great majority of his pictures were to be Dutch, and though the gross exuberance of the Hals strikes a surprising note among his generally sombre paintings, we shall see later that, in sculpture at least, Altman was not wholly averse to gaiety and riotous living. The following two years saw the purchase of two more paintings by Hals and another Rembrandt, as well as the first (and until 1910 the only) Italian picture in his collection— Montagna's *A Lady of Rank as St Justina of Padua*.

This was a reasonably distinguished opening, but in retrospect it seems scarcely more than a rehearsal for the truly spectacular year of 1908, on the second day of which he bought nine major pictures, all of them of the Dutch seventeenth century, with the exception of Van Dyck's beautiful portrait of the Marchesa Durazzo. The group included Vermeer's *Girl Asleep*, three paintings attributed to Rembrandt, and one each to Maes, de Hooch, Hobbema and Cuyp. All these pictures came from the collection of Rodolphe Kann in Paris, and as they and four pictures subsequently bought from the estate of Rodolphe's brother Maurice constitute the biggest single group from one source in Altman's collection (and in certain other American collections), it is worth discussing briefly the nature of that source.[16]

Rodolphe Kann, a bachelor who died in 1905 without having made a will, was in many respects so similar in background to Altman himself that one cannot help feeling that, along with his pictures, the American acquired something of his spirit. It is true that Kann's raffish features, as recorded for us by Boldini, have nothing in common with Altman's sober, dignified appearance, but in other respects the two men are comparable. The Kann brothers had been born in Hamburg and had then prospered as bankers in Paris, but they owed their vast fortunes to the diamond and gold mines of South Africa. They had begun to acquire pictures only in 1880, at very much the same moment as Altman, and in the course of twenty-five years had built up what were looked upon as the finest private galleries in Paris, and among the finest in Europe. Rodolphe Kann belonged to the 'forceful type [of new collector] and he set about the formation of a collection that should be of the rarest and best. He obtained the assistance of the most scientific connoisseurs. He backed their opinion with adequate resources.' In 1900 Wilhelm Bode published a massive, extensively illustrated volume on Kann's pictures, and it was doubtless from this and the even more lavishly produced catalogue in four volumes that appeared in 1907 that Altman made his choice. That choice was highly significant, for Kann's pictures (most of which were bought in England) ranged widely in period and country—from Northern and Italian 'primitives' to Gainsborough, Watteau, Fragonard and Tiepolo. The acquisition of the whole collection by Duveen's (in association with Gimpel) was one of the great coups of the Edwardian era, and it was from them that Altman bought his carefully selected pictures and a few pieces of sculpture. He entirely ignored the somewhat over-rich 'decadent' side to Kann's taste and concentrated almost exclusively on the Dutch seventeenth century. He missed what was the greatest masterpiece of all, Rembrandt's *Aristotle contemplating the Bust of Homer*, which went to Mrs Collis P. Huntington, but he did nevertheless boldly buy what were (or, in some cases, what were thought to be) those other late works by Rembrandt that constituted the special glory of Kann's collection: *Pilate washing his Hands*, the *Old Woman cutting her Nails*, and the *Portrait of the Artist's Son, Titus*.

Although (with the relatively small exception of a Terborch) Altman now waited for more than a year before buying additional pictures, such as Van Dyck's *Lucas van Uffel* (pl. 184), his acquisition of the cream of the Kann gallery had already established him as one of the most important of all New York collectors. And the consequences of his purchase were, in fact, decisive for his own future, and hence for that of the Metropolitan. At the time, one cannot help feeling, the most surprising result was his giving of a reception for 'friends, art lovers and patrons'.[17]

In 1909 it was planned to hold in the Metropolitan Museum two concurrent exhibitions—one of Dutch seventeenth-century paintings and one of American art—in order to celebrate 'the tercentenary of the discovery of the Hudson river by Henry Hudson in the year 1609, and the centenary of the first use of steam in the navigation of said river by Robert Fulton in the year 1807'.[18] The Dutch section of the exhibition was to be organised by the recently arrived W. R. Valentiner, curator of decorative arts, and on 10 February the director of the Metropolitan, Edward Robinson, called on Altman to ask for the loan of some of his pictures.[19] It comes as no surprise to learn from the cor-

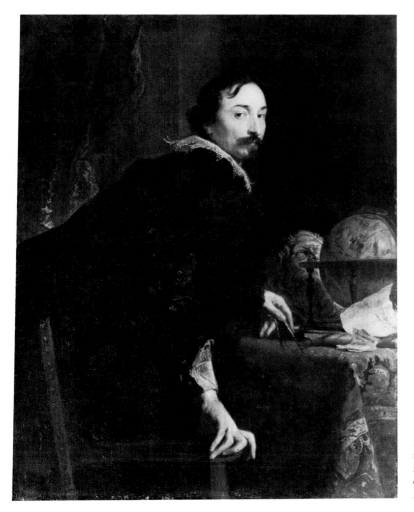

184. Van Dyck: *Lucas van Uffel* (New York, Metropolitan Museum of Art – Benjamin Altman Bequest)

respondence that followed this visit that Altman was extremely reluctant to make any such gesture to publicity; but any disappointment that this refusal may have caused Robinson was more than offset by the fact that he 'spoke to me at some length in regard to the disposal of his collection upon his death. He said that he had considered leaving his entire collection of works of art of all kinds to the Metropolitan Museum.'

Although as early as 1892 Altman had given the sum of $1,000 to help subsidise free Sunday openings of the Museum,[20] his relations with it had not hitherto been very close. Five years later he had refused to contribute to the purchase of a statue,[21] and, as we learn from the obituaries that only a very few people were ever privileged to see his pictures during his lifetime, it is not even certain that he had agreed to a request made to him in May 1907 that officials of the Museum should be allowed to look at the beautiful things in his house[22]—certainly there is no surviving letter to this effect in the archives.

The news, therefore, that he was thinking of leaving his collection to the Museum must have come as a wonderful surprise. There was, however, a serious drawback: Altman explained that he was deterred from taking any definite steps by his fears that the Museum

192

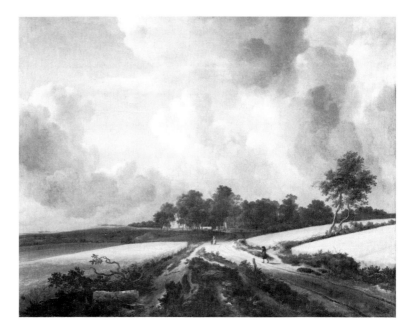

185. Jacob Ruisdael: *Wheatfields* (New York, Metropolitan Museum of Art – Benjamin Altman Bequest)

might not accept his condition that the whole collection should be kept together as a separate entity. In conversation with Robinson he now insisted that, although he was prepared to make an exception for his rugs and tapestries, he would not accept for himself the terms that the trustees imposed on other benefactors. Some indication of the extent of the collection by this time can be gauged from the fact that Robinson was reluctantly forced to agree that 'it was of such exceptional value and importance to the Museum, that if he insisted on his condition, rather than lose the collection I would favor the acceptance of his terms'. Altman did so insist, and at his request Robinson agreed to write to J. Pierpont Morgan, the president of the Museum, who was then in Egypt, asking him to use his influence to persuade his fellow trustees accordingly. Three weeks later he received a cabled reply from Cairo: 'my desire is great to meet his views and I will do whatever I can to accomplish it if requirements not too minute'.[23] To all intents and purposes this settled the matter, though there were many more discussions over detail (and the usual anxieties caused by Altman's dread of publicity) before Robinson was able, on 21 June 1909, to cable Morgan, who was now in Milan: 'The will was signed Friday in our favor.'[24]

As eventually modified not long before his death, Altman's will[25] obliged the Museum to exhibit permanently in at least two rooms, not less in floor space than those that had been devoted to the purpose in his private galleries at 626 Fifth Avenue, the entire bequest—and only that bequest. Moreover, 'notices of a proper size shall be placed and maintained in such room or rooms so as to indicate clearly that the collections therein contained were bequeathed to the Museum by me'. It must be admitted that such hankering for posthumous publicity comes strangely from a man who was so secretive in his lifetime, and (though sympathising with his dilemma) the outside observer can only share the regret expressed by Robinson at the nature of Altman's terms—terms that, as in the case of similar bequests in Europe and America, have not helped the cause of art and learning as fully as was evidently intended by public-spirited benefactors. Be that as it may, it is of the utmost

importance to realise that already by May 1909, more than four years before his death, Altman knew that his collections were to be bequeathed to the Museum. This knowledge unquestionably influenced the nature of all his remaining purchases and of many other steps that he now took.

The first of these was a compromise with the Museum authorities as regards the Hudson–Fulton exhibition. This opened in September 1909, and Valentiner explained in an addendum that 'the following works, generously lent by Mr. B. Altman, New York, were received too late to be included in the body of the catalogue'. The six of his pictures shown included some new purchases of exceptional quality and importance from the Maurice Kann collection in Paris;[26] he himself visited that city for the occasion and travelled also to Holland and Germany—the last time that he was to set foot in Europe.[27] Indeed, Altman made special efforts to ensure that the pictures reached New York before the exhibition opened, and the public was thus, for the first time, able to see Vermeer's *Girl Asleep* and Hals's *Merry Company*, as well as Ruisdael's superb *Wheatfields* (Fig. 185) and three magnificent Rembrandts, all just acquired: the so-called *Auctioneer*, or *Portrait of a Young Man*, the *Man with a Magnifying Glass* (Fig. 186), and the *Lady with a Pink* (Fig. 187). No better choice from his pictures could possibly have been made, and it would be interesting to know who was responsible for it: Robinson, Valentiner or—the most likely—Altman himself.

The second consequence of his (still secret) bequest to the Museum was his decision to have a special gallery built behind his house on Fifth Avenue (Figs. 188–90).[28] Though

186. Rembrandt: *Man with a Magnifying Glass* (New York, Metropolitan Museum of Art – Benjamin Altman Bequest)

187. Rembrandt: *Lady with a Pink* (New York, Metropolitan Museum of Art – Benjamin Altman Bequest)

the photographs that we have of this gallery date from after his death, when the final acquisitions had been made, it is likely that the principles governing its arrangement were established from the first, and it is of interest to examine them. The most striking feature (though it is one that Rodolphe Kann had also adopted) is the rigid separation of 'high art'—pictures and sculpture—from the decorative and applied arts that Altman was continuing to buy on a very extensive scale throughout all these years. The well-lit picture gallery was an austere place with no trace of the rich furniture, tapestries, rugs and so on that were, presumably, used to adorn the living rooms of the house itself. Thus Altman did not eat or sleep or work surrounded by his great masterpieces, as other collectors have often liked to do, and even the Chinese porcelain was kept severely isolated in glass cabinets in a second gallery. A further foretaste of the public museum was his grouping of the pictures (with a very few exceptions) into national schools and periods. Thus that same didactic purpose that he had ensured could not be theirs once the pictures became the property of the Museum was paradoxically insisted on by him in his own house.

Both the Rodolphe and the Maurice Kann pictures had been bought by Altman from the firm of Duveen Brothers, and although it is not true to claim (as has sometimes been done) that it was to them that he owed his entire collection, it is certainly the case that with no other dealers was his association so intimate. Although much must have been settled by word of mouth, enough of his correspondence with Henry Duveen (who spent some months each year in London and Paris) has survived for us to be able to gain some clear indication of his tastes and personality.

It has already been pointed out that Altman had made his first acquisitions of Chinese porcelain from Henry Duveen, and a close relationship between the two men continued for more than thirty years. Indeed, it seems more than likely that when Henry Duveen was in trouble with the law for infringing customs regulations, Altman was one of those who came forward to help him.[29] Though evidently marked by much friendship, the letters between them remain formal in tone to the very end. 'My dear Mr. Altman' and 'My dear Mr. Duveen' they almost invariably begin, but very occasionally one or the other will interrupt a sentence with a 'Dear Friend' or 'Friend Duveen'. On one occasion at least, the more spontaneous Duveen made a passionate plea that Altman should look after his health, to which came the rather frigid answer that 'your suggestions regarding taking care of myself are perfectly acceptable, and it is a fact that both of us should give attention to this. I am glad to know you are feeling so much better.'[30] Only very rarely do the letters ever touch on anything other than business affairs, and it must be admitted that when they do so, they are not of great interest: 'I presume that the people of both London and Paris, are terribly shocked as we all are here, at the appalling disaster which has just occurred at sea, and we all do hope that the proper measures will be taken to prevent a similar occurrence' is Altman's comment on the sinking of the *Titanic*.[31]

The friendship between Duveen and Altman was, however, exposed to constant risk by the directly opposing interests of the two men in two special fields. The first of these conflicts of interest is probably inherent in the relationship between client and dealer: Altman thought that Duveen charged him too much for works of art; Duveen thought that Altman was too slow in paying his bills. Both had some justification for the complaints

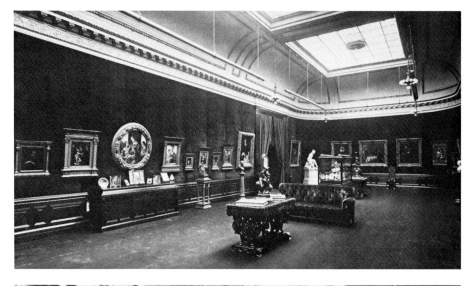

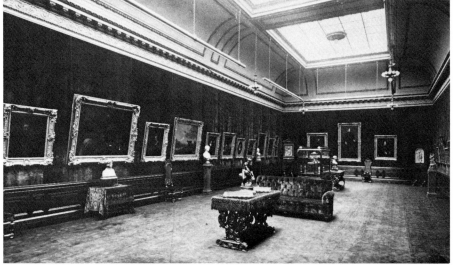

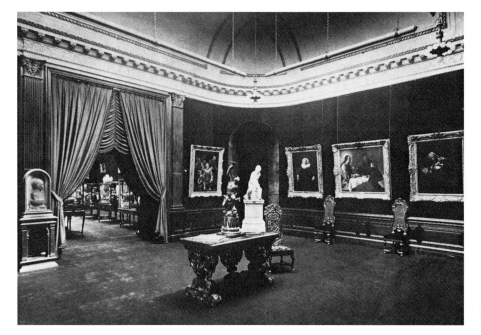

188–90. Altman's gallery at his home on Fifth Avenue

that occasionally flared up between them. The second conflict of interest, however, was peculiar to the particular men concerned: Henry Duveen (and especially his nephew Joseph, who was taking an increasing interest in the business) was as anxious for publicity as Altman was for discretion. Again and again storms would rage over this crucial matter. Altman would be '*terribly annoyed*', would find that Duveen's conduct 'amounts to a scandal and is outrageous and *inexcusable* and I can never forget it'.[32] Then the explanations and apologies would come pouring in, and everything would be resumed much as before.

Sometimes we can find a hint in these letters of that shrewd business sense and overpowering energy of will that had made—and was continuing to make—Altman so prosperous. He took the keenest interest in the new premises that Duveen's were having constructed in New York during the summer of 1912 ('our building' he once called it),[33] and when Henry was in London and Paris, he would receive long letters from Altman about the unreliability of the architect and the negligence of the builders: 'You can never depend upon their statements, nor even their judgement', he said, and to Henry's nephew Benjamin he wrote that builders and architects must be pushed the whole time, as he himself had had to do. '*Pushing means* that you want a knowledge of what is to be done and to see in *advance* they are *preparing for* it and will do it.'[34]

No one could read through this correspondence and believe that Duveen's were in a position to impose their own choice of pictures on a docile Altman. Though both Henry and Joseph recognised that he was 'a great friend and client of the house', they also felt that his independence of judgement and willingness on occasion to turn to other dealers made him 'slippery', and they had to devise careful tactics for dealing with him. 'I should like him to feel that he gets a bargain now and then, when we are able to take this course, having bought reasonably', writes Henry to Joseph, or 'I think you are making a grave mistake in showing Mr. A. too many things . . . Let him be hungry and enquire for beautiful things, and he appreciates our things because we only show him the very finest.'[35]

But, however 'particular' and 'slippery' Altman might be, the very conditions of travel and the art market inevitably forced him to rely heavily on the judgement of his dealers. Well-illustrated books and sale catalogues were still comparatively rare, and crossing the Atlantic took time. Consequently, the vast majority of pictures that Altman acquired were bought for him by Henry Duveen in Europe before he had actually had the chance to see them himself. Competition for great Old Masters was very keen, and quick decisions were essential. Moreover, for all their panache, neither Duveen's nor any other dealer had enough capital reserves to be able to make a habit of buying very expensive pictures without having definite clients in mind.

It was, therefore, Henry Duveen's business to bring to the attention of his demanding patron the sort of pictures he thought he would like and warn him off others about which Altman, who kept in the closest touch possible with all the available literature, would make inquiries. At the Doucet sale, for instance, 'a great number of things were only fit for French taste, being all of a class which we call "finicky" and effeminate, so much sought after by French people'.[36] At the Taylor sale, 'the Bronzino is a very fine and striking picture, but after all it is Bronzino and therefore decadent . . . Bronzino as you know is rather late as far as "great art" is concerned, and he is not an artist whom we should

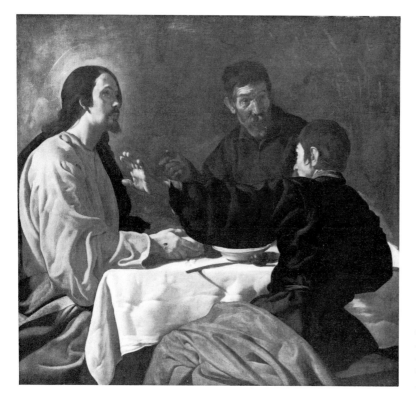

191. Velázquez: *Christ and the Pilgrims of Emmaus* (New York, Metropolitan Museum of Art – Benjamin Altman Bequest)

consider of any very great degree of importance.'[37] Another problem was that of 'unpleasant subjects', and Henry Duveen's category embraced a very wide range. While one can understand that Rembrandt's *St Bartholomew* ('an ugly man with a knife in his hand')[38] may merit the description, it comes as something of a surprise to learn that the same can be said of 'an interior with a woman nursing a child' by the same artist. Both Judith and Dido may perhaps be 'objectionable', but it is surely a strange taste that finds that the majority of Fra Angelico's pictures have 'disagreeable subjects'.[39]

It is not certain whether Altman ever actually told Duveen of the ultimate destination he had in mind for his pictures, but it was clearly understood by everyone that he was only interested in 'great art': more than once Duveen had to remind him that 'we can only approach you when we have something really and utterly GREAT'.[40] As far as this was concerned, however, his own taste was often more adventurous than that of his dealers. It was he who, toward the end of his life, was pressing again and again for a landscape by Rembrandt (he was probably influenced in this by P. A. B. Widener's famous purchase of Lord Lansdowne's *Mill*), whereas Henry Duveen would point out that 'I told you that we ourselves did not care overmuch for genre or landscape Rembrandts, but preferred portraits by that master, [which are] . . . more saleable and more understandable'.[41]

As Altman's collection grew better known—in July 1912 Joseph Duveen wrote to him from Paris that 'the fame of your collection is becoming more and more pronounced in Europe . . . Every French person who comes into our place seems to have heard of your Collection and is generally enthusiastic about it'[42]—he would sometimes get letters from perfect strangers offering him a strange assortment of pictures for sale. Thus, as early as

May 1909 he heard from a man in Málaga who was to insist that 'I am not a dealer, but a retired merchant, and a lover of Art,' which began bluntly, 'I have an authentic picture for sale by the great Master Velásquez . . .' This, in fact, proved to be the early *Christ and the Pilgrims of Emmaus* (Fig. 191), which, after some examination of photographs and expertise by Beruete (who, however, would not consent—as he had been asked to do—to call it a work 'of the first magnitude'), was acquired from Gimpel and Wildenstein before the end of 1910.[43] But not all the offers were so appealing.[44]

Altman's most spectacular venture into the field of Spanish art was also the purchase that caused him the most distress. In 1911 Agnew's acquired two full-length portraits by Velázquez of Philip IV and his minister Olivares from the Villahermosa Palace in Madrid, as well as receipts signed by the artist for payment he had received for these pictures. They were published in a very imposing brochure by the firm, and then bought by Duveen's, who sold them to Altman. The price of more than a million dollars was, however, leaked to the press, and the resulting publicity induced him, after much brooding and many bitter complaints, to sell back the Olivares.[45]

These examples will have shown that during his later years he was widening the range of pictures represented in his collection, in which the concentration had hitherto been almost entirely on Northern painters. He continued to buy works by these masters, but from 1910 he turned also to Italian art, and it was now that the character of his collection—like those of so many other American millionaires—began to reflect the taste and skill of Bernard Berenson, who for the previous two years had been working for Duveen's. Altman always relied scrupulously on the opinion of experts—Bode and Friedlaender for

192. Francia: *Federigo Gonzaga* (New York, Metropolitan Museum of Art – Benjamin Altman Bequest)

193. Titian: *Portrait of a Man* (New York, Metropolitan Museum of Art – Benjamin Altman Bequest)

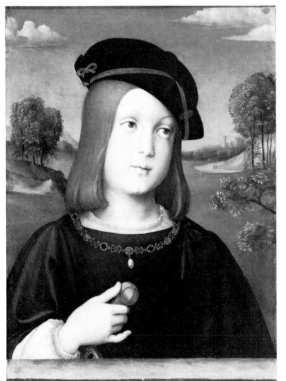

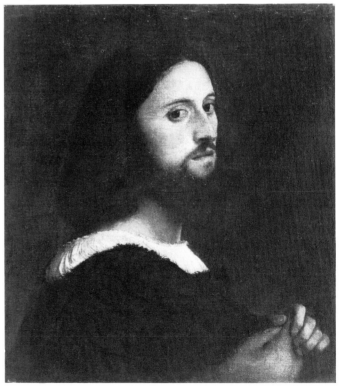

his Northern pictures, Beruete for his Spanish ones—but his reactions to the views of Berenson show that he was never prepared to accept their advice without question.

The first Italian picture to gain a permanent place in his collection since the Montagna, which he had acquired in 1907, was Fra Angelico's *Crucifixion*, which he bought in March 1910.[46] This was followed by Mainardi's rather tame tondo of the *Madonna and Child with Angels* and, in February 1912, by Francia's ravishing portrait of the ten-year-old Federigo Gonzaga (Fig. 192), painted for his mother, Isabella d'Este. It was in April of this year that there came his way the dream of every private collector in the world—a painting authoritatively attributed to 'the rarest, most wonderful, most fascinating and perhaps most discussed artist of the whole Renaissance—Giorgione!'[47]

Or was it? In 1895 Berenson had seen this *Portrait of a Man* (Fig. 193) at the famous loan exhibition of Venetian art at the New Gallery in London. It then belonged to A. H. Savage Landor, a descendant of the poet in whose house in Florence the picture had been kept. Berenson acknowledged its 'exquisite quality' but thought that it was 'a work by the young Titian, or else only a copy after such a work, the copy by Polidoro Lanzani'. Very pertinently he also pointed out its 'deplorably bad preservation'.[48] In 1912 it was acquired by Duveen, and in a rapturous private letter to Joseph Duveen, Berenson wrote: 'you may ask how I know it is Giorgione's—this head. To make a very long story short, I know it quite as well, and am quite as ready to prove it as that I know I am ready to prove that you are Joe Duveen . . . I am ready to stake all my reputation on its being by Giorgione.' In a more official letter to Messrs Duveen, two months later, Berenson elaborated: 'I would go further and challenge a comparison of your portrait [in his first letter he had written 'ours, as I already venture to speak of it'] with any of those that have ever been ascribed to Giorgione, and with any of those done by great pupils and rivals of his, like Palma or Titian. I am convinced that yours would come out triumphant as the unattainable model which they all had in mind from which they drew their inspiration.' There is nothing remotely surprising in the spectacle of a Giorgione scholar changing his mind when confronted by the unsuperably difficult problems posed by that artist's work. More curious, however, is the manner in which, during the seventeen years since Berenson had seen it, the portrait had changed from being in 'deplorably bad preservation' to a 'miraculously fine state'.[49] Visitors to the Metropolitan who ponder over this problem as they gaze at this sad, but still moving, ghost of a picture may be interested to know that Altman himself was not too happy about it. In May 1912 he wrote to Henry Duveen that

> the Giorgione has been placed in my gallery. I have given it the greatest consideration and have tried to study it with much interest as it is undoubtedly the work of a great master. I must confess, however, that I don't fully understand it, which has to be deeply studied. Up to now it has not impressed me as much as I should like, but I believe and hope it will grow upon me.[50]

It may have been this uneasiness that caused him to react firmly, only a month later, when he began to have some doubts about Botticelli's *Last Communion of St Jerome* (Fig. 194), which he had just acquired, and this episode should dispose finally of any idea

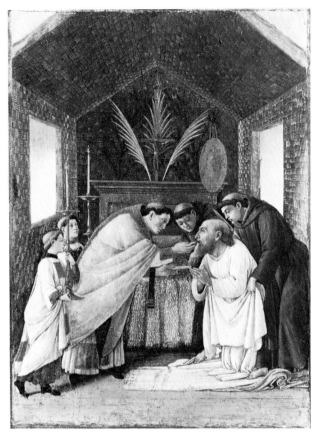

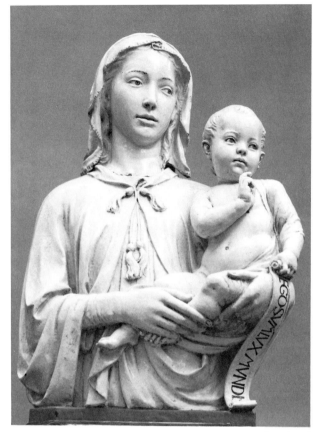

194. Botticelli: *Last Communion of St Jerome* (New York, Metropolitan Museum of Art – Benjamin Altman Bequest)

195. Luca della Robbia: *Madonna and Child with Scroll* – glazed terracotta (New York, Metropolitan Museum of Art – Benjamin Altman Bequest)

that Altman had no perception of his own. 'To my surprise', he wrote to Henry Duveen on 12 June 1912,

> upon examination and comparison of the Botticelli painting with the illustration in H. P. Horne's book I find that the Cardinal's hat has evidently been tampered with in some way, the hat in the painting has the positive appearance of having been repainted. Did you know of this, if so will you kindly let me know why it was done. I have sent you under separate cover a photograph which clearly shows a portion of the bed to be entirely obscured by the cardinal's hat while [in] the illustration in Horne's book the bed is seen through the hat.

Berenson was called in and was able to reassure everyone that

> the reproduction in Horne's book was taken from a photo made at least 15 years ago, as I happen to know perfectly well, when the process of photography was nothing like so perfect as it is now; and that all the difference which Mr. Altman may perceive is entirely due to that. Also that when the photo was first made, the picture was very slightly soiled by age, which soiling has since been cleaned away. I guarantee that the hat is precisely as Botticelli painted it at the time.[51]

Altman was not very happy about some of the other Italian pictures that Duveen's acquired for him—'I must tell you frankly', he wrote on 3 July 1912, 'that neither of them [the Mainardi and the Filippino Lippi] have made the impression upon me which I think they should, and I am inclined to think I don't care for them'[52]—and while this may have been caused by his far greater sympathy with Northern art, the unprejudiced observer will probably agree with Altman that his Italian pictures do not on the whole constitute a very exciting group. If only, one sometimes feels when reading through his letters, he had trusted his own judgement more than the opinions of Duveen and Berenson. It is true, however, that, as Duveen insisted on several occasions, 'fine Italian pictures generally . . . are very scarce indeed, much more so than you can imagine,'[53] and after the very battered Antonello da Messina, and the distinguished (but not, surely, GREAT) Mantegna and Verrocchio, one can easily understand the enthusiasm that he expressed toward the end of his life for Titian's fine portrait of Filippo Archinto, Archbishop of Milan.[54]

Fortunately, Altman had developed a taste for early Flemish and German art at much the same time as he was buying Italian pictures, and here, with the purchase of distinguished works by Holbein, Dürer, Gerard David and Van Orley, as well as the beautiful series of portraits by Memling and Bouts—most of these bought from Kleinberger on the advice of Bode and Friedlaender—he not only acquired paintings whose grave austerity seems to have been most in tune with his own taste, but also added to his collection works that hold their own with his great seventeenth-century masterpieces.

He was also on the lookout for scupture, which alone among all his variegated treasures he kept with his paintings in his picture gallery. Beginning somewhat modestly with Venetian andirons of the late Renaissance, he became much more ambitious after 1909, and in the course of the next four years he was able to acquire a few very fine pieces, though it must be admitted that some of his choices have about them an element of paradox. We can see the appeal for him of Luca della Robbia's tender, but very grand, Madonna and Child in enamelled terracotta (Fig. 195), and a number of other busts and religious groups that were bought, on the authority of Bode and Berenson, as by Donatello, Mino da Fiesole and other great names of the Tuscan Quattrocento, though the majority of them today would more likely be regarded as distinguished school pieces;[55] it is more difficult to visualise his relishing the entrancingly sensuous terracottas by Clodion (Fig. 196) or Houdon's graceful *Bather* (Fig. 197), part of a group designed for the Duc de Chartres in 1782. The superb quality of these works is beyond doubt, but it is not easy to reconcile them with the concept of 'great art' as formulated for Altman by Henry Duveen.[56]

Of all the sculptured works in his collection, however, the one that attracted the most attention was a cup of gold and enamel bought from the Rospigliosi family (Fig. 198). Sumptuous yet refined pieces of this kind—and the Altman cup is of excellent quality—had an irresistible fascination for the contemporaries of Fabergé and were at that time invariably attributed to Benvenuto Cellini. Altman followed their appearance on the market with the greatest interest and was reassured when Henry Duveen was able to inform him in 1912 that the one that Pierpont Morgan had just bought was 'very small, half the size of yours'.[57]

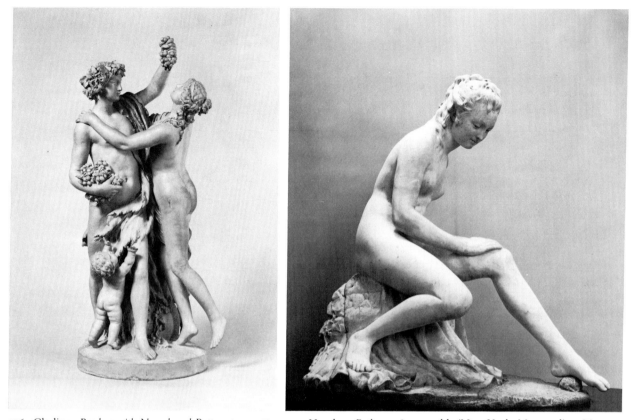

196. Clodion: *Bacchus with Nymph and Putto* – terracotta (New York, Metropolitan Museum of Art – Benjamin Altman Bequest)

197. Houdon: *Bather*, 1781 – marble (New York, Metropolitan Museum of Art – Benjamin Altman Bequest)

The last picture to find a permanent place in Altman's collection was, like the first, a Rembrandt; and for no work of art had he ever fought with greater passion.

In the spring of 1912 Baron Steengracht died, childless, in The Hague, and speculation at once began about the future of the famous art collection that he had inherited from his grandfather.[58] For many years it had been one of the chief sights of Holland, and foreign visitors had come to look upon it so much as a public institution that they were disconcerted to find it suddenly closed. Most of the pictures had been acquired in the 1830s when Baron Steengracht was director of the Mauritshuis, and, though not very great in number, they included a few of exceptional fame, which had been repeatedly published—Metsu's *Sick Child*, Steen's *Merry Company*, Brouwer's *Smokers*, and, above all, Rembrandt's *Toilet of Bathsheba*, signed and dated 1643 (Fig. 199). It was on this latter picture that interest was mainly concentrated during the year that followed its owner's death. After some months of rumour it was confirmed that all the paintings were to be auctioned in Paris, and eventually, in the middle of May 1913, a handsome catalogue was issued.

Duveen's had already been interested in securing the Rembrandt for Altman, and, after getting confirmation from Bode that it was 'really an *exceptionally fine* picture . . . in excellent state',[59] they remained in the closest, almost daily, touch with him about it. Altman made no attempt to conceal his enthusiasm, and the underlinings in his letters as well as repeated cables to and fro across the Atlantic convey something of the excitement that he felt: '*Now I should like to have that picture, especially if my information so far received is*

correct, it being I understand well worthy of my collection.'[60] But there were problems: it was known that the bidding would be very keen, and Altman was most anxious that Duveen's themselves should not act for him, but should instead employ someone not known to be working on their behalf, as he was all too aware of the fondness of the firm for making a splash. Such a proposal was completely unacceptable to Duveen. 'Our very absence from such a very important sale would provoke comment creating suspicion', they insisted in a series of coded cables that surrounded the deal with an atmosphere of melodrama.[61] Altman, however, was not so much worried about the price—though Duveen's had suggested that he would have to pay £30,000 for it, he himself said that he was ready to go at least £10,000 higher—as about the publicity, and this time Henry Duveen was careful to warn him in advance that, whatever precautions they might take, some leakage to the press was inevitable.[62] And there were further complications: Altman knew that the Metropolitan Museum was interested in the Metsu ('a dreadful subject', as Henry Duveen characteristically described it), the Steen ('fine quality but much too large vulgar picture'), and the Brouwer, and he naturally did not want Duveen's to bid for him against the Museum.[63] Finally, there was the fear that Kleinberger, who had acted for him on many occasions, would be offended by his desertion this time and would deliberately bid against him. As far as this was concerned, Duveen was able to reassure him not only that 'German collectors are very cautious prices they pay', but that in any case a conciliatory cable would do the trick—as it did.[64]

At last on 9 June the sale took place. Newspapers all over the world were able to announce that a new record (£40,000) had been established in the auction rooms, and Duveen cabled

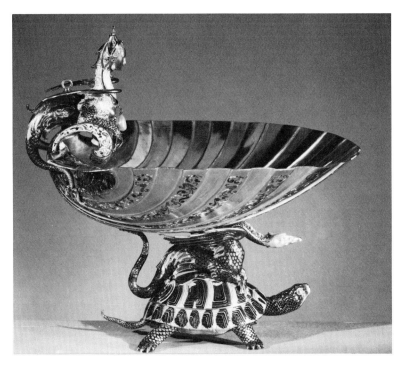

198. The Rospigliosi Cup (New York, Metropolitan Museum of Art – Benjamin Altman Bequest)

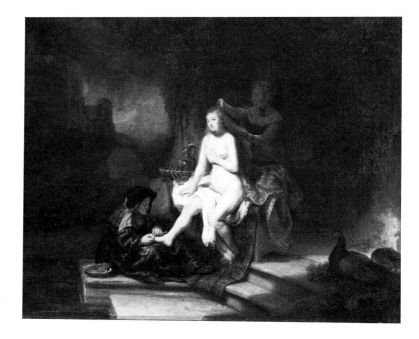

199. Rembrandt:
Toilet of Bathsheba
(New York,
Metropolitan Museum
of Art – Benjamin
Altman Bequest)

Altman that the picture was his, adding later in a letter that 'your "lucky star" has followed you, for had it not been for the tremendous drop on the Stock Exchange last Saturday and on the day of the Sale, I am *positive* that the price would have gone fully to your limit, if not over'. Altman's cable in reply to the news that the picture belonged to him will seem laconic only to those who have not studied his correspondence in detail: 'Many Thanks Very Happy Kindest Regards To All Altman.'[65]

Benjamin Altman was now aged seventy-three. His health was failing, and in April he had been saddened by the death of Morgan[66]—a rival collector but the man who had ensured that his bequest would be accepted by the Metropolitan. He was moreover very heavily involved in the extensive rebuilding of his store.[67] His intentions were still ambitious in the extreme: only two days after the acquisition of the Rembrandt, he wrote to Duveen of a rumour that Lord Radnor might be willing to sell his pictures: 'The pictures which particularly impressed me are the following:—Pierre Gilles "Quentin Matseys". Erasmus "Holbein". Children of Christian II, King of Denmark, also Mother and Child "Mabuse". The Velasquez "Juan de Pareja" did not strike me hard.' [68] And he showed interest both when Duveen's announced that they had bought 'a very fine Bellini . . . quite a "corker"' and when, even more dramatically, they referred to the possibility that the Duke of Devonshire might be ready to sell his entire collection.[69] Time was pressing. Already Duveen's had warned him that the English were becoming alarmed at the number of pictures leaving the country and were thinking of legislation to prevent this; now they wrote that the American government might be on the verge of reintroducing import duties on works of art.[70] But it was too late. Money matters were difficult, and Altman warned Duveen not only that during 1914 he could buy nothing more but that he was even thinking of selling Holbein's *Lady Rich*, which they had acquired for him some months earlier.[71] On 7 October he died. A few days later it became officially known that he had left his collection to the Metropolitan.

Benjamin Altman only started seriously collecting Old Master painting and sculpture when he was aged sixty-five, and from the first he must have realised that time was short. He once claimed that he always made up his mind quickly, and, given the scale on which he was buying, this is true enough.[72] Fifty-one pictures were included in his bequest, but he certainly owned many more at different moments, for we know from a number of sources that he was constantly weeding out works that no longer appealed to him or that no longer seemed sufficiently important.[73] Indeed he spent almost as much energy on trying to get rid of a Turner as he did on trying to acquire a Rembrandt.[74] Like all collectors at all times he responded to fashion, and he could on occasion desire a picture just because it was celebrated and apparently unattainable (he once toyed with the idea of trying to buy Gainsborough's *Blue Boy*)[75] or because some other collector had just bought one like it (he seems to have acquired Holbein's *Lady Rich* partly because Frick had bought the *Thomas More*).[76] Indeed, living as he did in one of the great epochs of art collecting, he was constantly observing the activities of his rivals—just as they kept an eye on him.[77] He certainly liked his pictures to be famous as well as beautiful and would worry if his Van Dycks were not to be found recorded in Bryan or his Dürer in the *Klassiker der Kunst*.[78] But he also had strong views of his own. He did not like majolica or ivories or drawings— even drawings by Rembrandt;[79] and although, like most collectors at the turn of the century, he accumulated rugs and tapestries, crystals and enamels, jewellery, and Oriental porcelain, he always showed himself far more keen on quality than on quantity. When he died, this was the point that was most strongly emphasised by many of those who were best aware of his tastes, such as Wilhelm Bode, Edward Robinson and Henry Duveen. How far, then, was he successful in his aim of building up a collection of masterpieces?

Surely no one can walk through the Altman rooms in the Metropolitan without being struck by a number of exceedingly beautiful paintings, sculptures and objets d'art. Tastes will obviously vary, but it seems likely that some of these would be included in most people's lists of treasures in the Museum: Van Dyck's superbly aristocratic portrait of Lucas van Uffel (Fig. 184), for instance, with its surprising combination of the instantaneous and the pensive; Rembrandt's *Man with a Magnifying Glass* (Fig. 186) and *Lady with a Pink* (Fig. 187); Francia's tender little *Federigo Gonzaga* (Fig. 192); one of the finest of all Ruisdael landscapes (Fig. 185); the beautiful *Young Girl peeling Apples* by Maes, to which one can turn with pleasure again and again even after gazing at Vermeer's *Girl Asleep* opposite; the Memling portraits (Fig. 182). Many more could be added, for this selection makes no pretence to be other than a personal one, and it is easy enough to visualise what a dramatic difference this magnificent bequest made to the Museum in 1913. Nevertheless, even in the issue of a *Journal* designed to celebrate the centenary of that Museum, it may perhaps be permissible to try to probe a little further and, considering the collection as a whole, to ask whether it entirely fulfills the ambitions of its creator.

The question should perhaps be put in another way. To what extent was it possible in the early years of the twentieth century for an American to build up a collection of 'great art' on the lines envisaged by Altman? The concept of 'great art' is central to the question, for by this term was clearly meant painting of a kind that had already been sanctified by the taste of half a century and that had earlier been collected with such con-

spicuous success by an institution such as the National Gallery in London: that is to say, works of the Flemish and Italian masters of the early Renaissance, the Venetian High Renaissance, the Dutch seventeenth century, and Van Dyck (but not Rubens—and not, more surprisingly, Claude and Poussin). Looking at the history of American collections in general, it will at once become clear that with the notable exception of Hals, Rembrandt and Van Dyck few acquisitions of really outstanding importance were made in these fields before the death of Altman. Isabella Stewart Gardner's collection in Boston, so wonderfully built up by Berenson, is the one outstanding exception, but elsewhere one may be reminded of those English aristocratic collections that attracted such vast attention all over Europe in the eighteenth century but that, in fact, acquired most of the more important of their treasures in the nineteenth. Similarly, if one again excludes the Gardner Museum and the special cases of Hals, Rembrandt and Van Dyck, one soon becomes aware that most of the really 'great art' in America (as both Duveen and modern taste would agree on the term) entered the country after 1914: the Frick and Washington Bellinis (1915); the Raphael *Small Cowper Madonna* (Duveen, 1913; Widener, 1917; Washington, 1942)—and this list could obviously be very much extended. Indeed, the richest single supply of 'great art' in this traditional sense was not available until the 1930s, when Mellon was able to buy some of the treasures of the Hermitage. Altman's collection must therefore be gauged not against the Platonic idea of some sublime 'museum without walls' but against the possibilities that were open to him—against, for instance, the Frick as it was in 1913; or against the purchases made by the Berlin Museum in the early years of the century, for we know from frequent complaints by Bode that Altman's resources were much greater than those of that institution. When looked at in that way it remains a great collection, but it cannot be denied that it suffers from the comparisons.

The real drawback, however (and it must be emphasised once again that drawback is a strictly relative term in this context), lies in the concept of 'great art', and here it is necessary to take another vantage point and give up trying to look, as we have until now, at Altman's pictures through his own eyes, but gauge them instead against a wholly different criterion, though it is one that is historically valid. If we now abandon the special meaning that Duveen attached to the term and broaden it so as to include such artists as El Greco and Goya, Fragonard and Tiepolo, Delacroix and Degas, we can see at once how great were the possibilities open to American collectors—and with what intelligence and discrimination many were able to take advantage of them.[80] For though the English, and the National Gallery itself, had excelled in accumulating the sort of pictures that Altman was later to search for, when faced with these less traditionally accepted masters, they suffered a complete failure of nerve—and it was lack of nerve rather than of finance that was responsible for their pitiful omissions. The lack in Altman's gallery of works by any of these masters, some of whom were superbly represented in other American collections of his day, must be noted by the historian of taste, but to insist upon it would lead to a total misunderstanding of his aims and achievement. Better by far to return once again to the Van Dycks, the Rembrandts, the Ruisdael and the Vermeer that this strange, silent man bequeathed 'to the benefit of mankind'.

14. Enemies of Modern Art

I WANT TO DISCUSS 'the curious and mad public which demands of the painter the greatest possible originality and yet only accepts him when he calls to mind other painters'.[1] Gauguin's brilliant *boutade* is to be found in a letter he wrote to Emmanuel Bibesco in 1900 and it is, I believe, the most acute observation yet made on the theme of my speculations here: the break, always noted but never seriously analysed except as a matter of polemics, between the public and a certain concept of modern art in the nineteenth century, as well as the consequences that this break may have had for the nature of art itself. For Gauguin's paradox seizes on the two conflicting (and often unconscious) attitudes toward contemporary art, the results of which are still with us: on the one hand, the search professed by virtually every writer of any significance for the new, the vital, the inspired, the unconventional; and, on the other, an almost uncontrollable distaste for just those qualities when (so it seems to us) they do in fact appear.

Let me begin with a startling and familiar example—indeed, I choose it just because it is so familiar. Just over a hundred years ago the journalist Albert Wolff (Fig. 200) began his article on the second Impressionist exhibition of 1876 with the following words:

> The rue Le Peletier is out of luck. After the burning down of the Opéra, here is a new disaster which has struck the district. An exhibition said to be of painting has just opened at the gallery of Durand-Ruel. The harmless passer-by, attracted by the flags which decorate the façade, goes in and is confronted by a cruel spectacle. Five or six lunatics, one of them a woman, an unfortunate group struck by the mania of ambition, have met there to exhibit their works. Some people split their sides with laughter when they see these things, but I feel heartbroken. These so-called artists call themselves '*intransigeants*', 'Impressionists'. They take the canvas, paints and brushes, fling something on at random and hope for the best.[2]

And so on . . .

Vulgar abuse, typical of the reactionary hostility met with by all great innovators? But Wolff, however mediocre, was in fact famous for his extreme liberal views in both politics and the arts. A homosexual and a Jew, he was pilloried by the right, associated with the opposition under the Second Empire, and claimed to be constantly on the lookout for young talent and to be eager to defend every kind of novelty.[3] He was, according to Jacques-Emile Blanche (the special friend and admirer of Degas), a critic of the extreme

200. Jules Bastien-Lepage: *Portrait of Albert Wolff* (London, Sotheby's, 9 May 1977)

left—in artistic, as well as in political terms (I will return to the confusion between the two). In other words, the most striking opposition to much that we today think of as modern art came from those who believed, and genuinely believed, that they were its most devoted supporters.

The problem I have raised has in fact never been more difficult to discuss than it is today. For we are all, to varying degrees, revisionists. Alma-Tadema and Gérôme are to be seen again in the sale rooms and feature in the theses of young art historians. We do not find it necessary to mock Couture when we praise his pupil Manet, or to assume that all art culminates in Impressionism, or in Cézanne or in the Cubists. We do not any longer believe that popularity is an infallible indication of worthlessness: indeed, in many fields (the cinema and architecture come to mind) the idea is again developing that popular approval is actually a sign of merit and virtue.

Nevertheless, all this admirable revisionism has led us to evade an important historical problem, which is that in the nineteenth century, for the very first time ever, in England, in France and elsewhere in Europe, an extraordinary number of great artists, from Constable and Turner, Ingres and Delacroix, Millet and Courbet, Manet and the Impressionists, Gauguin, Seurat and Van Gogh and so on, *did*—usually in the early stages of their careers at least—meet with a degree of incomprehension and often savage hatred that is to us astonishing. Astonishing, because so rarely can these painters be ostensibly linked with religious, political, social, moral or even sexual issues which do (very understandably) promote controversy. People roared with laughter over a landscape, lost their tempers over a guitar.

I know how many nuances are needed to turn this into the serious investigation that is actually required: how many of these artists had at least as many supporters as attackers;

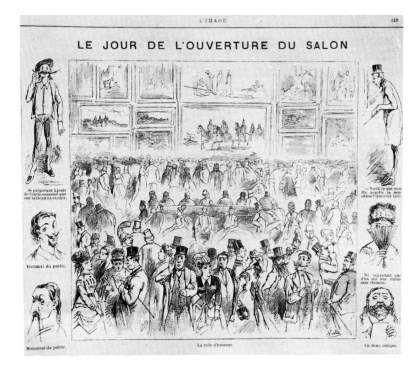

201. *Le Jour de l'ouverture du Salon*, from *L'Image*, 10 May 1868 (Gautier is 'Un doux critique' at bottom right)

how different, even actually antagonistic, could be the attitudes of the critics, of rival artists, of the public and of the authorities; how carefully we need to sift the evidence at our disposal, discuss personalities and gossip, corruption and twisted integrity. Still, it seems safe to say that, in the nineteenth century, many of the supreme artists worked in an atmosphere that was hostile or indifferent rather than welcoming.

Violent tirades against modern art were indeed commonplace between about 1815 and 1914, but although they continued for long after that they added little new to what had gone before, and I will therefore largely confine myself to the intervening hundred years and to France, where the issues were raised with the greatest vehemence, and also with the greatest clarity.

The nineteenth century itself was very well aware of the issues that concern us. Let us first read the words of the ageing poet and art critic Théophile Gautier, as he looks in bewilderment at the Salon of 1868 (Fig. 201):

Faced with all the paradoxes posed by this sort of painting it seems that one is afraid, if one does not accept it, to pass for a Philistine or a bourgeois . . . One feels one's pulse in something of a panic, one puts one's hand on one's belly and on one's head to reassure oneself that one hasn't become stout or bald, incapable of understanding the courage and daring of youth . . . One says to oneself: 'Am I a mummy, an antediluvian fossil?' And one is reminded of the horror which, some thirty years ago, was inspired by the first pictures of Delacroix, Decamps, Boulanger, Scheffer, Corot and Rousseau, who were kept out of the Salon for so long . . . And the more conscientious, when faced with such striking instances, ask themselves whether it is in fact possible to understand any art other than that with which one is contemporary, that is to say the art with which one shared one's twentieth birthday . . . It is probable that the pictures

of Courbet, Manet, Monet and *tutti quanti* do conceal beauties which are invisible to us old Romantics, whose hair is now laced with silver.[4]

This is a poignant acknowledgement—the first that I know of—of something that many of us have felt at one time or another. The only trouble is that, persuasive though it seems, it flies in the face of all the evidence; for why do we almost never hear of such attitudes of incomprehension or hostility before the nineteenth century? Where before the nineteenth century can one think of a single artist of talent, however original, who was not acclaimed at once: Giotto and Giorgione, Parmigianino and Caravaggio, Watteau and David, all so strikingly new in their own day, were all eagerly welcomed.

Nineteenth-century writers (and others since) have naturally been puzzled, as well as worried, by this fundamental change in attitude toward the new and the modern; and the favourite explanation given has usually been that a restricted group of select, aristocratic amateurs was—through the operations of the industrial and political revolutions—suddenly replaced in England and France by a large and undiscriminating public, interested only in small pictures, either of genre or depicting an affecting story, and, above all, highly 'finished'. In recent years (but even in the nineteenth century itself) this has been supported by rational arguments: the *fini,* or 'finish', it has been argued, provided evidence of work, and work was what appealed to the newly enriched middle classes (I use the word in no polemical sense) as opposed to the spendthrift aristocracy; moreover, 'finish', by reducing the role of the imagination and the part required of the spectator, was a safe, easily verifiable means of judging the value of a work of art (aesthetically as well as financially) for those without educated taste.

There is obviously something in this view. We have to try to account for the fact that a mid-eighteenth-century public found perfectly acceptable a landscape by Fragonard, say, whereas only eighty or so years later even the most carefully worked-over views of Corot could attract indignant denunciations as being lazy daubs. How tempting it is to attribute the admiration of the aristocratic patron, firmly ensconced in his hieratic society, to a sort of flirtatious complicity with the artist—from whom very likely he himself took drawing lessons, yet with whose lowly status he ran no greater risk of identification than did Marie Antoinette with a real milkmaid. Whereas, we could continue, the self-made businessman simply could not afford to identify himself with a painter whose own fortune might appear to come with such effortless aristocratic ease.

The attorney general's famous question to Whistler—'The labour of two days then is that for which you ask two hundred guineas?'—must have struck a responsive chord in many a juryman. It might even be possible to pursue the point a little further and suggest that, in portraiture at least, the reaction against 'finish' when it came later in the nineteenth century, is found mainly in the representation of two classes of sitter who did not work—and were not expected to work: that is, the second generation of those who had made great fortunes and who had bought themselves into the aristocracy, and (above all) women. I am thinking, for instance, of those patrons who had themselves and their wives painted by Sargent, in many of whose portraits the carefully arranged 'spontaneous' brushwork seems almost to be a deliberate and conscious metaphor for the spending rather than the saving of money.

Such theories are tempting, and I enjoy toying with them, and would welcome the results of further investigations along these lines. And yet the exceptions are all too obvious. And just because the equation between 'finish' and the 'bourgeoisie' is now so much of an *idée reçue* we must look at it at some length and with some care.

As I have already said, the nineteenth century itself certainly believed in the truth of this equation: 'The bourgeoisie is sure to admire this picture because it contains everything needed to please it: it is clean, it is finished, it is transparent'[5]—these words, written in 1802, constitute the first reference known to me to the notion that the bourgeoisie had a taste of its own in stylistic matters and not just in respect to subject. And the essence of this was to be repeated thousands and thousands of times thereafter. Does it correspond to the truth?

Throughout the first half of the nineteenth century English and French artists noted, with some apprehension, the increasing demands being made for a high 'finish' in art. David Wilkie, for instance, who had recently broadened his brushstrokes under the impact of seventeenth-century Spanish painting, wrote anxiously in 1839 that 'a smooth and finished style also gains, and is indeed exacted, bringing us nearer to Wynants, Gerard Dou, and Mieris, and aiming at that which our own great masters had not',[6] and if we look at the success enjoyed by Frith a few years later we can understand what he means. It may even be possible to correlate this change in style with a change in public and patronage. There is, for instance, a remarkable letter addressed to Frith in 1843 from one of the leading art patrons of the first half of the nineteenth century, John Gibbons, an ironmaster, very typical of the art lovers of the manufacturing classes who were coming into prominence just then: 'Just let me mention, while I think of it, that *I love finish*, even to the *minutest details*. I know the time it takes and that it must be paid for, but this I do not object to . . . Where there is beauty, finish, and taste, I care but little about "originality"' (Fig. 202).[7]

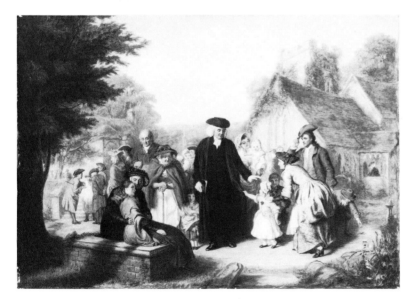

202. William Powell Frith: *The Village Pastor* (Christie's, 19 May 1978), the original, or a version, of the picture painted by Frith for John Gibbons

Finish—everyone knows that the concept becomes an obsession with the nineteenth-century art critics: all the innovating painters were attacked for their lack of finish, and all rebelled against its tyranny. Yet 'finish' was not a purely philistine burden imposed on the artist by an insensitive public. Many painters, some of them talented, and, often, deeply sincere, themselves visualised 'finish' in moral, almost religious, terms—even when there was no question of it being forced on them. There is no need for me to refer to the Pre-Raphaelites: a far more revealing, even moving (though perhaps to our eyes slightly absurd), expression of this attitude is to be found in the letters of the twenty-three year old English (but German-trained) artist Frederic Leighton.

After visiting Florence in 1853 and being overwhelmed by the Old Masters, he wrote that

> every little flower of the field has become to me a new source of delight; the very blades of grass appeared to me in a new light. You will easily understand that, under the influence of such feelings, I felt the greatest possible reluctance to *sketch* in the hasty manner in which one does when travelling; I shunned the idea of approaching Nature in a manner which seemed to me disrespectful and the consequence was that until I got to Verona I did not touch a pencil. In Venice and Florence, however, I made several drawings, some of which are most highly finished and afforded me, whilst I was occupied on them, that most desirable kind of contentment, the consciousness of endeavour. Of course I was obliged to conquer to a certain extent my aversion to anything but finished works, and, accordingly, I made a considerable number of *sketches 'proprement dits'*.[8]

I insist on this, because no one looking at Leighton's very attractive studies of the Italian landscape (Fig. 203) would ever guess that they were the product of tortured willpower rather than spontaneous delight. And this evidence should, I think, encourage us to be very sceptical about the whole notion of an imposed bourgeois taste. In fact, both in England and in France, small finished pictures were, at the beginning of the century, patronised largely by the aristocracy. And the campaign against even the very restrained middle-aged Turner was organised by Sir George Beaumont, a leading aristocratic connoisseur, while large quantities of the artist's later, more idiosyncratic pictures and watercolours were bought by the newly rich members of the middle classes.

All this you may think is exceptional, but let us turn to France and test the hypothesis by following for a few minutes the career of the single painter of the whole century who, in his own lifetime and ever since, has been charged with being the bourgeois painter par excellence—Paul Delaroche: a man, so it is said, who deliberately watered down the great Romantic innovations of Delacroix so as to make them acceptable to a 'bourgeois' public that was capable of responding only to finicky anecdote and melodrama.

Delaroche knew what was said about him and went out of his way to deny it, and we are entitled to believe him when he protests in the language of the proverbial misunderstood artist starving in his garret: 'Who can accuse me of having scratched at the door of the powerful to obtain [fame] . . . whose place have I taken by force of intrigue? . . . I can swear it, I have never asked for protection, plans or work . . . I have never prostrated myself before the fashion of the day.'[9] We should believe Delaroche if only because a

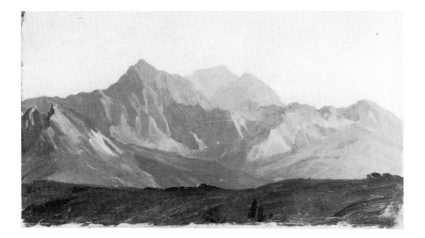

203. Frederic Leighton: *Monte alla Croce* – oil on board (Oxford, Ashmolean Museum)

moment's thought will show that the charge that he went out of his way to flatter bourgeois patrons is ridiculous, for nowhere does he demonstrate that he had an imaginative talent capable of being prostituted; if anyone, it was Ingres and Delacroix and Constable who, occasionally, adjusted their art to an uncomprehending public. Of Delaroche we can say, word for word, what Zola was later to write, in very different circumstances, of Manet: 'He did what he could, and he could not do anything else. There was no deliberation in it; he would have liked to please.'[10]

Delaroche, unlike Manet, did of course please; but just whom did he please? His famous painting *The Last Illness of Cardinal Mazarin* was bought by the Comte de Pourtalès-Gorgier—a banker, it is true, but the owner of one of the great European collections of Old Masters; and, later, this and other pictures by Delaroche passed to the third Marquess of Hertford, that richest of aristocrats and undoubtedly the greatest art collector in mid-nineteenth-century Europe, founder of the Wallace Collection in London (where the largest surviving group of works by Delaroche is still to be seen). Another extravagantly rich collector, the expatriate owner of great estates around Florence and in France, a dominant figure in the social life of the period and husband for a time of Napoleon III's cousin, the Princesse Mathilde, Count Anatole Demidoff (Fig. 204) bought Delaroche's *Execution of Lady Jane Gray* (Fig. 205), while his *Charles I Insulted by the Soldiers of Cromwell* (Fig. 206) was owned by Lord Francis Egerton (Fig. 207), inheritor of one of the greatest collections of pictures ever assembled, among which shine the wonderful Titians now on loan to the National Gallery of Scotland. And I could continue in this vein for some time.

Delaroche a painter for the upstart, uncultivated bourgeoisie? As I say the words I seem to hear behind me the pages of the *Almanach de Gotha* and of *Burke's Peerage* rustle with indignation. The admirers, the patrons and the purchasers of Delaroche constituted the richest, the most aristocratic, the most refined society in Europe, men who never reconciled themselves to the 'bourgeois' Louis Philippe or Queen Victoria or accepted their values: men—all of them—whose collecting was on a spectacular scale and of spectacular quality; men who could look up at their walls and see hanging next to their pictures by Delaroche others by Titian and Raphael, Rubens, Velázquez and Watteau. Indeed, I can think of no other artist since the French Revolution, or well before, who owed so much to the old, cultivated nobility of England and France.

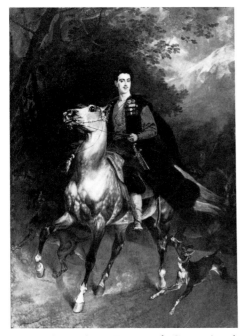

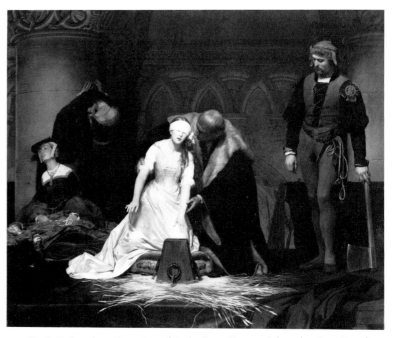

204. Karl Briulov: *Portrait of Count Anatole Demidoff* (Florence, Galleria d'Arte Moderna di Palazzo Pitti)

205. Paul Delaroche: *Execution of Lady Jane Gray* – Salon de 1834 (London, National Gallery)

What does this prove? Not much perhaps, except that a desire for 'finish' and a good, familiar story was not the monopoly of any one class, and that the standard social histories of art in the nineteenth century (not that there are many) need to be entirely rewritten. We can take nothing on trust, not even the words of contemporary critics: for in the light of hindsight, the real reproach that can be levelled against much nineteenth-century art criticism is not that it was too 'bourgeois' but that it was too aristocratic—by which I mean that it constantly chose to judge new art by the standards of a grand manner which had (so it was always assumed, and always wrongly assumed) been encouraged by the pre-Revolutionary nobility.

Nevertheless, these critics must interest us, because although their facts may often have been wrong and their judgements faulty (in our eyes), their influence on later developments proved to be powerful. What then was their attitude to the 'modern art'—as we see it—of the nineteenth century? Not, usually, that it was new, but on the contrary that it was old, reactionary. To most critics of the first half of the nineteenth century Ingres was deplorable because he seemed to be carrying art back to the Middle Ages. As to some extent he truly was. Those drawings by him which are today most acclaimed for 'anticipating' Matisse almost certainly struck his contemporaries as imitations of the more austere engravings published after fifteenth-century frescoes.

Similarly Delacroix was often strongly attacked because he seemed to be looking back to the eighteenth century. As late as 1855, when he received something of a triumph at the International Exhibition in Paris, a critic could confidently write that 'posterity will let him drop back into oblivion, or at least into indifference, and will place him alongside the Solimenas, the Luca Giordanos and the Tiepolos':[11] in other words, he was criticised not for being too modern, but for being too old-fashioned. And, as is well known, Courbet and Manet were despised for imitating the daubs of children and the uneducated.

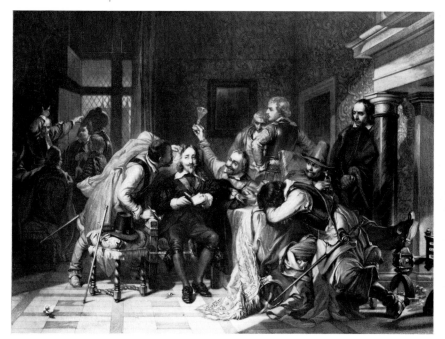

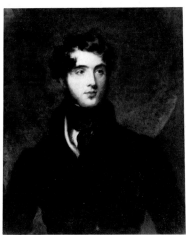

206. Paul Delaroche (mezzotint after): *Charles I^{er} insulté par les soldats de Cromwell* – Salon de 1837

207. Sir Thomas Lawrence: *Lord Francis Leveson-Gower* (from 1833 Lord Egerton, in 1846 created Earl of Ellesmere), 1827 (Duke of Sutherland Collection)

I am inclined to believe that such criticisms may go some way toward explaining a fact that puzzled so many observers in the nineteenth century: the distrust frequently shown by *politically* left-wing art lovers to what we think of as progressive tendencies in the arts. But, despite this, there can be little doubt that as a general rule one of the most powerful reasons for the hostility encountered by so much modern art was the association made between it and political subversion. It is only in this way, I believe, that we can begin to explain the unbelievable rancour of the public—the hysterical laughter described to us by Zola in his account of the Salon des Refusés, the virulence which is so apparent behind the caricatures and the mockery. Art and music cannot surely of themselves arouse such passions, except of course among rival (and hence threatened) artists. But politics and religion can.

If we consider the most bitter aesthetic controversy that raged in England during the eighteenth century, which was not concerned with paintings but with gardens, we will find that political imagery was used from the first. The informality of English parks was favourably compared with the 'despotism' of Versailles, and as the century developed even English taste seemed too tame (Figs. 208–9) Thus the connoisseur and theorist Richard Payne Knight compared the fashionable parks of his day, and even classicism itself, to authoritarianism, whereas Horace Walpole wrote of Payne Knight (who was in fact hostile to the French Revolution) that 'Jacobinistically he would level the purity of gardens'.[12] This equation between the formal garden and political tyranny as opposed to unrestrained nature and Whiggish freedom was a popular one, and yet a few moments' thought should have demonstrated how crude, but above all how wide of the mark, it was—after all, the gardens of Holland, the most 'liberal' of states in seventeenth-century Europe and one particularly admired by the Whigs, were even more formal and tortured into stylised patterns than were those of France.

But such parallels then as now were essentially slogans rather than the products of thought, and the use of political and religious imagery spread rapidly: a change in style could—indeed inevitably did—imply a change in the whole system, it was argued. This concept, so familiar to us today, was an entirely new phenomenon, quite unknown to the *ancien régime,* and its importance can hardly be overrated. In 1846 we come across a French critic writing about David's *Oath of the Horatii* (of 1784) that 'if we only had vague information about the date of this picture . . . no one would hesitate to attribute to the first stages of the Revolution at least some influence on the choice of subject and the manner in which the artist has treated it'.[13] This view has now become a cliché (though in the case of this particular picture a highly controversial one), although it is a cliché still as unsupported by any serious evidence as it was in 1846. But the importance of the cliché is obvious enough: it implies that a change in artistic style heralds, rather than merely reflects, social and political change—thus Cubism is sometimes seen as 'anticipating' the First World War, the Russian Revolution and so on.

It goes without saying that artists themselves have often enjoyed this projection of themselves as particularly sensitive barometers, alert well before the ordinary man to any hint of change in the political climate. But, for all that, the danger is also very evident and has never been wholly forgotten. As late as 1873, when Manet finally won popular approval with *Le Bon Bock* (Fig. 210), a comparatively harmless, indeed conventional, picture, there was still at least one visitor who could claim that the sitter was 'wearing the official dress for the next Commune'.[14]

For the historian of modern art the Manet of the 1860s is, of course, a crucial figure. His *Olympia* (Fig. 211) gathered about herself what seems to have been a form of mass hysteria from public and critics alike. But although the hatred was certainly more extreme, it was not, I believe, essentially different from what had gone before. To the difficulties I have already touched on there were added the problems of a certain ambiguity in the treatment of the subject matter, the implications of indecency and social hypocrisy, and possibly a great increase in the number of visitors to the Salon, who would not have been soothed by the defence offered by Manet's friends that the picture was to be viewed as a sort of abstract—a combination of colours and lines and forms, wholly devoid of any

208. Thomas Hearne (etched B. T. Pouncey): Pl. 1 of Richard Payne Knight, *The Landscape – a didactic poem,* 1794

209. Thomas Hearne (etched B. T. Pouncey): Pl. 2 of Richard Payne Knight, *The Landscape – a didactic poem,* 1794

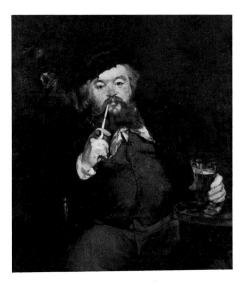

210. Edouard Manet: *Le Bon Bock* – Salon de 1873
(Philadelphia Museum of Art)

narrative content or significance. And it is well enough known that in 1863, two years before the Manet was shown, the public had reserved its greatest enthusiasm for Cabanel's *Birth of Venus* (Fig. 212).

This is the contrast beloved of every modern art historian, a juxtaposition that, at this very moment, must be flashing across thousands of paired screens all over Europe and America, giving the lecturer his opportunity to launch into a discussion of the meretricious, pastichelike composition of Cabanel compared to the 'bold modernity' of Manet's picture, and so on, and so on. Everyone must know the very words by heart, and I need not bother to repeat them. What I would like to quote is something much less familiar and to my mind much more interesting and thought-provoking. At almost the very moment when Cabanel's picture was proving such a success, one critic could write in defence of popular taste that 'the public would rather have an original picture, inferior though its style may be, than a pastiche of M. Ingres; is the public wrong?'[15] Although it cannot be proved that this writer was specifically referring to the *Birth of Venus,* it seems more than likely that Cabanel's picture (which every art lecturer in the world can now demonstrate in two minutes to be a pastiche of Ingres) could, at the time that it was exhibited in 1863, be visualised as a work of originality breaking away from the conventions of Ingres. Nothing could possibly demonstrate more vividly the perception of Gauguin's words (which I have already quoted) about the 'curious and mad public which demands of the painter the greatest possible originality and yet only accepts him when he calls to mind other painters'.

In any case, for the historian of the 'idea of modern art' rather than of modern art itself, Manet is certainly much more significant for a far feebler picture than the *Olympia,* for it was with his slightly comical portrait *M. Pertuiset, the Lion Hunter* (Fig. 213) that in 1881 he won his second-class medal at the Salon; a few months later, through the intervention of his friend Antonin Proust at the Ministry of Arts, he was awarded the Légion d'honneur—a religious and civil marriage, so to speak, for in this very same year there came about a total separation between the Academy and the State.

It is difficult to convey the importance of all this. Manet, the greatest enemy the Academy had ever known, Manet who had been mocked as no other artist ever before him: Manet was now honoured by the Academy, decorated by the State, accepted (however grudg-

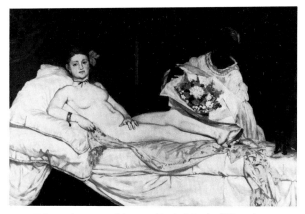 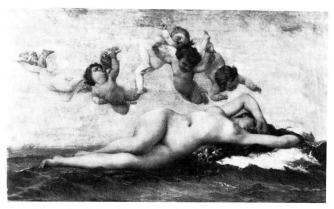

211. Edouard Manet: *Olympia* (Paris, Musée d'Orsay) 212. Alexandre Cabanel: *Naissance de Vénus* (Paris, Musée d'Orsay)

ingly) as an artist of major significance. Everything will now be acceptable at the Salons: that is the implication that is drawn from all this. There have been mistakes, it is acknowledged, but they have been remedied. The future is assured.

There is something touching, almost poignant, about those first great reappraisals of the recent past, which are now so familiar to us from every cultural weekly, explaining with relish that we were wrong about the 1950s, still more wrong about the 1960s, misguided about the Americans, confused about Op art, obstructive about Pop art . . . When these reappraisals began on a large scale in the 1870s and reached a climax in the 1880s they were still exhilaratingly new and masochistic in their intensity. Of course, it is explained, in a hundred articles, ministerial speeches, volumes of memoirs—of course, past attitudes had been deplorable. How could Delacroix have been refused admittance to the Academy for so long, how could Théodore Rousseau have been prevented from exhibiting, how could Corot have lacked appreciation for so many years? Romanticism—the generation of the 1830s—is one of the great glories of French art; and we failed to see it.

There is worse. Courbet, despite his regrettable political outlook, was a real master, and Millet, whom we (or our fathers) took to be a subversive, was in fact a painter of rural life in the great tradition of our national art. Realism too is one of the glories of French art; and we failed to see it at the time. But now everything is all right: the government has withdrawn from control of the Salon—artistic lack of conformity can no longer be thought of as political defiance. Manet has his medal, his Légion, two years later his posthumous exhibition at the Ecole des Beaux-Arts.

The Academy is saved. Why? Just because it is not academic. Manet wins his second-class medal; in the same year Baudry wins the medal of honour with his allegorical *Glorification of the Law* (Fig. 214). Everything is acceptable, and the great battle between public opinion and modern art is finally over. An observer writes: 'Full of good will towards everyone, modern art is afraid of only one thing—that it may be too exclusive or not sufficiently open; and modern art criticism claims only one virtue for itself—that it understands everything.'[16] This is in 1882, just two years before the rejection from the Salon of Seurat's *Baignade*.

Had nothing changed then? Were the critics back where they were fifty years earlier, claiming that they were interested in the new, but in fact always missing it? To some

extent, yes—but there was a difference. Critical innocence had now been lost. Pronouncements about modern art are made with one eye turned back to the past, one eye somewhat apprehensive about the future. Much hatred survives and will continue to do so for fifty years and more, but it has lost intellectual energy or even moral justification. The acknowledgement that there had been a war, but that the critics had (so to speak) lost it and that it was in any case now over, is perhaps the single most important prelude to the development of what we now think of as modern art.

In these years, the crucial late 1870s and early 1880s, two men pondered what had happened from directly opposite angles, and came up with propositions that are still very much alive today. 'How many people see in the young school [the Impressionists] the renewal and the future of French art?' asked Henry Houssaye in 1882.[17] 'If we do not admire the Impressionists are we then as blind as the critic Kératry who wrote that [Géricault's] *Raft of "The Medusa"* was an insult to the Salon? Kératry was wrong, but he was sincere, just as we too are sincere. If criticism should aim to be so timid that it will never ever run the risk of having had its judgements faulted, then it would be necessary to praise everything to the skies on the grounds that everything may one day be consecrated by posterity. And, in any case, supposing posterity does one day put Impressionism on the same level as Romanticism, who can be sure that posterity is not mistaken?'

Zola, writing about Bastien-Lepage, is very much more sure of himself, but surely also very much less subtle: 'All great creators have, at the beginning of their careers, met with strong resistance: that is an absolute rule, to which there are no exceptions. But he is applauded. It's a bad sign.'[18]

Now whatever we may think of Bastien-Lepage—and most of us would agree with Zola in ranking him pretty low—historically speaking this is nonsense. Let me repeat like

214. Paul Baudry: *Glorification de la Loi* – Salon de 1881, reproduced from *Le Livre d'Or du Salon de Peinture et de Sculpture*, 1881

213. Edouard Manet: *Portrait de M. Pertuiset, le chasseur de lions* – Salon de 1881 (São Paolo Museum, Brasil)

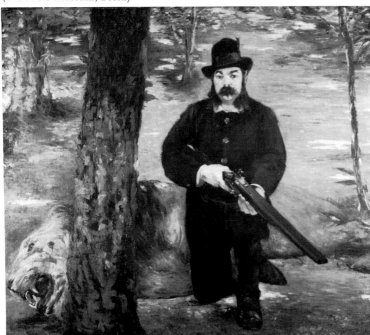

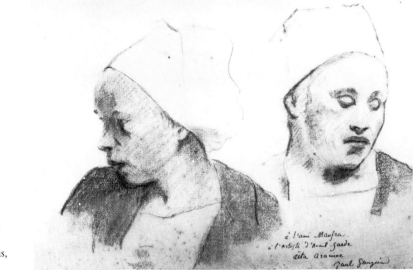

215. Paul Gauguin:
Two Breton Girls —
pencil drawing (Paris,
private collection)

a litany the names of Giotto and Giorgione, Parmigianino and Caravaggio, Watteau and David—all of them innovators and 'great creators' who did *not* meet with 'strong resistance at the beginning of their careers'. But half a century or more of misunderstandings, during which less brash adumbrations of Zola's doctrine helped to comfort many an unhappy young painter, brought about the concept of an avant-garde and proclaimed its most potent myth. But, in so doing, it almost strangled the new creation at birth: for if the artist is told that initial hostility is a necessary precondition not just of his future success (that was already an old and tired cliché by the time that Zola was writing) but also of his actual merit, the critic also could pick up the message. By 1895 (but perhaps well before) it was being said that 'what the snob desires more than anything else is to be noted on the side of the avant-garde'.[19] The avant-garde was thus born under the auspices of quarrelling godparents: critical neglect and hostility on one side, snobbish identification on the other.

The whole concept of the avant-garde has been extensively investigated in the last few years, and fascinating researches into its significance are continuing: so much so that anything I now say runs the risk of being half stale and half out of date. But a few words on the subject are necessary and will bring this paper conveniently to an end.

Conceived in the ambiance of Fourier and Saint-Simon in the 1830s and 1840s, the term seems at first to have implied that new art, any art—whether the art of Delacroix or of Delaroche—was, by its very nature, in the forefront of society. Though derived from military terminology, 'avant-garde' (like other 'political' terms which we have already looked at) soon took on a life of its own, and in the 1870s and 1880s it acquired the specifically cultural overtones with which we associate it today: namely that there is some particular kind of art that is 'ahead' of others; an art that, by definition, would not run the risk of being contaminated by too early a welcome, of the kind that Zola had seized upon when discussing the case of Bastien-Lepage.

Painters themselves appear to have been somewhat confused and unhappy about this notion when it first appeared. The writer Félix Fénéon caused trouble in Seurat's circle by referring to Dubois-Pillet as belonging to the 'avant-garde of Impressionism'. There

is some dicussion about what he actually means by the phrase. 'Dubois-Pillet belongs no more to the avant-garde *than do you and Signac*', Guillaumin tells Seurat, who temporarily solves the problem by commenting in his usual sardonic manner: 'It seems that the whole thing is decided by age.'[20] Gauguin also is scornful about the attempts made by some artists of always trying to be 'ahead' of the latest style—attempts especially associated in his eyes with Pissarro's conversion to the Divisionism of Seurat and his circle. For Gauguin isolation is more important than competition, but he nonetheless dedicated a beautiful drawing, *Two Breton Girls* (Fig. 215), to his friend and rather banal follower Maufra with the inscription '*A l'artiste d'avant garde'*, which must, I think have been intended as a compliment, a badge of honour, rather than (as might now appear) ironically.

Soon afterward the concept becomes common currency. We can appreciate its force by looking at the frenzied attempts made by artists on the one hand not to be liked too soon (and thus appear to be, so to speak, a Bastien-Lepage) and on the other to have anticipated the future. Thus Signac specifically (but surely wrongly) claimed that the neo-Impressionists were revolutionaries not only in boldly adopting new techniques which rendered them totally unacceptable to the bourgeois public and critics, but also in choosing to portray can-can dancers, café-concerts and circuses, in order to show the decadent pleasures of the bourgeoisie and the 'vileness of our epoch of transition'.[21] In this way Seurat and Signac could claim to be putting back into style those very political implications that had been repudiated by Corot when a journalist asked him in 1848, 'How is it that you, M. Corot, who are such a revolutionary in art are not also with us in politics?'

Seurat himself wrote in a well-known letter: 'The more we are, the less originality we will have, and the day when everyone makes use of our technique, it will have no value and people will start looking for something new. And this is already beginning to happen.'[22] Cézanne accused Gauguin of exploiting his *'petite sensation'*. Emile Bernard's whole life was poisoned by the belief that Gauguin had been given the credit for his, Bernard's, discoveries. German and Russian painters falsified the dates on their pictures to suggest that they owed nothing to the French. Kandinsky claimed that the merit of all great art had always lain in its being out of reach of ordinary immediate comprehension. A group of Italian artists called themselves the Futurists.

All this is a grotesquely inadequate, almost caricatured, summary of a theme that has been studied in far greater depth and with far greater sensitivity by many historians in recent years. I am raising these points here only in order to present them in one particular light—that is, to suggest that in varying ways, consciously or unconsciously, they spring from attempts made by artists in the last years of the nineteenth century and the first years of this one to re-create—in less painful, more productive forms—those circumstances that had arisen more spontaneously at an earlier date: that is, an instinctive hostility toward contemporary art (for various reasons I have tried to indicate) which—so it came to be believed—was the necessary breeding ground for true art. The consequences of that hostility, its repudiation, and its re-creation are still with us. Under apparently peaceful fields unexploded weapons lurk dangerously.

Benedict Nicolson (1914–1978)

A FEW LINES in Benedict Nicolson's monograph on Terbrugghen (1958) will probably conjure him up vividly to those who were happy enough to know him and may also help to indicate some aspects of his attitude to art and to scholarship: 'I have walked up and down that stretch of the Oude Gracht, ridiculously imagining myself in the artist's shoes. But this section of the canal has been ruined by improvements and traffic; and no amount of historical melancholy could conjure up the atmosphere of the Snippevlucht in his time. And the house that might have given me a clue to his way of life has long since disappeared.' It is easy to visualise Ben's long strides and rather sloping gait; his shabby, patched clothes; the cigarette hanging from his mouth; the air of intense concentration on his brooding face which would surely have made him dangerously indifferent to the traffic that had ruined the canal . . . Ben, despite the reputation for austerity acquired by this Journal under his editorship, did not despise a private, imaginative approach to those artists whom he studied. On the contrary. Biography was always his favourite reading, and his reviews of current exhibitions were freely sprinkled with the personal pronoun. It is not inappropriate to try to convey some impression of the man as well as the achievement.

The two cannot, of course, be separated, not only because the personality of any editor is directly relevant to the success of the journal for which he is responsible, but also because for the last thirty-one years the *Burlington Magazine* had constituted an intimate part of Ben's life. I can think of no other person I have ever known for whom a job was so intrinsically woven into the very fabric of his being: from the discovery of a new article ('Oh, Francis, there's *such* an interesting piece in the February number') to the minute correcting of page-proofs. And yet—to those who did not know him—it has to be stressed that, though his life did indeed revolve round the magazine, he was never a bore about it. I can convey his feelings best if I suggest that the *Burlington Magazine* gave Ben something of the security that can be given by a really happy home—always there, but not to be inflicted on others unless they wanted to hear about it: in which case, whether or not they were his colleagues, he would love to explain its problems, its virtues, its weaknesses; never mysteriously or condescendingly, but just as one talks to friends who share common interests.

Ben really did have a genius for friendship. He retained his old friends, and he was always acquiring new ones, and he treated them all as if they were exactly the same age

as he was. He loved social life of almost every kind whether in the acute discomfort of an undergraduate room or squalid restaurant or in the splendour of some grand, ceremonial dinner—for one of the most appealing sides to his character was that he never seemed to discriminate by category or on principle. Of course, he liked some people and some occasions and of course he disliked others, but—although he had decided opinions which he could express decisively—he was exhilaratingly unpredictable. How often I remember asking him, after he had been away to see some friend, or country, or museum, whether he had enjoyed himself: there would be a moment of hesitation before he answered, as if he was trying to get the nuance exactly right, and then he would begin: 'I thought it was *absolutely*' and here would follow a long pause during which I had no idea whether he was going to conclude '*terrible*' or '*wonderful*'. But it was usually the latter, for he had a great capacity for liking people and things.

He loved clubs, going regularly to Brooks's and to the Beefsteak and, with Philip Toynbee (one of his oldest and closest friends), he founded an informal lunch club which meets once a fortnight at Bertorelli's in Charlotte Street—and he belonged to other institutions of the kind. And yet, despite so much social life (for, being much loved, he was also much invited out by his friends), he was not always an easy companion. He could sit absent-minded and silent through a whole dinner, for no apparent reason and quite unaware of what must have appeared bad manners to an embarrassed neighbour, for afterwards he might well comment on how pleasant an evening he had passed. When concentrating on some issue he would become so absorbed that he would ignore everything that went on around him. He liked eating, but (as if defying the cliché that taste in cooking and art go together) he had little, if any, discrimination. 'The paté is simply *delicious*', he would say enthusiastically about some raw, indigestible mess and when, towards the end of his life, he took to making suppers for his friends in his own flat, the results were sinister—but somehow became palatable through the warmth of his advocacy and because it was almost impossible to be with him without enjoying what he enjoyed.

He loved reading, but music he actively disliked rather than found meaningless: almost the only time I have ever seen an expression of real misery (rather than boredom) on his face was when he was compelled to attend an—admittedly awful—evening of Irish folk songs at a splendid country house in County Cork. His appreciation of natural beauty was genuine, but it did not (I think) play a very important part in his life. Despite his mother's passion for the countryside he was essentially an urban man.

Ben could be extraordinarily perceptive (and sometimes sharp) about the people he met. This may come as a surprise, for what he said so often appeared to be ponderous, conventional, at times even banal. But then, when discussing some friends whose marriage might be in difficulties or some bizarre social occasion, he could suddenly, unexpectedly, analyse the situation with a finesse that truly was worthy of a Stendhal or a Proust. There were moments when he could seem so innocent of the ways of the world as to be ingenuous; others when he could surprise one with an oblique comment that revealed that he knew exactly what were the issues at stake.

This combination of directly contradictory qualities was, I believe, one of the secrets of his exceptional success as an editor. He could feel very strongly about issues affecting

the arts, and readers of his editorials will know that he could express himself very vigorously (even harshly) about them; and yet, having done so, he had the rare and enviable capacity of being able to separate his private and public personalities, and to adopt a resigned, if necessary calm, attitude to those very same issues. Similarly, he loved his friends, but he would never accept articles from them if he thought that they were not up to the standard that he expected and he would not interfere with their making venomous remarks about each other in the pages which he edited. He did this neither because he enjoyed goading his contributors so as to stimulate circulation nor because he was insensitive, but because he genuinely could not understand that people could carry over scholarly disputes into private relationships. In fact, people usually do just this, but Ben himself did not; he had a real streak of innocence about him which was constantly surprising and constantly delightful. And he had no sense of possessiveness about his researches which he freely communicated to others working in the same field.

Ben was an exacting scholar of the first order who really loved pictures: he was not, however, eloquent about them—except sometimes in print. Visiting an exhibition with him was exciting because of the intense feeling he generated (like an electric discharge) rather than because of anything he specifically said: in this he was unlike his great friend and admirer, Vitale Bloch, who shared so many of his tastes and who was commemorated so recently by him in these pages. For years he refused to lecture, but quite recently he had taken to accepting invitations from undergraduate societies and similar bodies, and his casual, conversational, undogmatic approach was greatly appreciated by his audiences. And he, too, very much enjoyed such occasions—because he was a man who genuinely loved communicating with people more than merely imparting information or showing off his personality.

Ben was born on 6 August 1914, the elder son of Harold Nicolson and Vita Sackville-West, and until the end of his life he remained devoutly attached to the memory of his father (in whose published diaries there are many references to him) and to those 'Bloomsbury' values which came to him at first hand from Virginia Woolf. He was not happy at Eton, but he enjoyed his time at Oxford (he was at Balliol), and he made lasting friendships there with Jeremy Hutchinson, Stuart Hampshire, Francis Graham-Harrison, Isaiah Berlin—the values of Beaumont Street, where he had lodgings, with its 'almost harsh demand for *emotional integrity*' are vividly recalled in Philip Toynbee's *Friends Apart,* and they remained with him to the end: he could, on occasions, be painfully frank—even tactless—when what one wanted from him was sentiment and consolation.

With some of these friends he helped to found the 'Florentine Club', which invited guest speakers such as Kenneth Clark, Herbert Read and Duncan Grant to talk about art. Ben's own tastes at this period were centred on the early Italian and the contemporary. He travelled quite widely in Europe and America, and—like many other English and American art historians of his generation—he 'graduated' with Berenson at I Tatti. Recalling his stay there, Nicky Mariano referred to his 'slow and halting reactions. B.B. used to say that Ben was like a deep well of crystal-clear water, and that it was worthwhile making the effort to draw it up.' While writing this brief memoir of Ben, I have tried to get in touch with as many of his friends from this period of his life (before I knew

him) as possible, and—without exception—they have all told me that in all essentials he never changed: Berenson's comments did indeed remain extraordinarily apt.

Through the influence of Kenneth Clark he was appointed Deputy Surveyor of the King's Pictures in 1939, but the war intervened almost immediately. Ben served in the army in the Middle East and in Italy, where he was badly injured in an accident that had nothing to do with the fighting. In 1947, at the age of thirty-two he took up his appointment as editor of the *Burlington Magazine*.

It is little more than a year ago that the Editorial Board of Directors tried, on the occasion of his thirtieth anniversary in the post, to record his achievements. There is obviously not much that can now be added to the editorial of April 1977, especially as many of the readers of that tribute will themselves have had personal experience of his direction of this magazine. To what was then said I would like to add only that Ben treated contributions from the most distinguished of veterans to the rawest of newcomers with exactly the same degree of critical attention: he was never overawed by celebrities and he was impossible to bluff. It will be up to others to gauge the true extent of his achievement, but they will have to realise that he was a stubborn as well as a kind editor and that, for better or for worse, the *Burlington Magazine* has, since 1947, been the creation of one man.

His books and articles too can only be adequately judged by the experts in the many fields in which he worked (it is to be hoped that a bibliography can be drawn up before too long to show his extraordinary range), but a few points can be made about them even in a personal memoir, for they offer so vivid a reflection of his own character. The son of a diplomat and man of the world, educated at Eton and Oxford, trained by Bernard Berenson (the last serious historian to be wholly convinced that real art came to an end with the end of the Italian Renaissance), Ben was drawn instinctively to the outcasts, the offbeat, the provincial: the painters of Ferrara (1950), Terbrugghen (1958), Wright of Derby (1968), the treasures of the Foundling Hospital (1972), Courbet (1973), Georges de la Tour (1974; with Christopher Wright), the followers of Caravaggio (to be published next year). How many art historians are there whose *œuvre* is at once so consistent in spirit and yet so varied in time and place, so personal and yet so absolutely scholarly? Nearly all these books make major contributions to the history of art, but though the *Wright* is his most ambitious and most important work, perhaps the *Terbrugghen* is the one to which Ben's friends will turn most often: the contrast he draws between the shy, introverted, sensitive Terbrugghen and the coarser, worldly-wise, successful Honthorst may perhaps be a little simplistic but it gives him a wonderful opportunity to proclaim the values that were always dear to him and that he could describe with unrivalled sensitivity—for when on form he was surely one of the very best contemporary writers on art in the English language.

Over the past two or three years Ben's health had deteriorated noticeably. He had become a little deaf; he had had to spend some time in hospital after being knocked down by a taxi; and, above all, while staying with friends in the country during the Christmas holidays of 1976, he had suddenly been afflicted with a disturbance of the circulation which left him lame in one leg. He was (he had always been) an impossible invalid. His friends

conspired to organise appointments with the doctor, tried to stop him smoking (which he had been told was particularly dangerous) and urged him to drink more carefully. Such precautions—understandably—irritated him and brought accusations of nagging. Who can now tell whether they would, if pursued more systematically, have delayed the final outcome? It can only be said that while his death was a terrible shock, it was not entirely unexpected.

Yet these last years of his life were certainly among his happiest—for it was his friends, and not he, who worried about his health. In 1955 he had married the distinguished Italian art historian Luisa Vertova who was then working for Bernard Berenson. Six years later the marriage broke down, causing great grief to both of them. Yet time healed the wounds, and they became warm friends (Luisa arrived in London to stay with him on the day after his death). Their daughter Vanessa, after the inevitable reaction against two art historical parents, herself took up the study of art history and this gave Ben (who had always been a most loving parent as well as enchanting companion) the utmost pleasure. Phobias resulting from an injury suffered during the war—notably a horror of walking across bridges, which led to infinite complications in cities such as Florence and Pisa—gradually vanished and he even began to relish air travel once again (he had first been taken into an aeroplane by Lindbergh), which enabled him to visit exhibitions far more frequently than he had been able to do for years. Honours came and he enjoyed them: membership of the Executive Committee of the National Art-Collections Fund, a CBE (1971), fellowship of the British Academy (belatedly, in 1977). In the same year, the *Burlington Magazine* celebrated the thirtieth anniversary of his editorship with a handsome party at Brooks's and, surrounded by colleagues and admirers, he heard his toast drunk in the splendid room hung with Reynolds's group portraits of the Society of Dilettanti of which he was a member (characteristically, he gave a tiny dinner afterwards for a few close friends in the upstairs room of a small Soho restaurant to which he had long been attached). Messages arrived from all over the world and he was obviously very pleased—but not (I think) wholly surprised. He was a genuinely modest man, but he knew that he was a remarkable editor.

On 22 May the Chairman of the Editorial Committee of this journal wrote to tell him that by a unanimous decision of the Committee he was invited to stay on as editor despite the fact that he was about to reach normal retiring age. There is every reason to believe that Ben knew of this invitation, but he never received the letter. On the same day he dined at the Beefsteak, and the friends who were there all described him as having been cheerful and on excellent form. He walked to Leicester Square underground station and there he collapsed and died instantaneously. The coronary thrombosis that killed him was so massive that he could neither have felt any pain nor even realised that he was ill.

Notes to the Essays

NOTES TO ESSAY I

1. King's College, Cambridge—Newton MSS 212 (14).
2. John Hughes (1677–1720)—quoted by H. N. Fairchild, *Religious Trends in English Poetry*, I, p. 251.
3. In 1778—in *Lettre à l'Académie française*, as preface to *Irène*.
4. C. L. Becker, *The Heavenly City of the Eighteenth Century Philosophers*.
5. Desaguliers, *The Newtonian System of the World*, 1728, in Fairchild, *Religious Trends*, I, p. 357. See also Marjorie H. Nicolson, *Newton demands the Muse*.
6. M. I. Webb, *Mychael Rysbrack Sculptor* (1954), p. 82.
7. The correspondence of Alexander Pope, ed. George Sherburn (1956), II, pp. 457 ff.
8. Webb, *Rysbrack*, p. 84.
9. King's College, Cambridge—Newton MSS.
10. *Novelle della Repubblica delle Lettere* (1738).
11. See, for instance, Blunt and Croft-Murray, *Venetian Drawings of the XVII and XVIII Centuries in the Collection of Her Majesty the Queen at Windsor Castle* (London, 1957), p. 60—and there are many other examples.
12. Orazio Arrighi-Landini, *Il Tempio della Filosofia*, Venezia (1755), p. 30.
13. Whitley, *Artists and their friends in England, 1700–1799*, I, p. 9.
14. For the most recent account of McSwiny's activities, with detailed references to the sources and subsequent research, see F. Haskell, *Patrons and Painters*, 2nd ed. (New Haven and London, 1980), pp. 287–92, and, especially, Barbara Mazza, 'La vicenda dei "Tombeaux des Princes" . . .', *Saggi e Memorie di storia dell'arte* (1976), pp. 79–102, and George Knox, 'The Tombs of Famous Englishmen', *Arte Veneta* (1983), pp. 228–35.
15. [Abbé de Guasco], *De l'usage des statues chez les anciens* (1768), p. 267.
16. *To the Ladies & Gentlemen of Taste*, undated; copy in British Museum, 816 m.23 (134).
17. For the related drawings, see *I disegni di Giambattista Pittoni*, ed. Alice Binion (Florence, 1983), p. 76.
18. King's College, Cambridge—Newton MSS.
19. F. Saxl, '*Veritas Figila Temporis*' in *Essays Presented to Ernst Cassirer*, 1936.
20. For this picture and much additional material about the theme of this essay, see *The European Fame of Isaac Newton* (an exhibition in the Fitzwilliam Museum) (Cambridge, 1973–4).
21. King's College, Cambridge—Newton MSS. Professor Gombrich kindly drew my attention to the following quotation from Francesco Milizia, *Dell'arte di vedere nelle belle arti del disegno* (Venice, 1823), p. 104, which is of considerable interest as it suggests that he may have had access to a version of one of these pictures: 'E qual effetto della scuola d'Atene? Se un pittor filosofo volesse rappresentare la filosofia d'Inghilterra, non si contenterrebbe soltanto effigiarvi Bacone, Bayle [*sic*], Locke, Newton, Priestly, Francklin ec., ma caratterizzerebbe ciascuno di questi valentuomini con quelle cose per le quali ciascuno si è reso insigne. Il ritratto di Newton e poca cosa. Ma un Newton solo può fare un gran quadro co' suoi principii matematici, coll'attrazione, colle flussioni, coll'ottica, colla cronologia, e fin anche con quell'apocalissi, con cui egli volle chiedere scusa al mondo d'averlo illuminato.'
22. Sir David Brewster, *Memoirs of the Life, Writings and Discoveries of Sir Isaac Newton*, II, p. 396.
23. Two allegories by Januarius Zick in the Landesgalerie, Hanover, are often said to refer to Newton's discoveries, but I can find no evidence to suggest that this is their true subject.
24. See Boullées *Treatise on Architecture*, ed. Helen Rosenau (1953), pp. 83 ff. Starobinski (*The Invention of Liberty* (1964), p. 207) publishes a very similar Newton cenotaph designed by Pierre-Jules Delépine.

25. A. F. Blunt, 'Blake's Ancient of Days', *Journal of the Warburg and Courtauld Institutes,* II, no. 1, p. 61.
26. Benjamin Robert Haydon, *Autobiography and Memoirs,* ed. Alexander P. D. Penrose (1927),

p. 231.
27. Katherine A. Esdaile, *The Life and Works of Louis François Roubiliac,* p. 102.
28. *The Prelude,* III, 60.

NOTES TO ESSAY 2

1. *Gibbon's Journey from Geneva to Rome: His Journal from 20 April to 2 October 1764* (hereafter cited as *Journal*), ed. Georges A. Bonnard (London, 1961), pp. 97, 179. Gibbon's conversion to Correggio was to have a satisfying sequel. One of the few analogies with art which he makes in the *Decline and Fall* comes in the course of an ironical account of miracles in the famous chapter 15: 'The recent experience of genuine miracles should have instructed the Christian world in the ways of providence, and habituated their eye (if we may use a very inadequate expression) to the style of the divine artist. Should the most skilful painter of modern Italy presume to decorate his feeble imitations with the name of Raphael or of Correggio, the insolent fraud would be soon discovered and indignantly rejected' (*Decline and Fall,* I, p. 571, edition cited in note 33, below). Gibbon had more right to make this bold assertion than he himself could have realised, or than the results of eighteenth-century connoisseurship could have justified. In Reggio Emilia he was shown a *Crucifixion* said to be Correggio; he was evidently not convinced and merely commented in his *Journal* (p. 102): 'J'ignore l'auteur de ce tableau.' He was right to be sceptical of the attribution, for the picture (now in the Galleria Estense in Modena) is in fact by Guido Reni.
2. The glib answer would be to say that before Michelet no historian would have thought of drawing on the arts to substantiate his arguments. I hope to show that the issue is much more interesting than that, but would like to point out that I cannot agree with Albert Hoxie who has discussed just this problem and appears to suggest that Gibbon did not refer to late Roman or medieval art because he did not like it. See Albert Hoxie, 'Mutations in Art', *The Transformation of the Roman World: Gibbon's Problem After Two Centuries,* ed. Lynn White, Jr (Berkeley and Los Angeles, 1966), pp. 266–90.
3. For whom, see especially Ludwig Schudt, *Italienreisen im 17. und 18. Jahrhundert* (Vienna and Munich, 1959).
4. J. Winckelmann, *Histoire de l'art chez les anciens,* 2 vols. (Amsterdam, 1766), 'Préface de l'auteur', p. x—the edition used by Gibbon.
5. *Journal,* p. 74. Here, as elsewhere, I have silently corrected some of Gibbon's more obvious slips of spelling, etc. The picture was almost certainly a version of a lost composition by Caravaggio.
6. *Journal,* June 1764, pp. 112–18.
7. Gibbon's scepticism about the value of ancient portraiture to the historian was taken up again—perhaps consciously—by Norman Douglas in a brilliantly entertaining account of the surviving busts of Tiberius, which concludes: 'But what type of man these busts figure forth can only be deciphered by those who have made up their minds on the subjects beforehand. Long years will elapse before serious psychological deductions can be drawn from the data of iconography' (*Siren Land* (Penguin Books, 1948), pp. 66–8).
8. *Journal,* 5 July 1764, p. 138. The version in the National Gallery in London is now accepted as the original of this portrait.
9. *Journal,* 16 July 1764, p. 166.
10. For Byres and his guiding of English visitors and references to him in the letters of Winckelmann, see Brinsley Ford, 'James Byres—Principal antiquarian for the English Visitors to Rome', *Apollo* (1974), pp. 446–61.
11. *Journal,* 21 July 1764, p. 178.
12. *Voltaire's Correspondence,* ed. Theodore Besterman, 107 vols. (Geneva, 1953–65), LXXVII, letter 15812, 17 October 1770, pp. 169–70.
13. As there is no biography of Seroux d'Agincourt except the brief account of his life by Gigaut de La Salle in Michaud's *Biographie universelle,* most of what we know about him comes from his own books. Except where otherwise indicated, all the information in this and the next few paragraphs is taken from the following pages in his *Histoire de l'art par les monumens, depuis sa décadence au IV^e siècle jusqu'à son renouvellement au XVI^e,* 6 vols. (Paris, [1810]-1823) (hereafter cited as *Histoire de l'art*), I, 'Notice sur la vie et les travaux de J. L. G. Seroux d'Agincourt', and (for the friendship with Buffon), I, 'Architecture', p. 48. For Louis XV and the Soubise, I, 'Architecture', p. 84, and II, 'Sculpture', p. 70. For his relations with Caylus and Mariette, II, 'Sculpture', p. 85, and I, 'Architecture', p. 103. For his reminiscences of Hubert Robert, 'mon très ancien ami', see I, 'Architecture', p. 15, and for Horace Walpole, I, 'Architecture', pp. 69, 80.
14. The portrait is used as a frontispiece to his (posthumous) *Recueil de fragmens de sculpture antique en terre cuite* (Paris, 1814).
15. See, for instance, *Correspondance de directeurs de*

l'Académie de France à Rome avec les surintendants des bâtiments, published by Anatole de Montaiglon and Jules Guiffrey, 18 vols. (Paris 1887–1912), XIII, p. 385, and XIV, p. 350.

16. Jean-Baptiste Le Brun, *Almanach historique et raisonné des architectes, peintres, sculpteurs, graveurs et ciseleurs, Année 1777* (Minkoff Reprint, Geneva, 1972), p. 185.

17. *Recueil de fragmens,* p. 8. For Seroux's contacts with England, see the two interesting letters which he wrote to Horace Walpole in 1783 and 1784 published in *The Yale Edition of Horace Walpole's Correspondence,* ed. W. S. Lewis (New Haven and London), XLII, pp. 63–9, 101–4.

18. See Lionel Gossmann, *Medievalism and the Ideologies of the Enlightenment: The World and Work of La Curne de Sainte-Palaye* (Baltimore, 1968), who discusses Sainte-Palaye's importance for Gibbon, but does not mention Seroux d'Agincourt.

19. The exact date is given in the 'Notice' at the beginning of the *Histoire de l'art,* and is confirmed in the *Correspondance des directeurs,* XIII, p. 477. It is odd that it should have aroused such controversy and confusion in recent years.

20. He himself says that he began his research in 1779, *Histoire de l'art,* II, 'Peinture', p. 129. The 'Notice' (p. 5) mentions that he spent several months in Bologna, almost certainly in that year, 'car déjà il avoit conçu le vaste plan de l'ouvrage qui devint l'objet de toutes ses recherches, et la principale occupation de sa vie'. It is, however, possible that he had begun to think of it some two years earlier, and hence under the immediate impact of Gibbon; see II, 'Peinture: Décadence', p. 45: 'Occupé depuis longtemps du projet de composer, par les monumens, l'histoire de l'art de peindre, depuis sa décadence', and (in a note), 'Je m'étais proposé de faire usage de quelques uns des beaux manuscrits que possédait M. le duc de La Vallière, surtout pour les XVᶜ et XVIᶜ siècles. Cet illustre amateur m'avait promis, en 1777, avant mon départ pour l'Italie, de m'en donner une libre communication.'

21. *Histoire de l'art,* I, 'Discours préliminaire', p. v.

22. *Ibid.,* p. iii.

23. The essential modern contributions to our understanding of Seroux d'Agincourt are those by Giovanni Previtali, *La fortuna dei primitivi dal Vasari ai Neoclassici* (Turin, 1964); André Chastel, 'Le Goût des 'Préraphaëlites' en France', *De Giotto à Bellini* (an exhibition at the Orangerie) (Paris, 1956); Christopher Lloyd, *Art and its Images: An Exhibition of Printed Books Containing Engraved Illustrations after Italian Painting* (Oxford, 1975); Angela Cipriani, 'Una proposta per Seroux d'Agincourt: la storia dell'architettura', *Storia dell'Arte* (1971), pp. 211–61; and Henri Loyrette,

'Seroux d'Agincourt et les origines de l'histoire de l'art médiéval', *Revue de l'Art,* no. 48 (1980), pp. 40–56.

24. *Histoire de l'art,* I, Preface, p. 1.

25. *Ibid.,* 'Tableau Historique', ch. 3, and see also chs. 7 and 14.

26. See, especially, *Histoire de l'art,* II, 'Sculpture', p. 47, and I, 'Architecture', p. 43. It is true that his attitude to Greek *painting* was often very much more hostile.

27. Jacob Spon and George Wheler, *Voyage d'Italie, de Dalmatie, de Grèce et du Levant, fait aux années 1675 et 1676,* 2 vols. (Amsterdam, 1679), I, pp. 76–81. I am grateful to Mrs Richard Kindersley for her help concerning travels to Spalato.

28. Johann Bernhard Fischer von Erlach, *Entwurf einer historischen Architektur* (Vienna, 1721), Book II, tables 10 and 11.

29. Robert Adam, *Ruins of the Palace of Diocletian at Spalatro in Dalmatia* (London, 1764).

30. Winckelmann, *Histoire de l'art,* II, pp. 332–3.

31. For Fortis and his reputation, see Gianfranco Torcellan, 'Profilo di Alberto Fortis', reprinted in *Settecento Veneto e altri scritti storici* (Turin, 1969).

32. Abate Alberto Fortis, *Viaggio in Dalmatia,* 2 vols. (Venice, 1774), p. 2.

33. Edward Gibbon, *The History of the Decline and Fall of the Roman Empire,* 6 vols. (London, 1776–88), ch. 22, notes 121–2.

34. *Histoire de l'art,* I, 'Architecture', pp. 119, 11.

35. Joseph Lavallée, *Voyage pittoresque et historique de l'Istrie et de la Dalmatie, rédigé après l'itinéraire de L. F. Cassas* (Paris, 1802). There is an intriguing sequel. As late as 1887, when the architect and traveller T. G. Jackson wrote his great book on Dalmatia, he found it necessary to refer to Seroux's opinions on Diocletian's palace, but by now he could refute them from a new standpoint: 'the ... irregularities at Spalato are so well executed and artistically managed that it seems mere pedantry to condemn them as barbarisms of men who would have done better if they could. If, as seems likely, the architect of Spalato deliberately forsook the old paths because he found a clue that led him to a new one he should surely be praised for having enriched his art rather than blamed for degrading it' (T. G. Jackson, *Dalmatia,* 3 vols. (Oxford, 1887), II, pp. 30–1). Thus, at last, after more than a century, was the ghost of Gibbon's *Decline and Fall* exorcised from art history.

36. See, especially, Previtali, whose important book is nonetheless fundamental to most of the issues discussed here.

37. *Histoire de l'art,* I, 'Architecture', pp. 68–9.

38. It appeared in 24 *livraisons* between 1810 and 1823.

39. *Decline and Fall,* ch. 35.

40. Quoted in Haskell, *Rediscoveries in Art: Some Aspects of Taste, Fashion and Collecting in England and France,* 2nd ed. (Oxford, 1980), p. 192, note 9a. The book contains some further references to Seroux d'Agincourt and his contemporaries.
41. *Decline and Fall,* 'General Observations on the Fall of the Roman Empire in the West', after ch. 38.
42. *Histoire de l'art,* I, 'Discours préliminaire', p. v.
43. *Recueil de fragmens* (cited above, note 14).
44. See note 41.
45. J. H. Newman, 'Milman's View of Christianity', reprinted in *Essays and Sketches,* 3 vols. (New York, 1948).

NOTES TO ESSAY 3

I am most grateful for much help to Peter Funnell, Nicholas Penny, Alex Potts, Don Franco Strazzullo and especially Gerard Vaughan.

It goes without saying that this essay is designed only as an introduction to the subject. It makes no attempt at completion, and I am very conscious of having omitted numerous references to d'Hancarville which are known to me—let alone the far greater number which are not.

1. Isabella Teotochi Albrizzi, *Ritratti* (Padua, 1808), Ritratto XI.
2. Mario Pieri, *Della vita di Mario Pieri corcinese scritta da lui medesimo* (Florence, 1850), I, p. 75.
3. Wolstenholme Parr, *Dissertation on the Helicon of Rafael,* written in the French language by the late Baron d'Hancarville, and translated with some alteration by Wolstenholme Parr Esqr, the depositary of his manuscripts (Lausanne, 1824).
4. Leopoldo Cicognara, *Storia della scultura dal suo Risorgimento in Italia* (Venice, 1816), II, p. 271.
5. *Ibid.,* II, p. 295; see also N. F. Cimmino, *Ippolito Pindemonte e il suo tempo,* II, (*Lettere inedite*) (Rome, 1968), pp. 203–4; and Pieri, *Della vita.*
6. Pietro Estense Selvatico, *Sulla Cappellina degli Scrovegni nell'arena di Padova e sui freschi di Giotto in essa dipinti* (Padua, 1836), pp. 9, 34, 125–43.
7. Cimmino, *Pindemonte,* II, pp. 455–6 (letter from Pindemonte to Bettinelli of 18 November 1805).
8. M. Valery, *Voyages historiques, littéraires et artistiques en Italie,* 2nd ed. (Paris 1838), I, p. 412.
9. There are naturally frequent references (usually short and dismissive) to d'Hancarville in all studies of eighteenth-century archaeology, but it is only in very recent years that he has attracted serious attention. See Johannes Dobai, *Die Kunstliteratur des Klassizismus und der Romantik in England,* II (1750–1790) (Berlin, 1975), pp. 1206–20; Alex Potts, 'Winckelmann's History of Ancient Art in Eighteenth-Century Context' (London, 1978) (unpublished Ph.D. thesis); and especially Peter Funnell, 'The Symbolical Language of Antiquity', in Michael Clarke and Nicholas Penny, eds., *The Arrogant Connoisseur: Richard Payne Knight* (Manchester, 1982).
10. *Nouvelle Biographie générale . . .* sous la direction de M. le Dr Hoefer, XXIII (Paris, 1858), pp. 286–7.
11. G. E. Lessing, 'Collectanea', *Sämtliche Schriften,* ed. Karl Lachmann, XV (Leipzig, 1900), p. 140.
12. Johann Joachim Winckelmann, *Briefe,* II (Berlin, 1954), p. 29 (letter of 2 September 1759).
13. Lessing, 'Collectanea'.
14. Voltaire, *Correspondence and Related Documents,* definitive edition by Theodore Besterman, The Voltaire Foundation (Geneva and Banbury), XVI, Letters D 6260 and D 6422—from the Duke of Wurtemberg to Voltaire, and from Voltaire to the Comte d'Argenson, May and August 1755.
15. [D'Hancarville], *Collection of . . . Antiquities from the Cabinet of the Hon.ble William Hamilton,* II (Naples, 1767) (Preliminary Discourse).
16. Voltaire, *Correspondence,* XIII, Letter D 5039 of 9 October 1752.
17. *Ibid.,* XIII, Letters D 4893, D 4921, D 4932, D 4962, D 4967 and others from the year 1752; and XVI, Letter D 6422.
18. Winckelmann, *Briefe,* II, pp. 30–1 (letter of 5 September 1759).
19. *Ibid.,* II, p. 131 (letter of 27 March 1761).
20. For some references to d'Hancarville's activities in Naples (and elsewhere), see J. J. Winckelmann, *Le scoperte di Ercolano,* introduction and appendix by Franco Strazzullo (Naples, 1981), p. 56.
21. Nicola Spinosa, *L'Arazzeria napoletana* (Naples, 1971). Nancy H. Ramage (*Burlington Magazine,* 1987) has shown how dependent Bracci's designs are on the prints of Piranesi.
22. See, for instance, Winckelmann's letter to Riedesel of 2 June 1767 in Winckelmann, *Briefe,* III (1956), p. 267.
23. *Ibid.,* III, p. 247 (letter of 8 April 1767).
24. *Ibid.,* III, pp. 317, 328.
25. See the unpublished letters from Thomas Jenkins to Charles Townley, dated 6 February and 2 May 1770, in the Towneley family archives, kindly drawn to my attention by Gerard Vaughan.
26. See the letter from Sir Horace Mann to Horace Walpole of 19 December 1772 in *The Yale Edition of Horace Walpole's Correspondence,* ed. W. S. Lewis (New Haven and London), XXIII, pp. 448–9, and similar letters with the relevant notes.
27. See the unpublished letter from Thomas Jenkins

to Charles Townley, dated 22 August 1770, in the Towneley family archives, kindly drawn to my attention by Gerard Vaughan; and for an authorisation granted to d'Hancarville to publish plates of paintings in Palazzo Pitti, see Fabia Borroni Salvadori, 'Memorialisti e diaristi a Firenze nel periodo leopoldino 1765–1790: spigolature d'arte e di costume', *Annali della Scuola Normale di Pisa. Classe di lettere e filosofia,* III (1979), p. 1233.

28. Letter from Sir Horace Mann to Walpole of 30 January 1773, *Yale Edition,* XXIII, p. 456.

29. Letter from Sir William Hamilton to Josiah Wedgwood, dated 2 March 1773, published in *The Collection of Autograph Letters and Historical Documents formed by Alfred Morrison* (The Hamilton and Nelson Papers), I (1756–1797) (1893), p. 19.

30. [D'Hancarville], *Collection,* III (1776), p. 32.

31. *Ibid.,* IV, p. 6–9.

32. The bibliographical problems posed by eighteenth-century obscene publications are notoriously tiresome and are hardly worth exploring here. D'Hancarville's expulsion from Naples in 1770 was believed at the time to be due to the appearance of his *Veneres et Priapi, ut observantur in gemmis antiquis,* which, however, is generally dated 1771. The *Nouvelle Biographie générale* suggests that this is in fact an earlier version of the *Monumens de la vie privée . . .,* which it dates to 1780. The *Monumens du culte secret . . .* seems to have followed four years later, though it is by no means certain that the edition dated 1784 is the first one.

33. Draft of a letter from Charles Townley to Richard Payne Knight, undated but probably of 1782, in the Towneley family archives, kindly drawn to my attention by Gerald Vaughan. For Hamilton's visit to England, see Brian Fothergill, *Sir William Hamilton—Envoy Extraordinary* (London, 1969), pp. 147–8.

34. For the most recent discussion of this picture (now in the Towneley Hall Art Gallery and Museums, Burnley), see Brian Cook, 'The Townley Marbles in Westminster and Bloomsbury', *British Museum Yearbook,* ii (1977), pp. 34–78, with references to the earlier literature.

35. See note 33 above.

36. Letter from Richard Payne Knight to Charles Townley, undated but probably 1782, in the Towneley family archives, kindly drawn to my attention by Gerard Vaughan.

37. There is a corrected manuscript draft of the work in six volumes in the Yale University Library (information kindly supplied to me by Mr Stephen R. Parks).

38. See, for instance, Partha Mitter, *Much Maligned Monsters: The History of European Reaction to Indian Art* (Oxford, 1977).

39. See, for instance, J. Deshays, 'De l'abbé Pluche au citoyen Dupuis: à la recherche de la clef des fables', *Studies on Voltaire and the Eighteenth Century,* ed. Theodore Besterman, XXIII (1963), pp. 457–85.

40. See his unpublished letters in the Biblioteca Comunale at Lodi addressed to Maria Cosway between 1787 and 1789. See also the references to him in *The Autobiography of Colonel John Trumbull* (New Haven, 1953) and in *The Papers of Thomas Jefferson* (Princeton), V, pp. 443, 495; XI, pp. 150, 182, 387; XIV, p. 446.

41. Anatole de Montaiglon, ed., *Correspondance des directeurs de l'Académie de France à Rome avec les Surintendants des Bâtiments,* 18 vols. (Paris, 1887–1912), XVI, pp. 410–11 (*Nouvelles de Rome,* February 1796), for his theories about the relationship between the Scythian and Egyptian religions.

42. Nunzio Vaccalluzzo, ed., *Fra donne e poeti nel tramonto della Serenissima: Trecento lettere inedite di I. Pindemonte al Conte Zacco* (Catania, 1930), p. 98 (letter of 29 December 1804), and Cimmino, *Pindemonte,* II, p. 424.

43. At present on loan to the Victoria and Albert Museum in London—see Margaret Whinney and Rupert Gunnis, *The Collection of Models by John Flaxman R.A. at University College* (London, 1967), no. 91, pp. 52–3. See also Francis Haskell and Nicholas Penny, *Taste and the Antique* (New Haven and London, 2nd printing 1982), p. 313.

44. Letter from d'Hancarville to Townley, dated 30 January 1790, in British Library, Stowe MSS 755, fol. 101.

45. Montaiglon, *Correspondance,* XVI, p. 392 (letter from Cacault, dated 3 February 1795): 'd'Ancarville, homme de grand talent et de mauvaise conduite est à Venise'.

46. See the letter from a Mr Rosson to Sir Robert Peel, dated 13 August 1823, asking him to give his approval to the publication of unspecified d'Hancarville manuscripts (British Library Add. MSS 40358, fols. 1–2); this was kindly brought to my notice by Nicholas Penny. See also *Istoria della vita e delle opere di Raffaello Sanzio da Urbino del signor Quartremère de Quincy voltata in italiano, corretta, illustrata ed ampliata per cura di Francesco Longhena* (Milan, 1829), pp. 85–6.

47. *Memoir on the propriety of the word 'Oxford', as applied to a seminary of learning;* read to the Instituto of Padoua, in the Month of July last. Written in Italian and translated by Wolstenholme Parr, A.M., late of Corpus Christi College, Oxford, and now, with all respect and gratitude, dedicated to his parent university (Liverpool, 1820).

48. As well as Cicognara, *Storia,* see E. Q. Visconti, *Museo Pio-Clementino* (Milan, 1822), V, p. 124;

and also A.-L. Millin, *Introductions à l'étude de l'Archéologie, des pierres gravées et des médailles*, new ed. (Paris, 1826), pp. 75–7.

49. Cicognara, *Storia*, I, p. 32.
50. *Ibid.*, II, p. 271.

NOTES TO ESSAY 4

I am very grateful to the many friends who have helped me in preparing this paper, especially to Mr Hugh Honour (who drew my attention to, and lent me his copy of, Sommariva's letters), M. Pierre Angrand and Mr Jon Whiteley.

1. Albert Pingaud, *Bonaparte Président de la République italienne* (Paris, 1914), I, pp. 201–2, and many similar references elsewhere.
2. Keratry, *Annuaire de l'école française de peinture, ou lettres sur le Salon en 1819* (Paris, 1820), p. xiv.
3. For this portrait, and the many preliminary studies for it, see especially Jean Guiffrey, *L'Oeuvre de P.-P. Prud'hon* (Paris, 1924), notes 615–23. A version showing the head and shoulders only is in a private collection in Loches, another belongs to the Comte Doria and many more are known to exist.
4. See his obituary in *Le Moniteur Universel* (1826), p. 83.
5. Balzac, *Correspondance* (Paris, 1960), I, p. 79 (letter to Edouard Malus of 26 March 1820).
6. For Stendhal's reactions to Canova's *Magdalene*, see note 26. It seems virtually certain that Stendhal was familiar with Sommariva's collection—see *Historie de la peinture en Italie*, ed. Paul Arbelet, in *Oeuvres complétes* (Paris, 1924), II, p. 23.
7. See 'Journey to Paris in 1825 described by Mary Rogers who accompanied her uncle and aunt (Miss Sarah Rogers and the poet)'—Bodleian Library, Oxford, MS Eng. Misc.e.231 (21 October).
8. See Crawford papers in the John Rylands Library, Manchester—letter of Lord Lindsay to his mother from Paris, dated 31 July 1828. I am very grateful to Mr John Fleming for bringing this reference to my attention.
9. See Lady Morgan, *France*, 4th ed. (1818), II, pp. 84–6. She is particularly enthusiastic about Canova's *Terpsichore* and *Magdalene*, but says that Sommariva himself looked upon a head of Christ by Guido Reni as his favourite object in his collection.
10. For Sommariva's cordiality, see especially Miel, *Essai sur les Beaux-Arts et particulièrement sur le Salon de 1817* (Paris, 1817–18), p. 209, note 1, and Keratry, *Annuaire*. Amidst the chorus of enthusiasm with which the art critics invariably greeted every reference to Sommariva, a note of irony may perhaps be detected in the words of Delpech (*Examen raisonné des ouvrages . . . exposés au Salon du Louvre en 1814* (Paris, 1814), pp. 166–7). Writing of Prud'hon's portrait he comments that 'M. Prud'hon a du employer tous ses soins pour

reproduire dignement l'image d'un amateur qui fait le plus grand cas de sa personne et de ses ouvrages'.

Mr Michael Pidgley, of the University of East Anglia, has very kindly drawn to my attention records of several other visits to the collection, some of which throw much interesting light on it and all of which confirm its standing as the most important private collection of contemporary art in Paris: Eastlake (see the memoir by Lady Eastlake in *Contributions to the Literature of the Fine Arts*, 2nd ser. (1870), p. 64) found the French pictures 'detestable' except for those by Prud'hon; Andrew Robertson (see his *Letters and Papers*, ed. Emily Robertson (1895), pp. 259–60) admired the Guérin as well as the Prud'hons and was swept off his feet by Canova's *Magdalene* which he found to be 'equal to the Antique'; Thomas Dibdin (in *A Biographical Antiquarian and Picturesque Tour in France and Germany*, 2nd ed. (1829), II, pp. 309–16) was less enthusiastic but gives a most interesting description of the setting arranged for the statue by Sommariva, and the repulsion he felt for David's 'heartless' *Cupid and Psyche* is expressed with much eloquence; Dawson Turner (in *Outlines in Lithography from a Small Collection of Pictures* (Yarmouth, 1840)) makes a passing reference to the Prud'hon's in Sommariva's 'noble gallery'.

11. See *Souvenirs du Baron de Frénilly, pair de France, 1768–1828*, introduction and notes by Arthur Chuquet (Paris, 1908), p. 278.
12. What seems to be the most accurate short account of his life—contradicting many other versions, even as regards date of birth—is to be found in Angela Ottino Della Chiesa, *Villa Carlotta* (Ente Villa Carlotta, Tremezzo-Cadenabbia, n.d.).
13. See Treccani, *Storia di Milano*, XIII, pp. 22–3. This volume gives a succinct account of the political situation in Napoleonic Milan and contains many references to Sommariva.
14. But see also note 20.
15. For this episode, and for Sommariva's relations with Canova and other Italian sculptors, see Gerard Hubert, *La Sculpture dans l'Italie Napoléonienne* (Paris, 1964), pp. 141, 234.
16. There are a number of mostly very cryptic references to Sommariva in Stendhal's journals, but see

especially the entry for I^{er} prairial (21 May) 1801 in *Oeuvres intimes* (Editions de la Pleiade, p. 1406)—also, quoted, with other information about Sommariva, in François Michel, *Fichier Stendhalien* (Boston, 1964), III, p. 433.

17. For this, and for much important information about Sommariva's villa and collections, see Ottino Della Chiesa, *Villa Carlotta*. This contains an inventory and bibliography.

18. See Francesco Cusani, *Storia di Milano dall'origini a' nostri giorni* (Milan, 1867), VI, p. 107. For contemporary references to Sommariva's intrigues in Paris with Melzi's enemies, see Pietro Pedrotti, *La prima repubblica italiana in un carteggio diplomatico inedito (Corrispondenza ufficiale Cobenzl-Moll)* (Rome, 1937), pp. 10, 45, 49, 60, 141, 180; and for his relations with Murat, in particular, the letters of Mareschalchi to Melzi (especially that of 3 April 1802) published in Francesco Melzi d'Eril, *Memorie-Documenti*, 2 vols. (Milan, 1865). Despite their common hostility to Melzi, motivated by jealousy and ambition, Murat seems to have had few illusions about Sommariva—see the scornful reference to him ('Melzi fait regretter ici Sommariva. *Jugez maintenant de son administration!*') in a letter from Milan to Napoleon, dated 13 December 1802, printed in *Lettres et documents pour servir à l'histoire de Joachim Murat,* published by S. A. le Prince Murat (Paris, 1909), II, p. 314.

19. Variants of this story are told in virtually all the early lives of Canova. J. S. Memes, for instance (*Memoirs of Antonio Canova with a Critical Analysis of his Works . . .* (Edinburgh, 1825), p. 403), claims to have heard it from 'the accomplished owner himself'. His account, however, needs to be supplemented by the documents published in Vittorio Malamiani, *Canova* (n.d), p. 97.

20. That Sommariva was by now reconciled, on the surface at least, to the new régime is shown by a letter from him to Canova of 12 May 1805 (published in Antonio d'Este, *Memorie di Antonio Canova* (Florence, 1864), p. 430) in which he writes of having just arrived in Milan 'per assistere all'Incoronazione del nostro Re'.

21. Jacques Hillairet in his *Dictionnaire historique des rues de Paris,* I, p. 264, says that Sommariva bought the *hôtel* in the Rue Basse des Remparts—which had been acquired by the Montmorency family in 1775—in the year 1807. He also gives a list of the other property owners in the district.

22. Frénilly, *Souvenirs,* p. 278.

23. Sommariva never once mentions his wife in any of his published letters, which run from 1809 to 1825 (see note 36), and she is never discussed in any of the many contemporary comments on his relationship with Madame d'Houdetot. On 20 December 1843, *La Presse* reported a rumour that

the famous legitimist lawyer Berryer was to marry 'la veuve de M. de Sommariva, ce riche Piemontais, mort il y a deux ans à Paris et à qui appartenait la belle galerie où figurait la Madeleine de Canova' (see André Gayot, *Une ancienne Muscadine—Fortunée Hamelin, Lettres inédites, 1839–1851* (Paris, n.d.)). This highly inaccurate rumour can only refer to Sommariva's daughter-in-law.

No entry in any biographical dictionary records how he acquired the title of Count; Lord Lindsay calls him (or his son) Marquis; elsewhere he is sometimes described as Senator.

24. See Sommariva, *Lettere* (described in note 36), p. 330, 22 January 1825, and *Biographie nouvelle des contemporains . . .,* ed. Arnault, Jay, Jouy, Norvins etc. (1825), XIX, p. 245. There is at least one significant difference between the entry on him in this volume and his obituary (see note 4), which was used as a source for the *Nouvelle Biographie générale* (Paris, 1864), XLIII. The obituary states that during the Austro-Russian occupation of Milan in 1799 Sommariva remained hidden in the area; whereas the *Biographie nouvelle . . .,* published while he was still alive, specifically mentions that he sought refuge in France at this time.

25. See Jal, *De Paris à Naples: études de moeurs, de marine et d'art* (Paris, 1836), II, p. 89; *Lettres à David sur le Salon de 1819 par quelques élèves de son école* (Paris, 1819), p. 163; Kératry, *Du beau dans les arts d'imitation* (Paris, 1822), pp. 154, 295; Miel, *Essai.*

26. For a full bibliography of this picture, see the catalogue by Jacqueline Pruvost-Auzas of the Girodet exhibition held in Montargis in 1967, no. 44.

27. The picture—by Dejuinne—is described at some length in Sommariva's sale catalogue (see note 54). The preliminary drawing was exhibited at the Girodet exhibition, 1967, no. 154; and for the copy, see the Appendix to this essay.

28. See the article 'De la galerie de M. de Sommariva', *L'Artiste,* 2nd ser., ii (1839), pp. 185–6.

29. For a discussion of this work, its sources and its place in David's *oeuvre,* see the article by Henry S. Francis in *Bulletin of the Cleveland Museum of Art, l,* no. 2 (February 1963), pp. 29–34. In 1813 David had, apparently, already given Sommariva a preliminary drawing for the *Leonidas*—see Louis Hautecoeur, *Louis David* (Paris, 1954), p. 232.

30. See René Schneider, 'Le Mythe de Psyché dans l'art français depuis la Révolution', *Revue de l'art ancien et moderne,* xxxii (1912), pp. 241–54, 363–78.

31 For the fullest recent discussion of this figure, correcting earlier views as to its history, see Hubert, *Sculpture,* p. 75.

32. Frénilly, *Souvenirs,* p. 279.

33. See especially the rapturous account ('pour la

foule des spectateurs . . . sembloit tenir de l'effet d'un miracle') given by Quatremère de Quincy— a friend of both the artist and the owner—in his *Canova et ses ouvrages* (Paris, 1834), pp. 68 ff. It was Quatremère de Quincy who arranged to have it exhibited at the Salon of 1808.

34. Stendhal constantly refers to the *Magdalene*. For one instance, among many, see his invocation to Canova as 'Vous, auteur sublime des *trois Graces* et de la *Madeleine*' in Pierre Martino's edition of *Racine et Shakespeare* (*Oeuvres complètes*, Paris, 1925), II, p. 236.

35. See René Schneider, *Quartremère de Quincy et son intervention dans les arts, 1788–1830* (Paris, 1910), p. 107.

36. *Lettere del Conte Gio. Battista Sommariva, a suo figlio Luigi, dall'anno 1809, fino all'anno 1825* (printed for private circulation, Paris, 1842), p. 161 (31 October 1822). The references to the arts in these letters were published, with some useful notes, by Anatole de Montaiglon in *Nouvelles Archives de l'art français* (1879), pp. 297–320.

37. *Lettere*, p. 99 (12 January 1818).

38. There are countless references in the letters to these enamel copies by Mlle Chavassieu, which were regularly exhibited in the Salons. They have recently been traced by Fernando Mazzocca—see the Appendix to this essay.

39. For this relief, which was only completed in marble in 1828 after Sommariva's death, see Hubert, *Sculpture*, p. 190, note 4, and Jørgen B. Hartmann, 'Alcune inedite italiane di Berthel Thorvaldsen e del suo cerchio', in *Analecta Romana Instituti Danici*, I (1960).

40. *Lettere*, p. 109 (9 March 1818).

41. *Lettere*, pp. 323 ff. (15 December 1824). He specifically mentions that this commission had been suggested to him by his friend Joseph La Vallée, Marquis de Bois-Robert.

42. *Lettere, passim.* See also the obituary (note 4): 'il achetait, non des tableaux faits, mais des tableaux à faire, et quand on s'étonnait de cette manière d'agir, il répondait: C'est un moyen de m'assurer qu'ils travailleront.'

43. *Explication des ouvrages de peinture . . . des artistes vivans, exposés au Musée Royal des Arts* (25 August 1824), no. 734.

44. *Lettere*, pp. 323–4 (15 December 1824).

45. For the life of Madame d'Houdetot, her relations with Sommariva, her poems written to him, portraits of her, etc., with references to most of the early sources, see the two books by Hyppolyte Buffenoir: *La Comtesse d'Houdetot—une amie de J.-J. Rousseau* (Paris, 1901), and *La Comtesse d'Houdetot: sa famille—ses amis* (Paris, 1905). See also Morgan, *France*, I, pp. 298–300.

46. See Frénilly, *Souvenirs*, p. 279.

47. For the emphasis placed on peace in Sommariva's commission to Acquisti, see *Memorie enciclopediche romane sulle belle arti . . .* (Rome, 1806), I, p. 13.

48. For Yusupoff's collection, which contains striking similarities with that of Sommariva's, see Serge Ernst, *Yusupovskaya Galereya—Frantsuskaya Skola* (Leningrad, 1924). Note, in particular, the letter to Yusupoff from Guérin which refers to Sommariva, published in this catalogue.

49. We know that Sommariva owned a picture of Abel de Pujol's studio from references in his letters of 30 November and 31 December 1822 (see *Lettere*, pp. 172, 182), but he nowhere mentions the name of the artist. As the picture in the Musée Marmottan, signed by Adrienne Grandpierre (who was later to become Abel de Pujol's second wife and to paint another picture of his studio, now in Valenciennes) is dated 1822, it seems entirely reasonable to assume both that it is the painting exhibited in the Salon of that year (*Intérieur d'atelier de peinture*, no. 605) and that it is the one that belonged to Sommariva.

50. See, for instance, for later accounts of the villa *Manuel pittoresque des étrangers à Milan* (Milan, n.d.), p. 112, and M. Valéry, *Voyages historiques et littéraires en Italie, pendant les années 1826, 1827 et 1828; ou l'indicateur italien* (Paris, 1831), I, pp. 225–6.

51. There remains an unsolved problem concerning this replica by Tadolini of a famous Canova original. Mr Hugh Honour has kindly pointed out to me that Jørgen Hartmann has (in *L'Urbe*, xxxi (1968), fasc. VI, pp. 15 and 19, note 12) proved beyond doubt that it was completed by August 1824, and not in 1827 as has always been assumed, partly on the evidence of Tadolini himself (*Ricordi autobiografici* (Rome, 1900), pp. 166–7). This means that it was certainly commissioned by G. B. Sommariva, and not by his son. On the other hand the Baron de Frénilly claims (*Souvenirs*, p. 280) that when he visited the Villa in 1834, which then belonged to Luigi, 'on venait de déballer une autre oeuvre de Canova, le groupe de *l'Amour et Psyché* que nous admirâmes; mais deux ans plus tard, à Rome, le sculpteur Tadolini, premier elève de Canova, m'apprit que l'original de ce groupe était à Londres et que Sommariva n'avait eu qu'une copie faite par lui, Tadolini'. Ten years seems an unusually long time for the marble to have taken on its journey from Rome to Lake Como: it is, of course, possible that between 1824 and 1834 it had been installed in one of the other family residences.

52. See Frénilly, *Souvenirs*, pp. 279–80, and Jal, *De Paris à Naples*, II, p. 89.

53. Both the huge crowds and the disappointment are recorded in a report of 19 February 1839 among

the series of very interesting (and unpublished) 'Rapports à la direction des musées, 1839—1848' by an anonymous writer, who must, in fact, be the *expert* Cayeux. These are now in the possession of M. Jean Cailleux, and I am most grateful to him for showing them to me. A very similar account of reactions to the sale is to be found in *L'Artiste*, 2nd ser., ii (1839), pp. 185—6. Among the marked copies of the sale catalogue—Lugt 15288, 18–23 February 1939—is one in the Victoria and Albert Museum which shows that many of the pictures were bought in at low prices by the dealer Paillet. There is another account of the sale in *L'Album, Journal des Beaux-Arts et de la Littérature, publié par la Société Centrale des Amis des Arts et des Lettres*, 4th year, ii (Paris, 24 February 1839), p.83.

Valéry (*Voyages historiques*) mentions the *Mona Lisa*, but in general the Old Master attributions were ridiculed by the experts.

54. This is not the place to discuss and attempt to identify the very many pictures belonging to Sommariva which have not been mentioned in the text. The problem is made difficult by the fact that the sale catalogue of 1839 records only those pictures which were in Paris at that time—and by no means all of them, as we can tell from many sources including the Letters. Some further information is given in the articles by myself and, above all, by Fernando Mazzocca referred to in the Appendix to this essay.

NOTES TO ESSAYS 5

This paper forms part of an investigation into nineteenth-century attitudes to art on which I am at present engaged.

1. *The Farington Diary*, ed. James Greig, VIII, pp. 9–12 (June 1815).
2. Clarendon Press, 1971.
3. Quoted in Charles Clément, *Géricault* (Paris, 1868), p. 171.
4. Quoted in Fernand Beaucamp, *Le Peintre lillois Jean-Baptiste Wicar, 1762–1834: son oeuvre et son temps*, I, p. 185.
5. Quoted in E.-J. Delécluze, *Louis David, son école et son temps* (Paris, 1863), p. 105.
6. Bernardo de Dominici, *Vite dei pittori scultori ed architetti napoletani* (Naples, 1843), IV, p. 139; referred to in Ferdinando Bologna, *Francesco Solimena* (1958), p. 21.
7. Andries Pels—see Seymour Slive, *Rembrandt and his Critics, 1630–1730* (The Hague, 1953), p. 102.
8. See Jacques Thuillier, 'Polémiques autour de Michel-Ange au XVIIᵉ siècle', *XVIIᵉ Siècle—Bulletin de la Société d'Etude du XVIIᵉ Siècle* (July–October 1958), nos. 36–7.
9. Edgar Quinet, 'Allemagne et Italie', in *Oeuvres complètes* (1857), VI, p. 300.
10. Diderot, *Salons,* ed. Jean Seznec and Jean Adhémar (1963), III, Salon de 1767, pp. 335–6.
11. Lady Morgan, *France,* 4th ed., 2 vols. (London, 1818), II, p. 215.
12. Quoted in Pontus Grate, *Deux Critiques d'art de l'époque romantique* (Stockholm, 1959), p. 17.
13. Stendhal, *Mélanges d'art* (Paris, 1932), Le Salon de 1824, p. 6.
14. Stendhal, *Histoire de la peinture en Italie* (ed. Paul Arbelet in *Oeuvres complètes*), 2 vols. (Paris, 1924), II, p. 120.
15. Quoted in Robert Baschet, *E.-J. Delécluze, témoin de son temps, 1781–1863* (Paris, 1942), p. 282.
16. Quoted by Léon Rosenthal, *La Peinture romantique* (Paris, 1900), p. 105.
17. *Revue Encyclopédique*, xxxiv (1827).
18. E.-J. Delécluze in *Journal des Débats* (31 July 1849). I am grateful to my friend Dr Jon Whiteley for bringing this reference to my attention.
19. Quoted from Paul Robert, *Dictionnaire alphabétique et analogique de la langue française* (1966), IV, p. 415.
20. In a strictly non-political sense, for instance, the architect J. F. Blondel had, in 1762, called for a 'juste milieu entre ces deux excès (*pesanteur* and *prodigalité de petites parties*)' in interior decoration—see his 'Observations générales sur la décoration intérieure' quoted by Svend Eriksen, *Early Neo-Classicism in France* (London, 1974), pp. 253–4.
21. Diderot, *Salons,* p. 148.
22. P. J. Proudhon, *Du Principe de l'art et de sa destination sociale* (Paris 1865), pp. 193–4.
23. Pierre Courthion, *Corot raconté par lui-même et par ses amis,* 2 vols. (Geneva), I, p. 141.
24. See, for instance, Leonello Venturi, *Les Archives de l'Impressionnisme,* 2 vols, (Paris, 1939), II, p. 304.
25. *Ibid.,* I, p. 122.
26. Quoted by John Golding, *Cubism: A History and an Analysis* (London, 1959), p. 30.
27. See Eugenia W. Herbert, *The Artist and Social Reform* (New Haven, 1961), pp. 189–90.
28. See Jacques Lethève, *Impressionnistes et Symbolistes devant la presse* (Paris, 1959), p. 79, and Venturi, *Archives,* II, p. 297.
29. Martin Archer Shee, R. A., *The Elements of Art, a Poem . . .* (London, 1809), p. 43.
30. *Ibid.,* pp. 235–6.

31. Quoted in A. Tabarant, *Manet et ses oeuvres* (Paris, 1947), p. 138.
32. Baudelaire, 'Richard Wagner et Tannhauser à Paris', in *Curiosités Esthétiques: l'art romantique et autres oeuvres critiques* (Paris, 1962), p. 700.
33. See *Lettres de Gauguin à sa femme et à ses amis,* ed.

Maurice Malingue (Paris, 1946), p. 63, from a letter to Schuffenecker of 24 May 1885.
34. Quoted in John Rewald, *The Ordeal of Paul Cézanne* (London, 1949), p. 150.
35. See Venturi, *Archives,* II, p. 150.

NOTES TO ESSAY 6

1. Heine's 'Salon de 1831' has been translated by C. G. Leland and published in *The Salon: Letters on Art, Music, Popular Life and Politics in Paris* (London, 1905); see pp. 68 ff.
2. This is quoted by E. H. Gombrich in *The Story of Art* (London, 1966 edition), p. 364, but I have been unable to find any reference to it in Jules D. Prown's standard work, *John Singleton Copley* (Cambridge, Mass., 1966).
3. We are told this (presumably by the artist himself) in the Salon catalogue of 1831, but it is worth stressing that Chateaubriand rather surprisingly reports the episode in a wholly cursory manner. So too does Guizot (see F. P. G. Guizot, *Histoire de la Révolution d'Angleterre depuis l'avènement de Charles Ier jusqu'à sa mort,* 4th ed. (Paris, 1850), II, p. 528), to whom — as Mr Jon Whiteley has kindly pointed out to me — Viel Castel refers in his discussion of the picture: *L'Artiste* (Paris, 1831), p. 269. In 1833 A. Colin exhibited at the Salon a picture of *Cromwell retournant le portrait de Charles I* (now lost), citing Walter Scott's *Woodstock* as his source. Delacroix had exhibited a picture of the same subject at the Salon of 1831 (see Lee Johnson, *The Paintings of Eugene Delacroix: A Critical Catalogue,* I, no. 129). It is interesting that Delacroix, who strongly supported the Orleanist dynasty, found the attitude of Cromwell in Delaroche's picture to be too *insolente,* and in the same year that it was exhibited made a small watercolour of his own to correct this impression. This can no longer be traced, but there is a minute reproduction of it in A. Robaut, *L'Oeuvre complet de Eugène Delacroix* (Paris, 1885), no. 368.
4. See Louis Gillet, *Le Musée de Nîmes* (Paris, n.d.), and the catalogue of the exhibition *The Romantic*

Movement held at the Tate Gallery (1959), p. 120, and, above all, Norman D. Ziff, *Paul Delaroche* (Garland Publishing Inc., 1977), pp. 105–14.
5. See H. Bessis, 'Ingres et le portrait de l'Empereur', in *Archives de l'art français,* xxiv (1969), pp. 89–90.
6. For the whole episode, see J. Tripier le Franc, *Histoire de la vie et de la mort de Baron Gros* (Paris, 1880).
7. By Taddeo Zuccari in the palace of Caprarola near Viterbo—conveniently reproduced in Italo Faldi, *Gli affreschi del Palazzo Farnese di Caprarola* (Milan, 1962), pl. XII.
8. Jules Michelet, *Histoire de la Révolution française* (Paris, 1853), V, Bk. XII, ch. 7, pp. 217–18.
9. François-Rene de Chateaubriand, *Mémories d'outre-tombe* (Pleiade edn), II, p. 98.
10. *Ibid.,* I, p. 44; II, p. 241; I, p. 277.
11. Quoted in F. Benoit, *L'Art français sous la Révolution et l'Empire* (Paris, 1897), p. 169.
12. C. P. Landon, *Annales du Musée et de l'Ecole Moderne des Beaux-Arts,* iv (1803), pp. 13–14.
13. See M.-J.-F. Mahérault, *L'Oeuvre de Moreau le Jeune* (Paris, 1880), p. 457, no. 403.
14. Despite the fact that, in an interesting article 'Historical Genre in French Pre-Romantic and Romantic Painting', published—in Russian—in *The Arts of the Romantic Period* (Moscow, Pushkin Museum, 1969), Elena Kojina has produced some evidence that Napoleon disliked theatrical performances involving Henri IV, the number of paintings alluding to that king that appeared during the Empire makes it quite clear that he was keen to associate his dynasty with that of the most popular of French monarchs.
15. Quoted in A. Poirier, *Idées artistiques de Chateaubriand* (Paris, 1930), p. 398.

NOTES TO ESSAY 7

1. The only detailed treatment of such pictures that I know is the excellent article by Richard Verdi devoted to those representing Poussin: *Burlington Magazine* (1969), pp. 741–50. Robert Rosenblum has some very interesting comments on the earliest examples of the genre in *Transformations in Late Eighteenth Century Art* (Princeton, 1967), pp. 35–7. There are also some illuminating com-

ments in Werner Hofmann, *Art in the Nineteenth Century* (London, 1961), p. 226; and in Léon Rosenthal, *Du romantisme au réalisme* (Paris, 1914).

Although the phenomenon was a European one, I have in this article largely confined myself to pictures that were exhibited in the Paris Salons. Unfortunately I have not by any means always been able to see the originals of the paintings I

discuss, and for a description of content I have often had to rely on the description in the catalogue or the comments of contemporary critics. Furthermore, French provincial museums are not the easiest of places in which to carry out research, and I have sometimes had to rely on Bénézit and other biographical dictionaries for my information about the whereabouts of certain pictures.

2. For a discussion of this legend and the many pictures inspired by it, see Robert Rosenblum, 'The Origin of Painting: A Problem in the Iconography of Romantic Classicism', *Art Bulletin* (1957), pp. 279–90. Another classical painter frequently depicted was Zeuxis, who chose the best features of the five most beautiful virgins of Croton for his picture of Helen.

3. John Gere, *Taddeo Zuccaro* (London, 1969), p. 29.

4. See Rudolph and Margot Wittkower, *The Divine Michelangelo* (London, 1964), pp. 163 ff.

5. For all this, see André Chastel, 'La Légende médicéenne', in *Art et Humanisme à Florence au temps de Laurent le Magnifique* (Paris, 1959).

6. See Oreste Ferrari and Giuseppe Scavizzi, *Luca Giordano* (Rome, 1966), II, p. 37. There are no early references to this picture, and the painting on the easel does not appear to be related to any actual composition by Rubens.

7. See the catalogue by Benedict Nicolson of the exhibition *John Hamilton Mortimer ARA* (Towner Gallery, Eastbourne, and Iveagh Bequest, Kenwood, 1968), and the article by John Sunderland, 'John Hamilton Mortimer and Salvator Rosa', *Burlington Magazine* (1970), pp. 520–31.

8. Rosenblum, *Transformations*, p. 35, with a discussion of other versions of the subject.

9. Denis Diderot, *Salons*, ed. Jean Seznec (Oxford, 1967), IV, p. 369.

10. A. L. Girodet-Trioson, 'Première Veillée', in *Oeuvres posthumes*, ed. P. A. Coupin (Paris, 1829), I, p. 362. Girodet himself, however, was powerfully attracted by the image of the solitary artist, as is made clear by much of his astonishing poem *Le Peintre* and by his drawings of Raphael, Michelangelo, Poussin and others, which are reproduced in Coupin's selection of his works. Among the Sujets de Tableaux which he proposed, but never carried out, was one (*Ibid.*, II, p. 265) of 'Le Poussin travaille à la lueur d'une lampe: la jalousie et l'envie, qui veillent près de lui et qui regardent ses ouvrages avec consternation, veulent empêcher la gloire de le couronner, et la renommée de publier ses illustres travaux; mais leurs efforts sont inutiles.'

11. See C.-P. Landon, *Annales du Musée et de l'Ecole Moderne des Beaux-Arts* (Paris, 1815), X, p. 102.

12. See the catalogue by Daniel Ternois of the exhibition *Ingres* (Petit Palais, Paris, 1967–8), p. 96.

Ingres also planned a series to be devoted to the life of Poussin—see Verdi, in *Burlington*.

13. Quatremère de Quincy, *Histoire de la vie et des ouvrages de Raphaël* (Paris, 1824).

14. *Le Pausanias français* [P.-J.-B. Chaussard] *ou Description du Salon de 1806 ...* (Paris, 1808), pp. 84–96.

15. Landon, *Annales, Salon de 1814*, p. 77.

16. *Ibid., Salon de 1824*, II, pl. 26.

17. Ch. XLIII.

18. See, for instance, Bergeret; *Michel-Ange* (Salon de 1817, no. 37): 'Etant devenu aveugle, se faisait conduire auprès du Torse antique qu'il touchait pour se rappeler la beauté des formes qu'il ne pouvait plus admirer.' And Couder: *Michel-Ange* (Salon de 1819, no. 243): 'le grand homme fait admirer à ses disciples les beautés du torse antique d'Hercule'. This picture is reproduced in Landon, *Annales, Salon de 1819*, II, p. 71. Many of the other Michelangelo pictures showed similar themes.

19. Mr John Shearman has pointed out to me that the rather sour figure who can be seen in the background of some of Ingres's versions of *Raphael and the Fornarina* (Wildenstein, *Ingres* (London, 1954), figs. 46 and 48) is intended to represent Giulio Romano and not Michelangelo as is sometimes stated.

20. See G. Laviron and B. Galbaccio, *Le Salon de 1833* (Paris, 1833), pp. 221–4; and G. Planche, 'Salon de 1833', in *Etudes sur l'Ecole française*, pp. 194–7.

21. See A. Dayot, *Les Vernet* (Paris, 1898), pp. 134–6.

22. See Antoine Etex, *Les Souvenirs d'un artiste* (Paris, 1877), p. 126. Etex tells a curious story about this picture. Apparently Vernet asked his advice about it, and 'Venant de beaucoup étudier les maîtres primitifs à Florence, je lui avouai que suivant moi, qui venais d'étudier les maîtres de la Renaissance, son tableau n'avait pas le caractère du temps. Il prit la chose assez bien et me pria de lui prêter plusieurs de mes dessins faits d'après les maîtres florentins. Plusieurs mois après, sur son invitation, étant entré de nouveau dans l'atelier de M. Horace Vernet, je vis que la composition de son tableau, qui autrefois était en largeur se trouvait alors en hauteur!'

23. For a detailed analysis of this picture, see Charles De Tolnay, '"Michel-Ange dans son atelier" par Delacroix', *Gazette des Beaux-Arts*, LIX, (1962), pp. 43–50.

24. See the entry for 9 August 1859.

25. For the reaction to this picture and for Hesse's desperate and unsuccessful attempts to repeat his triumph of 1833, see Pol Nicard, *Alexandre Hesse: Sa vie et ses ouvrages* (Paris, 1883), pp. 26 ff. When this book was written all trace of the picture had already been lost, and Nicard comments (p. 30) that 'il ne nous en reste que la très médiocre

gravure sur bois du *Magasin Pittoresque*'.

26. She is also shown alive being painted by her father in a picture by Jeanron of 1857, now in Le Mans.

27. See T. Thoré, *Salon de 1844*, p. 120, and also Antonio Boschetto, *Savoldo* (Milan, 1963), pl. 30.

28. See Bernard Prost, *Octave Tassaert* (Paris, 1886), pp. xviii and 2–4.

29. Paul Mantz in *L'Artiste*, 3rd ser., v (1844), pp. 238 ff.

30. The picture is reproduced in Landon, *Annales, Salon de 1817*, pl. 38.

31. There were Fra Angelicos in the Salons of 1842 (Landelle), 1845 (Dumas), 1848 (Cartier), 1850 (Delaborde), 1866 (Picou), 1872 (Sautai), 1873 (Dauban), 1882 (Maignan), 1882 (Sautai), 1884 (Merson).

32. Maurice Denis, *Journal*, (Paris, 1957), I, p. 53. See the references to Fra Angelico also on pp. 36, 37, 42, 57.

33. This picture, which was called *Le Supplice des coins* in the Salon of 1867, was apparently intended to represent the torture inflicted on Alonso Cano, who was under suspicion of having murdered his wife: see Louis Viardot, *Les Musées d'Espagne . . .*, 3rd ed. (1860), p. 237. The picture is recorded in the museums of Rouen (*Catalogue des peintures*, by Olga Popovitch (Paris, 1967), p. 106), from which this illustration has been taken, and of Nice.

34. See George Levitine, '*Vernet tied to a Mast in a Storm*: The Evolution of an Episode of Art Historical Romantic Folklore', *Art Bulletin* (1967), pp. 93–100.

35. Amaury-Duval, *L'Atelier d'Ingres*, 6th ed. (Paris, 1924), p. 2.

36. The most conspicuous—but only partial—exception to this general interpretation of death-bed scenes is Gigoux's famous *Derniers Moments de Léonard de Vinci* (Salon de 1835, no. 910) in the Besançon museum. In his *Les Artistes de mon temps*, 2nd ed. (Paris, 1885), p. 31, Gigoux tells us that: 'Je n'entrepris cette grande composition que parce que j'avais lu dans Vasari comment Léonard de Vinci avait voulu se faire descendre de son lit pour recevoir son Dieu à genoux, avant de mourir, et pour lui demander pardon de n'avoir pas fait assez de peinture en sa vie. Je ne savais assez témoigner mon enthousiasme pour la peinture et pour les peintres; ainsi la fin superbe de Léonard de Vinci m'impressionnait-elle extrêmement.'

37. Robert-Fleury's *Benvenuto Cellini dans son atelier* (Salon de 1841, no. 1719; reproduced in *L'Artiste*, 11th ser., vii, p. 376), which shows him brooding and solitary, is exceptional.

38. See Allan Cunningham, *The Life of Sir David Wilkie* (London, 1843), III, p. 296.

39. See Emile Ripert, *François-Marius Granet* (Paris, 1937), p. 59.

40. Laurent: *Trait de la vie de Callot* (Salon de 1817, no. 485) reproduced in *Galerie de Son Altesse Royale Madame la Duchesse de Berry—Ecole française, peintres modernes* (Paris, 1822), II.

41. See pictures by Lecomte (1822, no. 832), Mme De Bay (1831, no. 464) and Goyet (1831, no. 975).

42. In the pictures by Perignon (Salon de 1817, no. 608) and Baille (Salon de 1846, no. 60). The Perignon is reproduced in Landon, *Annales, Salon de 1817*, pl. 30. On the other hand Lechevallier-Chevignard's *Antonello de Messine et Giovanni Bellini* (Salon de 1872, no. 961) shows Bellini introducing himself to Antonello on the pretext of painting his portrait, but in fact in order to discover from him the secret of oil painting; and Rembrandt's unpleasant behaviour towards Rubens in the picture by Wallays in the Salon of 1842 (no. 1864) has already been referred to. Rembrandt was also portrayed in an unattractive light by Jules Dehaussy in *Les Derniers Moments de Rembrandt* (Salon de 1838, no. 441), where the painter asked to see his treasure once more before dying.

43. See the catalogue for the Salon of 1822, under no. 78: Bergeret: *Le Tintoret et l'Arétin*, and also the notes copied out by Ingres in Schlenoff, *Ingres: ses sources littéraires* (Paris, 1956), pp. 182–3. The story is found in Ridolfi.

44. Gustave Planche (in *L'Artiste*, ii, p. 101) was one of a number of critics who were quick to point out that Puget did nothing of the kind. The mistake is, however, highly indicative of the whole trend of all these scenes, which paid more attention to royal munificence than the rivalries of artists.

45. Mme Cavé: *Enfance de Lawrence* (Salon de 1845, no. 279).

46. These can be compared with Quatremère de Quincy's *Raphael* of 1824, which disposes of the artist's childhood in just a page.

47. Verdi, in *Burlington*, p. 745, who reproduces an engraving after this picture.

48. See E. H. Gombrich, 'Raphael's "Madonna della Sedia"', reprinted in *Norm and Form* (London, 1966), esp. p. 66.

49. Colin: *Raphaël dessinant dans la campagne de Rome* (Salon de 1857, no. 569; now in the Nancy museum).

50. Lazerges: *Albani dans son atelier*, in the museum at Narbonne, was painted in 1853, but does not appear to have been exhibited at the Salon.

51. The picture was apparently not exhibited at the Salon, but was referred to in *L'Artiste*, 3rd ser., iv (1843), p. 183.

52. Thoré, 'Salon de 1861', reprinted in W. Bürger, *Salons de 1861–1868* (Paris, 1870), I, p. 13.

53. See Thoré (who saw the picture when it was

exhibited in Brussels) in *Gazette de Beaux-Arts*, viii (1860), p. 94, and *Salon de 1861*, p. 42.

54. For this picture, which was not exhibited at the Salon, see the catalogue by Anne Hanson of the Manet exhibition in Philadelphia and Chicago (1966–7), pp. 8 and 9.

55. E. J. Delécluze, *Louis David, son école et son temps*, 2nd ed. (Paris, 1863), p. 297.

56. In a picture, not exhibited at the Salon, now at Le Puy.

57. See Ripert, *Granet*. His account is distinctly unreliable, but Granet's *Stella*, which is now in Moscow, was presumably 'Un tableau représentant un intérieur de prison' in the *Inventaire après*

décès de l'Impératrice Joséphine à Malmaison, ed. Serge Grandjean (Paris, 1964), p. 168.

58. See Eugène Montrosier, *Peintres modernes: Ingres, H. Flandrin, Robert-Fleury* (Paris, 1882); and for an excellent account of his style, Rosenthal, *Du romantisme*, pp. 221–2.

59. See especially the *Salon de 1845*, but also *Le Musée Classique du Bazar Bonne-Nouvelle* (1846) and the posthumously published *Catalogue de la collection de M. Crabbe*, a Belgian collector.

60. See *L'Artiste*, 3rd ser., iii (1843), p. 209.

61. Quoted by John Rewald, *Post-Impressionism—from Van Gogh to Gauguin*, 2nd ed. (New York), pp. 242–3.

NOTES TO ESSAY 8

1. *The Athenaeum* (30 January 1858). For this and comments from *The Times* (27 May 1858), see 'Tragedy and Comedy: Opinions of the Press on Gérôme's Celebrated Picture of the Duel after the Masquerade, published by E. Gambart and Co.' (n.d.).

2. For a full account, see *The Times* (Tuesday, 18 May 1858), p. 12, and references in the Goncourt *Journals* and Viel Castel, *Mémoires*.

3. See Edmond About, *Nos artistes au Salon de 1857*, pp. 70–3.

4. In an interesting article 'The Wintry Duel: A Victorian Import' published in *Victorian Studies* (June 1959), Coleman O. Parsons claimed that the pictures by Gérôme and Couture discussed here were based on a specific duel between two masqueraders, Deluns-Montaud and Symphorien-Casimir-Joseph Boittelle which took place in the winter of 1856–7. Unfortunately I have not been able to track down the principal sources to which he draws attention in his note 1. However, although the Goncourt *Journals* as well as contemporary and modern biographical dictionaries all discuss Boittelle, who was a prominent politician, none of them refers to the duel in question. In any case a full investigation of these pictures is not strictly relevant to the main theme of this paper.

5. About, *Nos artistes*.

6. I do not feel that the sententious verses

> Ce que t'offre ici le pinceau,
> Quoique pris de la Comédie,
> N'est que trop souvent le tableau
> De ce qui se passe en la vie

attached to the 1719 engraving of Watteau's *Arlequin, Pierrot et Scapin*, now at Waddesdon, in fact 'gives an explicit indication of the half-melancholy vein which informs all Watteau's pictures of this kind', as Ellis Waterhouse claims in

his catalogue of *The James A. de Rothschild Collection at Waddesdon Manor—Paintings* (1967), p. 286.

7. See Théodore de Banville, *Mes souvenirs* (1882), p. 93. Also Seymour O. Simches, *Le Romantisme et le goût esthétique du XVIII siècle* (1964).

8. *Paris Guide* (1867), p. 544.

9. J. Michelet, *Histoire de France* (1863), XV, *La Régence*, ch. XIX, quoted by Hélène Adhémar, *Watteau* (1950), p. 156.

10. D. Panofsky, 'Gilles or Pierrot', *Gazette des Beaux-Arts*, xxxix (1952), p. 319.

11. Théophile Gautier, *Histoire de l'art dramatique en France depuis vingt-cinq ans* (Paris, 1858–9), V (January 1847), p. 27.

12. But see P. L. Duchartre, *La Comédie italienne* (Paris, 1924), and *La Commedia dell'arte et ses enfants* (Paris, 1955).

13. For his biography, see Tristan Rémy, *Jean-Gaspard Deburau* (Paris, 1954).

14. Jules Janin, *Deburau: histoire du Théâtre à Quatre Sous* (1832) and 1881 edition (Librairie des Bibliophiles) with preface by Arsène Houssaye.

15. See also A. G. Lehmann, 'Pierrot and fin de siècle', in *Romantic Mythologies*, ed. Ian Fletcher (1967), which is concerned with some of the same problems as this lecture, though from a rather different angle. Also Enid Welsford, *The Fool* (London, 1935, reprinted 1969).

16. Gautier, *Histoire*, I, p. 43.

17. *Ibid.*, V, p. 25—quoted also by Maurice Sand in *Masques et bouffons* (Paris, 1860).

18. Though George Sand in *Questions d'art et de littérature* (1878), ch. XV, gives a far more attractive picture of him.

19. See Gautier, *Shakespeare aux funambules*, reprinted in *L'Art moderne* (1856).

20. Gautier, *Histoire*, V, p. 23.

21. *Ibid.*

22. C. Magnin, *Les Origines du théâtre moderne* (Paris, 1838).

23. Maurice Sand, *Masques et bouffons* (1860).
24. Champfleury, *Souvenirs et portraits de jeunesse* (1872), ch. XII.
25. Champfleury, *Souvenirs des funambules* (1859), pp. 11 ff.
26. *Ibid.*
27. Paul Hugounet, *Mimes et pierrots* (1889). But see note 4.
28. Gautier, *Histoire*, V, p. 23.
29. I am most grateful to Mr Andrew Calder of the University of Kent for putting at my disposal the extensive literary material he has collected round this theme. My friend M. Pierre Georgel has also kindly shown me many further references.
30. Kurt Badt in *The Art of Cézanne* (London, 1965), gives an interesting psychoanalytic interpretation of this picture, which was painted in 1888.
31. See, for instance, the relevant section in Albert Boime's book on Couture.
32. K. E. Maison, *Honoré Daumier* (1967), I, p. 144.
33. In *The Absolute Bourgeois* (1973), pp. 120–3, T. J. Clark has pointed out another – and very cogent – explanation for the misery of these *saltimbanques*: the incessant harassment which, as from 1849, they faced at the hands of the government.
34. Baudelaire, *Oeuvres complètes* (Pléiade 1966), p. 247.

35. Henry James, *Honoré Daumier* (1893) — reprinted in *The Painter's Eye* (1956).
36. Edmond and Jules Goncourt, 'Un comédien nomade', in *Une voiture de masques* (1856).
37. See Linda Nochlin, 'Gustave Courbet's *Meeting*: A Portrait of the Artist as a Wandering Jew', *Art Bulletin*, xlix (1967), pp. 209 ff.
38. See Hugounet, *Mimes*, and Edmond Pijon, *Paul et Victor Margueritte* (1905).
39. Hugounet, *Mimes*.
40. *Ibid.*
41. Edmond de Goncourt, *Les Frères Zemganno* (1879), especially chs. XXVII and XXXI.
42. I am extremely grateful to Dr Anita Brookner for bringing to my attention the episode in chapter XXV of *Manette Salomon* (1867) in which, in the year 1846, when strongly under the influence of Deburau, Anatole Bazoche repaints his 'Christ humanitaire' as Pierrot.
43. Byron, *Don Juan*, IV, 4. See also Walpole: 'The world is a comedy to those that think, a tragedy to those that feel' (letter to Countess of Upper Ossory, 16 August 1776); Richardson, *Clarissa Harlowe*, Letter 84; and Beaumarchais, *Le Barbier de Seville*, Act 1, scene 2. There are, of course, many authors who probe far more deeply into the subject.

NOTES TO ESSAY 9

1. *Rossetti Papers*, p. 319.
2. *Gustave Doré* (London, 1946).
3. Konrad Farner, *Gustave Doré* (Dresden, 1963).

NOTES TO ESSAY 10

I am most grateful to Mme Sylvie Béguin and the Department of Conservation at the Louvre for allowing me to see the files concerning this picture.

1. [Roger de Piles], *Conversations sur la connoissance de la peinture, et sur le jugement qu'on doit faire des tableaux* (1677).
2. See Bernard Tesseydre, *Histoire de l'art vue du Grand Siècle* (1964), p. 271, note 5.
3. See, for instance, the entry for the picture in Pignatti, Giorgione (Venice, 1969), p. 129, who also discusses other attributions.
4. I am grateful to Carlos van Hasselt for bringing to my attention the copy in Paris and to the late Jan van Gelder for telling me about the one in Leiden to which he had first referred in 1955 — *Venezia e l'Europa – atti 'del XVIII congresso di storia dell'arte*, p. 336. He subsequently published it in *Jan de Bisschop*, offprint of *Oud Holland*, lxxxvi, no. 4 (1971), fig. 50. In a letter to me Professor van Gelder said he thought it unlikely that the original picture was ever in Holland, and quite possible that de Bisschop went to Paris in 1668. There is also a reversed (and inaccurate) mezzotint

by Jacob Vaillant about whose movements almost nothing seems to be known.
5. See Frits Lugt, 'Italiaansche Kunstwerken in Nederlandsche Verzamlingen', *Oud Holland*, liii (1936), pp. 97–135.
6. See Catalogus van Schilderyen, van der Graaf von Arondel, verkocht den 26 September 1684, in Amsterdam, item 1 — reprinted by Gerard Hoet in 1752 — see Lugt, *Repertoire des catalogues de ventes publiques* (1938), I, no. 7.
7. See A. P. de Mirimonde, 'La Musique dans les allégories de l'Amour', *Gazette des Beaux-Arts*, 6th ser., lxviii (1966), pp. 265–90, who does not, however, draw any conclusions as to the picture's history from his discussion of the Wouters.
8. Sir Oliver Millar has, however, confirmed my opinion that there is no proof of any kind to suggest that the picture did in fact belong to Charles I.
9. But, as Professor Kurz has kindly pointed out to

me, in 1661 the name 'Pastorales' was given to a series of compositions by Jacques Stella engraved by his niece Claudine Bouzonnet-Stella. These represent rural occupations (reaping, haymaking, etc.) and diversions, which are treated in a 'realistic' convention in no way related to the imaginative world of Giorgione.

10. Mr Richardson, Sen. and Jun., *An Account of Some of the Statues, Bas-Reliefs, Drawings and Pictures in Italy, &c, with Remarks* (London, 1722), p. 8. It is, however, possible that Félibien in his *Entretiens sur les vies et sur les ouvrages des plus excellens peintres anciens et modernes . . .*, 1st ed. (1666–88), was referring to this picture when he wrote: 'Et dans le cabinet du Roy, il y a un tableau de plus de quatre pieds de long, sur trois pieds demi de haut (by Giorgione), composé de plusieurs figures si admirablement peintes, qu'on les prend souvent pour être du Corege; tant le Giorgion s'est surpassé lui-meme dans cet Ouvrage', new ed. (Trevoux, 1725), I, p. 273.

11. Parallels are pointed out by René Huyghe in his preface to Hélène Adhémar, *Watteau: sa vie—son oeuvre* (Paris, 1950).

12. See, for instance, [Mariette] in *Recueil d'Estampes d'aprés les plus beaux tableaux . . . qui sont en France dans le Cabinet du Roi, dans celui de Monseigneur le Duc d'Orléans, & dans d'autres Cabinets . . .* (Paris, 1763), II, pp. 23–4. This contains the earliest reference that I have so far traced to the story that this picture belonged to Charles I.

13. See *Galerie du Musée Napoléon*, published by Filhol graveur . . . an XII (1804), no. 36, pl. 3, where the picture is first called *Concert champêtre*, and De Perthes, *Histoire de l'art du paysage* (1822), p. 10.

14. See Stendhal, *Ecoles italiennes de peinture* (Paris, Le Divan, 1932), II, p. 97, ch. VIII.

15. See Finberg, *Turner's Drawings: Inventory*, I, p. 181, LXXII—'Studies in the Louvre,' sketchbook Schedule, No. 310, pp. 56a, 57. These drawings are in the British Museum, but the pencil version of the whole composition is too faded for adequate reproduction. Incidentally, Turner attributes the 'Pastoral Subject' to Titian.

16. Delacroix, *Journal*, 11 April 1824.

17. See A. Gilchrist, *Life of William Etty, R.A.* (London, 1855), I, p. 293, and Denis Farr, *William Etty* (London, 1958), pp. 59–60, 181. This copy is now in the author's possession.

18. See Ambroise Vollard, *Souvenirs d'un marchand de tableaux* (Paris, 1937), p. 174.

19. See M. Calvesi, 'La Tempesta di Giorgione come ritrovamento di Mosè', *Commentari* (1962), p. 226.

20. Paul Gsell, *Millet* (1928), p. 16.

21. Alfred Robaut, *L'Oeuvre de Corot* (Paris, 1905), I, p. 209.

22. Kenneth Clark, *The Nude: A Study of Ideal Art* (London, 1956), p. 116.

23. The file on the picture in the Louvre contains references to copies by Bonnat (unfinished) in the Musée Bonnat Bayonne; Fantin-Latour (some, but not all of which are listed in *Catalogue de l'oeuvre complet de Fantin-Latour* (1911), p. 51); Degas (see T. Reff in *Burlington Magazine* (June 1958), p. 205); Poterlet (Vente Decamps, 23–4 May 1865, no. 38, and other sales); Ricard (see Stanislas Giraud, *Gustave Ricard: sa vie et son oeuvre, 1823–73* (Paris, 1932), inv. 71 and p. 716); Cézanne (in catalogue of *De l'Impressionisme à nos jours—aquarelles, pastels, gouaches* at Musée d'Art Moderne (1958), pl. 5, cat. 28. Another copy, attributed to Cézanne, in the Matsukata collection, Tokyo, is reproduced in K. E. Maison, *Themes and Variations* (London, 1961), pl. 181; Meyer Shapiro discusses the possible impact of this picture on Cézanne in 'Les Pommes de Cézanne', *Revue de l'Art*, i–ii (1968), p. 78). A copy by Cabanel in the Musée Fabre, Montpellier, is reproduced in Albert Boime *The Academy and French Painting in the Nineteenth Century* (London, 1970), pl. 113.

24. A. Proust, *Edouard Manet—Souvenirs*, quoted in Giacomo (Jacques) Mesnil, '"Le déjeuner sur l'herbe" di Manet ed "Il Concerto Campestre" di Giorgione', *L'Arte* (1934), pp. 250–7. No painted copy by Manet is known to survive, but several drawings of the *Concert champêtre* have been attributed to him, though none has won universal acceptance. The most recently published is reproduced by Jacques Mathey in *Bulletin de la Société d'Etudes pour la Connaissance d'Edouard Manet*, nos. 4–5 (July 1970), p. 17.

25. Zola, *Salons*, selected and annotated by F. W. J. Hemmings and Robert J. Niess (Geneva, 1959), pp. 83 ff.

26. Théophile Gautier, 'Le Musée du Louvre', in *Paris Guide* (1867), 1st part, p. 331.

27. Dante Gabriel Rossetti, *Letters,* ed. Oswald Doughty and John Robert Wahl (London, 1965), I, p. 71 (8 October 1849).

28. This is the version printed in Dante Gabriel Rossetti, *The Collected Poems*, edited with preface and notes by William M. Rossetti, 2 vols. (London, 1886), I, p. 345.

29. Swinburne, *Letters*, ed Cecil Y. Lang (New Haven, 1959), I, p. 40 (19 January 1861).

30. John Addington Symonds, *Renaissance in Italy: The Fine Arts*, 2nd ed. (London, 1882), p. 367, note 1.

31. J. A. Crowe and G. B. Cavalcaselle, *History of Painting in North Italy* (London, 1871), I, pp. 146–7. Waagen's earlier attribution of the picture to Palma Vecchio seems to have attracted little attention.

32. This copy was kindly drawn to my attention by Dr Lino Moretti, who has generously allowed me to reproduce it here.

33. *Entretiens de J.-J. Henner, notes prises par Emile Durand-Gréville après ses conversations avec J.-J. Henner, 1878–1888* (Paris, 1925), p. 13.

34. See especially Patricia Egan, '*Poesia* and the *Fête Champêtre*', *Art Bulletin*, xii (1959), pp. 305–13.

35. P. Fehl, 'Hidden Genre: A Study of the *Concert champêtre* in the Louvre', *Journal of Aesthetics and Art Criticism* (16 December 1957), pp. 153–68.

NOTES TO ESSAY 11

My interest in the story of Morris Moore was first stimulated by the brief account of it given by Redford, pp. xxii–xxvi. Although Redford was personally acquainted with Moore, his version of the events is not strictly accurate. I am very grateful to the following who have all helped me in different ways: Hugh Brigstocke, Mlle Chardonneret, Margie Christian, John Fleming, Jacques Foucart, Celina Fox, John Gere, Edward Goldberg, Robert Halsband, Michael Jaffé, Michael Levey, Angelina Morhange, Nicholas Penny, Romeio de Maio, Duncan Robinson, Francis Russell, Jon Whiteley. Because such bitter controversies were at stake I have found it necessary to make my notes more than usually numerous and detailed. See bibliography, pp. 245–6.

1. Lugt 19699: 22 February–2 March 1850. In his will of 12 July 1849 (Public Record Office: Prob. II—2112, page 387) Duroveray makes no mention of his career as a publisher and it seems likely that he had given this up many years earlier. The sale catalogue specifically refers to the engravings which 'comprise fine proofs of the beautiful works published by Mr Duroveray,' and he did own a remarkable collection of artists' proofs by Stothard, Turner, Smirke and many others.

2. This is suggested by Gruyer (1859), p. 6.

3. The question of provenance remains baffling. Gruyer (1859), p. 6, and (1889) p. 13, consistently accepted the view, first suggested in the Christie sale catalogue, that the picture had belonged to the very important collection of John Barnard; and Crowe and Cavalcaselle (I, p. 210) claimed that the initials 'J.B.' on the back of the panel confirmed this. Redford however, had doubts (p. xxvi), and in fact not one single inventory of Barnard's collection or any of the catalogues of sales through which his pictures are known to have passed lends any support whatsoever to the theory that he had owned the *Apollo and Marsyas*.

4. Moore, *European Scandal*, p. 4.

5. This point was first made by Gruyer (1859), pp. 5–6.

6. Méliot, pp. 12–14. Méliot was clearly one of the many people in France to whom Morris Moore gave a colourful account of the circumstances surrounding his acquisition of the *Apollo and Marsyas*. He claimed to have known Moore very well indeed and to have been 'directement mêlé aux peripéties de cette singulière odyssée'. We have only his word for the very important role he assigns to himself in obtaining the picture for the Louvre, as his name does not seem to occur in any of the vast documentation surrounding the transaction, although the entry concerning the picture in the copy of the Duroveray sale cata-

logue belonging to Christie's is annotated in pencil: 'A Méliot, 99 Avenue des Champs-Elysées.' It may conceivably be to him that F. A. Gruyer was referring when he wrote in a letter of 25 April 1883 (Archives du Louvre, P⁶): 'Quant à ce que vous a écrit Mʳ M. au sujet du tableau de Morris Moore, n'en tenez, je vous prie, aucun compte. Mʳ M. est tout à fait à côte de la question. Vous savez, d'ailleurs, à quoi vous en tenir sur sa compétence en matière de peinture. Il ne croit pas à l'authenticité de la *Vierge d'Orléans*, mais il croit à celle de tous les Raphael qu'il possède. C'est tout dire.'

I have found it very difficult to find out anything about Méliot, as there were a number of writers of this name involved in differing activities. It seems likely that he was the critic writing about the Salons of the early 1880s in the *Revue Libérale*, and also the editor of a sumptuous edition of Dante published in 1909.

7. Méliot, p. 14.

8. For the outlines of Moore's life, see the manuscript 'Notes on the late Morris-Moore' written by his son in 1908 and sent to the Keeper of the Tate Gallery (Library of the Victoria and Albert Museum—2R.C.H.24). There is a very brief, but not wholly accurate, summary in Boase, and his participation (as a second-lieutenant as early as 1828) in the Greek War of Independence is also recorded in Dakin.

9. See [Moore], *Verax*.

10. See [Moore], *Opinions of the Press*. The last pages of this somewhat repulsive publication are devoted to 'Opinions of the Press on Mr Morris Moore'.

11. See Fitzgerald, I, p. 272—4 May 1848: 'Moore is turned Picture-dealer; and that high Roman virtue in which he indulged is likely to suffer a Picture-dealer's change, I think.' In 1853 Moore himself stated that he was then dealing 'as ex-

12. Moore, *Prince Albert*, p. 13, note 1.

13. Méliot, p. 15, note 2.

14. *Ibid.*, p. 18.

15. *Art-Journal* (1851), p. 32.

16. See 'The Moore Raphael', *The Leader* (7 September 1850), p. 571. If not actually by Moore himself, the whole tone of this anonymous article makes it clear beyond any doubt that it was directly inspired by him.

17. See the documents published by Moore in *Debate of April 7th*.

18. See the account given by Morris Moore in 'To the German Public: A Dissection', published by Batté, pp. 24 ff.

19. See the letter from Lord Elcho to the *Morning Post* (10 June 1850), republished in Batté, pp. 19–21, and frequently by Moore himself in later pamphlets.

20. See the letter from Wolfgang Böhm to the *Morning Post* (13 June 1850), republished in Batté. pp. 68–72. Years later, J. G. Waller, who copied the picture for the wood-engraver, wrote that he too had been present when Passavant came to see it, and that 'he had no opportunity of giving the picture a study'—see letter to *The Academy* (1883), p. 253.

21. See Lord Elcho's letter referred to in note 19.

22. See, above all, Pungileoni.

23. Passavant (1860), II, pp. 354–5.

24. See unpublished letter from Moore to Gladstone of 28 June 1851 (B.M. Add. MSS 44370.f.173).

25. Moore, *Debate of April 7th*, pp. 23–4.

26. Another drawing—this one in the so-called sketchbook in Venice (Ferino Pagden, no. 6)—was also sometimes discussed in connection with the *Apollo and Marsyas*—see Moore's letter to Gladstone referred to in note 24, and also Crowe and Cavalcaselle (who made a copy of it, now in the Library of the Victoria and Albert Museum), I, pp. 210–11. In general, however, interest centred on the cartoon, which is in Venice—but not in the 'sketchbook' (Ferino Pagden, no. 54). Ferino Pagden considers this—and the painting—to be among Perugino's finest works, probably dating from the late 1480s.

27. See letter from J. G. Waller to *The Academy* (13 October 1883), p. 253.

28. Passavant (1858), pp. 174–5.

29. Moore, *Prince Albert*, pp. 8–9.

30. *Ibid.*, pp. 6–7. Moore says that this was the explanation given to him by Andrea Tagliapietra, sub-director of the Accademia, who was present when Cicognara made the note; it was, apparently, confirmed by Francesco Zanotto, who was secretary when Cicognara was president.

31. Moore, *Debate of April 7th*, pp. 24 ff., and elsewhere.

32. For his own documented account of this attribution, see 'The Rejected Michelangelo: The Manchester Exhibition', in Moore, *Prince Albert*, pp. 41–7.

33. See Moore's letter to Gladstone referred to in note 24.

34. In fact, Rumohr (accepting an old tradition) had already suggested this authorship for the controversial Manchester Madonna—see Gould, pp. 95–7. The attribution had, however, been lost sight of.

35. The question of Moore's 'eye' is obviously crucial, but it is difficult to solve, as we know so little about the pictures he owned, and his attacks on Eastlake and the National Gallery are too hysterically and personally motivated to be taken seriously. In his will, drawn up in Rome on 8 March 1878, he notes that 'a considerable proportion of my property consists of paintings and other valuable works of art, a list whereof for the guidance of my executrix and trustees will be found amongst my papers', but unfortunately I have not been able to find this list. It must be admitted that the available information is not very encouraging. The Menichoni Madonna, now in the Akademie der Bildenden Kunst in Vienna, has been discussed by Zeri: it is now usually attributed to Antonio Mini. Two fine Saints, now attributed to Butinone and belonging to the Earl of Wemyss and March, were apparently acquired from Moore's collection as Mantegnas (see the, rather inaccurate, catalogue entry in *Pictures from Gosford House lent by the Earl of Wemyss and March* (National Gallery of Scotland, 1957), nos. 14, 16). Moore's friend, the poet Edward Fitzgerald, bought on his advice a 'Titian' which, in the present catalogue of the Fitzwilliam Museum, Cambridge, is attributed to Scarsellino—see also the comments of Sidney Colvin in a letter to *The Academy* (20 October 1883), p. 270. In *A European Scandal*, pp. 177–9, Moore describes in great detail a portrait of Dante by Raphael in his collection, but even his closest friends maintained a discreet silence about this improbable picture, whose present whereabouts are unknown to me. One incontestable masterpiece passed through his hands—a drawing by Raphael for the Borghese *Entombment* (now in the British Museum, 1963–12–16–I), but this was already a celebrated and reproduced work when he bought it at the Samuel Rogers sale in 1856.

36. [Selvatico], p. 40: 'indubbiamente di Raffaello. Il sig. Moore di Londra ha un dipinto tenuto del Sanzio, colla stessa composizione'.

37. Moore, *Debate of April 7th*, p. 27.

38. *Ibid.*, p. 28.

39. Moore, *Prince Albert*, p. 33.

40. *Ibid.*, p. 31.

41. *Ibid.*, p. 33.

42. See *The Leader* (7 September 1850), pp. 571–2. The drawing for the engraving was made by J. G. Waller (see his important letter to *The Academy* (13 October 1883)). The picture was soon afterwards photographed by Bingham.

43. See Linton, II, p. 13, and Smith, p. 26.

44. *Disegni di Raffaello e d'altri maestri esistenti nelle gallerie di Firenze, Venezia e Vienna riprodotti in fotografia dai Fratelli Alinari e pubblicati da L. Bardi di Firenze.* I have used the four large volumes in the Library of the Victoria and Albert Museum.

45. Moore, *Prince Albert*, p. 12, and pp. 19–22 for the letter to Moore from Batté of 7 May 1859.

46. The Prince Consort's researches culminated in the remarkable posthumous publication [by Ruland] of 1876, in which the vendetta continued: Moore's picture is listed among those 'ascribed to Raphael'.

47. Moore, *Prince Albert*, pp. 16–17. Moore's other German enemies, apart from the Prince Consort, Waagen and Passavant, included that great connoisseur, and adviser to the National Gallery, Otto Mündler. But a number of Germans—and Austrians—strongly supported his claims.

48. Moore, *Debate of April 7th*, p. 21.

49. See, in addition to Moore's own account of this episode, Waagen, pp. 28–9.

50. Apart from many accounts in *The Times* and other newspapers, this whole episode can be studied (with some amusement) in the Foreign Office papers preserved in the Public Record Office—F.O. 64–419.

51. See *L'Artiste* (28 March 1858), p. 220.

52. Méliot, p. 19.

53. Reiset's attitude is difficult to fathom. Redford, p. xxiv, claims that he wanted to buy the *Apollo and Marsyas* for the Louvre at once, and there is supporting evidence in Gruyer's letter of 30 March 1883 (Archives du Louvre P⁶). It is not really clear why Moore (*European Scandal*, pp. 49–50) assumed that the anonymous, friendly and somewhat inaccurate article in *L'Artiste* of 28 March 1858, which attributed the picture to Francia, must have been written by Reiset.

54. Adhémar, p. 26.

55. Haskell, pp. 53 ff. for a discussion of this phenomenon.

56. Gruyer (1859).

57. Batté. I have been unable to find out anything about him.

58. About, pp. 277 ff.

59. Passavant (1860), II, pp. 354–5.

60. For the dates in which the picture was exhibited in these towns, see [Moore], *Quelques documents*.

61. [Moore], *Apollo e Marsia*, p. 12.

62. Moore, *European Scandal*, pp. 59 ff.

63. Rossetti, p. 124 (letter dating from October 1879).

64. Moore, *European Scandal*, p 8.

65. [Moore], *Dichiarazioni*.

66. Müntz, pp. 231–6.

67. Crowe and Cavalcaselle, I, pp. 209–13.

68. See the letter from J. G. Waller to *The Academy* (13 October 1883), p. 253.

69. For a description of this episode, see the account by his son published in Moore, *European Scandal*, pp. 157 ff.

70. For Delaborde's letters to Moore of 1864, 1868 and 1882, see the publication by Morris-Moore, *Documents inédits*.

71. *Ibid.*, for the various stages of the transaction.

72. In 1875, and again later, Moore turned down an offer of 300,000 francs from the Duke of Leuchtenberg, and he was to let the Louvre buy it for two-thirds of that price.

73. See the draft of a letter from F.-A. Gruyer of 30 March 1883 in the Archives du Louvre P⁶. There is an entertaining correction made by Gruyer to his manuscript: he erases the words 'mettons que je me trompe' and substitutes 'que nous nous trompions'.

74. Letter from F.-A. Gruyer of 24 April 1883 in the Archives du Louvre P⁶.

75. Letter from F.-A. Gruyer of 25 April 1883 in the Archives du Louvre P⁶.

76. The contract is published in Morris-Moore, *Documents inédits*, p. 3.

77. See the letter of complaint from John Morris-Moore (fils) of 24 October 1921, kept with the file on the picture in the Documentation of the Louvre; and, *ibid.*, the answer, dated 22 January 1884, from the Directeur des Beaux-Arts to a complaint made by Moore himself.

78. *The Times* (31 May 1883).

79. See letters of 1 and 5 March 1885 from Beluet, Rue St Sauveur, no. 122, à Tours, in the library of the National Gallery—Box G IV, 5a 28.

80. A de L., 'L''Apollon et Marsyas'' du Louvre', *Chronique des Arts* (12 January 1884), p. 12.

81. See Claude Phillips, 'Signor Morelli's new book . . .', *The Academy* (30 May 1890), pp. 306 ff.

82. [Moore], *Apollo e Marsia*, p. 12.

83. Morelli, p. 306.

84. See Ivan Lermolieff, 'Raphael's Jugendentwicklung', *Repertorium für Kunstwissenschaft*, v (1882), pp. 151–2,

85. See Henry Wallis's letter to *The Academy* (3

November 1883), pp. 305–6.

86. See Crowe and Cavalcaselle MSS in library of Victoria and Albert Museum, 72.C.8. Cavalcaselle copies out Frizzoni's letter to him, of 5 February 1881, and his own answer of 4 March, and sends both, with additional comments, to Crowe.

87. See letter from Conway to *The Academy* (22 September 1883), pp. 202–3. In a later letter (*ibid.*, 20 October 1883) Conway says that he had looked at the picture with Morelli.

88. Had he read them, Moore might (but probably would not) have been comforted by the following words which, generations earlier, had been written by a man whom he highly esteemed: 'Perchè le bellissime opere del Perugino ognuno potrebbe attribuirle a Raffaello' (Cicognara (1818), III, p. 312).

89. Gruyer (1889).

90. *Ibid.*, p. 10.

91. Pater, pp. 151–2.

Books and Articles referred to in the Notes. Unpublished material and letters to newspapers are described under the appropriate notes.

About, Edmond. *Lettres d'un bon jeune homme à sa cousine Madeleine*, 2nd ed. (Paris, 1861).

Adhémar, Jean. 'Deux membres de la Société, Delaborde et Duplessis, Conservateurs du Cabinet des Estampes, 1855–1898', *Bulletin de la Société de l'Historie de l'Art Français* (1972), pp. 25–9.

Batté, Léon. *Le Raphaël de M. Morris Moore: Apollon et Marsyas* (Paris and London, 1859).

Boase, Frederick. *Modern English Biography*, 6 vols. (Truro, 1892–1921).

Cicognara, Leopoldo. *Storia della scultura dal suo Risorgimento in Italia sino al secolo XIX*, 3 vols. (Venice, 1813–18).

Crowe, J. A. and Cavalcaselle, G. B. *Raphael: His Life and Works*, 2 vols. (London, 1882).

Dakin, Douglas. *British and American Philhellenes during the War of Greek Independence, 1821–1833* (Thessalonika, 1955).

Delaborde, Henri. 'Les Préraphaélites à propos d'un tableau de Raphael', *Revue des Deux-Mondes* (15 July 1858), pp. 241–60.

Ferino Pagden, Sylvia. *Disegni Umbri—Gallerie dell'Accademia di Venezia* (Milan, 1985).

Fitzgerald, Edward. *Letters and Literary Remains*, 7 vols. (London, 1902).

Gould, Cecil. National Gallery Catalogues—*The Sixteenth Century Italian Schools* (excluding the Venetian) (London, 1962).

Gruyer, F.-A. 'Apollon et Marsyas tableau de

Raphaël', *Gazette des Beaux-Arts*, iii (1859), pp. 5–20.

Gruyer, F.-A. 'Apollon et Marsyas au Musée du Louvre', *La Nouvelle Revue* (1 April 1889), pp. 5–14.

Haskell, Francis. *Rediscoveries in Art: Some Aspects of Taste, Fashion and Collecting in England and France*, 2nd ed. (New Haven and London, 1982).

Linton, Mrs Lynn. *The Autobiography of Christopher Kirkland*, 3 vols. (London, 1885).

Méliot, A. *Apollon et Marsyas: le nouveau Raphaël du Louvre* (Paris, 1884).

[Moore, Morris]. *Verax: The Abuses of the National Gallery* (London, 1847).

Moore, Morris. *The National Gallery—The Debate of April 7th, Mr Stirling M.P., and Raphael's 'Apollo and Marsyas'. A Reply* (London, 1856).

[Moore, Morris]. *The National Gallery etc.—Opinions of the Press on Sir Charles Eastlake, Mr Wornum, and Herr Mündler* (London, 1856?).

Moore, Morris. *H.R.H. Prince Albert and the Apollo and Marsyas by Raphael—To the Public, A statement with an appendix* (Paris, 1859).

[Moore, Morris]. *Apollo e Marsia opera di Raffaello Sanzio da Urbino* (Milan, 1860).

[Moore, Morris]. *Dichiarazioni intorno all'Apollo e Marsia di Raffaello dei Professori delle Classi di Pittura e Scultura dell'Insigne e Pontificia Accademia Romana delle Belle Arti denominate di S. Luca e di altri distinti pittori, con appendice* (Rome, 1866).

[Moore, Morris]. *Quelques documents relatifs à l'Apollo et Marsyas de Raphaël* (Rome, 1866).

Moore, Morris. *Raphael's 'Apollo and Marsyas': A European Scandal*, 2nd ed. (Rome, 1885).

Morelli, Giovanni. *Italian Masters in German Galleries* (London, 1883).

Morris-Moore, John. *Documents inédits concernant le tableau Apollon at Marsyas de Raphaël connu depuis 1850 sous la dénomination Le Raphael de Morris-Moore, avec une préface par John Morris-Moore fils* (Rome, 1921).

Müntz, Eugène. *Raphaël, sa vie, son oeuvre et son temps* (Paris, 1881).

National Gallery. *Report from the Select Committee on the National Gallery with Minutes of Evidence, Appendix and Index* (London, 1852–3).

Passavant, J. D. *Rafael von Urbino und sein Vater Giovanni Santi*, 2 vols. (Leipzig, 1839); and III (1858).

Passavant, J. D. *Raphaël d'Urbino et son père Giovanni Santi*, édition française refaite, 2 vols. (Paris, 1860).

Pater, Walter. *Raphael* (1892)—reprinted in Miscellaneous Studies in the Renaissance (London, The Fontana Library, 1961).

[Pungileoni, Luigi]. *Elogio storico di Timoteo Viti* (Urbino, 1835).

Redford, George. *Art Sales: A History of Sales of Pic-*

tures and other Works of Art, 2 vols. (London, 1888).

Rossetti, Dante Gabriel and Jane Morris, *Correspondence,* edited with an introduction by John Bryson (Oxford, 1976).

[Ruland, C.] *The Works of Raphael Santi da Urbino as represented in the Raphael Collection in the Royal Library at Windsor Castle formed by H.R.H. The Prince Consort 1853–1861, and completed by Her Majesty Queen Victoria* ([London], 1876).

[Selvatico, Pietro]. *Catalogo delle opere d'arte contenute nella Sala delle Sedute dell'I.R. Accademia di Venezia* (Venice, 1854).

Smith, F. B. *Radical Artisan: William James Linton, 1819–1897* (Manchester, 1973).

Waagen, Gustav Friedrich. *Kleine Schriften,* ed. Alfred Woltmann (Berlin, 1875).

Zeri, Federico. 'Il Maestro della Madonna di Manchester', *Paragone,* no. 43 (1953), pp. 15–27.

NOTES TO ESSAY 12

Material on Khalil Bey has been drawn from various biographical sketches (e.g. *Men of the Times: A Dictionary of Contemporaries,* 8th ed., revised and brought down to the present time by Thompson Cooper, F.S.A. (London, 1872), p. 563), memoirs of the period (the journals of the Goncourts and those of Emile Ollivier, Arsène Houssaye's *Les Confessions* and the letters of Sainte-Beuve) and contemporary journalism (Anthony B. North Peat, *Gossip from Paris during the Second Empire,* selected and arranged by A. R. Waller (London 1903), p. 226; Arthur Meyer, *Ce que je peux dire* (Paris, 1912), p. 165). The catalogue with Gautier's preface, *Collection des tableaux de S Exc Khalil Bey* accompanied the sale of the collection in January 1868 and Parisian journals of the period abound in references and rumours (see *L'Illustration* (1868), pp. 27–9; *L'Artiste* (1868); p. 285, *Le Moniteur* (14 December 1867); *Chronique des Arts* (1868), pp. 10–11, 14). For Jeanne de Tourbey and her portrait by Amaury-Duval, see the catalogue of the *Exposition Amaury-Duval* held in Montrouge in 1974 (cat. no. 8) and the article by Auriant, 'La Dame aux violettes' in the *Mercure de France,* mod. ser., ccxci (1 April–1 May 1939), pp. 49–82. I am particularly grateful to Mr Geoffrey Lewis of the Oriental Institute in Oxford for his great help in providing information on the Turkish background (see Serif Mardin, *Genesis of Young Ottoman Thought* (Princeton, 1963), p. 206; R. H. Davison, *Reform in the Ottoman Empire, 1856–1876*). For Khalil Bey's dealings with Courbet, the reader is referred to the catalogue of the exhibition *Gustave Courbet* (Grand Palais, Paris, 1977–8), pp. 40, 182–6, to the biographies by J. Lindsay and by G. Mack and to *Courbet raconté par lui-méme et par ses amis,* 2 vols. (Geneva, 1948–50), I, p. 194. The local Franche Comté reports in the *Revue littéraire de la Franche Comté* (1 August 1866) were reprinted in the bulletin of *Les Amis de Gustave Courbet,* no. 35, Paris, Ornans, pp. 4–5. For Ingres's *Bain Turc,* see *Le Bain Turc d'Ingres: Les Dossiers du Département des Peintures* (Musée du Louvre, Paris, 1971).

NOTES TO ESSAY 13

I am deeply grateful to the Altman Foundation and the Metropolitan Museum, which made possible my visit to the United States to collect the material for this article. I am also most grateful to Elizabeth Gardner, Claus Virch and everyone else in the Museum's Department of European Paintings, who gave me unrestricted access to all the relevant archives. I express these thanks with the greater feeling as I am aware that they may disagree with some of what I have written. Finally, I wish to thank Baron Cecil Anrep, who has kindly permitted me to quote from several of Bernard Berenson's letters.

1. *New York Times* (8 and 9 October 1913).
2. René Brimo, *L'Evolution du goût aux Etats-Unis* (Paris, 1938); S. N. Behrman, *Duveen* (New York, 1951); Aline B. Saarinen, *The Proud Possessors* (New York, 1958); W. G. Constable, *Art Collecting in the United States of America* (London, 1964); and many specialised articles on individual collectors. The only works dealing with Altman himself are 'The Benjamin Altman Bequest', *Bulletin of the Metropolitan Museum of Art,* viii (1913), pp. 226–41, various editions of the *Handbook of the Benjamin Altman Collection,* published by the Metropolitan Museum, which first appeared in 1914 (I have used the 1928 edition and refer to

it hereafter as *Handbook*), and three articles by François Monod, 'La Galerie Altman au Metropolitan Museum de New York', *Gazette des Beaux-Arts,* 5th ser., viii (1923), pp. 179–98, 297–312, 367–77.

3. See his letter to Henry Duveen of 6 September 1912, and his cable of 6 June 1913. This correspondence is kept in two files in the Department of European Paintings in the Metropolitan Museum. The files contain letters and cables between Altman and Duveen's from March 1912 until his death. I will refer to them hereafter as Duveen File.

4. Letter from Altman to Edward Robinson, 17 May

1909, in the Archives of the Metropolitan Museum (Altman Bequest), henceforth referred to as Archives.

5. Duveen File, letter of 11 June 1913.
6. *New York Times* (8 October 1913).
7. Duveen File, cable of 11 July 1912.
8. Duveen File, cable of 16 July 1912.
9. The following facts about Altman's life are taken from three obituaries that appeared immediately after his death—*New York Times* (8 October 1913); *Chicago Examiner* (8 October 1913); *The Times* [London] (9 October 1913)—and from the *Dictionary of American Biography* (1928). These sources are not always in agreement.
10. *Handbook*, and the (oral) recollections of Edward Fowles, to whom I am much indebted for this and for other information concerning the relationship between Duveen and Altman.
11. *Handbook*. See also Germain Seligman, *Merchants of Art* (New York, 1961), p. 19. The rock crystals came from the Spitzer collection.
12. (Oral) recollections of Edward Fowles.
13. Agnew's, 'London Day Book', no. 21, 4 June 1903, p. 125. I am most grateful to Geoffrey Agnew for making these records available to me.
14. René Gimpel, *Diary of an Art Dealer* (London, 1966), pp. 298–99, claims that it was his father who in 1905 first interested Altman in Old Masters, but the previous note shows that this is not strictly accurate.
15. Rugs, tapestries, and, above all, Oriental porcelain were always to remain as important for Altman as his pictures. If I have concentrated primarily on the latter, it is both because the documentation is much richer and because it is only in regard to his pictures that I feel qualified to write in any detail.
16. See two articles by Emile Michel, 'La Galerie de M. Rodolphe Kann', *Gazette des Beaux-Arts*, 3rd ser., viii (1901); also *The Times* (London) (7 August 1907), and the *Daily Telegraph* of the same date.
17. 'Mr. Altman's Reception', *American Art News* (14 March 1908), p. 1.
18. For full details see the catalogue of the exhibition, *The Hudson–Fulton Celebration*, September–November 1909, 2 vols. (New York, 1909).
19. See Archives, letter of 11 February 1909, from Edward Robinson to J. Pierpont Morgan.
20. Archives, minute book, vol. 3, report of 9 November 1892, p. 135. I am very grateful to John Buchanan for drawing my attention to this.
21. Archives, letter of 21 April 1897.
22. Archives, letter from Robinson of 2 May 1907.
23. Archives, cable from Morgan of 1 March 1909.
24. Archives.
25. See 'Altman Bequest', *Bulletin*, pp. 226–8.

26. He had also bought in the meantime three more paintings by Rembrandt.
27. Our information about this trip is unfortunately sparse. In an article in the *Vossische Zeitung* of 18 January 1914, Bode recalls Altman's visiting him in the Berlin Museum and telling him 'that he had just come from Paris—a visit to the Louvre had given him extraordinary pleasure, for previously he had only once seen the Louvre, in fact with a Cook's party'. Edward Fowles has kindly shown me some letters from Henry to Joseph Duveen in his possession dating from the summer of 1909; it is from one of these (8 August) that we know that he visited Holland.
28. See 'Art Gallery for Mr. Altman', *American Art News* (23 October 1909), p. 1.
29. For a discussion of the case, see S. N. Behrman, who, however, does not refer to Altman's intervention. I have deduced this from a letter of his in the Duveen File, dated 22 April 1913: 'I stood by you in your hour of trouble, alone! and unselfishly!! interviewing newspaper men, and stopping certain insinuating remarks made by private parties, as well as dealers, and emphasising to everybody my high opinion of you and your firm, knowing as I did these expressions would reach the government's ears, either directly or indirectly.—Do I not *desire* [sic] *some* consideration for all this?—'
30. Duveen File, letter of 22 July 1912. It is true that on other occasions Altman could be more forthcoming, and Mr Behrman has kindly let me know that he has information about the very warm relationship that existed between them on a more informal level.
31. Duveen File, letter of 23 April 1912.
32. Duveen File, letters of 23 April and 28 June 1912. Many similar examples could be quoted.
33. Duveen File, letters of 3 July and 6 September 1912.
34. Duveen File, letters of 19 and 23 August 1912.
35. Letters from Henry to Joseph Duveen of 8 August 1909 and 3 and 8 April 1913 kindly shown to me by Edward Fowles.
36. Duveen File, letter of 14 June 1912.
37. Duveen File, letter of 28 June 1912.
38. Duveen File, letter of 26 June 1912.
39. Duveen File, letters of 11 July, 14 June and 31 May 1912, respectively.
40. Duveen File, letter of 26 June 1912.
41. Duveen File, letter of 23 May 1913.
42. Duveen File, letter of 9 July 1912.
43. The letters from Warren C. Bevan bringing the picture to Altman's notice are dated 17 May, 3 June, 17 June, 11 August and 13 October 1909. He mentions the authentication by Beruete and says that Roger Fry had tried to buy the picture

for the Metropolitan. It actually belonged to a Mr De Soto of Zurich. Beruete's opinion is given in letters from him and from his son, dated 7 November 1910, and 7 January (misdated December) 1911. All this correspondence is kept with the picture's file in the Department of European Paintings. Gimpel (*Diary*, p. 303) has some interesting details on Altman's enthusiasm for this picture.

44. In 1913, for instance, a 'Country Court Bailiff' in Northallerton, Yorkshire, wrote directly to Altman: 'I have in my possession a fine old painting by Titian, the subject being "Venus Reposing". I wish to dispose of the same and shall be pleased to hear from you if interested in Old Master Paintings' (Duveen File, 24 July 1913).

45. There is a great deal of correspondence about this in the Duveen File. At one stage (12 October 1912) Altman actually decided to get rid of both the portraits. The Olivares is now in the Museu de Arte, São Paulo, Brazil.

46. About this picture Berenson wrote to Gimpel, from whom Altman acquired it: 'it was painted entirely by his own hand and not as was so often the case in pictures by old masters with the assistance of pupils' (letter of 21 April 1910, kept with the file on the picture in the Department of European Paintings). At that time the background of the painting consisted of a landscape with palm trees, 'low hills and a wide expanse of twilight sky, much in the spirit of the painting of the last century' (*Handbook*, p. 42). A cleaning in 1951 revealed the original gold ground.

47. Letter from Berenson to Duveen's of 11 March 1912, kept with the file on the picture.

48. Berenson's article 'Venetian Painting, Chiefly before Titian (at the Exhibition of Venetian Art, New Gallery, 1895)' is reprinted in *The Study and Criticism of Italian Art* (London, 1901), I, p. 145.

49. Berenson's two letters, the first to Joseph Duveen, dated 14 January 1912, and the second to Messrs Duveen, dated 11 March 1912, are kept with the file on the picture. In the first of these he referred to the article cited in the previous note but did not mention the fact that he had discussed this particular picture before. He did say specifically, however, that it was he who was bringing the picture to Duveen's notice.

50. Duveen File, letter of 17 May 1912.

51. The correspondence is to be found in the Duveen File, letters of 12 and 26 June 1912. Berenson's letter of 14 November 1912, confirming his conversation with Joseph Duveen in response to Altman's query, is with the file on the picture, as is an earlier letter by him of 12 March.

52. Duveen File.

53. See Duveen File, letters of 14 and 19 June 1912.

54. Duveen File, letter of 22 April 1913. The other outstanding Italian picture is Tura's *Portrait of a Member of the Este Family*.

55. Altman's finest piece of sculpture, Rossellino's marble relief of the Virgin and Child with Angels, came from the Hainauer Collection, which Bode had hoped to buy for the Berlin Museum.

56. Among his other eighteenth-century sculptures reference should be made to Pigalle's excellent Mercury (terracotta) and Houdon's bust of his daughter Sabine. On 14 June 1912 (Duveen File) Duveen wrote to Altman of the bust, calling it 'as great as anything that was ever executed by Donatello'.

57. Duveen File, 6 September 1912. In 1969 Yvonne Hackenbroch proposed (*Connoisseur*, clxxii, pp. 175–81) that the cup should be attributed to Jacopo Bilivert of Delft. She now suggests *Metropolitan Museum Journal*, 1984–5) that it is a nineteenth-century reconstruction.

58. See the sale catalogue of this collection, and also *The Times* (London) (1 June and 16 October 1912, and 17 March, 17 May and 10 June 1913).

59. Duveen File, 14 and 23 May 1913.

60. Duveen File, letters of 20 and 23 May 1913.

61. Duveen File, letter of 30 May 1913, and cable of 4 June 1913. As an illustration of the code, I quote from a cable regarding an earlier purchase (Duveen File, 29 June 1912): 'Agvapyafap/ inekiiwion/ubusodoud/memling' (Have seen Altman very good humor will answer in re Memling').

62. Duveen File, cable of 6 June 1913: 'you must not be angry if later some newspapers suggest that picture may be going to you or Frick or Widener, because the fame of your collection is so great here that some enterprising journal may hazard guess and couple your name with the other two'.

63. Duveen File, letters and cable of 20, 23 and 30 May 1913. The Brouwer was later presented to the Museum by Altman's closest associate and successor in his business enterprise, Michael Friedsam.

64. Duveen File, cables of 6 and 7 June 1913, and letter of 12 June: 'Of course your cable to Mr. K. certainly did good in one way but it was unfortunate that you had to expose your hand to him. I think he acted most loyally in the affair.' See also the letter from Altman of 26 June 1913.

65. Duveen File, cables and letter of 9, 10 and 12 June 1913. Altman had been prepared to go very much higher for the picture.

66. Duveen File, letter of 22 April 1913. Morgan had died on 31 March.

67. Duveen File, letter and cable of 18 July and 22 September 1913.

68. Duveen File, letters of 11 June and 1 July 1913.

69. Duveen File, letters of 1 and 18 July 1913.
70. Duveen File, letters of 19 June 1912 and 1 July 1913.
71. Duveen File, letters of 18, 19 and 22 September 1913. Altman also thought of getting rid of the 'Rembrandt' portrait of Hendrickje Stoffels (now tentatively attributed to Barent Fabritius).
72. Duveen File, letter of 6 September 1912.
73. It is, of course, not easy to track these down. We hear on several occasions of his rejecting pictures that were offered to him—a Jacopo da Sellajo, a Pintoricchio Madonna and Child 'as fine as Raphael', two portraits by Mainardi, and so on.
74. Gimpel sold Altman a Turner in 1907, but according to the dealer's son (Gimpel, *Diary*, p. 300) Altman returned it in 1908. If that is correct, it must

have been another picture by that artist that he was still trying to dispose of in July 1913 (Duveen File, 18 July) and that, in fact, was still with his estate after his death (Duveen File, 17 December 1913).
75. Duveen File, 19 June 1912.
76. Duveen File, letters of 12 and 26 June 1912.
77. For the comments of John G. Johnson on Altman, see Saarinen, *Proud Possessors*, pp. 108–9.
78. Duveen File, letters of 12 June and 5 July 1912.
79. Duveen File, letters of 12 and 14 June and 5 July, 1912.
80. One might also include Vermeer in this category. Though he was 'discovered' in the 1860s, European collectors were to show far less interest in him than were the Americans.

NOTES TO ESSAY 14

1. *Lettres de Gauguin à sa femme et à ses amis,* ed. Maurice Malingue (Paris, 1946), p. 298.
2. Albert Wolff in *Le Figaro* (3 April 1876)—frequently reprinted: see, for instance, Jacques Lethève, *Impressionistes et Symbolistes devant la Presse* (Paris, 1959), pp. 76–7.
3. See Gustave Toudouze, *Albert Wolff* (Paris, 1883); and Jacques-Emile Blanche, *De Gauguin à la Revue Nègre* (Paris, 1928), pp. 136–7.
4. Théophile Gautier in *Le Moniteur Universel* (11 May 1868)—reprinted in Lethève, *Impressionistes,* p. 51.
5. Quoted in François Benoit, *L'Art Français sous la Révolution et l'Empire: les doctrines, les idées, les genres* (Paris, 1897), p. 142, note 2.
6. Allan Cunningham, *The Life of Sir David Wilkie,* 3 vols. (London, 1843), III, p. 268.
7. W. P. Frith, *My Autobiography and Reminiscences,* 3rd ed., 3 vols. (London, 1887), III, pp. 201–2.
8. Mrs Russell Barrington, *The Life, Letters and Work of Frederic Leighton,* 2 vols. (London, 1906), I, p. 112.
9. From two letters by Delaroche of 1850 and 1852—in Charavay catalogue, October 1967, p. 24, no. 31915, and Ulbach, *Paul Delaroche,* p. 359, kindly drawn to my attention by Mr Norman Ziff.
10. *Exposition des oeuvres de Edouard Manet,* preface by Emile Zola (Paris, 1884), p. 22.
11. Maxime Du Camps, 'Les Beaux Arts à l'Exposition Universelle de 1855', quoted in Maurice

Tourneux, *Eugène Delacroix devant ses contemporains* (Paris, 1886), p. 95.
12. Letter to Rev. William Mason, 22 March 1796—in *The Letters of Horace Walpole,* ed. Mrs Paget Toynbee, XV, p. 398.
13. Ch. Lenormant, *François Gérard, peintre d'histoire* (Paris, 1846), pp. 16–17.
14. Quoted in G. H. Hamilton, *Manet and his Critics* (New Haven, 1954), p. 164.
15. Viollet-le-Duc, quoted in Albert Boime, *The Academy and French Painting in the Nineteenth Century* (London, 1971), p. 183.
16. Joséphin Péladan, 'Le Salon de 1882', in *La Décadence esthétique,* I, *L'Art Ochlocratique* (Paris, 1888).
17. Henry Houssaye in the *Revue des Deux Mondes* (1 June 1882), quoted in Hamilton, *Manet,* p. 254.
18. Zola, 'Le Salon de 1879', in *Nouvelles artistiques et littéraires,* reprinted in Emile Zola, *Salons,* ed. Hemmings and Niess (Geneva and Paris, 1959), p. 228.
19. François Coppée, quoted in Emilien Carassus, *Le Snobisme et les lettres françaises de Paul Bourget à Marcel Proust, 1884–1914* (Paris, 1966), p. 28.
20. Henri Dorra and John Rewald, *Seurat* (Paris, 1959), p. xlix.
21. Quoted in Eugenia W. Herbert, *The Artist and Social Reform: France and Belgium, 1885–98* (New Haven, 1961), p. 189.
22. Dorra and Rewald, *Seurat,* p. lxv.

INDEX

Acknowledgements

1. **The Apotheosis of Newton in Art**
This was delivered as a lecture to the tricentennial celebration of the *Annus Mirabilis* of Sir Isaac Newton organised by the Department of Philosophy of the University of Texas at Austin in November 1966. It was published in the *Texas Quarterly* (Winter 1967), pp. 218–37.

2. **Gibbon and the History of Art**
An earlier version of this was given as a paper at the conference held in Rome in January 1976 to celebrate the bicentenary of the publication of the *Decline and Fall*, and was published in *Daedalus*, Summer 1976, as Vol. 105, No. 3 of the Proceedings of the American Academy of Arts and Sciences. The revised paper was published in *Edward Gibbon and the Decline and Fall of the Roman Empire*, ed. G. W. Bowersock, John Clive and Stephen R. Graubard (Cambridge, Mass., Harvard University Press, 1977), pp. 193–205. Copyright © 1976 by the American Academy of Arts and Sciences.

3. **The Baron d'Hancarville: An Adventurer and Art Historian in Eighteenth-Century Europe**
An earlier, less complete, Italian version of this essay was given as a talk to the conference 'Carlo di Borbone da Napoli a Madrid. Aspetti e problemi della civiltà artistica del Settecento' held in Naples in 1980, whose proceedings (edited by Cesare de Seta) were published by Laterza. The present text first appeared in *Oxford, China and Italy: Writings in Honour of Sir Harold Acton on his Eightieth Birthday*, ed. Edward Chaney and Neil Ritchie (London, Thames & Hudson, 1984), pp. 177–91.

4. **An Italian Patron of French Neo-Classic Art**
This originated as the Zaharoff Lecture given in Oxford University in 1972 and was published by the Clarendon Press in that year.

5. **Art and the Language of Politics**
An earlier version of this was given as a lecture at the University of East Anglia in March 1974. It was published in the *Journal of European Studies*, iv (1974), pp. 215–32.

6. **The Manufacture of the Past in Nineteenth-Century Painting**
This article first appeared in *Past and Present*, no. 53 (November 1971), pp. 109–20. World Copyright: The Past and Present Society, 175 Banbury Road, Oxford, England.

7. **The Old Masters in Nineteenth-Century French Painting**
This was first published in the *Art Quarterly*, xxxiv, no. 1 (1971), pp. 55–85.

8. **The Sad Clown: Some Notes on a Nineteenth-Century Myth**
This originally appeared in *French 19th Century Painting and Literature with special reference to the relevance of literary subject-matter to French painting*, ed. Ulrich Finke (Manchester University Press, 1972), pp. 1–16.

9. **Doré's London**
This was first published in *Architectural Design* (December 1968), pp. 600–4. Copyright © *Architectural Design*. Reproduced from *Architectural Design* magazine, London.

10. **Giorgione's *Concert champêtre* and its Admirers**
This was first delivered as a lecture in March 1971 to the Royal Society of Arts, and was published in the *Journal of the Royal Society of Arts* (1971), pp. 543–55.

11. **A Martyr of Attributionism: Morris Moore and the Louvre *Apollo and Marsyas***
This first appeared in French in the *Revue de l'Art*, no. 42 (1978), pp. 77–88.

12. **A Turk and his Pictures in Nineteenth-Century Paris**
This was first published in the *Oxford Art Journal*, v, no. 1 (1982), pp. 40–7.

13. **The Benjamin Altman Bequest**
This was first published in *Metropolitan Museum Journal*, iii (1970), pp. 259–80. Copyright © 1971 The Metropolitan Museum of Art.

14. **Enemies of Modern Art**
This was first delivered as the James Lecture at New York University in April 1983. It was published in the *New York Review of Books* (30 June 1983), pp. 19–25. Reprinted with permission from *The New York Review of Books*, Copyright © 1983 Nyrev, Inc.

Benedict Nicolson 1914–1978
This obituary appeared in the *Burlington Magazine*, cxx (July 1978), pp. 429–31.